THE CHINESE SCHOLAR'S STUDIO
Artistic Life in the Late Ming Period

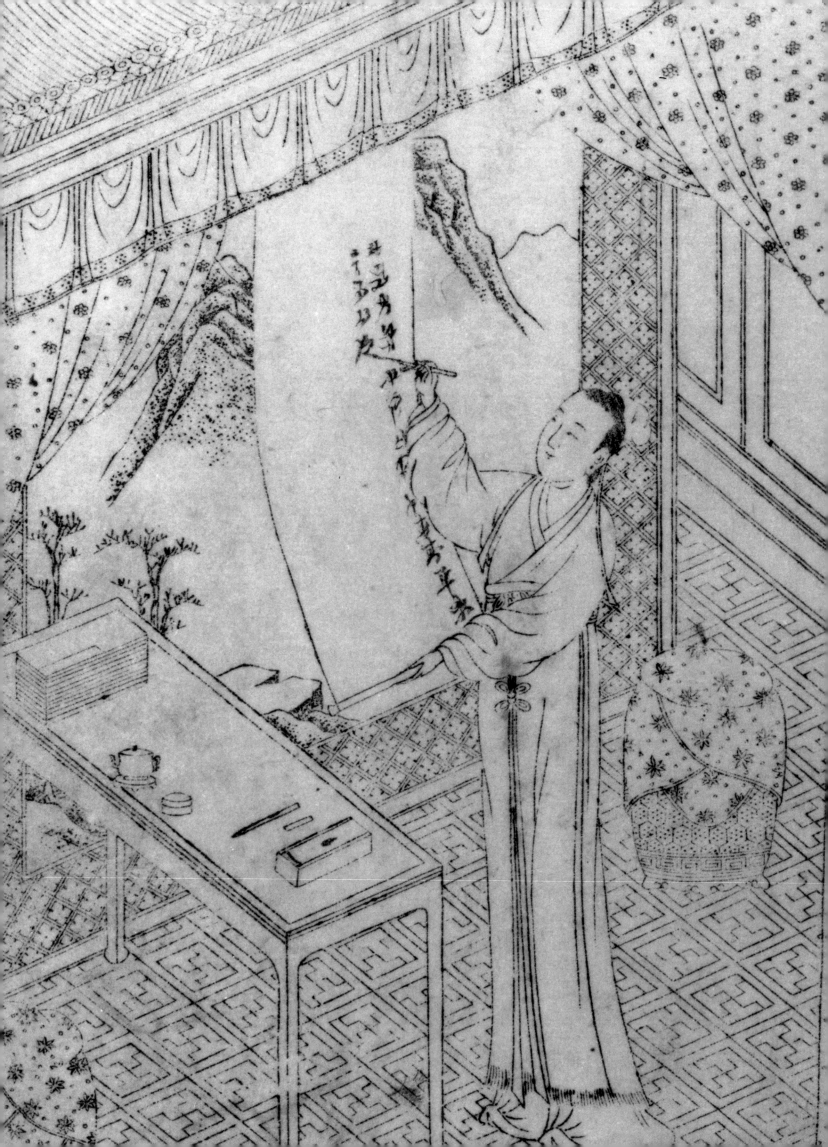

THE CHINESE SCHOLAR'S STUDIO

Artistic Life in the Late Ming Period

An Exhibition from the Shanghai Museum

Editors: CHU-TSING LI, JAMES C.Y. WATT

Contributors: JAMES C.Y. WATT, CHU-TSING LI, WAI-KAM HO, ZHU XUCHU, WANG QINGZHENG, ROBERT D. MOWRY

Thames and Hudson

Published in association with THE ASIA SOCIETY GALLERIES

Published on the occasion of
The Chinese Scholar's Studio,
organized by The Asia Society Galleries
in collaboration with the Shanghai Museum.

THE ASIA SOCIETY GALLERIES
NEW YORK
October 15, 1987–January 3, 1988

SEATTLE ART MUSEUM, SEATTLE
February 4, 1988–March 27, 1988

ARTHUR M. SACKLER GALLERY
WASHINGTON, D.C.
May 2, 1988–June 26, 1988

NELSON-ATKINS MUSEUM OF ART
KANSAS CITY
July 30, 1988–September 25, 1988

Frontispiece: *Illustrated Story of the Lute* (no. 26)

Project Manager: Osa Brown
Project Editor: Judith Smith
Designer: Peter Oldenburg
Photographer: David Allison

Composition by Trufont Typographers, Inc., Hicksville,
 New York
Map by Joseph Ascherl
Calligraphy on pages 65, 91, 103, 111, 123, 135 by Ben Wang
Rubbings made by the Shanghai Museum

First published in the United States in 1987 by Thames and Hudson
Inc., 500 Fifth Avenue, New York, New York 10110 and The Asia
Society Galleries, 725 Park Avenue, New York, New York 10021

First published in Great Britain in 1987 by Thames and Hudson Ltd.,
London

Library of Congress Catalogue Card Number 87-50187

Printed and bound by Toppan Printing Company Ltd., Tokyo, Japan

Table of Contents

FUNDING ACKNOWLEDGMENTS

The Asia Society Galleries gratefully acknowledges the generous support of the following funders for *The Chinese Scholar's Studio* exhibition and catalogue.

CORPORATE SPONSORS

Burlington Northern Foundation representing
Burlington Northern Railroad Company, El Paso
Natural Gas Company, Glacier Park Company,
Meridian Minerals Company, Meridian Oil Inc.,
Plum Creek Timber Company, Inc., BN Motor
Carriers Inc.
Weyerhaeuser Company Foundation
Boeing Company

MAJOR FUNDING

EXHIBITION AND CATALOGUE
National Endowment for the Humanities

ADDITIONAL CATALOGUE SUPPORT
Dr. and Mrs. John C. Weber

ADDITIONAL SUPPORT

National Endowment for the Arts
New York State Council on the Arts
The Armand G. Erpf Fund by Mr. and
Mrs. Gerrit P. Van de Bovenkamp
The Starr Foundation
The Andrew W. Mellon Foundation
Friends of The Asia Society Galleries
The B.D.G. Leviton Foundation

An indemnity has been granted by the Federal Council
on the Arts and Humanities

Foreword

DURING THE late Ming period, from the beginning of the Wanli reign in 1573 to the end of the dynasty in 1644, there were new developments in the history of Chinese art. In the area of calligraphy and painting, the Songjiang school of painting, with Dong Qichang as its leader, emerged to enrich these visual arts. In many areas of the decorative arts there also were new creative developments. Throughout the Ming period the region of the most active artistic development was the Yangzi River delta. Within the domain of the arts of calligraphy and painting, the center of activity in the late Ming was the Songjiang and Jiaxing region. This exhibition, *The Chinese Scholar's Studio: Artistic Life in the Late Ming Period*, focuses on the life of the artists of this region.

The intellectual world of the late Ming was complex. There were people who, confronting contradictions in society, advocated "using knowledge to benefit the world." Others followed the "unity of knowledge and action" school of thought which, developing the Neo-Confucian School of Principle, promoted "innate knowledge" and "the identity of mind and principle" as its theoretical foundation. There were writers who used their works to address social issues; and there were famous scholars who opposed the corrupt bureaucratic government. The artists of the late Ming, in contrast, took another approach: they strove to transcend the petty struggles of the mundane world, and in their own private realm they devoted themselves to creative artistic activities.

The painting entitled *Venerable Friends* in this exhibition (no. 1) is a work of special significance. Here, the famous painter Xiang Shengmo of Jiaxing recorded his friendship with the artists Dong Qichang, Chen Jiru, Li Rihua, Lu Dezhi, and Monk (Qiutan) Xiangong. Xiang Shengmo invited the painter Zhang Qi to paint the portraits, while he himself added the background. The artists depicted in *Venerable Friends* were the foremost masters of late Ming literati painting. Their art attained a high level through creative interaction and mutual discussion. The development of Ming literati painting constitutes a unique period in Chinese painting history. In particular, the Songjiang school, with its extreme elegance and unconstrained use of brush and ink, fully realized the manifestation of the literatus painter's personal taste, his high-level integration of calligraphy and painting, and his pursuit of the poetic realm. Just as in Chinese literary theory, "poetry expresses intention," so the literati painting of the late Ming represents the creative expression of the artist's attitude towards society and art.

Today Songjiang is one of the suburban counties under the jurisdiction of the Shanghai municipality. During the Ming period, the region under the jurisdiction of Songjiang prefecture included its neighboring counties of Jiading, Taicang, and Jiaxing. Together, they formed the most fertile region north of Qiantang Bay in the environs of Lake Tai—a region that stretched between Suzhou and Hangzhou. Amidst the unstable situation and mounting social conflicts of the late Ming, there emerged in this region a relatively settled situation after the suppression of "Japanese pirate" raids. Because of its flourishing culture and economy, and even more because of its historical traditions, this region attracted all types of people from the intelligentsia and supported the development of a number of artistic schools. The objects in the present exhibition center around the works of the artists of the Songjiang, Jiading, and Jiaxing area and decorative objects of the scholar's studio. A number of these works have been transmitted from generation to generation in this region over a long period of time; others are cultural relics that have been excavated during the last twenty or more years. I trust that the mounting of this exhibition will aid in future research and understanding of the life of the late Ming artists.

The Chinese Scholar's Studio exhibition and the catalogue written to accompany it are the laudable achievements of friendly cooperation between Chinese and American scholars. I wish to thank Dr. Andrew Pekarik, Director of The Asia Society Galleries, for his initiative, his endeavors from beginning to end, and his outstanding organizational work. Thanks are also extended to Osa Brown, Assistant Director of The Asia

Society Galleries, and to Maggie Bickford for all their painstaking work on the exhibition and catalogue. I also thank Wai-kam Ho, Chu-tsing Li, and James Watt for their great effort in selecting and researching the works of art for this exhibition. Robert Mowry's work during the period of preparation for the exhibition also is worthy of praise. The efforts of David Allison, photographer for the catalogue, remain memorable.

After its showing at The Asia Society Galleries, this exhibition will travel to the Seattle Art Museum, the Arthur M. Sackler Gallery of the Smithsonian Institution, and the Nelson-Atkins Museum of Art, Kansas City. I express my sincere thanks to these museums for their friendly cooperation. This is an instance of significant cultural and scholarly exchange between the Shanghai Museum and museums in the United States. I trust that this kind of exchange will in the future develop even further.

MA CHENGYUAN
Director, Shanghai Museum

Preface and Acknowledgments

AMERICANS interested in Chinese art, including academics, museum specialists, and collectors, have long realized the central importance of the scholar-artist tradition in Chinese art. The results of this can be seen in our museums and libraries and in the exhibitions of Chinese art that have traveled across the United States in the last twenty years. *The Chinese Scholar's Studio* was designed to look anew at the literati tradition in Chinese art and to express its unique character and richness in ways that would be accessible to those turning toward China for the first time.

The Asia Society Galleries is committed to displaying the best of Asian art in ways that enhance our understanding of the values and experiences of the people of Asia and the Pacific. Although the culture of the scholar-artist is firmly rooted in Chinese history and tradition, some of its features have parallels in our own systems of thought and creativity. Recognizing the similarities and differences helps us understand others and ourselves.

From the very beginning this exhibition project has been one of the smoothest and most pleasurable international collaborations that we have experienced, and I am deeply grateful to Mr. Ma Chengyuan, Director of the Shanghai Museum, for enthusiastically supporting this project and making it a reality. The project began over three years ago, almost immediately upon my arrival at The Asia Society. We proposed the theme to Huang Xuanpei, Deputy Director and Chief of the Archaeological Section, Shanghai Museum, who encouraged the idea and together with Ma Chengyuan set the project in motion.

We greatly appreciate the expertise of Wang Qingzheng, Vice Director, and Zhu Xuchu, Assistant to the Director and Chief, Department of Communication and Education, of the Shanghai Museum, who wrote illuminating essays for the catalogue. We owe our gratitude to the many other members of the Shanghai Museum staff who were extremely helpful to the exhibition curators and The Asia Society Galleries staff while they researched and photographed the objects. Specifically, we would like to thank Ding

Yizhong, Chief, Cultural Exchange Office, and his devoted assistants, Xu Jie and Zhou Yanchun; Chen Peifen, Chief, Department of Bronze Research; Fan Dongqing, Deputy Chief, Department of Ceramics and Artifacts; Zhu Shuyi, Head, Arts and Crafts Section; and Zhong Yilan, Leader of Painting Research Section, Department of Painting and Calligraphy. Huang Fukang, Deputy Chief, Department of Preservation, provided invaluable assistance with the photography. I also wish to acknowledge the friendly assistance of Ambassador Han Xu and Cultural Counselor Xu Jiaxian, the Embassy of the People's Republic of China to the United States, in encouraging this cultural exchange.

The team of curators who, in collaboration with the staff of the Shanghai Museum, put this exhibition together—Chu-tsing Li, Judith Harris Murphy Distinguished Professor of Art History, Kress Foundation Department of Art History, The University of Kansas; James C. Y. Watt, Senior Consultant for Chinese Antiquities and Decorative Arts, The Metropolitan Museum of Art; Wai-kam Ho, Laurence Sickman Curator of Chinese Art, the Nelson-Atkins Museum of Art; and Robert D. Mowry, Associate Curator of Oriental Art, Harvard University Art Museums—are uniquely qualified to deal with the difficult subject of literati art. At every stage of the project they brought imagination, scholarship, and a deep commitment to the values of the scholar-artist tradition. At organizational meetings I sometimes felt that I was in the modern equivalent of the Chinese scholar's studio. I deeply appreciate their cooperation and enthusiasm.

We are proud that this exhibition will be shown at other museums regarded as leading centers for Asian art, and we are especially grateful to Henry Trubner and Jay Gates of the Seattle Art Museum, Thomas Lawton and Milo Beach of the Freer Gallery and Arthur M. Sackler Gallery, and Marc Wilson of the Nelson-Atkins Museum of Art.

For the organization and display of the exhibition at The Asia Society I am indebted to James Watt for making the selection of the objects and for his constant

guidance on all aspects of the catalogue and exhibition. Dawn Ho Delbanco's writing of the labels, interpretive materials, and signage is also deeply appreciated. Cleo Nichols and David Harvey created the impressive display and graphic design for the exhibition. Dana Stein Dince, Registrar and Exhibitions Coordinator for the Galleries, efficiently organized all of the art handling and innumerable schedules and arranged the complex packing requirements with Jack Lucivero. My warm thanks also to Maggie Bickford, Assistant Professor of Art, Brown University, and Curator of Asian Art, Museum of Art, Rhode Island School of Design, for her expert help with the planning and photography, as well as for translating Ma Chengyuan's preface and the two Chinese essays. Thanks also to David Allison for his superb photographs, and to James Lally for his expert advice.

Osa Brown, Assistant Director and Publications Coordinator of the Galleries, had overall responsibility for the photography and catalogue and coordinated all aspects of the exhibition project during my frequent travels, and I am extremely grateful to her for handling all matters with grace, humor, and a never-failing commitment to quality. She, in turn, had the devoted and highly capable support of Pamela Sapienza. We owe our profound gratitude to Peter Oldenburg, who did a splendid job of designing this complex book. We are very appreciative to have had the dedicated and professional help of Judith Smith as the editor of this catalogue. Mary Laing worked on the editing of the essays and Katharine Parker helped prepare the footnotes and bibliography.

On behalf of the authors of this catalogue I would also like to thank Qingli Wan and Alan Atkinson, research assistants in the Kress Foundation Department of Art History, The University of Kansas; Eugene Wu and his staff at the Harvard-Yenching Library, Harvard University; Nancy Straight, Secretary to the Curators, Nelson-Atkins Museum of Art; John Rosenfield, Abby Aldrich Rockefeller Professor of Oriental Art and Curator of Oriental Art, Harvard University Art Museums; Fumiko E. Cranston, Research Associate, Oriental Department, Harvard University Art Museums; Nicole Fronteau, Staff Assistant, Oriental Department, Harvard University Art Museums; the staff of the Rubel Asiatic Research Collection of Harvard University's Fine Arts Library; and Shu-mei Cheng.

In the end a major exhibition of this kind is most indebted to those whose financial support makes it possible. I wish to thank David Drabkin for a planning grant to the project from The B.D.G. Leviton Foundation. I am deeply grateful to Richard M. Bressler, Chairman and Chief Executive Officer of Burlington Northern Inc., and Donald K. North, President of the Burlington Northern Foundation, for their leadership in coordinating the corporate sponsorship for the exhibition from the Burlington Northern Foundation, the Weyerhaeuser Company Foundation, and the Boeing Company. We are thankful to the National Endowment for the Humanities and the National Endowment for the Arts for providing major grants in support of this exhibition. We are also very appreciative of the generous support of Dr. and Mrs. John C. Weber, whose dedication to Chinese art and to international cooperation have been an inspiration. Dr. and Mrs. Weber first became involved in this project in Shanghai, while photography was underway, and their subsequent encouragement, advice, and support have played a major role in the success of this fruitful collaboration between The Asia Society and the Shanghai Museum. The exhibition was also assisted by a grant from the Armand G. Erpf Fund by Mr. and Mrs. Gerrit P. Van de Bovenkamp. We are grateful for the grant received from the New York State Council on the Arts. Additional support for this exhibition program has been provided by the Friends of The Asia Society Galleries, led by Mary Griggs Burke, The Andrew W. Mellon Foundation, and the Starr Foundation. An indemnity has been granted by the Federal Council on the Arts and Humanities.

We feel privileged to have had this opportunity to advance the understanding of Chinese art and culture in America, and I hope that it will lead to many more collaborations of this kind.

ANDREW PEKARIK
Director, The Asia Society Galleries

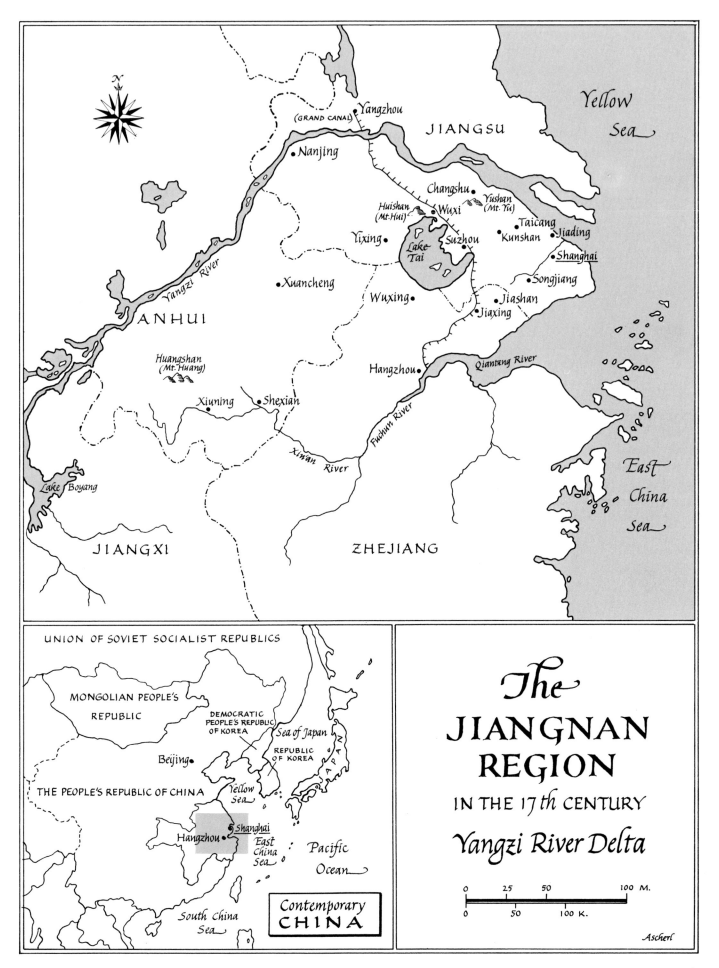

The

JIANGNAN
REGION
IN THE 17th CENTURY
Yangzi River Delta

0 25 50 100 M.

0 50 100 K.

Ascherl

Chronology

THE CHINESE SCHOLAR'S STUDIO
Artistic Life in the Late Ming Period

The Literati Environment

JAMES C. Y. WATT

THE ENVIRONMENT of the man of letters in the late Ming period, which for the purpose of the present discussion covers the last quarter of the sixteenth century to the end of the dynasty in the year 1644, was as much a product of his own creativity as the setting for his literary and artistic endeavors. In many ways, it was his crowning achievement. Possibly at no other time in Chinese history have artistic ideals been so successfully realized not only in the artist's works but also in his everyday life. In creating for themselves an extraordinarily rich and delicate world, the literati made a significant contribution to the cultural heritage of China whose effects can still be felt. This short essay attempts to explore the attitudes and critical views of the literati as recorded in their writings; to show how those views formed the basis of their artistic activities, including the creation of their environment; and to describe the principal ways in which they chose to express themselves as artists and connoisseurs.

The term literatus/literati, as used in this study, requires a word of explanation. It refers to a highly cultivated group of men in the late Ming whose basic training was in literature but whose major achievements were in almost any artistic activity outside their field of professional competence. Indeed, by their own admission and their own critical standards, the best writing of the Ming period was not done by any member of this group of highly cultured literary men. It was to be found in popular song lyrics and in folk literature in general. On the other hand, the literati disdained the work of professional artists who were not also versed to some degree in literature and who did not share their views. The only exceptions made were for those arts, such as jade carving, that involved materials difficult to work with and technical skills that required years of dedicated apprenticeship to acquire. Thus, the literati had high praise for the works of the literatus potter known as Hao Shijiu and the jade carver Lu Zigang, but little regard for those of professional painters and seal carvers beyond their level of technical competence.

It has often been remarked that the art of the Chinese literati is that of the amateur. The literati themselves cherished this illusion. It is perhaps more accurate to say that for the literati, all art pertains to the condition of literature and should be judged by standards derived from it.

What is important to us, therefore, is not the creative literature produced by the subjects of our study, but their numerous works of literary theory and criticism. The society of the literati was in some ways not unlike that described by W. B. Yeats in his poem "The Scholars": "All shuffle there; all cough in ink; / . . . all think what other people think; / All know the man their neighbour knows." It was a highly self-conscious, competitive, and tightly knit society in which much creative energy was channeled into achieving insights that would enable one to propose a new interpretation of an old poem or an apter choice of words in somebody else's line. Although desperate efforts were made to break away from thinking "what other people think," they were efforts that bore fruit in criticism and not in creative writing, which was hampered by a self-conscious awareness of fashionable rules of taste and exposure to critical scrutiny. Toward the end of the sixteenth century, the Yuan brothers and the writers of the Gongan school achieved a genuine breakthrough. Yet even with the works of these writers we are moved not so much by their purely literary quality as by their comparatively refreshing style and the sheer delightfulness of the ideas and personalities of the authors. Compared with so much of the prose and poetry of the Tang and Song periods, there is little in the writings of the Gongan school that one would wish to commit to memory. It was, in fact, not in literature but in the plastic arts, and to a lesser extent in music, that the late Ming literati unleashed their creative energy and made their lasting contribution to Chinese culture.

In recent writing the literatus, *wenren*, is often referred to as a scholar. It is true that the literati were scholars compared with the majority of the population, which was illiterate or semiliterate, but few of them would qualify for that description in the strict sense of the Chinese term for scholar, *xuezhe*, or as the word scholar is used and understood today in the West. Although learned and cultured, most late Ming literati did not conscientiously apply themselves to scholarship. Li Rihua (1565–1635), one of the most important literary figures of his time, was often careless in his references and quotations, as has been pointed out by later scholars such as the editors of the Qing imperial library collection, the *Sikuquanshu*. Nevertheless, Li Rihua was a man of considerable erudition, and his

writings on many subjects offer useful guidelines in a study of literati ideals and practices.

Concentration and patience are required to read Li Rihua, or any other late Ming author, on literary and artistic matters. Almost every work in this field takes the form of disjointed notes in no particular order, including comments on a poet or poem or one memorable line, an anecdote or a piece of personal recollection, sometimes a sudden flash of insight into the creative process, an attack on a contemporary, occasionally a word of praise for another poet (usually one of the Tang or Song masters), or yet a piece of philosophizing on society and the arts or on literature and morals. One is reminded of that great English work of literary criticism, Coleridge's *Biographia Literaria*, which has often been criticized for lack of structure. A latter-day editor of the *Biographia*, while noting that it is "one of the most annoying books in any language," also adds that "you must follow it step-by-step; and, if you are ceaselessly attentive, will be ceaselessly rewarded."[1] The same advice holds for the reading of late Ming authors.

Apart from their total lack of structure, the writings of our Ming authors are open to another serious criticism that is often leveled at the *Biographia*—"the tangled but always fascinating problem of plagiarism."[2] The question of plagiarism applies not so much to literary opinions as to a popular class of late Ming writing best described as notes on the appreciation of things: antiquities, everyday objects, gardens and plants, and anything that can be observed, used, and classified, and upon which an opinion can be expressed. Plagiarism in this field was indiscriminate and rampant, and the problem was compounded by the contemporary publishing practice of appending the names of well-known writers to the works of those less famous.

Another problem for the reader of late Ming authors is that the writing itself is like a maze constructed out of bricks collected from the ruins of many different periods spread over a very large territory. The vocabulary and the language were so worn by centuries of repeated use that they had all but lost any definition, not to mention freshness. And yet, using this tired language, writers with true originality of mind somehow managed to convey their meaning and to make individual statements.

LITERARY IDEALS

Certain literary ideals were to determine the character of most of the literary, artistic, and musical activities of the late Ming period, forming the ultimate values upon which literati taste would be founded. It is possible to trace the development of these ideals from the time of the pedagogue and philosopher Wang Shouren (1472–1528), known to the world as Master Yangming. He was the last major thinker in the Neo-Confucian

tradition and lived in the generation just before major political and socioeconomic changes took place in China, especially in the south, with far-reaching consequences in the artistic and literary life of the country. The germinal ideas of the freethinkers and the anti-Confucian intellectuals of the late Ming can be traced to Wang's teaching and his style of teaching, although he himself would have been surprised, if not hurt, by such an association.

As a moral philosopher in the Confucian vein, Wang Shouren was naturally against the free expression of ordinary human feelings and desires in literature and the pursuit of the arts for their own sake, but he was not opposed to the arts as a means of enriching a life lived according to the principles of *dao* (the way) and *ren* (humanity).[3] Unlike other Neo-Confucianists, he often mentioned poetry and music in his teaching, while stressing that the end of all the arts must be to cultivate the spirit and direct the mind toward a moral state.

More central to our present discussion is Wang Shouren's metaphysics, in which he took a stance not dissimilar to that of Bishop Berkeley (George Berkeley, 1685–1753), though without, of course, the important component of God. Wang asserted that nothing existed in the universe outside the mind (*xin*, the heart or mind).[4] From this position it was only a small step, not taken by Wang Shouren, to arrive at the view that all creation, including artistic creation, was the result of the working of the mind or the stirring of the human spirit. It was this concept of creativity that was to become central to the thinking of the late Ming literati.

The style of Wang Shouren's teaching, as distinct from its substance, was also an inspiration to later writers, who advocated spontaneity and agility of thought and expression. The early Qing dramatist Li Yu (1611–1679) wrote that transitions between passages in music and drama should be smooth and imperceptible, just as Wang Shouren had been able to reply to any question, however frivolous and irrelevant, in such a way as to restate the main point of his teaching without seeming to avoid the question.[5]

Yang Shen (1488–1559), one of the most gifted and learned writers of the Ming period, believed that true poetry must arise from *xingqing* (natural feeling, human nature). The ancient odes collected in the *Classic of Poetry* (*Shijing*) were the natural expression of human sentiment. Tang poetry, according to Yang Shen, was based on *qing* (feeling, sentiment, love) and was thus close to the classical odes, whereas Song poetry (*shi*) was based on *li* (reason) and was far from the spirit of early poetry. His younger contemporary Xie Zhen (1495–1575) judged the merit of poetry on its naturalness: "the best [poetry] is effortless excellence, and next to it is what has been achieved with fine skill."[6] Although not in principle against the imitation of the ancients, Xie Zhen warned against any contrivance in the attempt to follow the great poets of the past: the proper way was to capture their spirit but to "change

their appearance."[7] In a similar vein, Xie Zhen regarded learning as a hindrance to creative writing. He criticized Yang Shen for maintaining an extravagant way of life even in exile in Yunnan: there was so much food on his dinner table that he could not have tasted every dish. This Xie Zhen compared to a superfluity of learned references in writing, which only served to obscure the meaning and create the effect of contrivance.[8] A poet should have, but not display, learning.

From this it follows that one of the highest values in art, as in life, is the "unforced and undecorated" (*pingdan*, literally, flat and insipid). Late in life, Xie Zhen recounted the occasion of his conversion, at the age of fifteen (sixteen by Chinese count), from writing sentimental songs to pure (or "naive") poetry at his first meeting with his teacher, Mr. Su Donggao of his native town. For more than fifty years thereafter Xie Zhen adhered to the ideal of a calm and collected approach to life and art, leading a life of simplicity and contentment and taking pleasure in poetry.[9]

In his critical writing, Xie Zhen often discussed the question of balance—between the ornate and the plain, the expressed and the implied, the active and the passive, the difficult and the facile, and, above all, the balanced and the unbalanced (*zheng* and *qi*). This last pair of opposites is a centuries-old concept in Chinese thinking that may have originated with the military strategists of the Eastern Zhou period, *zheng* standing for the orderly (battle) formation and *qi* for the surprise (attack). This conceptual pair was later taken up in literary and art criticism and was much used by late Ming authors in their critical writings.

Both Yang Shen and Xie Zhen were basically conservative in their approach to literature but, in advocating spontaneity and being true to one's feelings, they had already made a major step towards the liberal outlook of later writers.

The decisive change in late Ming thought came about with Li Zhi (1527–1602), a man whose writings offended officialdom and who was regarded as a dangerous radical in both the Ming and Qing dynasties. He was eventually committed to prison, where he died. By present-day standards Li Zhi would not be considered a radical. What he preached was only a slight extension of the ethics taught by Wang Shouren, which was based on "individual conscience" as opposed to given standards of behavior. Li Zhi pushed this position to the point of militant nonconformity and was outspoken in his attack on established rules and conventions, not so much out of disrespect for authority but perhaps more from his conviction that human behavior (and artistic expression) must be based on "truthfulness." What he valued above all was "the heart of the child" (*tongxin*), which he explained as "pure truthfulness removed from all falsehood, the germinal thought that lies at the basis of all motivation. If we lose this *tongxin*, then we lose the true man. A man who is not true loses the basis [or reason for his existence]." He advocated a system of ethical naturalism based on natural feeling: "If [one's action] springs naturally from *qing*, it naturally stops [at the boundaries] of propriety." Li Zhi's influence permeated the entire spectrum of Chinese thought and letters, ushering in an era of self-expression never before known in Chinese society. The effect was immediately evident in the arts of painting and calligraphy, which at that time were intimately connected with literature. For a period of about a half a century, from the last decade of the sixteenth century to the end of the Ming dynasty, the concept of *qi* rather than *zheng*—the unbalanced as against the balanced—was in the ascendant. For once Chinese writers and artists were prepared to go to extremes.[10]

Of course, no major change in society is ever caused by one man alone. Liberalizing trends were already discernible in Ming society during the Wanli era, especially in the prosperous southeast, owing partly to an increasingly ineffectual administration and partly to the rise of a class of citizens (or city dwellers) who were financially independent of the state bureaucracy. The very fact that Grand Secretary Zhang Juzheng (1525–1582) could institute and rigorously pursue state policies based on purely economic—rather than moral—reasons was a sign of this growing liberalism. Nevertheless, the influence of Li Zhi on the most creative writers of his time was paramount. Foremost among his followers were Tang Xianzu (1550–1616), the dramatist, and the Yuan brothers, leaders of the Gongan school of writing.

The three Yuan brothers, in particular Yuan Hongdao (1568–1610), believed that all true poetry must come from the *xingling* (essential spirit, natural spirit) of the author. Unlike other theorists, Yuan Hongdao, who was certainly one of the most original writers of the entire Ming period, was able to practice what he preached. His distinctive prose, characterized by a directness of expression and the occasional use of the vernacular, with a mannered awkwardness of sentence structure and unusual imagery to heighten the dramatic effect, was certainly the most refreshing thing that happened in Ming literature. Of course, Yuan Hongdao's lack of reserve and of subtlety of allusion was inimical to the main tradition of Chinese literature, and the Yuan brothers were forever defending themselves against accusations of "overexposure."

This emphasis on individual values and the workings of the human spirit—so redolent of the Romantic movement in Europe a century later—had, among other manifestations in the late Ming, three salient aspects. First, there was the urgently felt need to escape from the everyday world, regarded by the literati as a disaster, in order to be free to cultivate the self. Second, there was the search for the true and the unadorned, which not only affected the literati's own artistic expression but also led them to take an interest in folk art, including popular songs, and, to a lesser extent, in all manner of crafts. Third, there was the concept of

the "interesting" as an artistic ideal, with the two components of *qi* and *qu* (a word to which we shall return). These are also the basic tenets that inspired the physical environment constructed by the literati for themselves.

Most of these men had the ability and official qualifications to play a part in public administration. All of them chose to stay out of office whenever possible, even if they proved, as Yuan Hongdao did, to be effective and upright officials. Both Yuan Hongdao and Li Rihua developed a remarkable knack for finding excuses to take sabbaticals. Even Dong Qichang (1555–1636), who had an insatiable appetite for honor and riches, managed to serve mainly in sinecure positions that had little to do with the task of government. This attitude was caused as much by a distaste for social conventions as by a positive quest for the quiet life of personal cultivation. In his inimitable manner, Yuan Hongdao writes to his friend Qiu Zhangru about his experiences as the magistrate of Suzhou:

As a magistrate I have to perform many indescribably ugly acts. Roughly speaking, [I am] a slave to superior officers, a female entertainer [*ji*] to visitors, an accountant when managing the public funds, an old village matron when dealing with the people. In just one day, [I am] warm and cold, male and female, and all the unpleasantness that exists in this world is heaped upon this magistrate. How painful and punishing![11]

Eremitism as an ideal has deep roots in the literary tradition of China. It was first manifested in the literature of the third century at the breakup of the Han empire and was revived from time to time, depending on the ability of the intelligentsia to fit into the existing social order. At no time, however, was this ideal more flourishing than in the late Ming when eremitism, no longer simply an escape from the world, became a means of mentally transforming one's immediate surroundings. Thus, in Xie Zhen's brief autobiographical passage referred to above, he speaks of "not knowing whether to go into minor eremitism in the mountains and woods or into major eremitism in the heart of the city." In the busy city of Nanjing there was a house by the name of Urban Hermitage.[12] One could "disappear" into the city as one could "take eremitage in trade." The literatus potter Hao Shijiu, an acquaintance of Li Rihua's from the time of his official service in Jiangxi province where the potteries were located, was described by Li as "taking eremitage in the potter's wheel."[13] The idea of seeking refuge by immersing oneself in an absorbing activity could justify any indulgence; one author, for example, advocated "taking eremitage in women."[14] Such activities, or action, can be classified as applied eremitism. At the same time there was a pure and uncompromising eremitism that went beyond the notion of taking refuge. Yuan Zhongdao (1570–1623), Yuan Hongdao's younger brother, criticized literary hermits of the past

for seeking refuge or consolation in nature, writing, or any other activity. Even the poet Tao Qian (365–427), the epitome of eremitic nobility, was thought by Yuan Zhongdao to have relied too much on wine. The only true hermit, according to Yuan Zhongdao, was Shao Yong (1011–1077), the Neo-Confucian philosopher who achieved total union with the *dao*, the natural principle, with his heart at rest, and who was able to enter true eremitism without the support of external things.[15] This is an extreme development of the concept of *pingdan* toward a quasi-religious quietism. The urgency of the late Ming quest for isolation goes deeper than any tired official's dream of *otium liberale*. It was impelled by the need to work out a personal morality based on traditional ethics, while rejecting that part of the Confucian code that stipulated some degree of public service. In disassociating themselves from the practical demands of conventional Confucianism, the late Ming intellectuals sought wisdom in Daoism and philosophical Buddhism as others had done before them in times of doubt. However, the late Ming thinkers made no apology for their interest in schools of thought other than Confucianism; there was even a movement to integrate the teachings of the three systems, allowing one to adhere to the old values in personal behavior while embracing the worldview of Daoism and Buddhism.

Dreams were another form of escape. Tang Xianzu, the great Ming dramatist and follower of Li Zhi, put much emphasis on dreams. According to Tang, "in this world, there is a universe of *qing* [feeling, love] and there is a universe of the law;" and "in nature [*xin*] there is neither good nor bad, but there is [both] in *qing*. *Qing* gives rise to dreams, and dreams to drama." And he, of course, was in the business of drama and hence in dreams and in *qing*.

The appeal of the theater for the late Ming literati can be explained in part by their interest in popular literature, the need they felt for escape, and their taste for the dramatic. The most original and perspicacious critics of the time, including Yuan Hongdao and the writer and short-story editor Feng Menglong (1574–1646), regarded popular songs as the truest and most natural expression of the age and thus the only part of Ming literature to have lasting value.[16] Interest in the dramatic was not restricted to the theater. It manifested itself, too, in the field of the occasional essay, where it was related to the search for the quality of *qi*—the unbalanced, the unexpected—and that which excites the mind. According to Xu Wei (1521–1593), the painter and dramatist, what gives value to a work of literature is its ability to deliver a shock, "like having cold water poured on one's back."[17]

Another concept central to late Ming literary criticism is that of *qu* (a word with many shades of meaning: delectation, delight, interest, taste, essential meaning, expression, tendency, inclination). For the literati of this period it combines the state of or the ability to

delight with the sense of taste or tendency. Thus the quality of *qu* in a poem is both the ability to cause delight and that which reflects the taste and/or inclination of the poet. A poem with *qu* is interesting and elicits a sympathetic response. A work of *tianqu* (natural *qu*) or *zhenqu* (true *qu*) captures the true nature of its subject and arouses the interest of its audience. A work that has no *qu* is dull and uninteresting, and one with bad *qu* (*e qu*) is in poor taste, unpleasant, or downright repulsive.

The quest for true or natural *qu* was common to conservatives and progressives alike in the late sixteenth century and was a dominant idea in art and literary criticism of the period. Thus Wang Shizhen (1526–1590), an extremely influential literary figure and one of the best art critics and historians of his time, observed:

Before the Five Dynasties there were few painters of landscapes. The two Lis [Li Sixun, 653–718, and his son Li Zhaodao, ca. 670–730] were highly skilled, but were slightly flawed by their stiffness and too much attention to detail. Wang Wei began to express *qu* beyond the landscape depicted, but it was not enough. It was not until painters like Guan Tong, Dong Yuan, and Juran that the painter worked from true *qu* . . . and the peak was reached with Li Cheng.[18]

Li Rihua, in writing about the effect of the environment, made several references to the Haiyue pavilion of the Song painter Mi Fu, which was built on the ruins of Ganlu Si, an ancient temple situated on a hill to the north of the present city of Zhenjiang in Jiangsu province. There Mi Fu could absorb "the *qu* of the rolling clouds, the mist, the water, and the shifting sands."[19] It was this internalization of the environment that enabled Mi Fu to reproduce the same *qu* in his paintings.

Qu applied to life as well as to art, and no one has discussed this more thoroughly and with greater clarity and wit than Yuan Hongdao:

What is difficult for people of this world to achieve is *qu*. There is *qu* in the colors in the mountains, the taste of water, the light in flowers, and beauty in women, but even the most eloquent cannot begin to describe what it is. Only those who respond with their hearts can know it. There are people nowadays who seek it through [activities that give] the appearance of *qu*. Thus, the discussion of paintings and calligraphy and the collection of antiquities are regarded as refined and noble [activities]. Below this level are those in Suzhou who burn incense and drink tea. All these are but the superficial aspect of *qu* and have nothing to do with spirit and essence. For *qu* that is derived from nature is profound, while that achieved through learning is shallow. An infant knows nothing of *qu*, and yet its every movement and gesture are pure *qu*. Its expression is never solemn, its eyes never still, its mouth moves as if to speak, and the feet are always kicking and stamping. There is nothing that can exceed the extreme happiness at this stage of one's life. This is what Mencius meant by "not losing [the heart] of the child" and what Laozi [Laotse] meant by being capable of [being like] an infant. In

terms of *qu*, it is the highest state of ultimate enlightenment. People in the country are free of encumbrances; they have a natural way of life and they are close to *qu*, even if they do not seek it. Those who do no good are also close to *qu*, precisely because they have no morals. The lower the level of morality, the less they ask of themselves. Whether they indulge in food and drink or music and entertainment, they do it to their hearts' content. Because they have no social aspirations, they do not care if the whole world censors and ridicules them. This is yet another kind of *qu*. But when one grows in years and rises in rank, then the body feels like fetters and the heart like thorns, and every pore of the skin and every joint in one's bones is bound by knowledge and experience. The more one knows of the way [of things], the farther one is from *qu*.[20]

Here Yuan Hongdao attributes the quality of *qu* to states and actions that are completely natural and therefore "true." He himself, however, was not above indulging in "peripheral" activities such as flower arranging, and his name was associated with one of several treatises on the subject that appeared in his lifetime.

THE PHYSICAL ENVIRONMENT

Ideally, the late Ming literati would have liked to disappear into the *dao*, freed of all external encumbrances. Nevertheless, they lived in busy cities and were in contact with traders and manufacturers (some of them of works of art). Happiest in each other's company, they established certain rules of style and taste by which they could be identified as a separate group. These rules were stated in considerable detail in the special class of descriptive writings mentioned earlier. The most important and comprehensive of these treatises was published in 1637 under the name of Wen Zhenheng (1585–1645), a great-grandson of the painter Wen Zhengming (1470–1559). Its title, *Zhangwu zhi*, can be translated as *On Superfluous Things* or *On the Things of This World*. The term *zhangwu* originated among the philosophizing aristocrats of the third century as an expression of disdain for worldly possessions, and it is indicative of the ambivalence of the late Ming literati that such a title should be used for a book describing in great detail the environment and possessions that so exercised their faculties of criticism and taste. Wen Zhenheng's position is clearly stated in the opening paragraph:

To live out in the far country is best; next best is to live in the rural areas; next comes the suburbs. Even if we are unable to dwell among cliffs and valleys and to follow the path of the hermits of old, and we have to settle in city houses, we must ensure that the doors, courtyards, buildings, and rooms are clean and smart, that the pavilions suggest the outlook of a man without worldly cares, and that the studies exude the aura of a refined recluse. There should be fine trees and interesting plants, a display of antiquities and books, so that those

who live there should forget about age, the guest forget to leave, the visitor to the grounds forget about fatigue. It should seem cold when the weather is hot and suggest warmth when it is freezing. Those who only use large quantities of timber and paint [i.e., construct large houses] are building themselves prisons and fetters.

Zhangwu zhi is divided into twelve chapters, which discuss buildings and rooms, flowers and trees, water and rocks, fish and fowl, calligraphy and painting, furniture, utensils, clothes and ornaments, boats and carriages, display of works of art, vegetables and fruits, aromatics and tea. In no other period in Chinese history has there been such a complete description of a total system of living, encompassing the full range of objects organized as a reflection of spiritual values. There is a poignant note in the dichotomy between the richness of external things and the literati's search for the simple and austere inner life, for all the things of this world that we love and use and care for become mere symbols when integrated into the total system and are ultimately superfluous as things in themselves.

Li Rihua describes his idea of a book room (library, study):

The library/study should be situated where the brook twists and bends between the hills. The total structure should not exceed two or three buildings, with an upper story to observe the clouds and mists. On the four sides there should be a hundred slender bamboo plants—to welcome the fresh wind. To the south a tall pine tree [on which] to hang my bright moon. A gnarled old prunus with low, twisting branches to come in through the window. Fragrant herbs and thick moss surround the stone foundation. The east building houses the Daoist and Buddhist sutras, and the west building the Confucian classics. In the center, a bed and desk with a scattering of fine calligraphy and paintings. In the morning and evenings, white rice and fish stew, fine wine and tea; a strong man at the gate to reject social callers.[21]

Li Rihua goes on to say that if one lived in such surroundings for ten years, one could hope for artistic achievements to match the Tang and Song masters of painting and calligraphy, if not the ancients.

Here is an integrated system where the aesthetic and the spiritual realms are given expression in the ordering of the physical setting, an environment that nurtures the soul and protects one from the encroachment of the world at large. At the same time, a certain amount of *qu* is provided by the tall pine and the old twisting prunus (with qualities of *qi*) and their placement in relation to other standard features.

Such an environment, of course, should be as individual as its occupant. However, a certain commonality of vision combined with the standard forms and features of traditional construction gave rise to a style identifiable as one befitting a person of refinement. This in turn led to the development of a class of profes-

sionals who worked within the broad confines of the style and followed the rules laid down in the writings of people like Wen Zhenheng to design and build residences for aspiring literati. One of the most successful of these "landscape architects" was Ji Cheng (1582–after 1640), who left a treatise entitled *Yuan ye*, which preserves many of the principles of late Ming landscape gardening. Ji Cheng was careful to emphasize that the success of the garden depended on the ideas and taste of the owner, thus maintaining the amateur ideal. There would be no dispute such as occurred in late eighteenth-century England between the theorist of aesthetics Uvedale Price and the professional landscape architect Humphrey Repton.[22]

Artists in other fields would occasionally try their hands at the design of a literary residence. The garden known as Gu Yiyuan (or Yiyuan when it was first built), in the town of Nanxiang in the Jiading district of the present-day municipality of Shanghai, was designed for a local administrative officer, Min Shiji, by the renowned bamboo carver Zhu Zhizheng (better known as Zhu Sansong, active 1620–1645) of Jiading. Today the garden has been reconstructed in a public park on the site of the original Yiyuan.

It may be mentioned in passing that not one of these elegant residences lasted in its original state much longer than the first owner. Most of the famous gardens in the Jiading area, such as the Tanyuan, which belonged to the family of Li Liufang (1575–1629), one of the artists represented in this exhibition (see no. 21), did not survive the civil unrest during the time of the change of dynasties. On a painting by Li Liufang's son Li Hangzhi (d. 1644) in a private collection in Hong Kong is an inscription dated 1837 by the Qing artist Cheng Tinglu (1796–1858) recording that he had visited Nanxiang in search of the remains of Tanyuan, which was nowhere to be found; he did, however, locate the ruins of Yiyuan, which had belonged to Li Liufang's nephew Li Yizhi and had presumably been bought by him from Min Shiji not long after it was built. Gazetteers of the late Qing period give approximate locations of these residences, but local historians are now often hard pressed to indicate the exact sites. In Suzhou most of the present-day gardens are located on sites of Ming or earlier residences, but it is doubtful whether any of them retain very much of their original appearance. Even if the basic structure had survived the change of dynasties, the character of these gardens would inevitably have altered, or been altered, over the years. Taste tends to change with each generation, especially if there are drastic social and political upheavals. The dramatist Li Yu, who wrote voluminously on garden design in the early Qing, is often regarded as one who carried on the Ming tradition. However, he approached architecture and the design and use of household objects from a purely epicurean point of view, with comfort and enjoyment as the prime objectives.[23]

It should also be mentioned that what went on in the residences of the late Ming literati was not all cultivation of the spirit. Women entertainers (*ji*), who were known for their beauty as well as their literary and artistic accomplishments, were often guests at these residences, and the "elegant gatherings" that resulted were frequently recorded in the poetic writings of the participants. The acceptance of women, not just as entertainers, into the company of cultivated men sometimes resulted in romantic marriages and was another noteworthy aspect of the openness of late Ming society. Qian Qianyi (1582–1664), who despite his later disgrace in the Qing dynasty was one of the most brilliant literary figures of the late Ming, defended Li Yizhi of Yiyuan—noted for his philandering—by quoting Ling Xuan's saying: "Only extremely gifted men are capable of deep interest in women."[24] Qian Qianyi himself married Liu Rushi, the most famous beauty of his time and many years his junior, a *ji* who used the sobriquet Yin (Hermit) in her writings and paintings.[25]

The actual layout and architecture of the gardens of the Jiangnan (Yangzi River delta) region of China have been the subject of many recent studies. Two works in this exhibition convey the special flavor of these garden residences of the Ming period. One is the album by Du Qiong (1397–1474) on the Nancun Villa of the fourteenth-century writer Tao Zongyi, an early and rather grand version of the Ming garden (no. 6). The second is the handscroll by Wen Jia (1501–1583), Qian Gu (1508–ca. 1578), and Zhu Lang (active mid-16th century) commemorating a literary gathering at the Herb Mountain-Cottage, a painting already regarded as a treasure in the late Ming (no. 7).

THE EXPRESSION OF TASTE

The key words in any discussion of literati taste are *ya* (elegant, refined, distinguished) and *su* (vulgar, common, unexceptional). In late Ming writings on the appreciation of things, such as the *Zhangwu zhi*, these words occur on almost every page. Superficially they can be taken as the common vocabulary of snobbery, both social and cultural, but this pair of antonyms can be understood in another way.

The society of the literati was that of a select few, and within it, as in any other society, were smaller circles of friends such as those appearing in the group portrait *Venerable Friends* (no. 1). Li Rihua's family was particularly friendly with Xiang Shengmo (1597–1658) and Lu Dezhi (1585–after 1660), as we know from the inscriptions and colophons on a number of paintings in the exhibition and from their published writings. These were close friendships developed over many years. However, literati society at large, although select, was not exclusive; the members were all writers in constant communication with one another and with

anybody else prepared and able to respond. The identity and integrity of this society would have been seriously undermined by the presence of insensitive intruders or, worse, self-styled affiliates, posing as literati but without true understanding. It was as a last-ditch defense against the outer world and against men of bad faith that the terms *ya* and *su* came to be used to such a degree by certain literati, who felt particularly protective of the world they had invented for themselves.

Another means of separating the true from the false was the concept of *qu*. Yuan Hongdao's exposition on *qu* quoted earlier had two objectives. The first was to distinguish between true delectation and the mere practice of drinking tea and burning incense. The second was to define what was ultimately undefinable, the meaning of *qu*.

The conceptual pair *ya* and *su* is reasonably useful as terminology for distinguishing between the select and the outsider, but an element of subjectivity makes the terms difficult to define. *Ya* in itself represents no absolute standard of taste; rather it describes the inclination and style of the literati—perhaps just one literatus. After all, the words and deeds of those who set standards are self-defining. Nevertheless, the concept of *ya* and *su* underlies much of the following discussion, in which the workings of literati taste are illustrated by examples from several areas of activity: collecting antiquities and other objects, including ceramics; playing the *qin* (the so-called Chinese lute, really a zither); seal carving; and making rubbings. But first, an activity that has literally to do with taste.

Water played an important role in the critical language. It was a metaphor for the ideal of *dan* (tasteless, slight taste, light coloring). The infinite changeability of the surface of the water as it responds to natural forces was an allegory for the artistic manifestations of the creative spirit. In real life water was the all-important element in tea making, and water tasting itself became a highly regarded form of delectation. Li Rihua named one of his studies "Water-tasting Studio," and one of his best-known pieces of writing was his "draft" of an agreement for the formation of a cooperative to transport spring water from Huishan (near Wuxi in Jiangsu province), which was judged by most connoisseurs of the period to be the finest of all the famous springs.

Yuan Hongdao tells a story about his good friend Qiu Zhangru, to whom he wrote the letter already quoted in which he complained of being a magistrate. Apparently, Qiu Zhangru, also a native of Hubei province, once toured the Wu district and came back with forty jars of water from Huishan. His servants, who failed to see the point of so much labor for a trivial purpose, poured the spring water away and replaced it with water from a river just outside the city where Qiu Zhangru lived. After his guests—assembled in feverish anticipation—had smelled and sampled the water and thanked the host profusely for the opportunity to taste

of the Huishan spring, the story of the change leaked out as a result of a quarrel among the servants and there was much embarrassment all round. This, of course, is a familiar story known under different guises in many different cultures and periods of history. Typically, Yuan Hongdao also relates the story of how he and his brother Zhongdao failed to tell the difference between the water from Huishan and that from another famous spring when the labels on the storage jars became illegible. However, he added that after he had been a magistrate in Wuxian for a while, he had many opportunities to taste water from different springs and developed the ability to appreciate and differentiate their tastes.[26]

In the appreciation of antiquities (gu), which in late Ming terminology stood for all works of art, old and new, and all things delectable, literati taste can be discussed in two parts: the hierarchy of different categories of objects, and within each category the preference for particular schools or styles. For the first, Li Rihua has left a comprehensive list ranking the items in his collection, which is quoted in full by Chu-tsing Li in his essay "The Artistic Theories of the Literati." The list generally reflects a predilection for painting and calligraphy over objects, and the archaic over more recent productions—except where porcelains are concerned, and these in any case are near the bottom of the list. Stones and trees occupy a relatively high position. The list itself can be read as a description of the cultural world inhabited by the literati, a world in which calligraphy can be found ranked against imported aromatics and white rice. Li Rihua's list represents in the main the literati's general system of values, slightly influenced by Li's personal preferences.

The position of porcelain in the list is to be expected and does not mean a lack of interest in ceramics on Li Rihua's part. We know, in fact, from his diaries and his writings on works of art that he was knowledgeable about porcelain and held progressive views on the subject. He was friendly with the literatus potter Hao Shijiu, and being rightly convinced that the potters of his time were capable of producing porcelain of the highest quality, he tried to persuade some of them to limit their production to quality wares and to sell these at higher prices. But he learned that retailers and consumers wanted porcelain at the lowest prices and would not pay for quality. Low prices and mediocre quality have been the strength and weakness of Chinese commercial pottery ever since. (One cannot help wondering how much finer the eighteenth-century drawing rooms of Europe would have been if the commercial potters had taken Li Rihua's advice—but then perhaps the merchants of the East India companies would not have been so eager to deal in Chinese porcelain.) Li Rihua also expressed strong disapproval of the high prices being paid for the fine porcelains of the Xuande and Chenghua eras, not because he failed to appreciate their quality but because he found it dis-

tasteful that any object so low in the absolute order of things should command prices comparable to works of art from antiquity. In this instance, Li Rihua, like a true literatus, failed to develop any sympathy for the workings of the marketplace.

Within the various categories of art objects, questions of preference or precedence were more a matter of personal choice. In painting, it was always in good taste to own a landscape by the Yuan artist Ni Zan (1301–1374), who was regarded as possessing a noble spirit. Otherwise, the order of the paintings in Li Rihua's list reflects an average contemporary view.

There was a consensus among connoisseurs that ge and guan wares of the Song period, with their greenish, crackled glazes, represented the peak of ceramic art. White Ding wares (rather than red or black) and monochrome Jun wares (as opposed to those with the copper-red splashes) were also admired. The taste, in short, was for simplicity of form, attractive glazes, and an absence of decoration. The irregular crazing of the glaze in ge and guan wares was also a source of natural qu.

Literati preferences in ceramics probably meant that there was continued production of the wares in question throughout the Ming period. The problem of ge ware in general, and its production in the Ming period in particular, has recently been the subject of study.[27] This exhibition includes a rare example of a ge-type piece with a Ming mark (of Chenghua, the best period, no. 89), together with several other ge-type pieces which appear to qualify for a late Ming date (nos. 31–34).

Decorated wares seem to have elicited different responses. Some literati connoisseurs did not like them at all, even if they came from the finest Xuande and Chenghua kilns, perhaps simply because they were decorated and were of recent manufacture. Others, like Li Rihua, may have thought that the very high prices attached to Xuande and Chenghua wares rendered them su objects. Some collectors, however, did like decorated ceramics, and a few pieces of Chenghua porcelain have survived to this day outside the old palace collection.

The high price of the decorated porcelain wares of the fifteenth century was a recent phenomenon in Li Rihua's time. In his work Gubugu lu, written in 1585 when he was sixty years old, Wang Shizhen comments:

In paintings, the valuable should be [those of] the Song period, but in the last thirty years Yuan painters have suddenly become highly valued, including Ni Zan, and down to Shen Zhou of the Ming—their prices quickly rose ten times. In ceramics, the most valued should be ge and Ru wares, but in the last fifteen years Xuande [wares] have suddenly become highly valued, and even those of Yongle and Chenghua have all risen ten times in price. This [trend] began with people in the Wu area [roughly present-day Jiangsu] and was spread by the people of Hui [Anhui]. It is all very curious.

In our Wu area today, the work by Lu Zigang in jade, Bao Tiancheng in rhinoceros horn, Zhu Bishan in silver, Zhao Liangbi in tin [pewter], Ma Xun in fans, Zhou Ye in inlay [on bronze], and in the She [Anhui] area the work of Lü Aishan in gold, Wang Xiaoxi in agate, and Jiang Baoyun in bronze are all worth double again the normal price. These people [the artisans/manufacturers] even socialize with the gentry. I heard recently that the taste [for these objects] has spread even to the palace. It seems that the trend will continue.[28]

This passage is useful not only for what it relates about the status of the decorative arts in the late sixteenth century but also for the way in which it reflects the conservative attitudes of Wang Shizhen and many of his contemporaries. Changes in taste can be understood only against the background of rapidly changing attitudes among collectors, themselves affected by the prevailing socioeconomic conditions. The rise of a capitalistic economy in the Jiangnan area in the late sixteenth century and the related problem of overseas trade have been the subject of intense research by Chinese historians in recent years, and it is clear from contemporary records that dramatic economic and social changes took place in the closing decades of the sixteenth century. The accumulation of wealth in the hands of traders and manufacturers and the general affluence of the urban population led to a strong demand for works of art, both ancient and contemporary. The new interest in fifteenth-century decorated porcelains perhaps reflected the taste of those who had recently joined the ranks of the affluent, a taste not shared by all members of the literati. Rising prices naturally followed the increase in demand. The status of Yuan paintings, on the other hand, can be interpreted as a sign of the triumph of the Wu school and the workings of the literati ideals already discussed.

The demand for contemporary works of art reflected both consumer affluence and the success of market forces. Under the stimulus of free competition among independent producers, the quality of many types of decorative art reached a rarely attained level, and certain art forms made their appearance or were popularized for the first time. Hardwood furniture and carvings in wood, bamboo, soapstone, rhinoceros horn, and, of course, jade (though jade carving is one of the oldest crafts in China) became extremely popular. As a by-product of the growth of the mining and smelting industries, metal objects of pewter, bronze, brass, and iron were made into works of art. Gold and silver plate was also plentiful, but most of it was subsequently melted down—the usual fate of precious metals—and little has survived. Woodblock printing of books and illustrations reached new technical and artistic heights with the use of multiple blocks for color printing and embossing and was to have a profound effect on the artists of Japan. In lacquer, while the palace workshops barely managed to keep going, commercial production successfully revived the technique of painted decora-

tion, stimulated, no doubt, by competition from Japan. Highly refined writing brushes, paper, and especially inkstones and ink cakes became collectible items. All this had basically very little to do with the literati, since they played no part in the design and production of such objects; but the objects were common in the homes of the well-to-do, and most literati, of course, were relatively wealthy men.

The literati's response to this profusion of decorative objects and refined articles of daily use is not easy to determine in general terms. Some, like Wang Shizhen and Wen Zhenheng, adhered to classical tastes in ceramics; others, including Li Rihua, accepted blue-and-white porcelain as worthy of "elegant delectation," even though it was not rated high in the absolute order of things. For Wen Zhenheng, anything carved out of wood and bamboo was not *ya*, but Li Liufang, a native of Jiading, where the art of bamboo carving flourished, actually practiced the craft himself.

A major psychological difficulty for the literati lay in the association of the decorative arts, however finely wrought, with the artisans as producers and the newly affluent as consumers. While most literati would not have gone as far as the reactionary officials at court, who petitioned for the revocation of the imperial order conferring official rank on craftsmen who rendered exceptional service,[29] some, like Wang Shizhen, felt uneasy about distinguished and prosperous craftsmen and manufacturers socializing with the gentry. On the other hand, the dramatist and painter Xu Wei (1521–1593) wrote a poem in praise of the jade carver Lu Zigang, and Li Rihua was friendly with potters.

Another problem for the literati was the use of fine decorative objects, some of them designed for the "scholar's studio," by undesirable elements seeking to emulate literati style. As the writer Fan Lian (b. 1540) wrote in 1593 in connection with the changing customs of his native district Yunjian (present-day Songjiang): "There are petty officers of the local administration who happened to own a house, who would set up a rest area with wood paneling, place fish bowls and various plants in the courtyard, with desks and dusters in the interior, and call it a study [book room]. I wonder what kind of books these people read."[30]

Fashion, then as now, was closely linked with decoration. Late Ming decoration was colorful, and one of the most conspicuous aspects of fashion at the time was the colorful robes worn by men and women alike. A contemporary writer remarked that "in the districts of the southeast, the students and the rich and scholarly families all wore red and purple clothes like women."[31] Even conservative Fan Lian confessed: "I am very poor and value frugality. In recent years I have made myself wear colored clothes. Thus we know that even sages are not exempt from the effect of the custom of the time."[32] Fan would have been more distressed had he been aware that the custom of the time was part of the workings of the market economy.

Headgear was also a matter of fashion. Fan Lian has left us a detailed account of the changes in the style of men's caps:

When I was a student, my contemporaries wore caps with a bridge-shaped ridge. Successful candidates in the Spring Examinations wore caps [woven] of gold thread. The gentry wore *zhongjing* caps. Later these caps were thought to be too troublesome [to wear]. It was then customary to wear "hermit" caps and plain square caps. Again it changed to Tang caps, Han caps, narrow caps. . . . [The fashion for] students to wear square wrapped caps was started by Chen Jiru.[33]

Fan Lian goes on to describe in some detail the materials and construction of the various fashionable caps of the day. Despite this information, the headgear depicted in the group portrait of the six literati friends (no. 1) is not always easy to identify. For example, the cap worn by the person identified as Li Rihua is described in Xiang Shengmo's inscription as a "Tang cap," but it is quite unlike that cap, the so-called *futou*, which is perhaps the one style that survived right through the Ming period from the beginning of the Tang dynasty. (The standard Tang cap should look more like the one worn by Li Zhaoheng in his portrait by Zeng Jing [no. 2], except that the "ribbons" are much shorter.) The hermit by tradition wore a tall cap,[34] and this may explain the type of cap that Li Rihua wears in the painting. Or perhaps by Ming times the hermit's cap was more like the Tao Yuanming (Tao Qian) cap that Lu Dezhi wears. At least in name, however, the headgear in this painting corresponds to the most fashionable styles mentioned by Fan Lian, affording touching confirmation that the "sages" were truly "not exempt from the effect of the custom of the time."

The accoutrements of the scholar's study also left room for individual taste. Among the recently excavated archaeological sites of the Ming period in Shanghai is the tomb of Zhu Shoucheng and his wife. This tomb of the Wanli period yielded many items of gold and silver jewelry and a carved bamboo incense holder with the signature of the famous artist Zhu Ying of the Jiading district.[35] It also yielded a set of objects for the scholar's study (no. 69), which in themselves are perfect illustrations for such late Ming texts on the appreciation of things as the chapter "Objects for Use" in the *Zhangwu zhi*. Most of these objects conform to contemporary standards of taste. Examples are the ruler (or scroll) weights of hardwood with a "knob" of jade—usually a flat piece of archaic jade, as in the smaller of the two weights, or a small animal carving such as the Tang/Song jade dog on the larger piece. The brushpot of *zitan* wood and the inkstone of Duanzhou slate are also standard items. The inkstone may even be an object of antiquity, as it is in a form commonly used in the Song period; or it may have been deliberately shaped in a classical style rather than a contemporary one. (An example of the contemporary style of inkstone is no. 73,

with the inscriptions by the eighteenth-century poet Yuan Mei, 1716–1798. From one of the inscriptions this inkstone appears to have been originally part of a set, whose pieces were probably all of different shapes and with "unfinished" edges to give a more interesting or "picturesque" effect.) The small table screen of marble would be perfectly acceptable in itself—after all, the grandest of all Northern Song literati collectors, Ouyang Xiu, had a marble screen—but it becomes an object of questionable taste when attached to the ungainly form of the rack for holding large brushes. The incense box and the paperweight(?) inlaid with mother-of-pearl are controversial items, as mother-of-pearl inlay might not have been thought in good taste when applied to small objects.

One of the essential furnishings of the scholar's study was the *qin*, which occupied a central position in the environment of the literati. As the only instrument on which classical music could be played and as a means of cultivation, it was a symbol of its owner's refinement. By its association with ancient music and the legendary sages, and with Confucius himself, it took on the nature of the sacrosanct. Thus it became *de rigueur* to hang a *qin* on the study wall as a symbol of one's aspirations, whether one played it or not. Many late Ming handbooks on *qin* playing were published, providing basic information on the instrument, fingering techniques, rules regarding when (and when not) to play, and tablatures for the pieces most often performed at the time. Thus the *qin* was popularized among the literati, who then made it into an instrument of exclusion.

The appropriation of *qin* music by the amateur literati players produced a result not unlike that in the field of painting. Virtuosity was rejected or ignored, and great emphasis was placed on expression. Tao Qian's aphorism—"as long as one captures the *qu* in *qin*, why bother about the sound of the strings"—was often quoted, perhaps as an indirect justification for limiting one's repertoire to a small number of short pieces. This repertoire, as cited in late Ming texts, usually consisted of a few pieces with Confucian overtones (extremely stately, "ancient," and boring), a few meditative pieces on such subjects as absent friends, and about twenty impressionistic pieces, mostly in slow tempo. In literati painting, great attention was paid to brushwork and to conveying a general sense of loftiness of spirit. Similarly, in literati *qin* playing much attention was given to the timbre of each note, down to the minutest details of the decoration, and to the interpretation, in which the performer's personality played a part at least as important as the music itself. Such characteristics are, to a large extent, inherent in *qin* music and playing. However, given that the literati players were drawn to the *qin* by avocation rather than vocation, their interpretation became at times too singular for general comprehension. Idiosyncrasy in performance was compounded by the fact that the tempo and rhythm of *qin*

music are much freer than in, say, Western music in recent centuries. Musicality could also be sacrificed for effects such as "slowness" and "calmness," which were advocated by literati players. Zhang Dai (1597–1679), a gifted writer and *qin* player, complained that *qin* players in Suzhou would wait for each note to die out completely before making the next sound.[36] This amusical tradition continued from the late Ming period until at least the Cultural Revolution in our own time.

On the other hand, there was no lack of musical literati who, within the limits of their repertoire, brought a special quality of sensitivity and expressiveness to their playing. This tradition, which is a legitimate one in the history of Chinese music, has also survived into our own time. The founder of the literati tradition of *qin* playing, called the Yushan school, was Yan Cheng from Changshu (also known as Yushan) in Jiangsu province, the son of Yan Ne, Grand Secretary during the reign of Jiajing. Yan Cheng was friendly with Shen Yin, the most renowned *qin* player in Beijing at the time, and after he returned to his native Changshu, he formed the *Qin* Society of Qinchuan with local musicians. The *qin* handbook that he edited, *Songxianguan qinpu*, first printed in 1614, was one of the most popular works of its kind throughout the Qing period. Yan Cheng's style of playing was described, not surprisingly, as *qing wei dan yuan* (limpid, soft, unforced, and distant). The influence of the Yushan school of *qin* playing in the Qing period was in its own field rather similar to that of the school of painting by the same name "founded" by the Changshu artist Wang Hui (1632–1717).

Included in this exhibition are two very fine instruments of the late Ming period, which was the last great period of *qin* making in China. One of them (no. 80), in the standard *Zhongni* (Confucius) style, was made in 1643 by a Zhang Jing(?)xiu for Ji Yuanru of Guyu. This instrument was formerly in the collection of Tang Yifen (1778–1853), better known as Tang Yusheng, one of the best respected scholar-artists of the Qing period, who was from Wujin (now Changzhou in Jiangsu province) and who lived in Nanjing. Tang Yusheng was reputed to be accomplished in various artistic activities, including *qin* playing. In the inscription on the back of this *qin*, Tang Yusheng noted that he had bought it in Nanjing. Also carved on the *qin* is the seal *Qinyinyuan* (Garden of the *Qin* Recluse), which is the most appropriate of the several studio names of Tang Yusheng's to be used here.

The other *qin* (no. 79), named *Lütian fengyu* (Wind and rain in the green season), is in the form of a banana leaf, a form that fitted in perfectly with the Ming garden, where the grouping of a banana tree and a rock was a common feature. The invention of the banana-leaf *qin* is traditionally attributed to the instrument maker Zhu Haihe of the mid-Ming period, and although it enjoyed great popularity in the late Ming, it was hardly, if at all, made in the Qing. This must be at least partly due to the difficulty of modeling the top board (made of a softwood) and partly because of its usually small size, which makes it a relatively quiet instrument. There is perhaps no single object that represents the ethos of the late Ming literati as perfectly as the banana-leaf *qin*.

The poetic associations of the banana plant are also invoked in the text of the seal by He Zhen (no. 72 C): "Banana-tree window night rain" (a line that might almost be the title of a late Ming composition for the *qin*, although surprisingly no such title exists in the better-known collections of *qin* music of this period). By the late sixteenth century seal carving had become one of the most important artistic expressions of the literati. For the first time, it was possible to distinguish oneself by the practice of this art form alone, and the work of those literati who specialized in it was much in demand; no longer was it artistically or socially acceptable to use seals that showed no qualities of learning and taste. Seal carving is a branch of literati art that was to reach maturity in the Qing period, accompanied by the great achievements of Qing scholars in studies of epigraphy and etymology, and it was carried well into the twentieth century.

The necessary condition for the birth of this new art form, or rather the transformation of an ancient artistic craft into a medium of literati expression, was the use of soft stones (or soapstone) for seal carving—an innovation attributed to the late Yuan artist Wang Mian (1287–1359); as with most stories about legendary figures, this attribution is only partially true. Soapstone could be accurately carved with a simple, chisel-like knife, thereby allowing the artist to transfer his own calligraphy and graphic design onto the seal and to exercise total control over the process. The carving of calligraphy in stone was in itself an activity that had the sanction of age-old tradition, and the noblest examples of calligraphy had been handed down from antiquity on stone stelae and tablets. Rubbings of these inscribed stones were among the literati's most highly sought after collectibles, ranking third on Li Rihua's list. A large proportion of late Ming literature on connoisseurship was devoted to rubbings,[37] and the meticulous attention and intense connoisseurship lavished on stone inscriptions sharpened the eye of the scholar/collector to an extraordinary degree. The quality of the calligraphy (whether the stone had been cut from the original or from a copy by a later master), the sensitivity of the carving (in preserving the subtlety and individuality of the calligraphy), the delicacy and faithfulness of the rubbing (affected by the right concentration of ink, the quality of ink and paper, and the correct degree of squeeze), and the age of the rubbing (determined by the extent of the damage to the stone through weathering and accidents or vandalism and by the appearance of the rubbing) were all subjects of endless scrutiny and critical debate. Thus, the requisite sensibility and the artistic and critical vocabulary were

both well established when literati artists first took the knife—the "steel brush"—to the stone, urged on inexorably by a consuming desire to reenact an ancient activity and to create in harmony with the ancients.

The acknowledged progenitor of literati seal carving was Wen Peng (1498–1573), the eldest son of the painter Wen Zhengming. He was not, in fact, the first literatus to design and carve seals. Zhao Mengfu (1254–1322) was known for a style of seal design called *yuanzhuwen*, the "rounded red line," but this design, its artistic merit notwithstanding, was only a refinement of a style commonly used in the Tang and Song periods; it was thus in the "modern" tradition, as opposed to the antique scripts and designs of the Han and Six Dynasties seals. Wen Peng's innovation was to study ancient seals in the conscious attempt to incorporate elements of ancient designs, and he modified Zhao Mengfu's fluent, facile style by giving the script a more archaic structure and the design a greater rigor. However, most of Wen Peng's seals were carved in relief, and some of them, such as the famous *ting yun* (still clouds, a reference to a poem by Tao Qian) seal for his father, still owed much to Zhao Mengfu. Moreover, he, like Zhao Mengfu, used mainly ivory for his seals and only occasionally soapstone.

The true founder of the literati movement in seal carving was He Zhen (active 1573–1620), whose relationship to Wen Peng was described as something "between a friend and a disciple." His seals were done mostly in intaglio, thus causing the characters to appear in white in the impression of the seal, and were closely modeled after the Han style in both script and design. There was a good reason why he favored the intaglio technique. Most Han seals were cast in bronze and had intaglio characters so that they could be used to stamp the lumps of clay that served—like sealing wax—to seal documents. There was, however, a class of seals for military officers that were made by cutting into bronze blanks, since very often there was no time for seals to be cast when appointments were made immediately before a military expedition or as a result of promotions in the field. Such seals were often crudely cut, lacking the sophistication of design or the refinement of script of the cast seals, but they displayed the quality of *tianqu* (natural interest) so appealing to the late Ming literati. From the technical point of view, direct cutting of the stone was an effective means of emulating the style of the cut bronze seal of the Han period; at the same time, it allowed the artist to exploit to the fullest the properties of his material. He Zhen's awareness of this factor is evidenced by his dedicatory inscriptions, or side inscriptions (*biankuan*) as they are called, carved on the side of the seal—usually the left side when the seal is held in the correct position for stamping. Whereas Wen Peng's side inscriptions were usually done in running script with the brush and subsequently carved into the ivory or stone thus retaining their calligraphic qualities, He Zhen cut directly into the stone using cuneiformlike strokes that emphasized

the properties of material and tool. This in turn opened the way in later periods for seal carvers to emulate ancient scripts found on stone stelae.

He Zhen's style is well illustrated by the two examples of his work in this exhibition (nos. 72 B, 72 C). Both are carved in intaglio after the fashion of cut bronze seals of the Han period, and the side inscriptions are executed in He Zhen's typical manner, which was to be one of the standard styles for side inscriptions for the next three hundred years. The texts of both seals are poetic lines rather than personal or studio names. If He Zhen was not the first to carve such seals, he certainly did much to popularize this particular type. One of his most famous works was a poetic seal commissioned by the Suzhou painter Wang Zhideng (1535–1612) for his friend Ma Shouzhen (1548–1604), a literary *ji* and painter of considerable talent from Nanjing, thereby commemorating a celebrated romantic liaison of the time.

He Zhen's art is an excellent example of true creativity achieved through the revival of ancient forms, a means by which the long artistic tradition of China regenerated itself through the centuries. But He Zhen went further. He introduced an element in his seals that was totally new and very much in keeping with the spirit of his time. When he "reproduced" seals of the Han period after long and arduous study of the originals, he was not working from the seals in their pristine condition. His actual models were the wrecks of Han seals that had been excavated in much later periods. Classicism was thus tempered by the Romantic ingredient of ruin and decay. By a deliberate and judicious "wrecking" of the seal after the basic text was cut, He Zhen added an extra dimension of antiquity to his work and, one might add, an extra degree of *qu*—meaning, in this case, something very close to the "picturesque"[38] as it was understood in late eighteenth-century England. This was, of course, a perilous operation as the slightest mistake in judgment could result in a contrived look, anathema to late Ming sensibility. It was in this one respect that many of He Zhen's followers—and there were many even in his lifetime—fell short of the artistic ideal, eventually setting off a reaction against the Wan (Anhui) school of seal carving, as He Zhen's followers came to be known; but the reaction did not occur until a century later, well into the Qing period. He Zhen himself seems to have been incapable of committing any error, and he was able to indulge in personal whims without falling into mannerism. The two seals in this exhibition illustrate his infallible judgment: the "Old fisherman in misty waves" seal (no. 72 B) sustained a considerable degree of deliberate damage, especially in the left half, while the "Banana-tree window night rain" seal (no. 72 C) has only very minor breaks, in the middle of the left and right sides. He Zhen's art illustrates well the quality of *qixian* (unexpected and perilous), which was a sought-after effect in late Ming art and literature.

He Zhen's influence was strongly felt among seal-

carving specialists such as Su Xuan, his younger contemporary, who carved seals for the Yuan brothers of Gongan and for artists like Chen Jiru (1558–1639). On the other hand, most of the late Ming literati who carved seals, such as Li Liufang and Gui Changshi (1573–1644), followed the more conservative—and technically much less demanding—style of Wen Peng. Gui Changshi's seal in this exhibition (no. 72 A) is in pure Wen Peng style.

The last example of literati activity to be mentioned in this summary essay is related to seal carving. This is the practice of having one's calligraphy collection carved on stone or wooden boards, from which rubbings were then taken. The practice itself began in the Song period under imperial patronage, when selections of calligraphy from the palace collection were carved on wooden boards by order of Emperor Taizong in the year 992 and rubbings were made as gifts to senior officials. Subsequently, imperial and private collections of calligraphy had been reproduced in the same way. In late Ming times, all major—and not so major—collectors indulged in this activity, for personal delectation and circulation of the rubbings among friends. Not every piece of calligraphy reproduced in one of these sets was necessarily owned by the person who had commissioned the carvings. Important examples were often borrowed from friends in order to enhance the value of a set or to fill the gaps in a collection. Nowadays, with the advent of modern means of reproduction, the practical value of such rubbings has greatly diminished. However, the late Ming sets that survive give us a good record of the contents of the major calligraphy collections at the time. As works of art in themselves, these rubbings are judged on the basis of the authenticity and quality of the originals and on the faithfulness of the carving, and, to a lesser degree, on the paper and ink used for the rubbing. The two examples included in this exhibition are considered to be among the better sets made in the Wanli period: the Yugangzhai Collection (no. 30) is known for the authenticity of the calligraphies and the Mochitang Collection (no. 29) for the quality of the carving—it took more than seven years for the complete set of calligraphies to be carved on stone slabs. The Mochitang stones, unfortunately, perished not long after they were cut. The Shanghai Museum also owns a rare, complete set of the Xihongtang rubbings, which was commissioned by Dong Qichang, one of the greatest collectors and connoisseurs of the Ming period. This set, however, has often been criticized because of the poor quality of the carving, which was apparently executed in some haste, even if most critics agree that the contents were, as one might expect, well selected.

The brief discussion of selected topics above gives an indication of the richness of the artistic legacy of the literati of the late Ming. The influence of this legacy on every area of Chinese art up to the present time has been paramount. And this influence is by no means confined to the narrow circles of the literati, as was the case with the founders of the literati movement in the Northern Song dynasty. In any full-scale study of the arts of the Ming period, one of the central academic questions must be the relation of the literati movement at the time to its beginnings in the Northern Song, and whether any direct line of development can be traced from the eleventh to the seventeenth century. Such an inquiry is beyond the scope of this essay. It may be relevant, nevertheless, to point out, by way of a conclusion to our present discussion, the major differences in the effects and ramifications of the literati movements in the Northern Song and late Ming periods. Whereas the major achievements of the Northern Song literati were in the field of literature, extending to a lesser degree to the arts of calligraphy and painting, the achievements of the late Ming literati were evident in every branch of the plastic arts and music. Moreover, the late Ming literati standards of judgement and manner of expression were soon adopted by professional artists. When imperial patronage was reestablished at the Southern Song court after the disruptions following the fall of the Northern Song capital, the academic painting tradition immediately reasserted itself; but, in contrast, the "orthodox" painters who served at the court of the early Qing emperors had embraced much of the style and expression of the Ming literati, who were opposed to the academic painting of their time. Even today, the art academies of China, training professional artists, are dominated by the literati tradition, while professional musicians who specialize in the *qin* still confront the dilemma of how to popularize the instrument without sacrificing too much of the "traditional" qualities of the music. Through their patronage of the decorative arts, the taste of the literati was also felt in much of the popular culture of the late Ming period and was to persist to some extent through the next dynasty. Although the simple, elegant forms that characterized the decorative arts of the late Ming soon gave way to arbitrary and elaborate shapes in the Qing period, the subject matter of the decoration continued to reflect the influence of the literati. The representations of Su Shi (1037–1101), Mi Fu (1052–1107), and Lin Bu (967–1028), idealized literary figures of the Song and much discussed by late Ming literati, still appear with great frequency on porcelain and other decorative art objects in the twentieth century.

It is an intriguing thought that the arts of the literati, which began as a means of retreat, should later come to dominate the artistic and literary life of China, sometimes over the protest of more conservative scholars of the Qing period. How much of the philosophy and critical views of the literati is still relevant to present-day society is a question not readily answered, but it is a question that must be asked.

The Artistic Theories
of the Literati

CHU-TSING LI

BEHIND the elegant and exquisite objects that inhabit the Ming scholar's studio stands a personality whose taste, ideas, ideals, and artistic theories they reflect. The concepts guiding the scholar in his careful selection of those objects are part of an age-old tradition that stretches from the very early history of China to the present day. The diverse strains of this long intellectual tradition finally crystallized into a coherent body of ideas during the early seventeenth century, largely as a result of the activities of a circle of literati who lived in the area of Jiaxing and Songjiang, which lies between Shanghai and Hangzhou. An understanding of their ideas will give us a basic grasp of the literati approach to art.

By the beginning of the seventeenth century Chinese culture had reached a point where pure enjoyment of the arts could become an end in itself. The Ming dynasty, seen in the traditional Chinese cyclical view of history, had long passed its prime and was in decline. Inept emperors, corrupt ministers, and greedy officials around the country had caused society to stagnate. For the literati, it was not a time to be active in public service; in despair over the political situation, they turned instead to the pursuit of the arts.

When a literati theory of art was first formulated in the latter part of the eleventh century by such poet-artists as Su Shi and Mi Fu, it was in terms that were relevant to the Northern Song period.[1] Through the centuries, this theory underwent some evolution as a result of changes in Chinese society, but there was no sharp divergence from the original conception, except that an interest in eremitism became a common literati ideal. The late Ming period, however, saw some major developments in the ideas of a number of the literati. Especially important in formulating these new ideas were Dong Qichang and Chen Jiru of Songjiang and Li Rihua of Jiaxing.

The prerequisites for inclusion among the literati during the Northern Song were scholarship in the Chinese tradition, official status at court, and ability in the creative arts of poetry, calligraphy, and painting. During the Yuan period, however, when vast numbers of scholars were given no opportunity to serve in the Mongol court, eremitism became a literati ideal. Although incompatible with the previous preference for official status, eremitism had a considerable influence on later literati, and many still chose not to serve in officialdom during the early Ming period.

By the late Ming, the idea of what constituted the literati seemed to be flexible enough to include several types. While the basic desire was to be a recluse free of all worldly obligations, serving as an official was still quite acceptable. As a result, we can see the existence during that period of many different types of literati—the official, the teacher, the hermit, the monk, and the artist.

In the group of literati depicted by Zhang Qi and Xiang Shengmo in *Venerable Friends* (no. 1), all these different types are represented. Both Dong Qichang and Li Rihua were officials; Chen Jiru was a literatus teacher; Qiutan was a literatus monk; Lu Dezhi and Xiang Shengmo were literati artists. All these men could, in one way or another, be considered hermits; at least that was the aspiration they expressed in their poetry and painting. However, in the cultural atmosphere of the late Ming, neither Dong Qichang nor Li Rihua could retreat from society to live a hermit's life. Indeed, both men had much more important roles to play.

It was generally true that the emperors who reigned during the latter half of the Ming dynasty, most of whom came to the throne while they were still minors, did not have the same interest in the arts that a number of their predecessors—Hongwu, Yongle, Xuande, and Jingtai in particular—had displayed in the late fourteenth to mid-fifteenth centuries. There was always a group of painters serving the early Ming court, and their works were genuinely appreciated by both the emperors and their court officials. By the late Ming, in contrast, very few painters were attached to the court, which meant that neither the emperor nor his court served as an arbiter of contemporary taste. As a result, this role was filled by some of the high officials who were both artists and connoisseurs. Thus Dong and Li became, inadvertently, the tastemakers of their time.

Both Dong and Li inherited ideas that had come down from the past concerning literati art and painting. For models, they looked back to the group of lite-

rati of the late eleventh century who had formulated the basic tenets of literati painting. Su Shi, Wen Tong (1018/19–1079), Mi Fu, and Huang Tingjian (1045–1105) were especially important to their thinking.[2] Some Yuan painters were also regarded as innovators within the literati tradition, contributing many new ideas and styles.[3] By the early seventeenth century literati painting as a subject had accumulated a considerable body of thought. It was then the work of Dong and Li—Dong in particular—to assemble all the ideas from the past and, by adding new ideas of their own, to create a reconstructed theory of literati painting.

LITERATI IDEALS

In virtually all literati writings the first requirements for a literatus are moral character and intellectual background. Li Rihua wrote:

In discussing calligraphy Jiang Baishi [Kui] said: "The first thing is that there should be high moral character." Wen Zhenglao [Zhengming], when putting an inscription on his mountains in Mi [Fu] style, also said: "If the moral character of an artist is not high, there is no way for him to handle the ink properly." From this we know that putting ink on paper is no small matter. There should be nothing mundane in his mind before he can bring out the wonderful and the unexpected with his brush, such as mist, clouds, and beauty, which naturally correspond to the spirit of growth in heaven and earth. If one is totally preoccupied with worldly thoughts, unable to wash them away, even though he can look at the hills and valleys and copy the marvelous pieces everyday, he will only be able to compete with those who put colors on lacquerware and plasters on walls, finding their skills in minutiae.[4]

Undoubtedly, this emphasis on moral integrity was directly influenced by some of the early literati masters, to whom later writers looked as their models. In 1629 Li Rihua wrote:

Zizhan [Su Shi] was a man of great talent and broad vision. He studied his books all day and discussed the *dao* [the way] all day and talked about the affairs of the world. Yuanzhang [Mi Fu] spent all day examining strange rocks and antiques. Yuke [Wen Tong] also liked antiques and practiced seal and clerical styles in calligraphy. Thus none of them was limited by mere painting. They had high and lofty aspirations, and reached deep into the ideas and interests of the ancients. They appreciated the spirit and beauty of mountains and rivers and the marvelous quality of all things.[5]

Here Li was emphasizing the fact that those early literati masters were men of culture who had broad interests, not confined to painting. It was this that distinguished them from ordinary painters, for the literati were learned scholars who loved antiques and rare objects and who had the ability to serve at court if they were needed.

The distinction between literati painters and mere artisans was an important one. An inscription that Li Rihua wrote on a painting by his son, Li Zhaoheng, begins:

The literati regard inner virtue and moral character as the most valuable assets. On the other hand, it is better to have fewer rather than more skills. Skills could not only lead to a life of servitude but could also hurt a man's moral standing.[6]

Li expresses the deep-rooted conviction of the Chinese literati that the standard literati pursuits—poetry, calligraphy, painting, and seal carving—were very different from those of artisans and craftsmen. Moral character was also basic to Dong Qichang's conception of the literati, even though he was not known for moral integrity in his own life.[7]

While the distinction between the literati arts and the trade crafts was still quite obvious in the late Ming, the literati of that period all seem to have developed a broad, encyclopedic interest in every kind of fine object, an interest that is reflected by what they collected in their studios. In Li Rihua's diary, there are numerous entries recording the different things people brought him, sometimes as gifts, sometimes as objects for sale, and sometimes as treasures to show him. One of the records in his *Zitaoxuan zazhui* (*Miscellanea from the Purple Peach Studio*, no. 24) has this interesting list:

My pupil Huang Zhangfu asked me to write a piece of calligraphy for him. Playfully I wrote down this

RANKING OF ANTIQUE OBJECTS:

1. Calligraphic pieces of the Jin and Tang dynasties.
2. Paintings of the Five Dynasties, Tang, and early Song.
3. Calligraphic writings and rubbings of the Sui, Tang, and Song.
4. Handwritings by Su [Shi], Huang [Tingjian], Cai [Xiang], and Mi [Fu].[8]
5. Paintings of Yuan artists.
6. Handwritings by Xianyu [Shu], Yu [Ji], and Zhao [Mengfu].[9]
7. Paintings by Ma [Yuan] and Xia [Gui] of the Southern Song.[10]
8. Various marvelous paintings by Shen [Zhou] and Wen [Zhengming] of this [Ming] dynasty.[11]
9. The running and cursive style calligraphy of Zhu Jingzhao [Yunming].[12]
10. Assorted handwritings by other famous literati.
11. Brilliant examples of bronze vessels and red jades before the Han and Qin.
12. Ancient jades of the of *xun* and *lin* types.[13]
13. Tang inkstones.
14. Ancient *qin* [zithers] and world-famous swords.
15. Finely printed books of the Five Dynasties and Song.
16. Strange rocks of a rugged and picturesque type.
17. A combination of some old, elegant pines and small needlelike rushes in a fine pot.
18. Plum trees and bamboos that are fit for poetry.
19. Imported spice of a subtle kind.
20. Foreign treasures of a rare and beautiful kind.

21. Excellent tea well prepared.
22. Rare and delicious food from overseas.
23. Shiny white fine porcelain and mysterious colored pottery, old and new.

In addition to these, white rice and green dishes, and cotton robes and rattan cane are exquisite objects for the literati to use. They should be aware of the ranking of these objects, like the ranking of scholars in the Lingyan Hall of the Han dynasty, which was arranged by the wisdom of a just ruler.[14] If a vulgar merchant marks some fragile pieces from the Xuande and Chenghua kilns with exorbitant prices, it will be an error, like making Dong Xian one of the Three Dukes.[15]

This list reflects the views not only of Li Rihua but also of many of the other leading literati of his time. Calligraphy and painting naturally rank highest on the scale, while other objects, such as ritual bronzes (nos. 82–85), ancient jades, inkstones (nos. 73, 74), musical instruments (nos. 79, 80), swords, printed books (nos. 24–28), and picturesque rocks, all rank lower, even though some of them are much older than calligraphy and painting. The list also includes garden plants and flowers, spices, food, tea, and foreign treasures, as well as porcelain and pottery—all typical objects to be found in a scholar's studio during the period.

Chen Jiru, a close friend of both Dong Qichang and Li Rihua, also wrote many books recording the valuable things he had seen and heard about during various periods of his life. One of his books, *Nigulu* (*Record of Cherishing Antiques*), consists of extensive notes on what he saw during the 1590s, mainly in his hometown, Songjiang, and in Jiaxing. Chen wrote in the preface:

I am fond of very few things, but as a person of taste I am fond only of calligraphy and famous paintings, and of bronze vessels and *huan* and *bi* jades and their like from the Three Dynasties and Qin and Han. I consider that in these things I can find the Kingdom of Eternal Happiness.[16]

While most of the notes in this book are devoted to calligraphy and paintings, some do deal with inkstones, seals, ceramics, lacquerware, jades, bronzes, and exotic objects, reflecting, like Li Rihua's list, the taste of the time.

In a short treatise called *Shuhua jintang* (*Sound Taste in Calligraphy and Painting*), Chen also drew up a list of the things he enjoyed most, which he called "Fond Interests":

Connoisseur. Studio. Clean table [for painting]. Cool breeze and beautiful moon. Vase of flowers. Tea, bamboo shoots, oranges and tangerines all in season. Between mountains and rivers. The host not being formal. Stretch under the sun. Famous incense as offering. Research. Peace in the world. Talking to high monks in the snow. With strange rocks and bronze *ding* and *yi* by my side. Getting up from sleep. Recovering from sickness. Freely displaying objects but slowly putting them away.[17]

Again, Chen's list reflects contemporary literati taste.

Although the literati clearly valued calligraphy and painting more than the various kinds of objects they collected, whether cultural relics or examples of the decorative arts, the artistic status of such objects definitely rose during the late Ming period. As Li mentioned in his diary, many of these things were regularly brought to him for enjoyment and evaluation. An indication of their importance is the fact that objects were often identified by the places where they were made or found: examples are Huizhou's "four treasures of the scholar's studio," namely brush, inkstick, inkstone, and Xuan paper; printed books from Suzhou and other cities (nos. 24–28); Jingdezhen's porcelains (nos. 31–34, 39–43, 89); Dehua's white porcelains (nos. 36–38); and Lake Tai's strange rocks.

Moreover, while most of the artisans who made such objects in earlier periods remained unknown, certain late Ming craftsmen were not only known but even enjoyed a status close to that of the literati. Just as signatures or seals were traditionally applied in painting and calligraphy, so objects could now be inscribed with their makers' names. There are examples in every craft: the small teapot of *Yixing* ware by Shi Dabin (no. 35);[18] the bronze cylindrical censer of Hu Guangyu (no. 62);[19] the inksticks by Cheng Junfang, Wang Hongjian, and Fang Yulu (nos. 75–77);[20] the bamboo carvings of Shen Dasheng, Zhang Xihuang, and Feng Xilu (nos. 55, 57, 59);[21] the rhinoceros horn cup by You Kan (no. 61);[22] the soapstone carvings by Wei Rufen and Yang Ji (nos. 53, 54);[23] the *qin* by Zhang Jing(?)xiu (no. 80).[24] Most of these people were contemporaries or near-contemporaries of Li Rihua.

As another mark of distinction, several objects bear the signatures of the literati who once owned and used them. One inkstone, no. 74, belonged to the great figure and landscape painter Chen Hongshou (1599–1652).[25] Another, no. 73, was owned by Yuan Jiong (1495–1560) and later by a descendant, a cousin of the famous eighteenth-century poet Yuan Mei (1716–1798);[26] a seal of the former and two inscriptions of the latter were carved on this inkstone. This practice is analogous to the addition of colophons and seals on calligraphy and painting. Li Rihua, in his *Tianzhitang ji* (*Writings from the Hall of Tranquility*), records more than a dozen inscriptions he carved on a number of inkstones, pewter teapots, and chessboards in his possession.

At the same time, Li Rihua and his fellow literati had no doubt that calligraphy and painting were the primary arts. The statements already quoted make this quite clear. Writing to a painter, Li elaborated the idea:

Painting is the expression of subtle observation and untrammeled thinking in the broad minds of the noble and cultured literati. It is certainly not something that ordinary hands can capture. Their proper origins and processes of cultivation can all be traced. They generally discard all their worldly connections and wander freely in mountains and rivers. They read a

great number of unusual books and know plenty of distinguished people. In their pure, quiet, and solitary moments, they will absorb all the changes between darkness and brightness, between morning and evening, and between light in trees and shadow in sands, until all the anxieties building up within suddenly reach bursting point. This is the way they will reach the wonderful realm.[27]

In another passage, Li Rihua wrote in the same vein:

Once I discussed painting with Shen Wuhui, saying: "First the painter must read extensively. Having read a great number of books and having understood all the changes of the past and present, he will not be confined to the narrowness of knowledge but will naturally have a breadth of mind that will enable him at any time he wishes to penetrate into all the mysterious and magnificent mountains and rivers. Why does he have to worry about his not reaching the wonderful realm?"[28]

In both statements the term "wonderful realm" is used to indicate the dreamland of the literati, which is the same as the Kingdom of Eternal Happiness in Chen Jiru's preface quoted above. In some ways, this is a place close to the Buddhist Western Paradise or the Daoist Isles of the Immortals, but it also has distinctive characteristics of its own. Whereas in the Buddhist paradise the saved souls tend to leave all worldly worries behind, and the Daoist immortals likewise retreat from the mundane, the wonderful realm of the literati is a place where scholarship, art, antiques, and all the beautiful and significant things in the world are treasured. It is a realm of learning and taste and sophistication. Something related to this is reflected in a famous statement by Dong Qichang, which discusses the preparations a painter must make before he can undertake creative work:

There are Six Canons for the painter. The first is "spirit consonance should be lively and vitalizing." But spirit consonance is not something that can be learned. We already know it when we are born, for it is endowed by heaven. There is, however, something that a painter can learn. Let him read ten thousand volumes and walk ten thousand miles. All these will wash away the turgid matters of the mundane world and help form the hills and valleys within his bosom. Once he has made these preparations within himself, whatever he sketches and paints will be able to convey the spirit of the mountains and rivers.[29]

The distinguishing characteristics of the literati—their moral character and their knowledge acquired from books and travel—correspond to the Confucian tradition. The literati are seen as the embodiments of moral, intellectual, and artistic perfection.

Beginning with the earliest literati in the Northern Song there was an emphasis on the amateur status of literati painters as opposed to the professionalism of painters for whom art was a means of livelihood. Such a distinction is at the heart of literati painting. Because

of his amateur status, the literatus painter did not have to please patrons by rendering what they wanted, but could follow the dictates of his own inspiration and express himself freely, without constraint. Li Rihua wrote of Huang Gongwang (1269–1354), the Yuan master known for his simple and free brushwork, who often visited the area of Songjiang and Jiaxing in his old age:

The prefect Chen once told me: "Huang Zijiu used to spend whole days sitting amidst the deserted mountains, disorderly rocks, thick forests, and deep waterfalls, feeling utterly free. People could not understand why. He also often went to the spot where the Mao River joined the sea, to watch the rapid torrents hitting the waves. Even though sometimes winds and rains came suddenly and the water monsters cried sadly, he did not care." Alas! This is why Dachi's [Huang's] brush can be so spirited and transforming that it can compete with the wonders of nature.[30]

Only when a man is completely free from worldly trappings and has become as natural as nature itself can he be a good literatus artist.

TRADITION AND TRANSFORMATION

It was typical of these Chinese intellectuals that the first step they took in order to escape from the ugliness of the present was a return to the past. This traditional view of the perfection of the past was deep-rooted among the Chinese. In all the literati arts—poetry, calligraphy, and painting—allusions to the past are common. Although many masters of Tang and Song painting were taken as models for imitation, the one who had the most influence on late Ming painting was Huang Gongwang. In his long life, he first served as a clerk in officialdom but soon felt frustrated by this occupation; later he became a recluse living alone in nature, free of all commitments. Huang's paintings show a corresponding sense of freedom and vitality. On his handscroll *Rivers and Mountains in My Dream* (no. 3), Li Rihua wrote an inscription saying that the painting was inspired by the brush of Huang Gongwang. This is borne out by the style of the painting, which displays the freedom usually found in Huang's works, particularly in the prominence of the brushwork, the unimportance of spatial recession, and the simplification of natural forms. Similarly, the poem Li wrote at the end of the painting is derived from poetry of the Tang dynasty; in the last line Bai Juyi (772–846) is mentioned as his model.[31] Li's calligraphy shows an indebtedness to the foremost calligrapher in history, Wang Xizhi (321–379 or 303–361).[32] Although in every case Li's personal touch marks the differences that exist between himself and his models, the allusions to past masters remain strong, enhancing the richness and subtlety of this scroll.

For Dong and his friends, referring to the past for models did not mean a simple process of copying or imitating; rather, the idea of transformation was seen as part of the artist's creative act. In the Chinese tradition of calligraphy and painting, copying and imitating had been considered important steps in learning ever since the formation of the famous Six Canons of painting by Xie He (ca. 500), and indeed, they are still so regarded. Dong's views on the need for transformation of the past were clear:

Those who study the old masters and do not introduce some changes are as if closed in by a fence. If one imitates the models too closely one is often still further removed from them.[33]

The same idea is expressed in a colophon written by Dong on *Autumn Colors on the Qiao and Hua Mountains* by the Yuan master Zhao Mengfu:

This painting by Wuxing combines the styles of [Wang] Yucheng and of [Dong] Beiyuan, capturing the refinement of the Tang without its minutiae and grasping the vigor of the Northern Song without its harshness. This is what is known as following the methods of the great masters but avoiding their limitations. In consequence, those calligraphers who merely copy directly from the ancients but cannot transform their styles are called "calligraphic slaves."[34]

In spite of its importance for Dong Qichang, this concept of transformation is perhaps the least understood among his major ideas. In the late Ming period, with the power of the imperial court in sharp decline, there was room for a departure from cultural orthodoxy. The philosophy of Wang Shouren (1472–1528) was a rebellion against the Zhu Xi school of thought, which had dominated Ming officialdom.[35] Some of Wang's ideas were later expanded and strengthened by Li Zhi, the strongest antitraditional voice at the time of Dong Qichang and Li Rihua.[36] In literature the rise of the Gongan school of the three Yuan brothers under the leadership of Yuan Hongdao,[37] as well as the influence of Li Zhi, defied the dominance of the traditionalist schools of the Early Seven Masters and the Later Seven Masters of the late fifteenth and sixteenth centuries by moving into the field of popular fiction and drama with contemporary subjects.[38] In the political realm, the rise of the Donglin movement and the radical attacks it launched against the court actualized the dissatisfaction of the intellectuals with the current situation.[39] Most significant was the formation of the Fu She as an organization combining many local groups to fight for clean and honest politics.[40] The emergence of these different voices and ideas in the late Ming contributed to a new cultural climate. Although the literati theories of Dong Qichang and Li Rihua were based on tradition, many of their ideas were innovative and even revolutionary. The need for transformation of the past is the key to an understanding of Dong's position.

In strangeness and rarity of natural scenery, painting is no match for actual landscape; in exquisiteness and marvel of ink and brush, actual landscape is no match for painting. There is a poem by Su Dongpo which says:
If anyone discusses painting in terms of formal likeness,
His understanding is nearly that of a child.
If when someone composes a poem it must be a certain poem,
He is definitely not a man who knows poetry.
I say: "This is Yuan painting." There is also a poem by Zhao Yitao which says:
Painting depicts the outward shapes of objects,
Thus preserving the forms of objects without any changes.
Poetry transmits expression beyond the shapes in painting,
Thus treasuring the expression in painting.
I say: "This is Song painting."[41]

From this it is clear that Dong's idea of literati painting was derived more from Yuan precedents than from Song. It was in the Yuan period that artistic expression became more important than formal likeness, giving rise to the development of personal styles that reflected the artists' individual temperaments. Dong then carried this idea a step further:

When literati talk about painting, they should do it in terms of the ways of cursive, clerical, and archaic styles of calligraphy. Thus trees should resemble bent iron bars, and mountains, drawings in sand. They must totally cut themselves off from the sweetness and vulgarity of the narrow path [actual nature] before they can capture the literati spirit. Otherwise, even if they try to compromise, they will fall into the tricky realm of the artisans, beyond the possibility of recovery. If they can liberate themselves from restrictions, they will be like fishes that have got through the nets.[42]

Here Dong is pointing out the close relationship between painting and calligraphy, both of them dependent not on formal likeness but on the handling of brush and ink. Dong's close friend Chen Jiru made similar comments: "Literati painting does not lie in the narrow path but in brush and ink."[43] And again, at greater length:

People love calligraphy and painting but do not admire the marvels of the handling of brush and ink. There are works that show excellence in brush but not in ink. There are those that show excellence in ink but not in brush. There are those that are excellent in both brush and ink. There are also those that lack excellence in both brush and ink.
Is this the result of energy? skill? spirit? courage? study? knowledge?
They are all here. In sum, they all depend on their cultivation, subtle and free.[44]

This emphasis on brush and ink instead of formal likeness is the most important development in late Ming literati theory, with Dong Qichang its outstanding exponent. Dong's paintings are themselves good examples of its application. The theory was also reflected in the works of the many painters in his circle.

Li Rihua's handscroll *Rivers and Mountains in My Dream* (no. 3) is a case in point. All the objects in this painting—trees, mountains, and pavilions—are done in an extremely simplified manner, so much so that the brushwork assumes greater importance than the actual shapes represented. Furthermore, spatial depth is compressed and viewpoints keep changing. All these elements force us to forget about formal likeness and to become aware of the rhythms, patterns, and variations created by the brushwork. This is clearly related to the brushwork in the calligraphy of the poem, which was written by Li Rihua himself. The expressive spirit is the same in both. Thus the whole scroll is a combination of the three arts: poetry, calligraphy, and painting. All express the typical literati desire, mentioned in the last lines of the poem, of seeking paradise, indicated here by "the dream of Mt. Kuanlu."[45]

Very close to Li Rihua's work in spirit and brushwork is a painting done for him by Li Liufang, entitled *Landscape* (no. 21). Younger than Li Rihua by ten years, Li Liufang lived in Jiading, not far from Songjiang and near Jiaxing. As a hermit-literatus Li Liufang was, like Chen Jiru, in the circle of Dong Qichang, and his paintings reflect Dong's theories. *Landscape*, a short handscroll entirely in ink, shows trees, rocks, and mountains similar to those of Li Rihua, with great freedom of brushwork and an emphasis on the calligraphic quality of the line. According to the inscription, Li Liufang painted this picture for Li Rihua in the year 1618 when Li Rihua visited him in the Sandalwood Garden in Jiading, indicating that the two men shared the same approach to their art.

Li Liufang's *Landscape* is mounted with a piece of calligraphy, a transcription of a poem on painting by the Tang poet Du Fu (712–770),[46] which was written out for Li Rihua at his request in 1620 by Lou Jian (1567–1631).[47] Neither the painter nor the calligrapher can have intended their works, done two years apart, to appear together. It was Li Rihua who, by mounting the two pieces as one scroll, again combined poetry, calligraphy, and painting into a whole. The result is a typical literati work, reflecting Li Rihua's friendship with both Li Liufang and Lou Jian.

Zhao Zuo (ca. 1570–after 1633), a contemporary of Li Rihua, in his handscroll *Autumn Mountains Without End*, dated to 1619 (no. 14), was another who took Huang Gongwang as his model, as indicated in his inscription at the end of the scroll:

Zijiu's [Huang's] ink play does not fall within the limitations of brush and ink. This is very similar to the fact that when the tea luohan drinks tea, he does not look for things in sounds, colors, and fragrances.

It is easy to see the similarities in style between Zhao's work and the two handscrolls already mentioned, for they all go back to the same Yuan painter, Huang Gongwang. Yet the three scrolls represent three distinct personal styles. This variety of styles derived from a common source is part of the subtlety of literati painting.

Zhao Zuo was a native of Songjiang and also a member of Dong Qichang's circle. *Autumn Mountains Without End* represents familiar objects—trees, rocks, and mountains. Although color is used as well as ink, the brushwork is free and simple, far from any attempt at accurate depiction but developing instead its own patterns and rhythms. Zhao is known to have been so close to Dong that he was one of those asked by Dong to paint for him when he could not meet the public demand for his paintings. The inscription by Zhao quoted above reflects his indebtedness to Dong's ideas. This is borne out by the two colophons following the painting, one by Chen Jiru and the other by Dong Qichang himself. Chen writes:

Zijiu [Huang] often painted for Chen Yanlian. The total number [of his works] done for Chen filled twenty albums. They were in the collection of Vice-Prefect Shen, but are now owned by Dong Xuanzai [Qichang]. They are totally devoid of all exaggerated faults. I have been able to enjoy looking at these albums with Wendu [Zhao Zuo]. This scroll shows that he is becoming an immortal.

This colophon is followed by Dong Qichang's, emphasizing the importance of brush and ink:

Whether ink is used or not, the painting is already done in ink. If the master uses ink, he can use it without faults. Wendu [Zhao Zuo] knows the secret of how to use ink. This scroll shows that he knows when to use it and when not to use it, all depending on thickness and thinness and on darkness and lightness.

The combination of Zhao Zuo's painting with colophons by Chen Jiru and Dong Qichang makes this another exemplary literati work.

STYLE AND CONTENT IN LITERATI PAINTING

Despite all the emphasis on brush and ink, it would be wrong to think that literati painting in the late Ming period was headed entirely in the direction of pure formalism or total abstraction, without any regard for representation and meaning. In Western Abstract Expressionism there is such a total devotion to purely formal elements that any resemblance to actual objects in nature is regarded as an aberration; meaning must come directly from the form itself. This, however, is not true of literati painting. However far it departs from the strictly representational, nature is always there, in the form of landscape or bamboo or plum blossom. The brushwork, though of primary importance, never denies the reality of what it is meant to represent. Dong himself in his writings always emphasized this point:

Painters of the past usually took the old masters as their models, but it is preferable to take Heaven and Earth [i.e., nature] as teachers. One should observe every morning the changing effects of the clouds, break off the practising after painted mountains and go out for a stroll among the real mountains. When one sees strange trees, one should grasp them from the four sides. The trees have a left side, which does not enter in the picture, and a right side which does enter; and it is the same way with the front and back. One should observe them thoroughly and transmit the spirit naturally, and for this purpose the form is necessary. The form, the heart, and the hand must correspond mutually, and one must forget all about the imagination [what the spirit offers]. Then there will, indeed, be trees in the picture, which have life also on the silk; they will be luxuriant without being crowded, vigorous and elegant without blocking the view, all fitting together like members of one family.[48]

In their paintings, Dong Qichang and Li Rihua always regarded nature as essential; at the same time they carried the display of brushwork to the utmost, until it sometimes borders on calligraphy. True, one becomes very conscious of the beauty of the brushwork, its lines, patterns, and rhythms, almost as in calligraphy; but just as in calligraphy, regardless of how freely the brush is used, the character itself and its meaning are never left behind, so in literati painting the objects depicted are still there and retain their significance. To achieve the best expression the painter must merge himself with nature in a spiritual union, as Dong explains:

The Dao of painting is to hold the whole universe in your hand [if you possess the real spirit of art, you can comprehend everything]. There will be nothing before your eyes which is not replete with life, and therefore painters [who have attained this] often become very old. But those who paint in a very fine or detailed manner [kehua] make themselves servants of Nature and impair their longevity, because such a manner adds nothing to the power of life.[49]

What Dong alludes to here is capturing the essence or spirit of nature, rather than meticulously depicting its outward forms. By so doing, the brush and ink take on the life of nature itself. This is one of the most important aspects of literati painting.

The goal of literati expression is often known as yi-jing, which can be translated as concretized ideal, or more literally, idealized realm. Often used by modern painters, the term is also appropriate for literati painting.[50] This concretized ideal is present in the paintings by Li Rihua, Li Liufang, and Zhao Zuo already discussed.

As we have seen, literati painting does not stand by itself, but is closely tied to poetry and calligraphy. Throughout his life, Li Rihua kept a record of all the poems he had written either on his own paintings or on those of his friends. These poems give us some interesting insights into Li's paintings, very few of which

have survived. On one fan painting, for example, he wrote the following verse:

Up in the mountains there is nothing to do;
Sitting on a rock I watch the autumn water.
The water is still; clouds cast shadows.
My heart is exactly like this.[51]

On another fan painting he inscribed a similar poem:

Rain from the hills comes from time to time;
Light mist appears morning and evening.
I open my book without knowing where to turn,
And find moss all over my desk.[52]

Most of the lines in these poems describe scenes in nature. The description is simple but clear, conjuring up an actual image. At the same time, the poems evoke a mood, that of the poet-painter himself. For the Chinese literati, this correspondence between poem and painting was not redundant, for poetry, painting, and calligraphy can be appreciated for their own sake, either together or separately. In a poem, one can enjoy the imagery, the choice of words, the rhymes, and the meaning. In a painting, one can see how the objects are depicted, how the space is handled, and how the brush and ink are used. In calligraphy, one can follow the lines, tendencies, and movements, and their stylistic sources. But combined together, all three—poem, painting, and calligraphy—enhance one another and are part of the total expression.

On yet another fan Li inscribed the following verse:

I was born to be a wandering scholar in lakes and the sea,
Sailing in a lonely boat right from the beginning.
Gazing into the blue clouds I see
A single dot of a gull flying alone.[53]

Here the lonely boat and the single gull are not only vivid images in themselves; they are also objectifications of the poet-painter's heart's desire. They are Li Rihua's concretized ideal. As in Li Rihua's *Rivers and Mountains in My Dream*, the objects in the painting are not realistically depicted, for they are done in very free and simple brushwork, nor do they refer to Li's actual life; rather they serve to express his ideal.

For the literati, the more their works are filled with allusions from the past the more sophisticated those works become. This is exemplified in an inscription Li Rihua wrote on a lost painting of his that must have depicted six different trees in a natural setting:

The tall catalpa, straight and towering, is like Lu Zhonglian.
The lonely pine, high and haughty, is like Kong Beihai.
The old juniper, quiet and elegant, is like Pang Degong.
The ancient locust, obstinate and proud, is like Xi Shuye.
The high *wutong*, quiet and restful, is like Tao Yuanliang.
The sparse fir, cold and stern, is like Wang Wugong.
In this autumn day I came out with new ideas to paint this

Six Gentlemen and imagined how the ancient people acted according to their ideals.[54]

Thus each of the trees in Li Rihua's painting was imbued with the character of one of the ancients. Lu Zhonglian, a man of the State of Qi during the period of the Warring States, was known for his ability in the arts of persuasion and negotiation at a time of constant fighting.[55] Kong Beihai, better known as Kong Rong (153–208), was an upright literary figure whose outspoken frankness caused his execution by the strongman Cao Cao.[56] Pang Degong was a lonely hermit who recommended several of his friends for high posts but declined an appointment for himself.[57] Xi Shuye, better known as Xi Kang (223–262), was one of the Seven Sages of the Bamboo Grove; in spite of his aristocratic breeding and his service as a high official, he took up eccentric behavior as an expression of his dissatisfaction with the contemporary political situation and was eventually executed as a result.[58] Tao Yuanliang is the famous Six Dynasties nature poet Tao Qian, who, after serving for a short period as an official, became frustrated with the political situation and retreated to live a hermit's life in the country.[59] Wang Wugong, better known by his official name Wang Ji (585–644), was also a poet who left officialdom to live the carefree life of a hermit at the beginning of the Tang dynasty.[60] In identifying these individuals with different trees in a landscape, Li Rihua was employing an indirect means of expression characteristic of the literati.

One of Li Rihua's close friends was Lu Dezhi, a painter whose main subject was bamboo; *Orchid and Rock Amidst a Clump of Bamboo* (no. 20) is a typical example of his work. He is not very well known today but Li thought him one of the greatest painters of his own time. As a pupil of Li, Lu stayed in his teacher's house in Jiaxing for more than a year, and their relationship was such that he would often ask Li to inscribe a poem or some comments on a finished painting. So many inscriptions were written by Li in this way that they were later collected by one of his pupils into a volume called *Zhulan Mojun tiyu* (*Zhulan's Inscriptions on Mojun's Paintings*), from which the following passage is often quoted:

The Yuan monk Jiaoyin said: "I have painted orchids with an air of happiness, and bamboos with an air of anger." What he means is that the orchids' leaves waving lightly in the wind and their pistils budding freely capture the spirit of happiness, and that the bamboos' stems and branches stretching out vertically and horizontally, like the crossing of spears and swords, seem to express the power of anger.[61]

This kind of approach, which lodges human emotions in plants and flowers, is also typical of literati expression, and it explains why the Chinese literati nearly always chose landscape or plant life as their subject matter. It stands in sharp contrast to the Western tradition of art, which takes the human body as the basic means of expressing human emotions.

The idea of using the bamboo as the symbol of the literati has long been a tradition in both poetry and painting. Here is a poem written by Li Rihua on a painting of bamboo by Lu Dezhi as a gift for an old gentleman by the name of Cheng in Shanyin:

To paint bamboo is to sweep away vulgarity;
Without vulgarity there is no need to sweep.
He has his mind set to leave vulgarity behind,
Even though he is surrounded by vulgar roots.
This gentleman is not a vulgar one;
Morning and evening he supports himself by planting and
　digging;
He is addicted to the taste of brush and ink;
He takes food only to avoid being hungry;
He is not attracted to profits;
Nor to the power of fame.
This gentleman's cultivation is tasteful;
The bamboo's movement is also graceful.
To each other neither is vulgar;
They should be friends forever.[62]

The bamboo, like the life of the true literatus, is the antithesis of vulgarity.

In a long inscription he wrote for an album of bamboo paintings by Lu Dezhi after Song and Yuan masters, Li described their relationship and Lu's development as an artist:

Lu Kongsun [Dezhi] has enjoyed the company of both myself and my son, perhaps hoping to benefit from the ancient paintings and other famous pieces in my collection, without realizing that there are very few. However, because of my taste I have come to know many friends from all around, and they have brought many things to show me. Kongsun saw many of them by my side and became intoxicated by them. After just over a year he has deeply understood them.

Since then the bamboos and rocks he has done have gained a place in the land of beauty. If his name is covered up, people will regard them as the works of Song and Yuan masters. This shows how Kongsun is able to synthesize both the ancient and the modern to come to his own.

Nowadays there are many hermits and retired people engaged in painting, but the art of painting is not flourishing. This is due to the fact that those people have not had many opportunities to see genuine works by ancient masters, and are thus unable to capture their spirit and elegance in order to enrich their own works and to wash away their muddy matters. In order to wash away muddy things, one must read more books and explore rare and distinctive mountains and rivers. Recently Kongsun has been working hard to develop his art, like ancient people polishing up their poems. He has made a bronze vessel, brought along some flints, and will wear his wooden shoes to go up alone to explore the exquisiteness of mountain terraces and caves and to become close friends with scattered clouds, flowing waterfalls, sharp rocks, and strange pines. With this, his art should be better every day. This album is his first result. In the future his development will be tremendous and without limits.[63]

As Lu Dezhi's mentor, Li must have been extremely pleased to see his development as a bamboo painter, absorbing the great styles of the past and recreating them in his own fashion. In his inscriptions on Lu's paintings, Li was actually expressing his ideal of a literatus painter.

The most important theory to come out of the circle of Dong Qichang, Chen Jiru, and Li Rihua was that of the Northern and Southern schools of landscape painting, which had far-reaching effects in the history of Chinese art. Although this theory has been ascribed to Mo Shilong (1539?–1587), recent research has confirmed Dong as its chief exponent.[64] In light of the development of Chan Buddhism in China, which branched out into the Northern and Southern schools during the Tang period,[65] Dong saw the history of Chinese painting in terms of a similar separation into two major schools during the same period:

In Chan Buddhism there is a Southern and a Northern school which first separated in the Tang period; in painting a similar division into a Southern and a Northern school was also brought about in the Tang period. But the men [who represented these schools] did not come from the South or the North. The Northern school took its origin from Li Sixun, father and son [Li Zhaodao], who applied color to their landscapes: their manner was transmitted in the Song period by Zhao Gan, Zhao Boju, Zhao Bosu down to Ma Yuan, Xia Gui and others.[66] The Southern school began with Wang Wei [Mojie], who used light washes [of ink] instead of a manner with fine outlines, and this was continued by Zhang Zao, Jing Hao, Guan Tong, Dong Yuan, Juran, Guo Zhongshu and the Mi, father and son, down to the four great masters of the Yuan period.[67] It was just as in Chan Buddhism, after the time of the Sixth Patriarch, the Maju, Yunmen, and Linji [schools] developed as flourishing offshoots [of the Southern school], while the Northern school was fading away.[68] Very important is the saying by Wang Wei, that the clouds, peaks and cliffs should be formed as by the power of Heaven, then, if the brushwork is free and bold, the picture will be penetrated by the creative power of Nature. Dongpo [Su Shi] praised Wu Daozi's and Wang Wei's wall-paintings and said that as to Wang Wei, there can be no word of dispraise. This is certainly right.[69]

In essence, this theory of the Northern and Southern schools of landscape painting was an early seventeenth-century affirmation of literati painting as the mainstream of Chinese painting from the Tang period until the Ming. By showing a strong preference for the Southern school over the Northern, it upheld the ideas developed by Dong and Li's circle, including those concerning moral integrity, book learning, extensive travel, respect for tradition with the need for transformation, symbolic expression of a subtle kind, and the importance of ink and brush. Following the distinction in Chan Buddhism between the conservative Northern school and the innovative and unorthodox Southern school, Dong and his circle regarded the Southern school of painting—characterized by intuitive, spontaneous expression—as much superior to the colorful and decorative Northern school. Basically, this was an extension of the distinction drawn by Li Rihua between the superior arts of painting, calligraphy, and poetry and the less favored crafts and skills.

In developing all these ideas, Dong Qichang and Li Rihua created a coherent body of thought underlying literati art. They also advanced an aesthetic theory of calligraphy and painting that has been the dominant ideological force in Chinese art since the seventeenth century. Indeed, during the past three hundred years, there were no major challenges to its supremacy until well into the twentieth century, when certain Western theories of art were introduced into China. Interestingly, its closest parallels in the West are found in the theories of modern art that were developed in Europe in the late nineteenth and early twentieth centuries.

Late Ming Literati: Their Social and Cultural Ambience

WAI-KAM HO

THE PERIOD under discussion covers mainly the two eras of Jiajing and Wanli, roughly the one hundred years before the fall of the Ming dynasty in 1644. The place was Jiaxing, a rich prefectural and county seat south of Lake Tai. In the history of literature and art Jiaxing was well known for great poets (Chen Yuyi, Zhu Dunru), painters (Zhao Mengjian, Wu Zhen, Sheng Mou, Yao Shou), scholars (Yue Ke, Song Lian, Bei Qiong, Sun Zuo, Tang Su, Dai Liang), collectors (Xiang Yuanbian, Feng Mengzhen, Wang Keyu), and hermits (Qian Dejun, Zhou Lijing). It was also known for Yuan silver wares by Zhu Bishan,[1] carved lacquerware by Yang Mao and Zhang Cheng,[2] inksticks by Shen Gui, and the boatman's songs under the famous Tower of Mist and Rain at Lake of Mandarin Ducks.[3] The men chosen as typical late Ming literati to be the focus of this sketch are Li Rihua and Xiang Shengmo, both natives and lifelong residents of Jiaxing, as well as members of their circles of close friends and relatives such as Dong Qichang and Chen Jiru.

Let us pick a fine autumn day, say October 21, 1623, and follow the footsteps of a visitor from a neighboring district, Pu Fangjun, who was returning home from Hangzhou and made a nostalgic one-day stop at Jiaxing to refresh his memory of a previous sojourn. In his *You Mingshenghu riji* (*Diary on a Tour to the West Lake*), an entry is found under that date:

I went again to Dongta Si [Temple of the East Pagoda] to visit the grave of Zhu Maichen. Several years ago, when I stayed at Jiahe [Jiaxing], the Six-mile [*li*] Street was the most prestigious address because of the splendor of its houses and the wealth of the people who lived in the district. The East Pagoda, resplendent in gold and blue, loomed majestically at the center of the street. [The inscription on the horizontal wooden tablet hung at its Bell Tower was written by Li Rihua]. It was a popular spot for spring outings; and ladies in fine jewelry paraded in competition with each other on moonlit evenings and mornings of flowers in bloom. Now the Buddhist images have been covered with dust, and dark moss and pale weeds have climbed and spread all over the stone steps. How sad is the change between prosperity and decline in less than ten years.

Next I visited the garden of the Xiang family, which was a villa of Mr. Molin [Xiang Yuanbian]. Precipitous rocks rise along winding paths. A stream is filled with water channeled from afar. Coming through the grove and flowing around some buildings the stream finally collects in a pond. Each pavilion or covered terrace, even a single plant of flower or bamboo, is placed with such elegant taste that this vision of hills and valleys must have existed originally in the old gentleman's mind. Indeed, among the famous gardens in Zuili [Jiaxing], this is the finest.[4]

It is not known whether the Tianlaige (Pavilion of Nature's Own Music), which housed by far the largest and greatest private collection of art ever assembled during the entire Ming period, was also located in this garden. We do know, however, that the collection was dispersed in 1645 when Jaixing was sacked by the pillaging Manchu army. Some years later, when Zhu Yizun (1629–1709), the eminent early Qing scholar and distant relative of the Xiang family, wrote in his *Pushuting ji* (*Record of the Pavilion of Sunning and Airing Books*) lamenting the tragic loss of the Tianlaige collection,[5] the estate was already in ruins and had been turned into a commercial vegetable garden, cultivated by Xiang's own impoverished descendants.

The decline of the once-affluent East Pagoda street that Pu Fangjun witnessed in 1623 underscored the kind of cyclical breakdown of the local economic and social structure that plagued many provincial towns. Silk, the main industry of Jiaxing, had fallen drastically in price.[6] Crops of rice dwindled to less than half the yields of the Jiajing period.[7] The value of farmland in the five richest prefectures in the Lake Tai and Shanghai region fell to a record low—one to two taels of silver for one *mu* (0.0667 acre), as compared with fifty to a hundred taels in the mid-Ming period.[8] At the same time, in 1624, the price of rice rose to more than one tael for each *shi*, practically the same as the price of one *mu* of land.[9] These dreaded signs of the lean years seemed almost providential, since they occurred only about two decades before a change of dynasty. The storm of 1644 was approaching and the muffled sound of its distant thunder could be heard in every courtyard of the troubled land.

The Chinese like to refer to better days as a dream, the very existence of which is never certain. Thus, the author Meng Yuanlao (ca. 1090–1150) called his book of reminiscences of city life in Kaifeng before its fall to the invading Jin Tartars in 1127 *Flowery Dreams of the Eastern Capital* (*Dongjing menghua lu*). Similarly

Zhang Dai, the late Ming historian, dilettante, connoisseur in the art of living, and close friend of the painter Chen Hongshou who shared many of his adventures,[10] immortalized his memories of the time, the places, and the people in two collections of hauntingly beautiful essays: *Tao'an mengyi* (*As Remembered in the Dreams of Tao'an*) and *Xihu mengxun* (*West Lake as Revisited in Dreams*).[11] Some curious aspects of late Ming culture seem to be comprehensible only by a study of this phenomenon—the inability or unwillingness to distinguish between reality and fantasy, the tendency to look back at one's own self (*fanji*) and at the past (*fugu*), and the seemingly deliberate attempts to confuse the imitation or the copy with the original and the genuine. Even forgeries regained some of their respectability through a strange process of rationalization. Li Rihua defended the relative merits of forgeries on more than one occasion,[12] and Zhou Rong (1619–1679) theorized eloquently on the concept of *yu* (encounter) from various points of view in his *Chunjiutang wencun* (*Literary Remains of the Hall of Spring Wine*).[13] Indeed, according to this concept of *yu* as presented in *Shuying* (*Shadows of Books*) by Zhou Lianggong (1612–1672) in a discussion of the imitation of the past,[14] the true spirit of the old masters may not be seen in broad daylight, but may be "encountered" under more unexpected and covert conditions, such as a chance rendezvous in a dream, in which the reality may appear in disguise.

Ming scholars were notorious for their fondness for manufacturing "old texts." Feng Fang (*jinshi*, 1523), who was a learned if boastful critic of calligraphy, was one of the best-known culprits in the history of old-text fabrication. During the Ming, however, Feng Fang had no lack of defenders. His biographer Zhang Shiche (1500–1577) considered such hobbies a regrettable form of eccentricity. Ling Mengchu (1580–1644), the celebrated dramatist and popular author of two collections of colloquial short stories, *Pai'an jingqi* (1628, 1632), devoted many years to publishing a series of books in persistent support of the authenticity of a controversial work by Feng Fang, the *Zigong shizhuan* (*Commentaries on the Book of Odes by Zigong*, a leading disciple of Confucius); it was later proved beyond doubt by Qing scholars to be an outright forgery.[15]

Books of a spurious nature from the period also abounded in the art field. The much-discussed *Xiang Yuanbian lidai mingci tupu* (*Illustrated Catalogue by Xiang Yuanbian of Porcelains from Various Historical Periods in His Own Collection*), for example, first published at Oxford in 1908 by Bushell and then annotated and reprinted in 1931 by no less a China expert than John Ferguson, was the subject of a meticulous and conclusive study by Paul Pelliot, whose findings predictably proved the work spurious.[16] Many beautiful artifacts, such as a jade table screen or an ivory arm rest, which proudly bear the inscriptions of Xiang Yuanbian—inscriptions that are doubtful at best—can be found in both Chinese and Western collections. The book purportedly written by the collector himself to discuss these artifacts, *Jiaochuang jiulu* (*Nine Chapters Written Before a Window Under the Shade of Banana Leaves*), is again a work of debatable origin.

Xiang Shengmo, a grandson of Xiang Yuanbian (1525–1590), was fortunate enough to have spent his youth among the treasures described in *Jiaochuang jiulu* before they were dispersed. Those precious things—fine Korean paper, Japanese lacquered writing boxes and folding fans, rare editions, and old ink rubbings—must have played a considerable part in the formation of Xiang Shengmo's artistic outlook and inclination. In a colophon for *The Free Immortal of Soughing Pines* (also translated as *A Carefree Immortal Among Waves of Pines*), a handscroll now in the Museum of Fine Arts, Boston, that he painted when he was in his early thirties, Xiang recalled:

He loved to do things with the brush since childhood. As he was hard-pressed by his father with the preparations for taking the civil examination, he had no spare time during the day. But he would burn the midnight oil to paint, by copying and sketching feverishly, everything from insects and plants to flowers, bamboo, and birds.[17]

Perhaps as a result of this side interest, Xiang was never successful in his pursuit of an official career. Like his grandfather Xiang Yuanbian, he acquired (through purchase?) the rank of *taixuesheng*, scholar of the National University.[18] He made a trip to Beijing in 1618, probably to register at the university. After that, except for one more journey to the north in 1628, he never left his hometown Jiaxing or abandoned his lifelong passion for painting.

SOCIAL STATUS

The Xiangs enjoyed great social eminence and wealth and were one of the oldest Jiaxing families, tracing their origins to a powerful ancestor, Xiang Zhong (1421–1502), who had served the Chenghua emperor as Minister of War. Li Rihua, by contrast, came from a very humble peasant background.[19] Li attained the *jinshi* degree in 1592, and was the first in his family to be accepted by the local gentry; one of his nieces later became the wife of Xiang Shengmo. In those days, a successful candidate for the *Libu* (Board of Rites) examination in the capital would become a celebrity overnight, proclaimed in gold characters on a red silk pennant erected on a post in front of the family residence by the rejoicing local magistrates. A visitor to Jiaxing even two hundred years later could not fail to be impressed by the somewhat exaggerated tribute engraved on the stone archway honoring Li Rihua: *Dagui tianxia* (Grand Champion Under Heaven), an extraordinary citation normally reserved for the *zhuangyuan* (head of the first list of *jinshi*). Li Rihua served in sev-

eral provincial posts to rise eventually to the vice-directorship of the Court of the Imperial Stud, hence he was commonly addressed as Taipu.[20] He spent most of his productive years, however, as a retired scholar-official in Jiaxing, enjoying a position of seniority and influence, a gentleman of leisure and fine taste who could devote his time to collecting and writing, a poet, prose writer, dramatist, critic, and painter who was the pride and leader of the local artistic community. The literary gatherings hosted by Li Rihua or by another in the close circle portrayed by Xiang Shengmo and Zhang Qi in *Venerable Friends* (no. 1) represent the quintessential event among the late Ming intelligentsia. These gatherings were long remembered, and so when Zhu Yizun wrote about the Xieshanlou (Tower for Painting the Mountains) of Li Zhaoheng (ca. 1592–ca. 1662, Li Rihua's son), he fondly recalled the glorious days of the father:

Our town is not known for scenery of hills and valleys. However, the geographical distribution of its numerous private gardens and the placidity of its waters and woods, together with the convenience of its many ferries and boats, make excursions easy and free from fatigue. An extensive period of peace since the Wanli era provided scholar-officials with opportunities to pay more attention to the elucidation and collecting of paintings and books. Literary gatherings accompanied with wine and music were exemplified by the Yuan-she [Mandarin Duck Society], whose membership—based on the contribution of poems—at one time or another numbered thirty-three people in all. Now less than one hundred years have passed and elders of the town can no longer remember the names of those people. The picnic ground that once glittered with jade cups and brocaded mattresses is now desolate in entangling weeds and chilling mist. Only a single pavilion, the Xieshanlou of the Li family, has survived in the ruins.[21]

It is no accident that Li Rihua's second request for retirement, in 1625, coincided with the eunuch Wei Zhongxian's tyrannical dominance of the political scene. The imprisonment and death under torture of the censors Yang Lian and Zuo Guangduo,[22] and the purge of Zhao Nanxing and Gu Xiancheng, the leading Donglin partisans,[23] had shocked the whole nation. Many officials begged to retire to the life of a country squire. These included Dong Qichang, who in 1626 resigned from his new appointment as president of the Board of Rites in Nanjing. Dong's friend Chen Jiru remained all his life an untitled, freelance, roving "prime minister in the mountains," enjoying the kind of national reception accorded only to the most famed and highly respected scholars.

To be able to live at the right time, blessed by benign political and economic conditions, is always essential to a good life, but perhaps not the most essential thing of all. A popular saying in the seventeenth century tried to epitomize what were commonly considered the four basic requirements for an ideally perfect life:

To live at a time of peace,
To grow up in a district of lakes and mountains,

To be privileged with a virtuous wife and
 clever children,
In a family of more than adequate resources.

In this late Ming dream of an individual and domestic paradise, the one key element is obviously missing, or has been taken for granted, and that is the social status of the person concerned. To put it simply, a man would not be in a position to realize these ideals unless he were a recognized member of the gentry, duly installed through the government-controlled system of formal admission, which alone could grant him the political and economic privileges necessary for a special mode of life, the life of an official literatus. A degree of *juren* from the provincial examination or a rank of *jiansheng* at the National University (*taixue*) were minimum credentials to gain entry to the class of "girdle and collar" (*shenjin*), the gentry. The successful graduation from both the *qiuwei* (the triennial Autumn Examination in the provincial capital) and the *chunwei* (the annual Spring Examination in Beijing) which was called *liangbang chushen* (credentials from the two lists),[24] was generally required for a more assured career in the bureaucracy. In some cases, especially in times of financial need or military emergency, there were ways to circumvent the regular channels or to skip the lowest examination level through the appointment of protégés or the purchase of one's degree. As noted above, both Xiang Yuanbian and his grandson Shengmo most likely took the second well-trodden shortcut to qualify for their standing in the upper echelons of society. It is interesting to add that the Wu school in the history of Chinese painting seems to have served as a hotbed for noncandidates. Neither Tang Yin (1470–1523) nor Zhu Yunming (1461–1527) ever succeeded beyond the provincial level. Among the Ming literati who either shied away completely from the civil examination or who contended only to fail, we find many familiar names from Suzhou and its vicinity: Wang Fu (1362–1416), Shen Zhou (1427–1509), Wen Zhengming, Wang Chong (1494–1533), Chen Shun (1483–1544), Zhou Tianqiu (1514–1595), Qian Gu (1508–ca. 1578), Wang Zhideng, Chen Jiru, and Cheng Jiasui (1565–1644).[25] Such men belonged to a separate category of gentry whose acceptance by the educated elite was largely based on their accomplishments in literature and the arts. In fact, throughout Ming history one can hardly find a more inspiring example than Shen Zhou, who in his simple way personified the purest ideal and quality of the literati.

QUALIFICATIONS FOR THE CIVIL SERVICE

There was a time at the outset of the Ming dynasty when high government office did not necessarily reflect success in the examinations. During the reign of

Hongwu, perhaps as a result of the emperor's own background, recruitment and important appointments were made among the uneducated. A sympathetic bias was shown particularly toward the craftsman and the "technician," in what was seemingly a continuation of the policy of the Mongols, as well as of the tradition of other northern nomadic tribes. Xu Xingzu, for instance, Director of the Imperial Banquet, was originally a kitchen hand. Du Andao, Director of the Imperial Sacrifice, was a comb maker. Kuai Xiang and Kuai Yi, Vice-Presidents of the Board of Works, were carpenters. Jin Zhong, Minister of War, was a fortune-teller. This pattern lasted only for a brief period, however. In 1384, sixteen years after the founding of the dynasty, the system of civil examinations (keju) based on the Confucian classics and a general humanistic education was officially reinstated. Once again a scholar-official class was firmly established, with complete control of the government and a monopoly of certain political and social functions both inside the bureaucracy and outside in the provincial towns and villages. As a social group it was unique in many ways, not the least of which was the prerogative of its members to be treated, even before the law, with ceremonies and civilities (li).

The early years of Ming rule were marked by the sway between two extremes—its generosity and seeming trust in the intellectuals, and its suspiciousness and unspeakable brutality toward them. The execution of numerous innocent scholars and the forced migration of thousands of landowners from Jiangnan to enrich or "to substantiate" Linhao, the ancestral seat of the imperial family, were nightmares that cast long shadows of pain and fear on the collective consciousness of the literati. With widespread resistance against recruitment into government service, the civil examinations were augmented in 1385 by a national school system, which by the turn of the century had become the major source of new talent for the bureaucracy. As time went by, the examination system, which emphasized literary achievements, gradually took hold of the national imagination, and keju became the only honorable and acceptable way for social advancement. A three-year program of shujishi, something comparable to a post-doctoral fellowship, was established for the first time in Chinese history in the Hanlin Academy to prepare the newly graduated jinshi for higher assignments and more important duties.[26] According to the dynastic history Mingshi, "beginning from the second year of tianshun [1458], no one but jinshi would be admitted to the Hanlin Academy, and none but a Hanlin Academician would be admitted to the State Council. The positions of President and Vice-President of the Board of Rites in both capitals, together with that of the Senior Vice-President of the Board of Bureaucratic Personnel, would be reserved exclusively for Hanlin Academicians." Consequently, even a freshman shujishi commanded public admiration as chuxiang (Prime Minister in Reserve). A statistic compiled by Xu

Yishi shows that out of 108 prime ministers between the Hongwu and Wanli periods, 79 came from Hanlin Academicians, and 46 from the shujishi program.[27] Since this program was irregular and not available in certain years, an ambitious young jinshi graduate with an eye on the "noble garden of belles-lettres" (hanyuan) would consider himself lucky if offered such an opportunity.

THE TRAINING AND OCCUPATION OF THE LITERATI

A bureaucratic society built on the strength of an examination system must depend on the quality of its education, and even more so on making that education accessible to those beyond the hereditary few. Although in the age of the commoners, a baiyi zaixiang (white-garmented prime minister) with the rural background of a small hamlet was still more plausible in theory than in reality, it was not unusual to find some of the leading scholars of the period coming from very poor families. The well-known bibliophile Yao Shilin (1561–1651) once confessed that at the age of twenty he was still illiterate and had supported himself by painting portraits.[28] Yang Xunji (1458–1546) was another pundit with problematic origins: he came from a merchant family. In a poem entitled "A Memorandum Written on My Bookcase," he told the bitter story of his struggle to acquire knowledge:

My family were merchants from the marketplace,
In Nanhao we have been settled for a hundred years.
At the time when I decided to become a scholar,
There was not one book in our family. . . .[29]

The scarcity of books was a problem faced by many aspiring young scholars. With the rapid development of the publishing business during the sixteenth and seventeenth centuries, especially in cities like Jian'an, Nanjing, and Hangzhou, primers could be bought in the south cheaply and in great variety.[30] Some of this popular reading matter aimed at children was sugarcoated as entertaining folk literature. The main purpose, of course, was to extol the glory of scholarship, to impress young minds with the power of wealth, even the "face of jadelike beauty" that one could expect to find in books, or to rhapsodize about the joy of studying in poems such as "Sishi dushu le" ("The Pleasures of Studying in the Four Seasons"). One of the most widely used primers in the late Ming was supposedly the work of a legendary genius from the early days of the dynasty. This was a collection of poems and tales attributed to Xie Jin (1369–1415), whose extraordinary accomplishments as a child had been the subject of endless commercial exploitation. According to his biography by Qian Qianyi in Liechao shiji xiaozhuan, "His fame as a great genius was so overwhelming and

widespread that every joke, idle remark, and absurdity circulated on the streets by the common people was invariably attributed to Academician Xie Jin."[31] In their aim to promote book learning, these poems and tales associated with the name Academician Xie were not unlike earlier readers such as *Taigong jiajiao* from Dunhuang, or the well-known story of the little boy Xiang Tuo, who easily outwitted Confucius in a test of quick reasoning and verbal skill.

In any case, education was always taken very seriously at the home of a literatus. Among the families of the gentry in Jiaxing, the example of Feng Mengzhen (1548–1605) was probably typical. Feng Mengzhen came from a wealthy family, which had made its fortune from processing hemp fiber for the local textile industry. Both his grandfather and father were illiterate. He was the first student in the family so absorbed in his schoolwork that every night he had to cover his bedroom window with the bedspread to fool his grandmother, who was very frugal about the burning of lamp oil. Feng Mengzhen became a *jinshi* in 1577, headed the list of graduates in the metropolitan examination (*huiyuan*), and was admitted to the Hanlin Academy as a *shujishi*. He finally rose to become president of the southern National University in Nanjing before retiring to his villa on West Lake, Hangzhou. His collection at the Kuaixuetang (Hall of Exhilarating Snow), with art treasures such as the famous handscroll *Jiangshan xueji* (*Clearing of Snow over River and Mountains*) attributed to the great Tang master Wang Wei, attracted connoisseurs from all over the country. Feng Mengzhen was a good friend of Dong Qichang and Li Rihua, and he was also very close to the three Yuan brothers of the Gongan school. In Jiaxing, as in his second, adopted hometown Hangzhou, he was intimately involved in the activities of the local literati.

The intellectual sector in late Ming society displayed a renewed interest and enthusiasm in religion. A remarkable number of literati professed ideological attachment to the Chan or Pure Land sects, more often both, although their attachment was usually philosophically oriented, with little pretense at Buddhist theology or devotional liturgy. Feng Mengzhen and many of his friends were among these prominent lay Buddhists. Feng was, indeed, an early disciple of the monk Zibo Zhenke (1544–1604), one of the four most renowned and outstanding Buddhist masters of the Ming period. Because he was also a follower of the Taizhou school, the "left wing" in Wang Shouren's thought, Feng was regarded as a natural believer in *dunwu* (sudden enlightenment) and *liangzhi* (intuitive knowledge), which seems to imply that he did not care much about book-learning. In his epitaph written by Qian Qianyi,[32] there were suggestions that he was extremely liberal at home and never forced his two sons to study hard for worldly advancement. This observation was apparently not true. Qian Qianyi probably never had a chance to read the literary collection of Feng Mengzhen, the *Kuaixuetang ji*. If he had, he would have found in the diaries and correspondence plenty of evidence of the man's Confucianist side; Feng appears as a stern, demanding father, seemingly obsessed with orderly behavior, self-discipline, and moral purposefulness. It would not be accurate to describe Feng Mengzhen as *daoxue* (by which is meant the boring, prudish, self-styled Neo-Confucianist). Still, the impression given in the correspondence is that a part of the house was set aside for the young masters which one associates with a grim-faced dining table, gloomy days of study, and a hush of conventionality. In fact, in his demand for a certain puritanical abstinence and his insistence on the observance of *gong* (deference) and *xiao* (filial piety), Feng Mengzhen seems to have been surprisingly Victorian, although in his case, of course, evangelical discipline was secularized in late Ming terms of moral assurance and social respectability. Here are some samplings selected and paraphrased from one of the instructions he wrote for his two sons:

Never believe in the saying that if you don't study today, there will be tomorrow.

You have now reached the age when Jia Yi presented his first memorial to the throne, or when Lu Ji moved to Luoyang to complete his masterpieces. Even though you may argue that people today cannot be compared with the ancients, you are too intelligent to hide behind an excuse of ignorance.

You have already had children. All the more reason why you should not stay in bed when the sun is high or waste your time fooling around.

Your father is forty-eight years old this year, and in no time he will be fifty. My ambition for an official career may have declined, yet my longing to escape to "the mist and cloud" [*yanxia*] has become stronger than ever. Even if I should live to old age, I cannot possibly stay forever to teach you and to work for you like horse and buffalo. You will be sorry if you don't resolve to establish yourselves by your own efforts. Now make these pledges to me:

You will get up early every day, never later than the hour of sunrise. Except for lectures, discussions, and the three meals, you will not go to see your teacher or friends and disturb each other. While I don't think the marital love of young people should be discontinued, it can be regulated by a departure in the morning and a return between 9 and 10 P.M. Periodically you shall sleep in the library; nor should you pay too many visits and waste time.

Shangu [Huang Tingjian] used to say that a scholar would wither away if for more than three days he was not "watered" by ancient writings. Granted your most urgent need is *shiyi* [or *shiwen*, period-style eight-legged essay required for civil examinations], you should be able to memorize two hundred words each day from such books as *Tan Gong, Zuozhuan, Guoyu, Shiji, Hanshu, Laozi, Zhuangzi*.

Now a chart of daily assignments will be on hand. You will fill out the chart each day with the amount of work accomplished—number of essays composed, paragraphs of the classics comprehended, pages of *shiyi* and *guwen* read and studied. A reason must be given for any incomplete assignment, which is to be made up the next day.

DAILY ASSIGNMENTS:

1. Reading: the *Four Books* (10 lines), the *Classics* (10 lines), *guwen* and annotations on the *Classics* (10 lines), examination paper by successful candidates (half an essay), *shiwen* (20 essays).
2. Assignments from the *Four Books* and the *Classics* shall be copied word by word in regular script and recited from memory the next day.
3. Additional assignment for memorizing: the examination paper.
4. Composition: one essay of *shiwen* is due every third, sixth, and ninth day in the ten-day week [*xun*].
5. Any failure in memorizing or unacceptable work in composition is punishable by whipping [five rods].
6. Every five days a family visit is allowed to inquire about the health of your mother. You may stay in your own bedrooms that night. On other nights, any place outside the library quarter is off limits.[33]

As president of the southern National University in Nanjing (*Nan Guozijian jijiu*), Feng Mengzhen was the official champion of Confucianism, the ideological perpetuator, indeed the defender of the whole sociopolitical system. Perhaps in this role he had to be a little harsh, even unreasonable, toward his own children. But we must not lose sight of the other side of his personality, the much less conservative and inhibited side that inevitably betrayed some of his religious and philosophical leanings. It has been said that a highly developed moral conscience that is not balanced by an equally developed intellectual insight and artistic sensibility can be obnoxious, an alarming sign of pious philistinism. Most late Ming literati seem to have been able to avoid this pitfall through their cultivated sense of the "intuitive knowledge and capacity" of the "child's mind," and in their tireless search for all things fascinating and enlightening, unspoiled and yet infinitely refined, that are imminent in life and nature (*tianqu*).

Such redeeming qualities can be seen in the assignments Feng Mengzhen designed for himself (which are interesting to compare with the ones he drew up for his sons), as recorded in *Zhenshizhai changke ji* (*Assignments at the Studio of the True Reality*):

1. Domestic routines, five items: educating the sons and playing with the grandchildren; leisurely conversing with the old ladies; entertaining the young concubines; meeting visitors; taking food and drink as they are desired, well prepared but not extravagant.
2. Studio routines, thirteen items: spreading out the books for browsing for my own pleasure; burning incense; making tea and sampling the spring water; playing the *qin* [zither]; meditating; copying or imitating model calligraphy; contemplating a painting; "playing with the brush and ink" [writing]; observing the fish swimming in the pond; listening to the birds; studying flowers and trees; deciphering odd scripts; enjoying the wrinkled rocks.
3. Once every few days, four items: visiting scenic spots for [the pleasures from] mountains and waters; visiting monks

and old friends; searching for flowers when in bloom; seeing mother-in-law, inquiring about her health.
4. At least once a month, one item: inspecting the ancestral tombs in Fancun and Hupao.
5. At least once every half year, four items: make sacrifice at my wife's grave; fulfill any social obligations in hometown; visit the tombs in Jiaxing; purchase rare books, old works of calligraphy, and paintings.
6. The three items to be completed before reaching the age of fifty: visit Tiantai, Yantang, and other famous mountains; buy a villa by the lake; locate a site in the mountains as a final retreat.[34]

A glance at Feng Mengzhen's list of assignments for his sons confirms what has been suspected, namely that priority was always given to preparing for the civil examinations and that the *shiwen*, or eight-legged essay, was emphasized at the expense of everything else. Pragmatism in education inevitably resulted in superficial scholarship, condoned mediocrity, and encouraged intellectual complacency and conformity insulated in the protective shell of provincial and middle-class conservatism. Although the examination system was designed to meet public administration requirements, any hint of professionalism was frowned on, and specialization in scholarship was usually discouraged. Since the Northern Song period, the so-called *jishu* (technology) or *jiyi* (craft) personnel, which included professional painters and calligraphers, were always looked down upon and classified as *buruliu* (outside the main current). For most of the time in Chinese history, they were excluded from the hierarchy of officialdom. The late Ming saw the appearance of such monumental works in science and technology as *Bencao gangmu* by Li Shizhen (1518–1593) and *Tiangong kaiwu* by Song Yingxing (b. 1587), but these publications never helped to win any official recognition for their authors. Among contemporary critics, Gu Yanwu (1613–1682) was probably the most cynical when he commented on the disastrous effect of the *shiwen* on Ming culture and politics. He pointed out that since 1592 successful papers selected by examiners of the "eighteen sections" (*shiba fang*) were reprinted periodically as students' guides, and as a consequence:

People of the world know this is the only publication that can lead to fame, power, and wealth. This is called scholarship, and [its perpetuator] is called scholar. There is no other book that needs to be read. Among those who graduated near the top of the list are ones who had absolutely no idea about important titles of historical works, or the chronological order of dynasties, or even the radical system used in dictionaries. . . . Alas, the eight-legged essays prospered and the Six Classics were ignored; the "eighteen sections" rose to eminence and the Twenty-one Histories became obsolete.[35]

Once, when a high-ranking graduate asked him who was the worst sinner in the world, the Buddhist master

Lianchi Zhuhong (1555–1615) replied, "It is you, sir, it is those of you who scored high on the seven essays in the first day of the examination."[36] What he meant was that out of the three-day examinations, the examiners had time to ponder more carefully on the merits of the seven essays mandatory for the first day. These essays were, therefore, all that mattered in determining the fate of an aspiring official. In an amusing story Zhang Dai described this type of scholarship as scholarship of the *yehangchuan* (night ferry). He put such scholarship of a provincial scholar to the test in a dimly lit, crowded cabin of a night-ferry run in the Shaoxing area. The embarrassing situation can be imagined when the intellectual authority of the poor scholar collapsed under the fire of hilarious questioning. It is only fair to point out, however, that the boat of the bureaucratic society carried not only these provincial passengers but also some of the country's most brilliant minds, who wrote a significant part of Ming history. In many respects, Ming culture was given its shape and character by this scholarly group produced and molded by the civil examination system.

Wolfram Eberhard wrote in 1952 that "Any understanding of the [Chinese] gentry is possible only when one conceives of the 'gentry' as families." This view cannot be accepted without qualification, as it implies that the gentry status is passed on from one generation to the next. The truth is that this status was not hereditary and had to be reinforced or renewed by individuals of each generation and that there was considerable social mobility involving every family member in the privileged upper stratum. Many families lost their gentry status as a result of a breakdown in their scholarly tradition. One of the most prominent families in Shangqiu, Henan province, for instance, the family of the famous early Qing collector Song Luo (1634–1713), was able to profit from the political accommodation that the father Song Quan (1598–1652) made with the conquering Manchu government. Another prominent family in Shangqiu, however, had a different fate: the descendants of Hou Fangyu (1618–1654), who was nationally known as one of the "four young scions of late Ming" and celebrated in Chinese literary history as the hero of the drama *Taohua shan* (*The Peach Blossom Fan*), degenerated into a life of gambling and drinking, completely forfeiting their claims to belong to the educated elite.[37] Divided fortunes similarly befell two old families in Taicang, Jiangsu province, where the Wangs of Langye were represented by Wang Shizhen, the undisputed leader of the late Ming intelligentsia, and the Wangs of Taiyuan were represented by Wang Xijue (1534–1610), a prime minister under the Wanli emperor and grandfather of the early Qing painting-master Wang Shimin (1592–1680). In a eulogy presented to Wang Shimin on his seventieth birthday, the Ming loyalist and famous local scholar Gui Zhuang (1613–1673), son of Gui Changshi (no. 72 A), wrote:

During the three hundred years of the present [Ming] dynasty, the eight counties in our prefecture have given rise to nine state councilors. The most prosperous of the families were able to maintain their eminence for three generations. The rest declined. Mr. Wang [Shimin] has carried on the tradition of his ancestors such as the prime minister and the Hanlin Academician, and for four generations the family has continued to produce high officials. Nothing of the family's great estates and gardens has changed, nor has its great social eminence.[38]

Such a phenomenon was considered unusual, partly because of obstacles inherent in the family structure. The law in Chinese traditional society did not recognize the rule of primogeniture: the eldest son as the sole heir to family property. According to *Da Ming huidian* (*Collected Statutes of the Ming Dynasty*), family estates were to be divided equally among the sons, including sons by concubines.[39] Under this system, large estates were broken up; divided expenses kept rising, while divided income diminished. As a countermeasure, many families of the landed gentry insisted on principle upon living together, even though frequently this led to the not very pleasant situation of *tongju yicuan* (living together but cooking separately). The gloomy picture of a partitioned courtyard and shared kitchen, with dogs barking and chickens roosting in the crowded quarters, was vividly depicted in the much-recited *Xiangjixuan ji* by the great Ming essayist Gui Youguang (1506–1571), grandfather of Gui Changshi.[40] Ding Yaokang (1599–1669), a younger friend of Dong Qichang, described how he and his younger brother divided their meager inheritance, with each person getting 600 *mu* of poor land.[41] They decided to work hard at their studies, and once they had passed the provincial examination, both brothers were able to improve their fortunes substantially in a few years, buying houses and farmland all over the county. Theirs is a good example of how a determined scholar could recover his place in society through the examination and civil service system.

For those family members who were not prepared for an official career, or who failed to distinguish themselves in the examinations, the choice of profession was usually limited. A man could lead an idle life if circumstances permitted, or he could try his luck in the trades, which had become increasingly acceptable in the late Ming, or he could become a schoolteacher or a tutor in a private family. Both Gui Zhuang and his father, the descendants of the Xiangjixuan in the famous essay mentioned above, were at one time private tutors. Feng Menglong, the great dramatist and author of three collections of colloquial short stories (*Sanyan*), taught school until the age of fifty-seven when he was finally admitted to the National University as a student. The country pedant was a favorite subject in Ming painting and literature. One of the best-known of such characters is portrayed in the great drama *Mudanting* (*The Peony Pavilion*) by Tang Xianzu. When

the newly hired old family tutor appears in scene 4, he introduces himself in a typical soliloquy:

> Mumbling of texts by window, by lamplight
> Freezes and sours the taste of hopes once bright,
> My progress through the halls of examination
> Thwarted, here I dither in desperation.
> 'Mid sighs for scholarship run down to waste
> Only my asthma flourishes apace.

I am Chen Zuiliang, styled Bocui, graduate of the prefectural academy at Nan'an. My father and grandfather both were medical practitioners. I myself followed the path of learning from an early age, entered the academy at twelve, and was eventually included among the recipients of government support. Fifteen times in forty years I sat for the examination until I had the misfortune to have my stipend cut off by the Supervisor, merely because I was placed in the lowest grade.[42]

Chen Zuiliang's experience seems to have been authentic, and his characterization becomes even more convincing when he introduces his father and grandfather as medical practitioners. The self-styled *ruyi*, or Confucian doctor, was usually a physician with some scholarly background. During the earlier days of the dynasty, the half-blind Suzhou recluse Han Yi was not only a famous physician but also a nationally known scholar in his own right.[43] In the town of Jiaxing, a dispensary named Tongshoutang (Hall of Equal Longevity) was owned by the Yang family, whose members had been medical practitioners for seven generations since the Southern Song period.[44] The poet Chen Ang, known in the trade of fortune-telling as Baiyun Xiansheng (Master White-Cloud), had a booth in the night market by the Qinhuai River in Nanjing. Another poet, Dong Pei, from Longyou, Zhejiang province, was a book dealer.

Then there were the distinctive groups known as *muke* (private secretary) and *shanren* (mountain dweller). Although the two functioned very differently, with the former playing an increasingly important role in the expanding bureaucratic system, they had many things in common. As one of the most peculiar phenomena in the late Ming scene, the *shanren*—self-styled hermits or unofficial scholars—could assume any role, ranging from an itinerant scholar like Wang Zhideng, a "professional" houseguest of honor, to a true hermit such as Wang Fuyuan, a Daoist pupil of Wen Zhengming, who after the death of his master moved to Jiaxing to take up the quiet life of a minor antique dealer.[45]

Abuses of the name *shanren* and the scandalous behavior attributed to some of them aroused suspicion and sarcasm among the scholars' ranks. In an account of the Wanli period, Shen Defu (1578–1642) devoted a whole chapter in his *Wanli yehuo bian* of 1606 to the problem of the *shanren*.[46] Yet in spite of their low profiles, neglected as they were by their contemporaries and ignored by later historians, the unsuccessful candidates did make up a large part of the educated populace. Their individual contributions and collective significance must be treated as of major importance in any comprehensive survey of late Ming society and culture. A list of such contributions—from both successful and unsuccessful candidates—was suggested by a contemporary scholar, Xu Shipu:

Since the year *guiyou* [the first year of Wanli, 1573], the culture of the empire continually flourished. Outstanding achievements included the moral integrity of Zhao Gaoyi [Nanxing, 1550–1628], Gu Wuxi [Xiancheng, 1550–1612], Zou Jishui [Yuanbiao, 1551–1624], and Hai Qiongzhou [Rui, 1514–1587], the philosophical studies by Yuan Jiaxing [Liaofan, a *jinshi* in 1586], the encyclopedic erudition of Jiao Moling [Hong, 1541–1620], the calligraphy and painting of Dong Huating [Qichang, 1555–1636], the astronomy of Xu Shanghai [Guangqi, 1562–1633] and Lixishi [Matteo Ricci, 1552–1610], the drama by Tang Linchuan [Xianzu, 1550–1617], the pharmacological science of Li Fengci [Shizhen], the philology of Zhao Yinjun [Huan'guang, 1559–1625]; and if we extend the list, the pottery of Shi [Dabin], bronze casting by the Gu family, inksticks by Fang [Yulu] and Cheng [Junfang], jade carving by Lu [Zigang], and seal engraving by He [Zhen]. All these are lasting contributions equal to those of the ancient masters that will decay only with the universe. However, during the fifty years of the Wanli reign, we have had no poetry.[47]

The last statement seems to reflect a consensus among late Ming critics. As pointed out by Yuan Hongdao, leader of the Gongan school, the one literary achievement that would be long remembered as the crowning glory of the Ming legacy was not its poetry, the works of the Early or Later Seven Masters with their faint echoes of the past, but the living ballads of the Wanli period, popular tunes such as *Guajier* and *Pipoyu* written by anonymous literati songwriters.[48] Together with Ming drama, novels, and colloquial short stories, these were splendid consolation prizes awarded to a largely forgotten group of those who may have lost their contest in the period-style eight-legged essays but who won in much more meaningful and enduring areas.

ART AND COMMERCE

Li Rihua made an extremely critical observation on some of the new developments in the literati world. He wrote in a supplementary collection of his miscellaneous notes, *Zitaoxuan youzhui* (see no. 24):

In recent days both calligraphy and painting in Suzhou have declined to such an extent that it is doubtful if they can ever recoup their former vitality. This is because the artists have made their art a profession in place of farming, and collectors have commercialized what they collect as commodities for investment.[49]

Li Rihua seems to have been one of the last literati painters who still believed in amateurism as the only

legitimate motivation for creative art. Evidently such idealistic, even naive attitudes had already become obsolete and were out of touch with early seventeenth-century realities. The nonofficials and noncandidates were a growing majority of the literati class, which was caught in the painful transition from the simple, self-sufficient agrarian order of the early Ming to an emerging modern society based on commerce and the money economy; in the circumstances, insistence on artistic amateurism was anything but realistic. This was a time when scholars were no longer ashamed to sell the products of their intellectual and creative labors. The terms *bigeng* (farming with the brush) and *yantian* (inkstone rice field) had in fact become part of the common vocabulary.

Unlike their high-minded and fastidious predecessors in the fourteenth and fifteenth centuries, the late Ming literati generally did not discriminate among their customers on social grounds. Defending his open-sale policy in an essay "Bigeng shuo" ("On My Farming with the Brush") Gui Zhuang explains:

In my family, from the time of my ancestor Taipu [Gui Youguang], who sold his writings, to the time of my father Chushi [Gui Changshi], who sold his calligraphies and paintings, it has been several generations that we have farmed with our brushes in order to be self-supporting. Since the ruin of our family during the great turmoil [1644] and the passing of my father, I have fallen prey to hardships and starvation and more than once was at death's door. In the last few years, as I have made a small name with my writing, as well as with my calligraphy and painting, people have begun to come to buy them. My daily food depends on these demands for my literary and art works.⁵⁰

In its unadorned straightforwardness, the essay is close to a statement announcing the literati's readiness to join the ranks of the professionals, indeed to "merchandise" their art, if merchandising it meant a dignified means of exchange for a livelihood. The statement certainly spoke for many, if not the majority, of late Ming and early Qing calligraphers and painters. Whether it had a negative influence on the arts, as claimed by Li Rihua, is debatable. The dividing line seems to have been one drawn between the mainstream stalwarts, the spokesmen of the New Orthodoxy such as Dong Qichang and some of his friends and followers, who had no apparent need to paint or write for hard cash, and the individualists, such as Chen Hongshou, who did depend on "farming with the brush" for a living.

One of the side effects of an open and expanding art market was the prevalence of forgeries, coupled with the new trade specializing in their manufacture. According to a poem entitled "Bogus Antiques" by Shao Changheng (1637–1704), Suzhou was a major center for these activities:

In old Suzhou, at Changmen the city gate,
Many shops stand neatly in rows like fish scales.

Among the most numerous are antique stores.
Let's see what works of calligraphy and painting are in
 store.
Wang Xizhi is represented by look-alike "iron-stones,"
Zhu You is called Wu Daozi.
Previously, fakes were mixed with the genuine;
Now it has become cleverer in recent years.
The good artists do not create their own works,
They copy and take pride in their close-likenesses.
Buffalo and horses are invariably signed Dai [Song] and Han
 [Gan],
Landscapes are always called the Elder and Younger Li.
From Dong [Yuan] and Ju [ran] to Tang [Yin] and Qiu [Ying],
Every master is subject to all manner of imitation.
Calligraphy by Su [Shi] and Huang [Tingjian] were copied
 by filling out the shapes delineated with double outlines
 (*kuotian*).
Tang and Song stelae are ground and cleaned.
Sutra papers are made to look old by smoking,
Xuanhe collection is documented by "imperial seals."
The bigger the name, the easier the sale;
A thousand pieces of gold is nothing uncommon.
The current trends have been dominated by Dong Qichang;
Labels boasting his name can be found in every village.
How amazing that the world of brush and ink could be
 so commercialized by a few unethical merchants!
When it comes to the authenticity of bronze *yi* and *ding*,
Be wary of the Qin and Han archaic scripts.
Patination can be made by chemicals;
How pleasing are their colors in rich red and green.
Ceramic wares of Chai, Ru, *guan*, *ge*, and Ding:
Their prices are comparable to fine jade pieces.
People in high places are so proud of their connoisseurship,
They will keep on buying with all the money they have.
How many authentic antiques can there be?
No wonder the market is filled with forgeries.
Trust your ears and ignore what you see—
All sad things in the world are just like this.⁵¹

In an account entitled *Feifu yulüe* describing the intrigues of the Suzhou art dealers, Shen Defu included stories of *shanren* literati like Wang Zhideng and Zhang Fengyi (1550–1636) and their involvement in the forgery business.⁵² A famous anecdote, the tragedy related to the Northern Song scroll *Qingming shanghe tu* (*The Qingming Festival Along the River*), was dramatized in the play called *Yipeng xue* (*A Handful of Snow*).⁵³ The late Ming was probably the only period in Chinese history when popular fascination for art forgeries was immortalized on the stage.

THE IMPACT OF URBANIZATION

After a century of relative peace and prosperity Ming society reached a turning point, both economically and culturally, during the Jiajing and Wanli periods. The manorial order with its large estates and serf-like tenancy, though still functioning, was in decline. The rapid development of the textile and other types of industry south of the Yangzi valley, notably cotton goods

in Songjiang and sericulture in Huzhou, stimulated interregional commerce, quickened the pulse of a money economy, and greatly increased the interdependence of communities. New towns sprang up along waterways and other lines of communication from what were originally small villages or marketplaces. A typical example was Wangdianzhen, a suburb about thirty-five *li* south of the prefectural seat Jiaxing, and a town "where merchants converged."[54] Most traders came to buy rice and silk. Its silk products, nationally known as "Wangdian silk," were especially sought after by painters. According to local history, the town was founded by a former minister Wang Kui; having retired from the government, Wang opened a general store in the village—hence the name of the new town, "Wang's Store." Wang Kui's son and grandson both became *jinshi*. As more businesses were attracted to Wangdianzhen and more successful local candidates entered government service, the town grew and prospered. Thus the establishment of a new town and its gentry class seems to have depended on a commercialized agriculture and an expanding local industry, developed hand in hand with a vigorous scholar-official tradition. This appears to be the common pattern discernible in most of the satellite towns of Jiaxing, all of which were located within thirty or forty *li* from the center of the city. Descriptions of these settlements given in the gazetteer *Jiaxingfu zhi* are strikingly similar:

Wangjiangjing: Large profits were drawn from the local silk industry. In a population of more than seven thousand households, there were hardly any farmers but a large number of Confucian scholars, including some successful candidates.

Xinfengzhen: Most inhabitants were in agriculture and sericulture. Many were engaged in buying and selling. There were also Confucian scholars.

Xinchengzhen: Most male inhabitants were shopkeepers going after timely profits, while most women worked in silk-weaving. Among its more than ten thousand families there were many Confucian scholars and successful candidates in the provincial examinations.

Puyuanzhen: Originally founded by the Pu, a prominent clan, during the Zhizheng period [1341–1367] of the Yuan dynasty. Now with a population of more than ten thousand households. People were mostly engaged in silk weaving, farming, and trading. A continuous heavy traffic of out-of-town merchants was quite comparable to Wangjiangjing. But the people here were much less aggressive, as manifested in their preference for the profession of Confucian scholar. . . . The local gentry has continually flourished with many successful graduates from the examinations, and among the more eminent clans there were the so-called Former Eight Families and Later Eight Families.[55]

A traveler's impression of the prefectural seat of Jiaxing in the early seventeenth century, surrounded as it was by a ring of productive and affluent suburbs,

must have been that of a middle-class urban idyll, a mixture of the bustling farmer's markets at daybreak and the lantern-lit wine shops at night by the willow-shaded canals. A section of the canal between the Yueboqiao (Moon-Wavelets Bridge) and Hongjingqiao (Rainbow-River Bridge) was depicted in 1344 by the Yuan master Wu Zhen (1280–1354) in the handscroll *The Eight Views of Jiaxing*, and described three hundred years later by the early Qing poet Zhu Yizun in his series of poems "The Boatman's Songs of the Mandarin Duck Lake."[56] The most conspicuous difference between the two versions of the same scene is the addition in the Qing poems of numerous rice-carrying river boats moored in front of a palisade that shut off the canal in the evening. This crowded picture of the sails furled for the night testifies to the busy river traffic characteristic of a commercial town in the Lake Tai area in the late Ming. Not very far from this customs post or police station on the canal was the Temple of the East Pagoda mentioned earlier; and somewhere nearby was the garden where the Xiang family—with the wealth accumulated from Xiang Yuanbian and his brother's many commercial undertakings—was able to create an aesthetically conducive environment for painters such as Qiu Ying (1494/95–1552) and Xiang Shengmo.

By nature an agrarian society can rarely feel comfortable with any idea of change. Life on the land has a regular pattern, which repeats itself in annual cycles. Tillers of the soil are accustomed to accept the four seasons, clearly defined by their changing weather and labors, and all the sadness and joy associated with their cyclic fluctuations. The rural life in some back country in the Middle Tang as depicted in Bai Juyi's poem "Zhu-Chen cun" ("The Two-Clan Village of Zhu and Chen")[57] remained basically unchanged for centuries in the same sequestered and enclosed communities. But with the growth of interregional commerce, as markets sprang up and roads improved and expanded, the picture of the economic and social life in the Jiangnan area became one of movement, exchange, travel, and migration. The deep-rooted preoccupation with the concept of *antu* (to live contentedly on one's own native soil) was threatened in these booming areas by a new sense of mobility. The medieval phenomenon of an isolated "two-clan village," where intermarriages were confined within the village and where people "never stepped out of the village gate till their hair turned snowy white," was rapidly becoming a thing of the past. The migration from country to town was tied in with the development of trade and transportation and the expansion of the bureaucratic and merchant classes. As more retired officials, merchants, and even landed gentry wanted to move away from their rural backwaters and enjoy their wealth and leisure in the materially and socially more congenial environment of an urban center, towns attracted a continuous stream of immigrants from the country. As a result, the polarity between

town and country, with all the tantalizing discordance inevitably invoked by such a duality, was one of the most fascinating aspects of late Ming society.

The movement toward a concentric urban culture usually suggested a movement from provincial piety to greater ideological freedom or permissiveness, from Confucian prudence and frugality to a higher regard for aesthetic experience and sensual delectation and other tangible qualities of life. The duality of late Ming culture, however, extended far beyond the mismatched virtues of country and town. Indeed, almost every contrapuntal feature that noticeably set the age apart was embodied in this dialectical antithesis and synthesis. Breathing in a thin air of intellectual monotony, where the "Cheng-Zhu commentaries" on Confucian classics dominated as officially sanctioned dogma, the fifteenth century somehow seemed to remain an age of stagnation. Then came the Jiajing and Wanli periods, and we begin to sense a restlessness, a yearning for the idealized past, and a blurred vision of changes struggling to be formed. A list of late Ming dualities might include the contradiction between the revivalist and the antirevivalist, between the Cheng-Zhu orthodoxy and the Wang Shouren school's iconoclasm, between the eight-legged essay and *shiwu* (pragmatic studies, including the newly introduced European science and technology), between High Tang and Middle or Late Tang, Song and Yuan, Zhe and Wu, classical and colloquial, the north and the south, the professional and the amateur, the religious and the secular, the Chan and the Pure Land, the Caodong and the Linji. Indeed, the list is endless. We should look at this bewildering opulence from the vantage point of the literati, whose views on the comparative merits of town and country tell us something about their values and the kind of reward they were pursuing.

It is true that to be uprooted from one's native soil was in principle very much against the traditional values of the Chinese landed gentry. And yet, for the scholar-officials, the obligation to serve wherever the bureaucratic system sent them had made migration (*qiaoyu*) and the eventual change of household registration (*luoji*) an acceptable and increasingly common necessity. The mobility of the scholar-official class since the Northern Song period was noted by the Qing historian Zhao Yi (1727–1814). The selection of a proper place to live (*buju*) and to raise a family had become an obsession for many of the literati, as it profoundly affected their sense of belonging and continuity. The common sentiment was expressed as early as the end of the Yuan dynasty, in *Zhizheng zhiji* by Kong Qi, who wrote: "The first choice of a location for making a home is the countryside, then the suburb, and lastly the city."[58] This seems to have been the general consensus also in the late Ming, when the greater virtue of life in the suburbs as against the city was reiterated by practically every writer on the subject. Mo Shilong, for example, who in the circle of Dong Qichang was

known particularly for his aristocratic tastes, stated his preference for a cottage built a few *li* away from the city wall, explaining his distaste for "the noise and vulgarity" of urban life; at the same time he raised doubts about the wisdom of a "mountain dwelling" on the grounds of family and other social responsibilities.[59] From a practical point of view, however, one suspects that there must have been more compelling reasons behind this partiality toward the suburbs. Perhaps economic considerations played a part. For one thing, the farmland in the inner suburb called *fuguotian* (rice field with the outer city wall at its back) was always the first developed and the most valuable. Land of this type would make its owner self-sufficient if all its natural resources were wisely utilized, and if part of it were converted into market gardens, it would bring in extra income. This was precisely the argument made by some seventeenth-century writers like Gui Zhuang, a staunch believer in the suburban way of life, who took a dim view of the Suzhou gardens as a waste of useful space in the city for mere entertainment and decorative effects.[60] Other Ming scholars debated the issue on even more conservative grounds. The "Family Admonition" left by Pang Shangpeng enumerated ten advantages of living in the country and stated explicitly Pang's objection to any intention of moving from his native village:

Our family has been living in the country for so many generations that each of us has been identified with a fixed, particular line of work. No descendant of mine would be allowed to move his home from the country. For if he does, after three years of living in the provincial capital he will become utterly alien to farming and sericulture, and after ten years he will have no more concern for his own relatives and clan.[61]

It is safe to say that in the Jiajing and Wanli periods, while retired officials, merchants, and large landowners tended to be attracted by the conveniences of a city, most of the minor landed gentry still clung to the security offered by the familiar patterns of rural life.

Although the lure had always been there, the real movement toward urban settlement with gardens specially planned for retirement purposes did not become a vogue among the scholar-officials until the second quarter of the sixteenth century, or the beginning of the Jiajing era. Newly prosperous towns such as Suzhou, Songjiang, and Jiaxing were not yet known as "garden cities" in the early Ming, when public opinion seemed to favor some of the older cities such as Jinling (Nanjing), Jingkou (Zhenjiang), Biling (Changzhou), and Wuxing as the most desirable places for an urban retreat. It should be recalled that during the Tang dynasty the most famous estates—such as Wang Wei's Wangchuan Villa at the foot of Mt. Qinling southwest of the capital of Chang'an, Bai Juyi's Thatched Hall across the river from the Longmen Caves at Luoyang, and Li Deyu's Pingyuan Villa by the willow-shaded bank of

the Yi River—were located in the countryside not far removed from a metropolitan center. It was only toward the middle of the Northern Song period, when the medieval system of enclosed city wards (fang) with nightly curfews was abandoned in favor of open streets and predawn markets, that private gardens began to appear in major cities in north China. The great Northern Song historian Sima Guang had his celebrated Dule Yuan (Garden for Self-Enjoyment) quietly laid out in anticipation of the days when he could withdraw to Luoyang and devote himself to the monumental, historical project of Zizhi tongjian. Upon his departure for his villa in Luoyang, the newly retired Grand Imperial Preceptor Wen Yanbo, who is known to every Chinese schoolchild for his fame as a prodigy, was given the most magnificent official farewell, unprecedented in scale and pomp in Song history. Luoyang, then, was the hub for retired officials, the only "city of gardens" in north China. The record entitled Luoyang mingyuan ji (Famous Gardens in Luoyang), compiled by the antiquarian Li Gefei, bears witness to these events, which underscore not only an important early chapter in the development of Chinese gardens, but also the time-honored choice between town and country confronting every retiring official.

If, however, one looks at the problem philosophically, even the all-important Confucian principle of chuchu (to serve or to retire) could be interpreted, if sometimes conveniently, as no more than a state of mind. "The lesser recluse withdraws to the hill or marshland; the greater recluse withdraws to the royal court or marketplace"—in the mellowed tradition of Chinese eremitism, there was really no need to draw a line between town and country. The country begins where the town ends. So toward the end of the Ming dynasty, there was a new trend among the affluent to keep multiple residences and reap the benefits from both modes of living. The Wangs of Taiyuan, for example, had two gardens in the county seat Taicang: Nanyuan (South Garden) in the city and Dongyuan (East Garden) outside the city. In their heyday under the prime minister, these gardens offered a distant second choice after Wang Shizhen's Yanyuan, in the same city, as the national mecca for literary and artistic pilgrimage. Then in 1651, when he had reached sixty, the painter Wang Shimin added a third family estate to "escape the world and to enjoy his own old age." This was Xitian (West Field), about ten li west of the city, which was an important setting for early Qing painting represented by such prominent houseguests as Wang Hui and Yun Shouping (1633–1690).[62]

The late Ming literati did not have to go far in their search of a model to justify the compromise. The well-known argument and the most soothing words ever said on the absence of any real distinction between country and town had been supplied by Tao Qian—their cultural idol from the Six Dynasties, teacher,

friend, and paragon of Confucian virtue and Daoist self-emancipation and integration:

I built my hut in a zone of human habitation,
Yet near me there sounds no noise of horse or coach.
Would you know how that is possible?
A heart that is distant creates a wildness round it.[63]

This was paraphrased, among numerous other reinterpretations, in the introduction to Zhangwu zhi by Wen Zhenheng, which was the authoritative late Ming testimonial and guide to "scholarly taste" in every conceivable area from architecture to incense burning and tea making:

Sima Xiangru eloped with Zhuo Wenjun. He sold his coach and horses to buy a small wine shop in town, where Wenjun presided over the cooking and the washing of wine vessels, while [Xiangru] helped around, wearing a "calf-nose"-style, short, girdled apron. In a contrasting picture, Tao Yuanming returned to the thatched cottages awaiting him in his country retreat with luxuriant chrysanthemum plants and the lonely eloquence of a single pine, where he could invite himself to drink whenever wine was available. The states of mind and the social and physical environments were completely different. And yet [the two modes of life] were in the final analysis harmonious with each other. There was no obstacle separating them from the attainment of the dao.[64]

Throughout Li Rihua's Tianzhitang ji, the collection of his literary works, and his voluminous miscellaneous notes, the recurring theme of the retired life of a scholar-official often seems to take on a lyrical tone of idealized projection. One is never sure whether he is speaking of a real or an imaginary world. But in Li's constant attempt to recapitulate the feeling of oneness, in his search for individuality and purity, the life at Liuyanzhai (Studio of Six Inkstones) and Weishuixuan (Water-tasting Studio) seems to have been rural in form and substance but urban in outlook and attitude:

For sitting cross-legged in meditation, the frosty gnarled root of an ancient tree is just perfect,
For lying back to contemplate at ease, moonlight streaming through the branches of sparsely planted trees is ideal.
The bedchamber is to be hidden unobtrusively on a winding path along a cliff side,
The writing desk is to be set out comfortably beneath the pines.
Under the veranda, every step is cushioned by fragrant grass,
Over the balcony railing, meeting the eyes are many kinds of flowers.
Talkative birds in a cage, whose chirpings caress the ears in one's state of half-sleeping and half-waking,
A pond filled with striped fish, which absorb one's thoughts while one watches casually and aimlessly.
The lad who takes care of my books must be a son of the snow.

The companions for composing poetry or fishing together
 must be friends from the mist.
In anger I will split the air with my sword, saying:
"A man must follow his inclinations; why must I wait for
 riches and honor?"
In quiet joy I will play with a short lute across my knee:
"Just as in the song 'Tall Mountains and Flowing Water,'
 there must be someone in the world who understands
 the music of my heart."
As long as one observes the Buddhist *gatha*, what is the
 point of leading a procession of "sour stuffing"?
Although one may wear a scholar's button on his cap, you
 can be sure he will not make that kind of commentary so
 as to receive posthumous offerings of "cold pork."
This is to be understood by heart,
Why should I waste more words?[65]

In the Wanli period, philosophical eclecticism was prevalent. The syncretism of the Three Doctrines, the rejuvenation of the Chan and Pure Land sects, the secularization of Buddhism to meet the spiritual as well as mundane needs of the layman, and the new direction given by Wang Shouren to Neo-Confucianist thinking—all these combined to intensify a growing movement of cultural introspection in which man and his world past and present were subject to a groping, if sometimes impetuous and quarrelsome, self-appraisal and reexamination. The theory of moral intuitionism developed by Wang Shouren and his more radical followers in the Taizhou school reconfirmed the absolute freedom and majesty of the realm of subjectivity. Their renunciation of many of the traditional values, their argument that Nature exists only in a man's consciousness, that "outside the mind there is no principle; outside the mind there are no phenomena" had greatly stimulated individualistic explorations and innovations in late Ming literature and art. To a few iconoclasts like Li Zhi, who dared to defy the authority of Zhu Xi and other Song philosophers, the new theories represented no less than a hymn of praise to the liberation and affirmation of self.

THE LITERATUS AS
AN INDIVIDUAL

The literatus' heightened awareness of his own individuality, his position in the world, and his relationship with his fellowman led to the simultaneous blossoming of a whole range of new literary forms that had never before been fully exploited. Among them were personal diaries, exemplified by such important historical and literary documents as Li Rihua's *Weishuixuan riji* (1609–1616), Feng Mengzhen's *Kuaixuetang riji* (1590–1605), and the hitherto obscure *Beiyou lu* (1653–1656) by Tan Qian (1593–1657), which is a truly exciting addition to the repertory of seventeenth-century records of literati activities and the individual's aspira-

tions and adventures in search of scholarship and identity.

If personal diaries documented the more intimate side of the literati's external and internal worlds, then correspondence with relatives and friends provided some of the most informative and enlightening annotations. Personal correspondence had been a significant part of literary output since the Northern Song, especially from the pens of Su Shi and his followers like Han Yuanji and Li Zhiyi; and letters had been incorporated into collections of literary works either indiscriminately or selectively. It was, however, only beginning with the late Ming that serious anthologies of personal correspondence (excluding, that is, the highly regulated and standardized formal or official letters) were compiled, published, and widely circulated. Without question, the most important among these anthologies is the *Chidu xinchao* by Zhou Lianggong, which preserved nearly one thousand letters written by more than 230 correspondents, including practically every better-known scholar and artist during the period of Ming–Qing transition.

With improved transportation both on land and on water, personal travel became much more common, and late Ming literature is extraordinarily rich in travel journals. In 1608, after failing the examination the previous year and spending a quiet and depressing summer at home in the Bamboo Valley, the poet Yuan Zhongdao suddenly had an urge to travel. He prefaced his journal with these excuses:

Firstly, famous mountains and beautiful rivers could purify my worldly concerns. Secondly, many Buddhist retreats in the Wu and Yue area could be havens where I may read and study in peace. Thirdly, in scholarship, although I have no problem in comprehension, my intuitive understanding still lacks penetrating power. Too often I became emotionally involved in phenomenal illusions, and was hindered, distracted, or misled into dead ends. It is hoped that I may meet some eminent teachers and excellent friends, and that with the nourishment of their rain and dew, I may be able to wash away my innate bad habits. This would be a hundred times more effective than restriction enforced by self-discipline. These are the reasons why I don't dare to remain indolent.[66]

Whatever the reasons, the late Ming literati took travel seriously as a significant part of a gentleman's education and a crucial means of broadening his social and scholastic horizons. Visits to friends were usually accompanied by visits to scenic spots, and visits to scenic spots were increasingly extended to include visits to witness flowers in bloom and autumn foliage. In the Tang and Song periods, the peony craze normally worked itself out within the confines of a single city such as Chang'an or Luoyang. In the late Ming, however, the craze for plum blossom, chrysanthemums, and other flowers could take addicts all over several prefectures, even across the provincial line. A typical

example was Gui Zhuang. In 1661, during the period of one week in early April, he was to be found traveling by small boat to four prefectures searching for peonies in thirty-five different private gardens.[67] This obsession with flowers not only gave great impetus to the development of horticulture but was also instrumental in making the art of *penzai* (*bonsai*, in Japanese) increasingly sophisticated; eventually this art was to arouse devastating criticism in the early nineteenth century, epitomized by the famous satirical essay "Bingmeiguan ji" ("On the Studio of Sick Plum Trees") by Gong Zizhen (1792–1841).[68]

THE DEMISE OF LITERATI SOCIETIES

As the travel time between communities shortened and the sphere of personal activities and contacts expanded, *yaji* (literary gatherings) were organized much more frequently. There were many kinds of *yaji*, each with its own purpose, format, regulations, and membership. A gathering in Jiaxing in September, 1592, from which a collection of poetry (*Yuanhu changhe gao*) still survives today, involved a visiting group of nine scholars from the county of Yunjian (Songjiang); the group included Chen Jiru and Dong Qichang, who in that autumn happened to be on leave from the Hanlin Academy. One of the most noted poetry societies in the late Ming was the Qingxishe (Blue River Club) in Nanjing organized by a number of immigrants who met regularly at Yaodibu (Stone Steps Inviting Songs of the Flute) near the Qinhuai River.[69]

It is well known that toward the end of the Ming era, most literati societies became increasingly involved with politics; thus the sad and violent end of the Donglin movement was more than symbolically identified with the fall of the dynasty. The historical irony was well conveyed in the following lines written after the fall of the dynasty in memory of some of the former members of the Blue River Club:

Amidst the lush strings and soaring flutes, many youthful heads have now turned white,
Under the Brocaded Cliff in the autumn wind, life's lonely fishing rod.
When I look back to the pavilion where we bade each other farewell,
Still wind and rainstorm, still the cold river, separating the two banks.[70]

The Literati Life

CHU-TSING LI

THE SMALL GROUP portrait entitled *Venerable Friends* (no. 1) is a valuable record of the leading literati during the early seventeenth century.[1] It is also a rare gem in the history of Chinese painting, for it is the first group portrait of its kind. A look at this painting offers an interesting introduction to literati life at the time.

The painting represents six late Ming literati. Zhang Qi painted the six figures,[2] and Xiang Shengmo, who is shown at the upper right corner, did the background trees and rocks. Xiang also wrote the long inscription, which identifies the different figures and gives the reasons that lie behind the painting:

PORTRAIT OF MY VENERABLE FRIENDS

When I was at the age of forty, I was a member of the circle of these five venerable gentlemen, who were both teachers and friends and who held one another in esteem and often wrote poems for one another. After all the turmoils, however, only one-tenth of their poems are left. Now only Lu the Bamboo Painter is still around, while the four others have left us. Therefore, recalling that period of time, I have painted my venerable friends to recapture their likeness and spirit. The one wearing a Jin cap and a red-colored gown, with one hand holding one end of the scroll and the other as if pointing at something and with his eyes staring at us, is my teacher Zongbo [Minister of Rites] Scholar Dong Xuanzai [Qichang]. The one in a brown gown with a blue cap, seated on the same rock as Dong, holding the scroll and talking, is Meigong, Mr. Chen [Jiru] the scholar. The one seated upright in a Tang cap with his hand as if drawing a picture on his chest is my wife's uncle Junqing, Li Jiuyi [Rihua]. The one in a Tao Yuanming cap looking like a sick crane is the Bamboo Painter Lu Lushan [Dezhi]. The monk is the poetic Chan monk Qiutan Zhixian. The one in a simple dress with a high cap standing under the pines and the *wutong* trees, with one hand holding a book on a rock and the other hand gesturing as if to ask the two old gentlemen some questions, is myself, the Woodcutter of Mt. Xu, Xiang Kongzhang [Shengmo]. I also wrote a poem for this:

> Deep was their interest in letters and writings that bound these five venerable gentlemen together;
> So strong was their friendship that they could be called friends without regard for age.
> Their mutual respect and expectations will last for a thousand ages;
> Their paintings and their Chan poems will live forever.

The year *renchen* [1652], the eighteenth day of the eighth month, Xiang wrote this himself. The portraits were done by Zhang Qi and the rest was painted by Kongzhang himself in lamplight.

Thus the painting was conceived by Xiang Shengmo and done in 1652 by himself and his friend Zhang Qi as an imaginary work commemorating the days when all six men had spent time together in their literati pursuits. At the age of forty, according to Chinese count, Xiang was the youngest member of the circle. Since he was born in 1597, the scene in the painting would have been set around 1635. At that time, Dong Qichang (1555–1636) was an old man of eighty-one; Chen Jiru (1558–1639) was seventy-eight; Li Rihua (1565–1635) was seventy-one and in the last year of his life; Monk Qiutan (1558–1630) was already dead. Lu Dezhi (1585–after 1660) would have been fifty-one. Xiang knew all of them as either teachers or friends. Together they constituted the most revered group of literati in the area of Jiaxing and Songjiang.

Although Dong is the best known of the group as a painter, calligrapher, poet, and theorist, perhaps the most representative of the perfect literatus is Li Rihua,[3] who was also a painter, calligrapher, and poet. Li's life exemplifies the ideal of the Chinese intellectual both morally and aesthetically. One of the most interesting aspects of his career is the fact that he kept extensive diaries and took notes concerning many of his daily activities. After his death, Li's son and grandsons managed to collect most of these writings, including his poetry, essays, inscriptions, and colophons, and compiled them into many volumes. From these materials, together with his few surviving paintings and calligraphic pieces, we can derive a clear picture of what his life was like. In consequence, Li Rihua is the chief focus of this investigation into the life of the late Ming literati, although we shall also be looking at members of his circle and of the generation that followed him.

In 1592, Li Rihua, a young man in his late twenties from Jiaxing, passed the palace examination in Beijing and became a *jinshi*, a recipient of the highest civil service degree in China.[4] He was the first member of his family ever to attain that status. For such an intellectual, the future was wide open. Following the standard Confucian tradition, he could devote the rest of his life to being an official serving in various capacities under the emperor in either the court or the provinces. As an official, he would have high social status, a comfortable income, and a certain amount of influence, in addition to being a great help to his family, relatives, and friends in their careers or material endeavors. Such

were the usual expectations of a successful official, but not of the best minds of China. A small group of intellectuals would choose a different path after passing the examination for the highest degree—the literati life. Li Rihua was one of these men.

Following his success in the examination, Li Rihua was engaged in an official career for a number of years. Then, for nearly twenty of his most active years he stayed at home in Jiaxing and led the life of a literatus, devoting the greater part of his time and energy to the pursuit of the arts. This was mostly by his own choice, the result of his personality and aspirations.

The period Li lived in, the late Ming, during the late sixteenth and early seventeenth centuries, was not one of the most exciting times in Chinese history. The country had already enjoyed more than two hundred years of peace and stability since the founding of the Ming dynasty, and its social institutions were well established. Ordinary people could become successful in life by simply climbing the ladder of success, first gaining an education, then passing the government examinations, and finally serving as government officials. However, many of the best minds of China were restless; they found their society already stagnant. The emperor and the court took no interest in state affairs or the development of the country. It was a period in which nothing seems to have happened.[5] Under these circumstances, even an official would find life boring unless he were interested in the acquisition of wealth and power. For someone who wanted to maintain his moral integrity, the best course was to retreat into a kind of eremitic life dedicated to the arts.

Li Rihua was born into a family of the minor gentry with moderate means in Jiaxing, one of the prominent prefectures of the Yangzi River delta, then the richest and most cultured region in China. With an economy based on rice, silk, salt, and many handicraft products sold all over the country, the region had the best communications system, the most prosperous cities, the best teachers and academies, the most extensive libraries, and the largest number of successful candidates in the government examinations. Although some of Li's ancestors had risen to the status of officials, by his father's generation the family was in decline. Deeply committed to the restoration of the family fortunes, Li's father worked hard and was eventually able to become a member of the landowning gentry. He put all his hopes in his son, Li Rihua, whose success in the government examination in 1592 must have been the happiest event of his father's life.

Yet for both Li Rihua and his father, official status was only a means, not an end itself. With the *jinshi* degree and official appointments, Li Rihua was already among the elite of the country, with all the prestige and material reward his position entitled him to. Despite this both father and son had looked for something higher with respect to their spiritual needs. In this they had come under the influence of a Jiaxing scholar,

Zhou Lijing,[6] who was a cousin of the elder Li on the maternal side and one of his close friends. In Zhou, Li's father probably saw what he himself might have become had it not been for his family circumstances. Their friendship could have given him the partial fulfillment of his own dream of being a literatus. Above all, through Zhou, he could offer his son the sort of education required to enter the ranks of the elite.

Zhou Lijing represents a type of literatus without official status—the hermit-literatus. Although there is little information about his early years, Zhou is known to have shunned the life of an official, and to have taken no government examinations but to have acquired a solid education. He was a man of extremely broad interests, far beyond those of the ordinary literatus. Among the extant books he compiled are volumes on vegetables, flowers, animals, insects, and the seasons, making him a naturalist in the modern sense. He also compiled books on health, diseases, and the care of the human body and on the enjoyment of life. In short, he had an encyclopedic mind. As a literatus Zhou was especially known for his study of the ancient scripts, and for his poetry, essays, and drama. He wrote poems using the rhymes of such great poets as Tao Qian, Li Bai, Bai Juyi, and Feng Haisu, which was quite a feat.[7] Well known for his calligraphy, he was capable of working in a number of styles, such as the regular, the running, and the cursive, as well as the seal and the clerical. He was also a painter and a connoisseur of antique objects. A great lover of plum blossom, Zhou called himself "plum crazy." In an autobiographical essay patterned after Tao Qian's "The Gentleman of Five Willows," he wrote about himself as follows:

Simple, pure, and reticent, he had a disdain for official life and material gains. Every day he read volumes of books to attain a serene, heartfelt understanding. Whenever he came to grasp the true meaning of the texts, he became so excited that he forgot to eat and sleep.

Often when he was intoxicated, he was inspired with some of his most excellent lines of poetry. Friends adored and greatly admired him. He loved wine, and often drank to the point of complete intoxication. High-minded in his pursuits, he enjoyed a leisurely life. Although he lived in a very simple house, he enjoyed his days fully. Though his clothes were ragged and full of mended patches, he did not worry about them, regarding material needs as illusions. He amused himself by writing little poems or playing music, not worrying about whether he had achieved anything. He died a very happy man.[8]

Because of Zhou's reputation he came to know many of the leading poets and painters in the region. Among those who exchanged poems with him were Wang Shizhen, a high official and a leader of the traditional school of poetry; Wang Zhideng, an academician and calligrapher from Suzhou; and Tu Long (1542–1605), a *jinshi* who was an official and a well-known dramatist. His artist friends included Wen Peng and Wen Jia, the

two sons of the great painter Wen Zhengming; Xiang Yuanbian, the noted collector and painter of Jiaxing; and Mo Shilong and Chen Jiru, two of the leading painters from nearby Songjiang. Among his many pupils the star was Li Rihua. As Li wrote:

When I was still a milk-sucking baby, my father began to teach me the *Daxue* [*Great Learning*] text while I sat on his knees, until I was able to recite it. When I was six, I first learned the characters. At seven, I began to study. At twelve, I began to write essays and became acquainted with antique objects. Since my family was poor, I was unable to get many books to read. Mr. Zhou then let me use his library, and he taught me. Later I studied at Zhou's Clear Snow Studio and learned about his own ideas. Zhou did not think that I was too young to learn, and he talked to me about many things. He would also bring out some old inksticks for me to use and teach me how to handle the brush. He would also read by candlelight the poetry of the Tang masters deep into the night. Although I completed my studies there when still quite young, I was already interested in writing poetry.

Once, when I playfully presented my teacher with some of my poems, he enjoyed reading them so much that he began beating the rhythms and exclaimed, "In the future you will be the one to be known for poetry and essays in this whole region."[9]

Li Rihua's talents must have pleased Zhou tremendously, for in spite of their age differences, they were more like two close friends than teacher and pupil. Li wrote about their relationship later, in 1580, when he was only sixteen:

I remember that in those days I and Mr. Xuchong [Zhou] used to spend our days and evenings together, chatting and discussing various subjects. Sometimes we unrolled old scrolls of paintings and sometimes we read sutras and books. Sometimes we played with our brushes and ink, doing calligraphy and painting freely and leisurely. We were so happy that we were hardly aware of any other world besides our own.[10]

For Li Rihua, Zhou was a model of the hermit-literatus who rejected the material aspects of everyday life, in accordance with what was basically a Buddhist and Daoist concept, and who sought a meaningful existence by living simply, learning extensively, and leading a creative life in writing and painting, a typically Confucian ideal. To have spent his youthful days with this mentor must have been one of the most decisive factors in Li's pursuit of the literati life.

As he grew up, however, Li Rihua did not choose exactly the same path as his teacher. Instead he took the standard route, up the Chinese ladder of success. But although he passed all the examinations and served in various official positions at court and in the provinces of Jiangxi and Henan, thereby gaining social status and wealth, at heart Li always aspired to be a hermit. Thus he belonged to the type of literatus that can be called a hermit-official.

In his youth Li also came under the strong influence of two of the scholars represented in *Venerable Friends*, Dong Qichang and Chen Jiru. Both were natives of Songjiang, about thirty miles northeast of Jiaxing, but they seem to have spent some time in Jiaxing in association with the famous collector Xiang Yuanbian, who died in 1590.[11] Li would then have been in his early twenties; he was close to Xiang's family and through them undoubtedly knew both Dong and Chen. Since they were his seniors, Dong being older by ten years and Chen by seven, Li must have sought their advice and learned from them. This is confirmed by the fact that Li regarded them both as his teachers although no formal relationship is known to have existed.

Dong was in many ways a model for Li in the development of his career.[12] Also from a rather modest family background, Dong studied hard in his youth and eventually passed the government examinations to become a *jinshi* in 1589, only three years before Li. After serving as an official for fifteen years in Beijing and the provinces, he resigned to return home in 1605, spending the next seventeen years in Songjiang.

As a *jinshi* who had served at court, at one point acting as tutor to the crown prince, and in the provinces, often as an educational commissioner, Dong already enjoyed great prestige and material wealth at the time he returned to Songjiang. Despite a number of short official assignments during the seventeen years he spent at home, he led a leisurely life devoted to the pursuit of the arts, especially painting, calligraphy, and poetry. As a connoisseur and art theorist, he enjoyed a reputation unmatched by any of his contemporaries. He collected paintings and calligraphic pieces himself, was often asked to evaluate art objects in private collections, and wrote colophons on many of these works. In the course of those seventeen years he saw a large number of paintings and examples of calligraphy, ranging in date from the Six Dynasties to his own time, and including a great many from the Song and Yuan periods.

The close relationship between Dong and the Xiang family in Jiaxing gave Li many opportunities to see Dong during the period when they were both at home in mid-career. In the *Tianzhitang ji* (*Writings from the Hall of Tranquility*), Li recorded a number of colophons he had written on Dong's calligraphic works and paintings, usually with high praise for their creator. On many important works of art there are colophons by both Dong and Li, indicating that the two men were regarded as noted contemporary connoisseurs. Li was always very respectful toward the older man, who had received his *jinshi* degree earlier than himself and had held positions of higher rank.

Dong's close friend in Songjiang was Chen Jiru. Perhaps because he had not been as successful as some of his contemporaries in the local examinations, Chen lived a simple, semireclusive existence in his home district throughout his more than eighty years of life. After building a house in the Sheshan hills, near Songjiang, he devoted himself mainly to teaching and writ-

ing. Like Zhou Lijing, he wrote many books on various subjects and compiled several series from the works in his library, which he published under his own name. Since these books were all published in Jiaxing, Chen must have gone there frequently and so came to know Li Rihua.

Li's writings convey the impression that he was closer to Chen than to Dong. This is due partly to the fact that Li and Chen saw each other more often, to judge from the number of references to Chen in Li's writings, and partly to Li's great respect for Chen's scholarship, which is evident from a colophon Li wrote on a piece of calligraphy that Chen had done for a friend:

Mr. Meigong's [Chen Jiru's] words are subtle, profound, and dignified. His sharp knowledge is superior and outstanding, shining over many areas, and holding the key to the practical world. Generally his ideas are based on Lao[zi] and Yi [Yijing, Book of Changes] and mixed with the true essence of the hundred schools.[13]

It is clear from their writings why Dong Qichang and Chen Jiru were regarded as two of the greatest connoisseurs of their time. Many of the most important paintings by Song and Yuan masters were either in their collections or passed through their hands at one time or another, and many of these works now bear colophons written by them. In addition, because of their reputation as scholars, people from far and near came to ask them to compose congratulatory or memorializing essays for various occasions. At the same time, they were both painters and calligraphers, and there were constant requests for their work. Dong especially, because of his high official position and great fame, was said to be so busy meeting such requests that he had some of his friends and pupils do paintings and calligraphic pieces that he would then sign as his own.[14]

On the whole, both Dong and Chen were able to devote themselves to the pursuit of a meaningful life by seeking less involvement with contemporary politics, especially the intrigues of the court, and by giving more time to the enjoyment of writing, painting, and collecting books and art works. In some ways this was typical of the late Ming when, as we have noted, state affairs fell into the hands of inept officials and public life lost interest for people of integrity. Involvement in the arts became almost a means of escape. Such was the basic character of literati life during the late Ming period. The example of Dong and Chen had a strong effect on Li Rihua.

After he had received the jinshi degree, Li was first appointed as a prefectural judge at Jiujiang, in Jiangxi province, a position he held for six years, from 1592 until 1598. Here he enjoyed his work and was well liked by the people. He had the reputation of being a good essay writer and also of having a marked interest in Chan Buddhism; the latter unfortunately led to criticism by a superior, which resulted in the loss of Li's position. In 1600, after his name had been cleared, Li went to Beijing and received a new appointment in central Henan province, where he stayed serving in various positions for four years. It was in 1604, upon the death of his mother, that he returned to Jiaxing for the standard two years of mourning. As Dong Qichang had done, Li was able to extend this period of leave, first to take care of his father who was in poor health, and then, between 1617 (when his father died) and 1624, for health reasons of his own.

This long period in Jiaxing, which overlapped the time that Dong Qichang was also at home, gave Li the opportunity to develop to the full as a literatus. With his jinshi degree and his official career, Li enjoyed high prestige among the people of his home district, and although he was on leave, he continued to draw a comfortable income as an official. For Li, these twenty years during the most active part of his middle age constituted the high point of his life.

During the seven years from 1609 to 1616, Li kept a diary of his daily activities, the Weishuixuan riji (Diary of the Water-tasting Studio), which reflects his interests and taste. Typical of many of the entries is the following, for the tenth day of the first month in the year 1609:

Clear. Sheng Yiyu brought me a small pot of plum as a gift. With its roots exposed and its stem reclining and with a few flowers sparsely scattered, the plum has a very strong antique manner. In the afternoon Sheng Dejia, Wu Xiantai, Dai Kanghou, and Zhang Jialin came for a small gathering. Xiantai talked about his previous visit to the central plains, making me rather sad.[15]

Here Li recorded three things characteristic of the literati. The first is their appreciation of beautiful and meaningful objects, in this case the potted plum tree in bloom given to him by a friend. The second is the gathering of a number of like-minded friends, an event typical of the literati's daily activities. The third is someone's talk about his visit to the central plains, that is, Henan province. Since Li had served for four years in that region, the talk apparently revived his memories of Henan, and he felt nostalgic about it.

Five days later the record reads:

In Dai Shengzhi's studio I took a look at Bamboos by the Window supposed to be by Ni Zan, but it was not genuine. There were also four sections of calligraphy by Zhao Ronglu [Mengfu], quite genuine.

It has been clear and warm for ten days. The narcissus and the plum in the small pot were in full bloom, their fragrance spreading all around. I was totally drowned in this aroma all day. Someone came to ask me to go somewhere. I declined, for I did not want to miss this pure delight.[16]

One of the most important pastimes in the lives of the literati was sharing with each other the treasures they had collected. Li's diary is full of such records of having viewed various paintings and pieces of calligraphy, testifying to the fact that he, together with Dong Qichang

and Chen Jiru, was respected as a discerning connoisseur. However, the literati's interest in works of art of the past was equaled by their feeling for nature, in this case the two types of flowers in bloom.

Chen has left an interesting record of his and Dong's activities as connoisseurs:

In the ninth month of the year *renchen* [1592] Dong Xuanzai [Qichang] and I stopped by at Jiahe [Jiaxing]. The things we saw included the copy of the *Orchid Pavilion* calligraphy by Chu Suiliang [596–658], the *Shaolin Poem* by Xu Jihai [Hao, 703–782], an essay on the funeral of Uncle Haozhou by Yan Lugong [Zhenqing, 708–785], and the *Daodejing* (*The Book of Dao*) in small regular style by Zhao Wenmin [Mengfu], all genuine pieces of calligraphy. On the same day I also borrowed the *Record of Princess Runan* by Yu Rongxing [Shinan, 558–638] from Wang Yiji, which had just arrived. Xuanzai made a copy of it.[17]

Another note by Chen confirms the literati feeling for nature as well art:

Running into the Cha [River] is the Flower Stream. During the last dynasty many people painted the subject of "Hermit Fisherman in the Flower Stream." That tradition was started by Zhao Chengzhi [Mengfu], and Wang Shuming [Meng], who was his grandson, also did several paintings of the same subject. All of these have come to the collection of Xuanzai [Dong Qichang]. Xuanzai always wanted to buy some land on a hill overlooking the River Cha in order to live a life of the Peach Blossom Spring as a fulfillment of the augury implied by having these paintings in his collection. He painted an album, *Peach Blossoms and Green Hills of Zhao* [Zhao Mengfu], *the Scion of the Song Imperial Family*, for me.[18]

Li's entry in his diary for the tenth day of the eleventh month of 1610 records another typical literati activity:

Zhou Zhongwei of Huating brought over a scroll of plum blossoms with a piece of calligraphy on the five-character poem on Mt. Gu from Sun Taigu to Lin Hejing, all by Sun Xueju [Kehong], with colophons by Dong Qichang, Chen Jiru, Zhang Xianwen, and Lu Boda, in a long handscroll. He asked me for a colophon. I wrote one for him.[19]

Sun Kehong (1532–1610) was a well-known painter in Songjiang in the generation previous to Li's. The value of this scroll would be greatly enhanced if leading connoisseurs showed their appreciation by writing colophons on it. The owner had already obtained colophons by Dong and Chen and some other Songjiang literati, and with Li's colophon added, the scroll became a great treasure. This does not mean, however, that the three men wrote their colophons together at the same time. Rather, as in this case, it was the owner of the painting who went around soliciting colophons one by one.

An example of this practice of contributing colophons is the handscroll *Herb Mountain-Cottage* (no. 7), a work that was done jointly by three painters—all pupils of Wen Zhengming—during the middle of the sixteenth century. In ink and colors on paper, the painting represents a typical literati subject, the scholar's

retreat, here located in an herb garden. A visitor is shown entering the gate of the garden on the right and being met by a gentleman inside. Above them and surrounding them on all sides are a number of tall trees rendered in a picturesque manner. In the middle section of the scroll two men followed by a servant are shown walking along a pebbled path through a bamboo grove toward the cottage. At the cottage, on the left, which is surrounded by Taihu rocks and tall trees, four friends are shown talking and drinking. Behind the cottage is the herb garden containing a variety of plants.

The original inscription by Wen Jia,[20] second son of Wen Zhengming, relates the circumstances of the creation of this painting in great detail:

On the nineteenth day of the tenth month in the year *gengzi* [1540], Zhou Gongxia[21] came to visit me in my studio. A slight rain was beginning to fall after a long period of clear weather. It happened that the day before I was invited by Cai Shupin[22] to a gathering at the Herb Mountain-Cottage. We then went with my elder brother Shoucheng [Wen Peng][23] and Zhu Zilang[24] in the rain. When we got there, the rain had stopped and the moon was out. Then Qian Shubao [Gu],[25] Peng Kongjia [Nian],[26] and Shen Xiuwen[27] also arrived. All in great high spirits, we started painting on the paper on the table. I, Shubao, and Zilang collaborated on the handscroll, and Kongjia composed two lines of verse. While the painters tried to paint the flowers in the herb garden, the owner of the cottage added the rocks and trees from the other side in an upside-down way. Since the eight gentlemen were unable to link the lines together into one poem, we decided to have each write a poem with a rhyme assigned. On that day Hu Shaozhi[28] was expected, but did not come. But Shi Minwang[29] was already there, and he added the narcissus by the rocks. Lu Zizhi[30] will write an essay for this occasion. I write this as the lead for it.

This is one of the best surviving descriptions of a typical literati gathering where artists and poets all contributed to the painting, calligraphy, and poetry that were the product of the occasion. The literati in this group were followers of Wen Zhengming in Suzhou, and their master's manner is apparent in both the painting and the calligraphy.

The gathering at the Herb Mountain-Cottage took place in 1540, more than a century before the group portrait in the Shanghai Museum was painted. Some of the late Ming connoisseurs had an opportunity to see the scroll, and Chen Jiru and Li Rihua wrote its last two colophons. Chen's inscription links the scroll to the past:

Compared with Herb Mountain-Cottage [which has eight literati], the Seven Sages of the Bamboo Grove have one figure less, and the Six Hermits of the Bamboo Stream have two less.[31] These were the most distinguished gentlemen of their age in the Wu region. There is only one servant half-shown who was not able to share with them the unrolling of the scroll. The painting shows how cultural activities flourished in their day. It should rank with the Literary Gathering of the Western Garden to survive the vicissitudes of time.[32]

Li Rihua's colophon is quite different:

I have seen three forged versions of this painting. In general appearance and composition they are not all the same, and they all lack the spirit. Having seen this, I feel like Emperor Yuandi of the Han upon seeing Wang Xiang, who was offered by him to be married to the nomad chief Huhan, and regretting the mistake he had made.[33] I have lamented the rampage of false practices in our time, from false morality, false reputation, false economics, and false scholarship to false appearance and false feeling. For those who are used to the practical world, they may serve some interesting purpose. Even in an ordinary neighborhood, some old acquaintances one happens to run into often put on false faces. The only one who does not show this falsehood is Mr. Xu Renqing.[34] Because he is such a truthful man, he has acquired this genuine piece. It was not only that he had an eye for true things, but also that he deserved the true reward. Mr. Xu has invited many of his friends to share with him the feeling for this scroll when he unrolls it. To me, this is also not unlike a kind of true herb that he shares with us.

It is typical of the literati to philosophize about life and society when they seem to be talking about artistic matters, and both these colophons are good examples, each in its own way, of the practice. They also illustrate why Chen Jiru and Li Rihua were so sought after as colophon writers. In this instance Chen and Li seem to have been invited to contribute colophons by the then owner of the scroll, Xu Renqing, who was a hermit-literatus of Jiaxing known for his poetry, painting, and calligraphy and for his collection of art works. Among the friends he often invited to his home were Chen Jiru, Monk Qiutan, and Li Rihua. Li eventually wrote a biography of Xu to eulogize him.[35]

Another famous set of paintings that has colophons not only by Chen and Li but also by Dong Qichang is the album *Ten Views of Nancun Villa* by Du Qiong, dated 1443 (no. 6).[36] Nancun Villa was the country estate of one of the most famous literati of the late Yuan and early Ming period, Tao Zongyi (1316–1403).[37] Tao was a close friend of many of his fellow literati, including the painters Ni Zan and Wang Meng (1308–1385), and many of the poets of Suzhou. Known as a teacher of many young literati, Tao also enjoyed a wide reputation as a scholar; he compiled several series of important books and a history of calligraphy, which still serve as major source books for the period. His Nancun Villa was commemorated in literature and art: Tao once wrote a set of poems inspired by the various scenes around the villa, and Wang Meng painted a handscroll of it.

The painter of this particular album, Du Qiong, is supposed to have been one of Tao's pupils, although in reality he was too young to have received instruction from the scholar. Nevertheless, the album is well known in the history of Chinese painting because it was one of the earliest topographical depictions of an estate, a genre that became very popular during the middle and late Ming, and because it has colophons by

many literati of the Ming period before Li Rihua. These include Wu Kuan (1436–1504),[38] a high official and a close friend of Shen Zhou; Yang Xunji,[39] a *jinshi*-degree holder who, after serving for a period as an official, retired to live in a hermitage near Suzhou to write poetry and drama; and Wen Zhengming,[40] the great master of painting in Suzhou. In the early seventeenth century the album came into the hands of the official Yang Wencong (1597–1645),[41] who during the reign of Chongzhen served as magistrate of Jiangning (present-day Nanjing). It was at this stage in its history that several of the later connoisseurs under discussion here had the opportunity to see the album, though not all at the same time.

Dong Qichang's colophon deals mainly with the transmission of the artistic traditions of the Wu school, which flourished in Suzhou during the Ming:

Shen Hengji [Heng] studied painting under Du Dongyuan [Qiong], and Mr. Shitian's [Shen Zhou's] painting came from Hengji.[42] Dongyuan was a pupil of Tao Nancun [Zongyi]. This then is the source of the Wu school. This fragrant petal of Longyou [Yang Wencong] makes clear the origin of the venerable Baishi's [Shen Zhou's] art. It must have been predestination.

Li Rihua's colophon, which precedes Chen's, also refers to the Wu school:

In the painting of this dynasty, first it was Shitian [Shen Zhou] who uttered the lion's roar, and then Hengshan [Wen Zhengming] and the others followed with their howls and shouts everywhere. It was a flourishing tradition indeed. However, this one single source from Caoyuan [origin of Chan Buddhism] was started by Mr. Yongjia [Du Qiong]. It continues the simplicity of Yuan without losing the complexity of Tang and Song. It combines the best from the three masters, Zijiu [Huang Gongwang], Shuming [Wang Meng], and Zhonggui [Wu Zhen], while reaching back to Dong [Yuan] and Ju [ran]. This then is the Heart Sutra. Longyou [Yang Wencong] should treasure it.
The year *jisi* [1629] of Chongzhen, by LI RIHUA

Chen Jiru's colophon differs from the other two in striking a much more personal note about Tao Zongyi himself:

Mr. Tao Zongyi came to live in Sijing in our Songjiang during the last days of Yuan when there was a lot of fighting. I have seen his *Chuogenglu, Fumo,* and *Shuofu* [all books written or edited by him], and *The Nancun Cottage* by Shuming [Wang Meng], but I did not know that there was an album of *Nancun bieshu shijing* [*Ten Views of Nancun Villa*], that he had a son called Jinan, and that Du Dongyuan [Qiong] was one of his pupils. Yang Longyou [Wencong] brought this over to show me. It is something rarely seen. It happened that Ren Dan is compiling the gazetteers. His poems and colophons have been recorded in the "visitors" and "literature" sections. In painting, this album opened up a whole new vein in the art of the venerable Shi [Shen Zhou]. In the inscriptions of the pre-

vious writers this has been mentioned in detail. There is no need for me to repeat it.

On the eighth day of the ninth month of the year *jisi* [1629] in the reign of Chongzhen, CHEN JIRU of Yunjian [Songjiang] wrote this in the Wanxianlu [The House of Playing with Immortals].

Here all three men seem to have echoed in some manner what the previous writers had said about the tradition of the Wu school. Although they added no great ideas, the fact that Dong Qichang, Li Rihua, and Chen Jiru, together with those before them, wrote colophons for this album greatly enhanced its aesthetic and material value, since the many pieces of calligraphy were works of art in their own right. For later connoisseurs the album's paintings, calligraphy, poems, comments, and aesthetic and historical remarks by a whole stream of prominent literati throughout the Ming dynasty made it a prized treasure to have in their collections.

Their reputation as connoisseurs and their location in the Jiangnan region—then the richest in all China and the area where most of the great works of the past could be found in local collections—gave Li Rihua, Dong Qichang, and Chen Jiru an unrivaled opportunity to see a large number of paintings by early masters that were still extant during their lifetime. Their writings show the wide array of masterpieces that came to their attention. It was Li and Dong's particular good fortune that they were able to devote such a long period of their lives to this type of connoisseurship, which was one of the major activities of the literati.

During the twenty years that Li Rihua was on extensive leave and enjoying his life as a literatus, the only official task that he accepted was to compile local material for the *Shilu* [*Veritable Record*] of the Wanli emperor after the emperor's death, a task that he could perform at home. The compilation of local material, both for this record and for the Jiaxing gazetteers later, was something very much in line with his own interest in writing and editing, and could be seen as an integral part of literati activities.

In 1624 Li was recalled to the court to serve as a secretary in the Ministry of Rites, and in 1625 he was appointed assistant to the director of the Seal Office. It was not, however, the best time to be serving at court, for with a young but stupid emperor on the throne power fell into the hands of the eunuch Wei Zhongxian, one of the most corrupt figures in Chinese history. Wei filled official posts with his greedy cronies and followers, and persecuted many of those who were conscientious and loyal. Eager to go back to the Jiangnan region, Li Rihua managed to obtain an order to serve as a representative of the court at the burial of the Tenth Duke of Qianguo in Nanjing. Because of a long waiting period he was able to stay home for a year. After the burial he returned to Beijing in 1627 and soon saw the accession of a new emperor, Chongzhen, to the

throne and the downfall of Wei Zhongxian. A year later, at the age of sixty-five, Li fell ill and requested permission to return home. Thus his service at the court in Beijing was very short. During the two to three years that he held official positions at this stage in his life, Li's heart was always at home in Jiaxing and he tried in whatever ways he could to return there.

Representative of Li's paintings during this period is a handscroll *Rivers and Mountains in My Dream* [no. 3]. Done in 1625, the first year he was back at court, the painting was executed in the manner of the Yuan master Huang Gongwang. In free, broad ink strokes, the painting depicts a very simple landscape starting from the foreground with a few sparse trees, then moving right to left from a small pavilion and across the river to some rocks and trees in the middle ground, and finally coming to mountains in the distance, done in the sketchiest brushwork. Although only Huang Gongwang is indicated as the source of inspiration, the painting also includes ideas from another Yuan painter, Ni Zan, as well as clear references to the brushwork of Dong Qichang. Typical of the literati approach is the poem written in large characters at the end of the painting:

> After fishing, the light boat floats in the mist.
> The distant mountains, all covered, seem to be at the tip of my flute.
> There is no need to be afraid of the scattered rain.
> The trees by the river, with their branches stretching out, are good for tying the boats.
> Clouds arrive from the trees and shrubs, and water flows from rocks
> Falling scatteringly in mist by the edge of the thatched hut.
> With the coming of autumn I take this as the dream of Mt. Kuanlu,
> And say that my previous incarnation was Bai Letian [Juyi].
> Early autumn in the year *yichou* [1625], painted respectfully by ZHULAN [LI RIHUA].

Here, in the literati tradition, is a combination of painting, poetry, and calligraphy in one piece of work. Neither the painting nor the poem had anything to do with the current state of affairs at court or with the problems of the country. As its title suggests, it is a dream of rivers and mountains, the landscape serving as the vehicle for the poet-painter to express his desire to rise above the vicissitudes of the mundane world. Through this metaphor Li turned his thoughts and feelings to the past, just as the Tang poet Bai Juyi had done on Mt. Kuanlu, where the hermits and immortals were said to have lived.

This does not mean that Li Rihua was unconcerned about the social problems of the day. In fact, he was a man of encyclopedic knowledge and wide interests. In a letter preserved in the Shanghai Museum as part of an album of Ming letters [no. 5], Li shows his involvement in public affairs:

The reason for the rapid rise of the price of rice is excessive purchasing by the people. The reason for the rampage of rioters is thievery and robbery. Mr. Yao must be well aware of it. Fire, if not contained, will light up the burning fields. Water, if not dammed, will form streams and rivers. Rioters today do not become so because they are hungry, but because they want to plunder. When the system of punishment breaks down, the country must take heavy measures. In the case of the riots of Songling, one or two rioters must be executed and their heads displayed in the open as a warning to those agitators in order to stop them. If they are merely beaten to death, it is only child's play.

The whole letter, though apparently referring to public events, seems to be based on some personal interest. The riot mentioned was probably the one that took place in Songjiang in 1616, when many of the townspeople burned down the houses of Dong Qichang in reaction to the treatment of some of the people in the area by Dong's sons and other members of his family.[43] Dong himself suffered not only great damage to his property and collections but also tremendous humiliation and a severe blow to his moral standing. Dong's family seems to have been to blame. Li Rihua's sympathies, however, definitely lay with his friend.

In his diaries, Li recorded many episodes of a similar nature, although not directly related to the Songjiang incident. As both scholars and officials, men like Li Rihua were supposed to be knowledgeable about everything, and indeed their opinions were often sought by the people.

Although the ideal life of the literati was not based on material gain, a considerable degree of wealth was required to pursue their interest in collecting books, paintings, calligraphic works, and the many other objects that filled their studios. For both Dong and Li, their official positions helped them tremendously in their collecting. Even Chen Jiru and Zhou Lijing, who did not come from wealthy families, managed to amass a considerable number of objects, especially books, and both became known for their large libraries. Collecting apart, all the literati wanted was to live a simple life dedicated to art. Li Rihua expressed this ideal in a colophon written in an album done by a friend:

All I want is that in my whole life I have white rice to eat, fish for soup, good wine and fine tea to drink, and in my home I have ten thousand volumes of books and a thousand stone rubbings. I do not have to go out all year or to see any vulgar person that someone tries to introduce to me. After I have lived like this for seventy or eighty years, I shall be a citizen of the Kingdom of Eternal Happiness.[44]

As a literatus Li Rihua was expected to ensure that he had one or more sons to continue the tradition in the family, and in this he was not disappointed: he had one son and one daughter. The son, Li Zhaoheng, turned out to be very much like his father in following literati pursuits. Also a painter, calligrapher, and poet,

he does not seem to have taken any examinations, perhaps because the family was already quite well off. As a result, he could devote all his time to the enjoyment of the arts. He participated in many literati gatherings with his father, and became acquainted with many of the famous scholars, painters, monks, and collectors of his own time. He edited his father's writings. One of Li Zhaoheng's closest friends was Xiang Shengmo, who, curiously, did not include him in the group portrait.

One of the rarer works in the Shanghai Museum is a fine hanging scroll by Li Zhaoheng, *Exquisite Scene of Lakes and Mountains* (no. 8), which depicts a scene on a clear day in the countryside of Jiangnan. The foreground is occupied by some tall trees rising above a few rocks and houses. Beyond them stretches a large lake, from which rises a hill with a sharply inclined cliff. Farther into the background rise some mountains that form a screen in the distance. It is a scene typical of the landscape around the lake region of Taihu, not far west of Jiaxing.

Over the upper left corner of the painting Li Zhaoheng inscribed a poem that reveals what he thought about himself:

The truly great people of the past,
Filled with mountains and valleys in their bosoms,
Often expressed themselves in their writings
And in forms as sketched in brush and ink.
Towering high are the cliffs and peaks,
Their beauty filling the vast open space.
Sprinkling rain is moving out from the sparse forest;
Autumn mist arises from the thin groves.
Both Ni [Zan] and Huang [Gongwang] are far into the past;
Even Wen [Zhengming] and Shen [Zhou] cannot be reached.
I am both lazy and clumsy,
Inexperienced as a beginner.
Exhilarated I am able to do some bad drawings;
Rather poorly I can paint some snow geese.
Your home nestles between two high peaks;
You can see the cloudy peaks day and night.
There is, alas, no mountain in my area;
I can only find it in ink and brush.
Seated by my window I can think about this
And do my painting with a laugh.
My friend Danchi came from the beauty of West Lake landscape, but became interested in my ink play. Isn't this the taste of Mr. Ye? I do this for a laugh!

This is a typical expression of the literati, displaying an almost total devotion to the pursuit of artistic creation. The poem, half in jest and half serious, reveals its author's preoccupation with self as well as the traditional identification of nature with the artist's mind as expressed in brush and ink.

Unlike his father, who lived his entire life under the Ming dynasty, Li Zhaoheng had to endure the great calamity that befell the comparatively peaceful life of the literati in his region. In 1644 the Manchus from the northeast sacked the capital city of Beijing and established a new dynasty called the Qing. The next year

they crossed the Yangzi River to crush the remnants of the Ming army, leaving behind many people dead, many houses burned, and many driven from their homes. Even wealthy families, including those of Li Zhaoheng and Xiang Shengmo, suffered loss of life and property. When things began to settle down, the two men returned to their homes in Jiaxing to try to resume their peaceful life. In 1646 Li made an album for his friend Xiang Shengmo, with six leaves of painting and calligraphy (no. 9). Again it is quite autobiographical, as reflected in his inscription for leaf 2:

There is a poem by a Yuan poet with these lines:
Dreaming I could not tell whether it was cool or raining;
Awake, I found the lotus blossoms slightly wet.
There is another:
Wood-pecking orioles rest on willows by the water;
Lotus-root gatherers in the snow sing to the mountain partridges.
These are the exquisite realms of a leisurely life in the summer. In the summer day of the year *bingxu* [1646] I came back to live in my home at Luoxi. Since it was right after the fighting and the destruction, I seldom saw any of my friends. Only with Xiang Shengmo was I able to play with brush and ink. In the garden there were no fine plants to see and no new sounds to listen to. But mist and clouds and trees and rocks often came out of my inkstone from my imagination. Looking at them, one can immediately be oblivious of the summer heat, and generally feel oneself to be out of this world. There is no need to worry about whether this is done skillfully or clumsily. Does Old Yi'an [Xiang Shengmo] think so?

Here is the strength of the literati life. In spite of all the turmoils that Li and Xiang had faced during 1645—being forced to flee from the fighting, losing their homes and property, and suffering other unpleasant consequences of civil disturbance and dynastic change—once they were able to settle back into their homes they tried to return to the same kind of existence they had enjoyed before, especially in their pursuit of the arts. The album reflects this clearly: although all six of the paintings seem to have been done in 1646, there is no indication of the previous year's upheavals except in the inscriptions. As the poems quoted by Li Zhaoheng in the album reveal, the paintings themselves show a world of peace and beauty that evokes the past rather than the present. The dream of the literati was what sustained them through all adversities.

Late in his life Li Zhaoheng became a Buddhist monk, probably of the Chan order, in the Chaoguosi Monastery in Songjiang, where he took the name Monk Changying. The circumstances surrounding this major change are not entirely clear. However, his father, Li Rihua, is known to have been deeply interested in Chan Buddhism, and as noted above, this caused problems for him in his early career. The elder Li often visited Chan Buddhist temples and he befriended many Buddhist monks. This interest seems to have been passed on to his son.

Li Zhaoheng was evidently not yet a monk in 1646, when he wrote the inscription just quoted; he must have taken his vows after his late fifties. This was a pattern followed by many literati during the period following the fall of the Ming dynasty, when refuge in temples and monasteries was seen as a means of achieving peace of mind under an alien regime. Li Zhaoheng may have chosen this course as his way of spending the rest of his life; if so, he, like Qiutan, represents the monk-hermit type.

One of Li Rihua's protégés was Xiang Shengmo, who was also Li Zhaoheng's good friend. As mentioned earlier, they were all related, for Xiang married Li Zhaoheng's cousin. But the connection was much more than that. In his early years, Li Rihua, living in the same town as Xiang Yuanbian, the great collector who was also Shengmo's grandfather, frequented Xiang's home to look at paintings and calligraphy. Li was of the same generation as Xiang's sons, and became very close to at least two of them. Born into this family with wealth and prestige (quite a few of its members over several generations were holders of *jinshi* degrees), Xiang Shengmo was extremely interested in painting when young, and later developed into a painter with excellent technique. He might have taken the local examinations but he never received the *jinshi* degree.

For Xiang Shengmo himself, the pursuit of a pure literati life seems to have been his ideal from childhood. As a youth, with his studies of the classics and painting completed, he was able to travel to many parts of the country, including the various parts of Jiangnan to as far as southern Anhui where Mt. Baiyue is located.[45] He is known to have traveled north with Li Rihua on the Grand Canal to Beijing in 1628 and then to have visited many other places in north China. (The trip could have been for the purpose of taking the examination in the capital, but there is no mention of this in any source.) His travels were the fulfillment of what Dong Qichang and Li Rihua both considered as one of the basic requirements for a literatus, to "walk ten thousand miles and read ten thousand books." Xiang, who aspired to be a hermit, assumed various names, among them "The Woodcutter of Mt. Xu" and "The Free Immortal of Soughing Pines."[46] He did not, however, take up residence in the mountains but lived at home in Jiaxing, surrounded by all the comforts of a wealthy family. It was a perfect way of life for someone of his kind.

In the years when Li Rihua was still living (before 1635) Xiang Shengmo was very close to him. There is no doubt that in addition to their family relationship Xiang looked up to Li as a model of taste, knowledge, and artistic talent. A reflection of this relationship can be seen in Xiang's inscription on the painting *Five Pines* (no. 17):

In an autumn evening of the year *jisi* [1629] of Chongzhen, I dreamed that on the broad terrace of Venerable Jiuyi's [Li

Rihua's] courtyard there were old pines, blooming flowers, exotic herbs, bamboos, and rocks, all quite elegant and charming. In the dream both Li and I were enjoying ourselves under them. Soon Kexue [Li Zhaoheng] came to join us. Suddenly we heard a clear whistle that lingered in our ears. I knew that it must have been a good omen for the Li family that would reverberate far and wide. Here, in response to this happening, I depict this scene in my dream to present it to them.

The twenty-third day of the ninth month, XIANG SHENGMO.

In the painting the terrace turns out to be something like a huge flowerpot in rectangular form out of which grow five large pines with some rocks and plants around them. The painting has somewhat the effect of a dream in that the pines seem to be part of a landscape but in reality are like flowers growing from a pot—a typical feature of the literati studio. It seems that Xiang was presenting Li Rihua a pot of pines, rocks, and other plants as a symbol of a good omen.

As shown in the group portrait, Xiang Shengmo was close not only to Li Rihua but also to Dong Qichang, Chen Jiru, Monk Qiutan, and Lu Dezhi. Among them the three that he held in greatest respect as mentors were Li, Dong, and Chen. The best indication of their relationship can be found in the colophons all three wrote on the first scroll of *Calling for Reclusion*, dated to 1626 and now in the Los Angeles County Museum of Art. This is a long handscroll showing a gentleman—a depiction of Xiang himself—starting his trip in his "calling for reclusion" through a stretch of marvelous landscape that includes hidden paths, strange rocks, towering pines, lonely pavilions, deep caverns, high cliffs, pointed peaks, picturesque mountain formations, and broad expanses of water. The painting runs to a length of twenty-five feet and is the first of a series of important autobiographical handscrolls that Xiang executed during his life. At the end of the pictorial section, Xiang wrote a total of twenty poems, each with eight five-character lines, on the same subject in small regular script. This monumental work by the youthful Xiang Shengmo reveals his heart's desire as being identical to the ideal of the literati. Xiang added a long inscription after the poems describing the genesis of the painting:

I painted this scroll because in the autumn of *yichou* [1625] when my boat was reaching Wujiang [about twenty-five miles north of Jiaxing] I, being quite free, found this set of paper, in a total of six lengths, and made them into a long handscroll to start to paint. Since then, sailing from Wujiang by way of Songjiang for almost a month, I completed less than a foot of this painting. Somehow some talkative people had already reported this to Mr. Dong Xuanzai [Qichang]. When I went to visit Mr. Dong, he kept pressing me to show him this painting. I returned to the boat and moored at the White Dragon Lake and then completed the first length of this scroll. Putting it inside my sleeves I went to see Mr. Dong again. When he looked at it, he kept nodding his head without saying a word for a while. Then he asked: "The mountains are high; the valleys are beautiful. The forests are green and the breezes touch our clothes. The man does not look back but seems to have the air of being out of this world. What is this painting about?" I said: "I was very much inspired after reading the poems 'Calling for Reclusion,' by Lu Ji [261–303] and Zuo Si [ca. 250–305],[47] and painted this piece." It was already evening and he invited me for dinner. Having drunk a lot of wine, we talked and talked and discussed the many famous calligraphic works and paintings in my grandfather's collection. When midnight came I got up and bade farewell to him, bringing the scroll back with me.

In the tenth month of that year I was together with Mr. Xuanzai again at Wujiang. Impatiently he asked: "Since I saw your scroll last time, how many mountains and valleys, and mists and clouds have you added?" I then replied: "Since I have not found a mountain companion, I have not yet finished it. Now I want to bring my inkstone and live like a hermit. I shall express what is in my bosom and try to attain my ideal, as a way to achieve fulfillment in my life. Many people at the point of making a decision to leave the world behind find that they are unable to cut off their ties because they cannot leave worldly things behind. When you heard about this, you smiled. This means that you understood what I said quite well, for you have the same ideal." Having said this, I thanked him and left.

Returning home, I worked with my brush and ink so hard that I seem not to have noticed the passing of months and years. When this scroll was finally completed, it had taken nine months, during which I was both sick and sad. Every time when I got up from my sickbed and stretched out my painting, I was often prevented from working on it by worldly matters, and sometimes had to spend my time meeting requests for paintings from various people. All these made me so confused and worried that I could not work on it except perfunctorily. Only after the sun was down was I able to clean my inkstone and light up my lamp. I abstained absolutely from drinking and ate only pine-flower cakes and tea-leaf soup. Then I ordered the servant to burn incense and grind the inkstick. I worked until I got very tired before putting down the brush. Then I held the candle to look at the flowers or rolled up the curtain to look at the moon. If I felt refreshed, then I picked up my brush again. I usually worked until midnight before I went to bed. If the time is added up, it amounted to a period of somewhat less than two months. Now when I look at it, I can see that the forests and hills are bright and smiling, grasses and trees are happy and growing, the air is lively and the spirit is pleasant, all being far from vulgarity. I then gave it the title *Calling for Reclusion*, and composed twenty poems of five-character lines with the same rhymes and wrote them down at the end of the scroll. I fully realize that many people in the world are not hermits, and that they want to be hermits but are not able to. Alas! There must have been some people who have become hermits before me. I say: Please call me for reclusion. I say: I shall call myself to reclusion. I can just say: It is all right for me to call myself for reclusion. I want to be a hermit in the cities, but cannot. I want to retreat into mountains and rivers, but cannot. I want to retreat into my poems and paintings, but they have been scattered around in the world, making it impossible for me to collect the names of those who own them.

Thus I must keep this in my arms and store it well, in order to wait for those who share my ideal. On the fifteenth day of

the sixth month of the year *bingyin* [1626] of the Tianqi reign, the Hermit of the Lotus Pond, XIANG SHENGMO, wrote this.

Xiang mentions here the very close relationship he had with Dong Qichang, and when the scroll was completed, Dong was probably one of the first to see it. He wrote the following colophon on it:

Wang Mojie [Wei, 701–761] wrote his "Peach Blossom Poems" at the age of nineteen,[48] and Pan Anren [Yue, 247–300] composed his "Poems on Leisure" when he was thirty-one.[49] Now Kongzhang [Xiang Shengmo] wrote his "Calling for Reclusion" at the age of thirty, with his ideal set at the forests and springs and his sounds being strong and firm. The subject of his poems comes from *Wenxuan* [a book of early Chinese poetry and essays compiled under the auspices of Prince Xiao Tong in the early sixth century],[50] and the form from Tang poems. Thus his poems have combined the best features of both Mojie and Anren and created the feeling of living in the Wangchuan Villa [of Wang Wei] and the Heyang Retreat [of Pan Yue] for the rest of his life, without the distraction of the cities. Even though he is at the age of thirty, his lines, "Hoary head is what everybody will eventually become; there is no completely secure earthly net," show that he was already well aware of the rugged perils one might have to face late in life, such as those that befell Mojie and Anren. However, although the characters of the poets are different, the practices of the painters are the same. Xiang's long landscape handscroll, while having some ideas from Youcheng [Wang Wei], also derives from Jing [Hao] and Guan [Tong] and is modeled after Dong [Yuan] and Ju[ran].[51] It is meticulous but does not hurt its bone structure; it is free but does not harm its spirit resonance. Thus it does not seem to take the Wangchuan as its ultimate goal, but goes far beyond. In the future, when he reaches full maturity like Wei Suzhou [Wei Yingwu, Tang poet, 737–ca. 792][52] and Li Xigu [Li Tang, Song painter],[53] how will his poetry and painting be? On the basis of this youthful work we can look forward with great expectations.

This is very high praise from a mentor who was at that time at the height of his political career and reputation as a literatus. Although Dong did not date the colophon, it must have been done between the sixth month of 1626, when the painting was completed, and the last month of 1627, when Li Rihua wrote his colophon, which follows Dong's and Chen Jiru's. Chen's colophon comes after Dong's and expresses his own point of view:

Kongzhang's "Calling for Reclusion" in both poetry and painting combines four lengths of Song paper to form a long handscroll. The road leads into winding paths, sharp turns, high peaks, thatched huts, and deep caves, all so clean that no dust can be found. Also there are vegetables and mushrooms in the valley that taste pure and desirable. When the scroll is unrolled, all desire for fame and profit has been drained away. Among the famous paintings in the collection of Mr. Zijing [Xiang Yuanbian], Lu Hong's [Hongyi's] *Thatched Hut* ranked the very first.[54] Kongzhang's handling of the brush has captured the strange and precarious compositions of this Tang

painter. There is no need for him to compete with the masters of the last dynasty.

Li Rihua's colophon is the longest of the three, and it shows that, as his mentor living in the same town and also as his wife's uncle, Li knew Xiang well:

The masters of the last dynasty, strongly inspired by Dong [Yuan] and Ju [ran] in their paintings, always achieved spirit resonance even though they handled their brush and ink with big sweeps and free strokes. Only in composing pictures did they seldom originate their own. Even though Huang [Gongwang] and Wang [Meng] originated more, their works of this kind are still not numerous. This is due to the fact that the importance of composition to painting is equal to that of *fu* [an irregular form of rhyming composition] to essay writing, for painting cannot be achieved unless one possesses the broad mind that can embrace the mountains and the seas and the sun and the moon, together with the skillful hands of the Weaving Maid in the heavens that can weave beautiful materials at all times.[55] Nowadays the art of painting in the world is getting worse every day because it has largely fallen into empty, ugly, wasteful, strange, and weird ways. So bad has it become that trees are done without order and depth and rocks are shown without front and back. To try to hide these shortcomings, people show their superiority by saying, "I do this to preserve the spirit of the untrammeled." Since this kind of excuse passes on from teacher to pupil as a general practice, there is no way to stop it. My friend Xiang Kongzhang, who is a youthful descendant of a famous family, has concentrated on this art after he has mastered the classics. One day he showed me this scroll, which is beautifully and skillfully done, and is powerful and dramatic in expression, with mountains and waters changing from section to section, in a length of about thirty to forty feet. Its brushwork has taken as its models [Lu] Hongyi's *Thatched Hut*, [Wang] Mojie's *Wangchuan*, Guan Tong's *Snowy Cliff-walks*, and [Li] Yingqiu's *Wintry Forests*, without a single stroke falling into the narrow paths of those who crossed the river to the south [i.e., Southern Song painters].[56] There is no lack of vividness and life. It is right in the mainstream of painting. Kongzhang's grandfather, Mr. Zijing, was a great collector and a discerning connoisseur with a collection of great masterpieces unexcelled in the world. There I once saw his own *Guo Wu Making Pills on Mt. Jiao* and *Wu Zuoxing Sailing in the Peach Blossom Spring*, both more than two feet long.[57] Now this scroll, so monumental and beautiful, is about three times as long. This makes me realize that the seed of the dragon is mostly found in the steppes of Wuwa [in present-day Gansu, famous for horse-breeding].[58] At present, when the art of painting is in a decline, with weird influences everywhere and restrictive nets all over with no way to escape, Kongzhang's lofty thoughts and vital spirit show that he is almost alone in his superior expression. He is one of the new heroes who have risen recently. Because he and I live in the same town and our families have known each other for generations, I feel that my praise and admiration for his work should count for double those of Dong and Chen.

In the first day of late winter of the year *dingmao* [1627] in the reign of Chongzhen, a friend from Baizhu, LI RIHUA.

Here the three teacher-friends, who were all over sixty at the time, wrote their colophons for Xiang

Shengmo's first major work at the age of thirty with great affection and feeling. Undoubtedly this was because all three of them had benefited from association with several generations of the Xiang family and had learned their connoisseurship from the paintings and works of calligraphy in Xiang Yuanbian's collection.

They must also have had a strong sense of Xiang Shengmo as the perfect literatus, for in this young man they found many of the things that they would have liked in their own backgrounds: a famous family with generations of members holding *jinshi* degrees and serving as high officials, a certain amount of wealth to release the younger members from the worry of making a living, a great library, an outstanding collection of art works, and many famous teachers to help with the education of the young. These were things that Dong, Chen, and Li did not have in their youth. In Xiang Shengmo, they had met the personification of their ideal, the inhabitant of their dreamland. Thus, seeing the completion of *Calling for Reclusion* was a source of great satisfaction for all three of them.

After the completion of *Calling for Reclusion* and before his long trip to the north in 1628, Xiang started another handscroll; he called this *The Free Immortal of Soughing Pines* (also translated as *A Carefree Immortal Among Waves of Pines*), a reference to himself, and finished it in 1629.[59] The painting, now in the Museum of Fine Arts, Boston, again shows imaginary landscape scenes, which were developed from views in his garden. In the following years, he continued to work on two more handscrolls on the same theme as *Calling for Reclusion*. One of these is now in the National Palace Museum, Taibei; the other is lost, though fortunately its long inscription by Xiang has been recorded.[60]

All four of these scrolls were autobiographical works painted by the artist for himself alone, dedicated to no one, and reflecting stages of Xiang's own intellectual as well as artistic development. This is the heart of literati painting. As distinct from the works of professional artists, which were usually done on commission and for profit, these scrolls were painted as a record of Xiang's spiritual growth, without any consideration for what the public might think, and least of all to make money. All four scrolls demanded careful planning and their exquisite execution took a considerable length of time to complete. They are expressions of Xiang's own mind, his imagination, and his dreams. Few artists in the history of Chinese painting have left a group of works of this character, and they make Xiang one of the best examples of a literati artist.

In the late Ming world, political and social conditions deteriorated rapidly. The court in Beijing was in constant turmoil because of weak emperors and power struggles among the court factions. Unrest and rebellion broke out in many parts of the country. Although the Jiangnan area, in which all these literati lived, was able to maintain some stability, it was not entirely peaceful. The impact of uprisings in many parts of China north of the Yangzi River and of the invasions of the Manchu armies from the northeast was keenly felt. Of the literati represented in Xiang Shengmo's *Venerable Friends*, most had died during the 1630s: Monk Qiutan in 1630, Li Rihua in 1635, Dong Qichang in 1636, and Chen Jiru in 1639. As a result, these men were spared the upheavals of 1644–45, when the Ming dynasty came to an end and the Manchus, "barbarians" from beyond the Great Wall, moved into the country and soon dominated the whole of China.

As Xiang's inscription, which was written in 1652, on that group portrait indicates, "After all the turmoils . . . only one-tenth of their poems are left. Now only Lu the Bamboo Painter is still around, while the four others have left us." For those who lived through the tragic events of 1645, when the Manchu armies, after capturing Beijing, continued their conquest southward, first taking over Nanjing, the second capital, and then moving through the Jiangnan area, life was never the same again. Xiang, in his own inscription on the *Third Calling for Reclusion* scroll, mentions these cataclysmic events:

I have painted the first and second scrolls of *Calling for Reclusion*, with one on paper and the other on silk and with one in ink and the other in colors, both quite long. Now, after many months and years, I have completed this scroll, which can be considered as the first try of my brush in the year of *jiashen* [1644]. While it is easy to ride wild horses, it is difficult to wait for inspiration to come. It is also not easy to count the days, forgetting about eating and sleeping. I shut my doors and lived a quiet life, letting my spirit wander in complete reverie. Then I spread out my scroll and held my brush, with my heart delving back more than a thousand years. I got up early in the morning to work, and went to rest during the night. After performing my duties to my parents and handling the family chores, I had nothing else to occupy my mind except to keep my brush moving. I went on without any doubt and faced the task with all my spirit without any feeling of disappointment. Now I painted a few inches, now I did a whole foot, and now I doubled the measures. When the sun was down, I worked on with a candle until my inspiration ran its course. When I did something that I liked, I would not want to see any friends, would not bother about the rain, or hear the thunder, or avoid the winds, or see the snow. I did not know whether my ten fingers were numb or my two eyes like the suns were unable to see. It was like this, forgetting about being hungry and thirsty for almost two dozen days before this scroll was completed. I thought about what had happened recently in Jing [western Hubei], Chu [central Hubei], and Hengyang [Hunan], and about the shaky situation in Zhe and Yue [both in Zhejiang].[61] While I was hoping that someday there would be good news to come, I was deeply affected by these events. I then called this *Third Calling for Reclusion*.[62]

The scroll was thus completed early in 1644, before the last Ming emperor, Chongzhen, hanged himself in Bei-

jing in the third month and the first units of the Man-chu armies entered the capital in the fifth. Already, in what seemed to be the safe south, Xiang had heard about the uprisings in Hubei and Hunan and even in Zhejiang. In spite of these events, he was still totally devoted to his art and to the life of a hermit.

Indeed, Xiang's family background and his literati upbringing do not seem to have prepared him for what would eventually happen to him and to his home and family. In another inscription on this third scroll Xiang recorded what he had gone through during the turmoil:

This is *Third Calling for Reclusion*, which I painted in the first month of *jiashen* [1644], and which includes thirty poems of "reclusion" that I inscribed at the end of the scroll. Somehow I did not keep it too well, for it was taken away by the servant boy who used to grind my ink for me. I spent a whole month searching for it, but could not find it. Soon I began to hear about the great calamity in the country. People in the north and south were driven away from their homes to become refugees and fighting took place all over the country. Grieving and weeping over all that had happened, I thought that I would never be able to see this scroll again, thinking that it had probably got lost in the land of missing things. In the following year, to the south of the Yangzi River, both soldiers and people were swept around in great disorder, and infantry and cavalry crisscrossed the country. On the twenty-sixth day of the leap sixth month, the city of He [Jiaxing] fell, with fires burning up the sky. I could only carry my mother by myself and flee with my wife and children to somewhere far from the city. Thus my home fell apart. All the famous calligraphic works and paintings that my brothers and I had inherited from my grandfather and some of those dispersed in other hands have been lost, half being trampled over and half being turned into ashes. How could I worry about the exis-tence of this one single scroll? It happened that in the tenth month of *dinghai* [1647], when I was residing in the Meihua Street of Wutang, in front of the pagoda of Monk Qinshi [the Yuan painter Wu Zhen], perhaps through the help of the spirit of this monk, I suddenly ran into my servant boy in the street. He had in the meantime become a monk. I first angrily scolded him several times for betraying his master. When he agreed to return my scroll, I felt somewhat relieved. The next day I got it back. Looking over it I was so happy that I could not sleep. So I got up to write this under lamplight. . . . Writ-ten after getting up again during my sleep on the twelfth night of the same month.[63]

Later on he added another short inscription:

In the eleventh month of the same year, I composed thirty poems but had no time to write them down. Now in the sixth month of the next year, *wuzi* [1648], when repeated rains have almost brought in the autumn, I wrote them here to go with the last inscription.[64]

Here Xiang recounts all the tragic events that he had had to face: loss of his home, flight with his family, the disappearance of the family collections of paintings, calligraphy, and books, and his existence as a refugee. Still, as a literatus, he found great joy in the recovery of

his *Third Calling for Reclusion* scroll and, typically, began to compose poems for it even before he had set-tled into a new life back in Jiaxing.

There is no doubt, however, of the shock to Xiang's rather quiet life brought about by his experiences. In the thirty poems that he wrote for this scroll after its recovery, he expressed his lament for the loss of his dream, as in this first one:

I painted the joy of reclusion, but lost it in an intoxicated dream.
I got it back also as in a dream, and should keep this as my achievement.
To think about the shadows cast by the mountains and rivers of my country,
I still try to keep my life as a recluse.[65]

In other poems he wrote about the loss of the country and the scattering of the *yimin*, or leftover subjects (those loyal to the Ming dynasty).

As we have seen, Li Zhaoheng, the son of Li Rihua, went through a similar experience during the turmoils. In the passage already quoted from his album of land-scapes and calligraphy (no. 9), he said that in the sum-mer of 1646 after he had returned home to Jiaxing he seldom saw any of his friends except Xiang Shengmo, who quite often joined him in painting. In spite of all they had gone through, both men tried to resume their literati life.

As literati, Xiang and Li were supposed to follow tradition in reacting to the change of dynasty. Accord-ing to the Confucian ideal of loyalty, the literati should not serve under two different dynasties, and those who did were generally criticized by their peers. In the tran-sition from Ming to Qing, there were three major courses to follow as acceptable ways of maintaining Confucian integrity. One was active participation in the military struggles against the Manchu invaders, which was especially attractive to those who had served as officials under the Ming dynasty. A fairly large number of intellectuals chose this course of ac-tion, even though they were unhappy with the corrup-tion and weakness of the Ming court. Their resistance led many of them eventually to defeat and execution. One of Xiang Shengmo's cousins, Xiang Jiamo, who had served as a military commander in the Beijing area earlier in his career, chose to drown himself and his family when the Manchu armies were approaching Jiaxing. He was not alone in this decision, for many other officials chose the same course.

The second, more passive alternative—apparently Li Zhaoheng's choice—was to retreat from society by becoming a monk, a common practice in Chinese his-tory. During periods of dynastic change, Buddhist monasteries were often swollen by large numbers of intellectuals, thus bringing new vitality to the Buddhist religion. Some felt forced into taking this step by their fear of persecution at the hands of the new rulers; others

saw it as the only safe means to express their intellectual and emotional reaction to the Qing regime.

The third alternative was a kind of spiritual resistance. Those literati who opted for it thought of themselves as *yimin*; they remained loyal to the Ming in their hearts, but on practical grounds they had to accept the Qing. Because of this attitude they chose to lead simple lives, renouncing any intention of serving under the new rulers. For many of them, including Xiang Shengmo, such a course was the fulfillment of the literati ideal of a hermit's life. Even before the fall of the Ming dynasty Xiang lived as a hermit at home, and his life changed little except in one major respect. He had been well provided for by his wealthy family, but after the disaster of 1645 he lost the greater part of his possessions. To support his family he seems to have taken to selling some of his own paintings. That is why during the Qing period he seldom did long handscrolls like the four discussed above; instead he painted hanging scrolls and much shorter handscrolls, usually dedicated to people who were probably his patrons.

A handscroll that Xiang painted for himself at this time was one on the theme of reclusion, *Meditative Visit to a Mountain Retreat*, done in 1648, not long after the fall of the Ming, and now in The Cleveland Museum of Art. Quite different from his early handscrolls, the scene in this shorter scroll (about nine feet long, less than half the length of the previous scrolls) is more realistic, lacking the imaginary, contrived, and somewhat fantastic mountains, rivers, caverns, and trees of the earlier ones. The biggest difference lies in the placing of the main figure, an autobiographical literatus. In Xiang's earlier scrolls this figure begins his dream journey from the right; now he is placed on the left side of the painting, looking back toward the right from across a river. The poem is also different, for it is no longer based on the form and style of "Calling for Reclusion" of Lu Ji and Zuo Si, but on the more nostalgic Han *fu* manner:

Look at this person—how carefree he is;
He is not carefree but yearning for his friend.
Yearning for his friend who is at the other side of the horizon,
Longing to visit him, but it seems so remote to turn my head.
Pine or cypress? You are known for your endurance;
Where, in grottoes hidden by misty rain, is your haven?
Mountains after mountains and waters after waters, how far away is this man,
So far beyond reach that I wonder if it's possible to communicate even in spirit.
Rivers and mountain passes are now beyond what my eyes can see.
There is no one now whom I can talk to and laugh with together.
Ask the swimming fish at what depth dwells their happiness.
Ask the flying birds to what grove they are returning.

Ask the gibbons and cranes how closely they are related.
Ask the deer and swine which are shorter or longer lived.
Ask the white clouds where they are from.
Ask the rustling spring where it is going.
Ask the fishermen and woodcutters who owns these rivers and mountains.
Ask the plants and grasses where their acres and ditches are.
Ask the spring and autumn seasons why the heat and the cold.
Ask the mortals how long their world will last.
Ask the sun and moon what separates the dark and the light.
Have they ever seen the Old Man of Crow and Hare from the days gone by?
In the *wuzi* year [1648], at the beginning of the twelfth month, I happened to do this painting, so did the inscription.[66]

As Sherman E. Lee and Wai-kam Ho have pointed out,[67] this poem and the painting have very strong symbolic overtones concerning Xiang's feelings for the Ming dynasty, here referred to as "his friend" whom he longs for. Among the many allusions in the poem, the most important are those in the last two lines. The sun and moon, in Chinese characters, are the two components that make up the character for Ming, and the Crow and Hare, in Chinese mythology going back to the Han dynasty, are the inhabitants of the sun and moon. Thus the "Old Man of Crow and Hare," which was a name Xiang adopted for himself after the fall of the dynasty, was a reference to himself as a man of Ming. Both the poem and the painting—in typical, subtle literati fashion—are expressions of Xiang's sense of loss.

We began with the portrait of a group of late Ming literati from the Jiaxing and Songjiang area, a representation of the most renowned circle of poets, calligraphers, and painters of the period. We have glimpsed their backgrounds, their breeding, their education, their aspirations, their interests, their travels, and their artistic expression. Among them Li Rihua and Xiang Shengmo have been dealt with more extensively since they can be seen as models of the hermit-official and the hermit-painter respectively. For both, we have found autobiographical material in diaries, poems, and paintings that has given us deeper insight into their lives. They represent the best of the literati spirit in the Chinese tradition.

What the Chinese literati longed for throughout history was an ideal society of moral perfection, in the Confucian sense, where people could enjoy peace and prosperity without having to work very hard. In such a society, the literati, ever the elite, could devote all their time and energy to the pursuit of the arts, including poetry, calligraphy, and painting, and to the enjoyment of great works of art transmitted from the past. Yet this proved to be an unattainable ideal. Human frailties of every kind have constantly prevented society from

reaching the moral perfection so desired by the great philosophers. Greed, corruption, jealousy, warfare, and many other evils have taken hold, leaving the best minds in despair.

In Chinese society the literati were so dependent on their rulers that they rarely saw radical or revolutionary measures as a means of attaining their ideal. Rather, they took a passive role by shaping their goals to follow in the footsteps of the ancient hermits. Combining the paths of Confucianism, Buddhism, and Daoism, they began by purifying their hearts and minds to achieve moral integrity, then went on to find solace in nature and to achieve spiritual communion with the mountains and rivers, and ended by devoting themselves to the arts, collecting the great works of the past and creating their own as part of their individual contribution to the world. It was a beautiful life contained within a great ideal.

However, both the life and the ideal had to be built on a society with benign rulers and bountiful materials. Short of this perfection the literati were forced to retreat into themselves, thus abdicating their social responsibility. As a result, they were unable to deal with the corruption and degradation that plagued late Ming society, and they were even less prepared to cope with the great calamity of the fall of the dynasty. For Li Rihua, facing the decline of the Ming, the solution was to retire politely from his official duties and to become totally immersed in his personal pursuits. For Xiang Shengmo, confronting the hardships brought about by the fall of the Ming, the solution was to remain loyal to his own ideals. Neither man tried to resolve the contradictions of his time. This failure illustrates the weakness of the literati life.

On the other hand, perhaps the greatest strength of the literati life lies in its total dedication to the pursuit of the arts. The long tradition, the great subtlety, and the profound sophistication of China's artistic achievement gave the literati a powerful means of dealing with adversity. When totally involved in their own concerns, they could forget about the outside world. As Li Rihua said when reflecting on the carefree days he had spent with his teacher Zhou Lijing: "Sometimes we unrolled old scrolls of paintings and sometimes we read sutras and books. Sometimes we played with our brushes and ink, doing calligraphy and painting freely and leisurely. We were so happy that we were hardly aware of any other world besides our own."[68]

The Songjiang School
of Painting
and the Period Style
of the Late Ming

ZHU XUCHU

IF WE TAKE a sweeping look at the history of Ming painting, we find, generally speaking, that it passed through three high-tide periods. First was the current of the Zhe school, led by Dai Jin (1388–1462). Its center of activity was the area around modern Hangzhou, Zhejiang province; its period of full florescence was in the fifteenth century during the Xuande and Chenghua reigns. The second high-water mark was the Wu school, which flourished in the early sixteenth century with Shen Zhou and Wen Zhengming as its most important representative masters. The center of activity in the painting world of that time was Suzhou, in modern Jiangsu province, and its environs. During the late sixteenth and early seventeenth centuries, that is to say the period comprising the Wanli and Chongzhen reigns, the Wu school gradually declined. There then emerged in the Songjiang region (now under the jurisdiction of the Shanghai municipality) an outstanding group of painters who with their new style brought vitality to the contemporary painting world. This group not only greatly influenced the late Ming painting, but also, over a very long period of time, influenced the development of Qing painting. This, then, is what in painting history is called the Songjiang school.

The great majority of painters represented in this exhibition had very close connections with the Songjiang school. Dong Qichang, Chen Jiru, and Zhao Zuo were the dominant figures of the Songjiang school. Although Li Rihua, Xiang Shengmo, Lu Dezhi, and Li Zhaoheng all were from Jiaxing, their personal relationships with members of the Songjiang school were very close and also artistically were mutually influential. Li Rihua's son, Li Zhaoheng, who lived for a long time in Songjiang—and who, becoming a Buddhist monk entered the Chaogousi temple to the west of the city of Huating, taking the monk-name Kexue—was a successful and favored disciple of the celebrated Songjiang painter Zhao Zuo. The painting *Venerable Friends* (no. 1) offers strong evidence of the friendship through painting and calligraphy shared by Li Rihua, Xiang Shengmo, and Lu Dezhi with Dong Qichang, Chen Jiru, and their associates. Furthermore, Li Liu-

fang and Cheng Jiasui, who sojourned in Jiading (now under the jurisdiction of Shanghai), could in no way escape the permeating influence of the Songjiang painting style. Therefore, if we proceed to investigate the formation and major distinguishing characteristics of the Songjiang school through the painters we encounter in the present exhibition, this will not only aid in understanding the exhibition, but also not be without advantage in understanding the period style of Chinese painting during the late Ming.

The establishment of Songjiang prefecture dates from the Yuan dynasty. During the Five Dynasties the area had been under the jurisdiction of Xiu Zhou prefecture. During the Song, Xiu Zhou became Jiaxing prefecture, with Huating as its subordinate city. Therefore, Songjiang and Jiaxing, in terms of geography, also share a kinship relationship. During the Wanli reign of the Ming, the jurisdiction of Songjiang prefecture included the three counties of Huating, Shanghai, and Qingpu—an area under the jurisdiction of modern Shanghai. In art history, there are minute and disunified designations such as the Songjiang school, Huating school, Yunjian school, and Su Song school. In terms of the unity of their geographical location and period style, however, all of these can be considered as belonging to the same single category: an artistic school composed of a group of painters who lived in the Songjiang area and who developed similar characteristics in their work.

The florescence of arts and letters in Songjiang has deep historical origins. Cao Zhibo (1271–1355), the celebrated Yuan painter, was a native of Songjiang whose home and garden was a gathering place for the scholars and painters of his day. Well-known personalities, such as Yang Weizhen (1296–1370), Huang Gongwang, and Ni Zan, often arranged with one another to meet there to chant poetry, paint, drink, and divert themselves. The great early Yuan master Zhao Mengfu also was a frequent visitor to Songjiang. Because his relative Mengjian had become a monk at the Benyi Buddhist monastery at Huating and also because the parental home of his wife, Guan Daosheng (1262–1319), was at

Zhenxi in Songjiang, Zhao Mengfu often lingered there. Subsequently, some of the most renowned Yuan masters—such as Gao Kegong (1248–ca. 1310), Huang Gongwang, Ke Jiusi (1290–1343), Ni Zan, and Wang Meng—resided in Songjiang at one time or another. These painters gave great impetus to the rise of a flourishing Songjiang painting atmosphere, the formation of a regional painting tradition, and hence the so-called Songjiang school that emerged during the late Ming. The important point is that the artists associated with this school continued the essential spirit and period style of Yuan painting, and building on this foundation, they formed their own strong and unique artistic style and left to us a splendid chapter in Ming painting history.

The formation of an artistic school has many causes. In addition to the influence of the natural scenery of the artist's environment and of the master-disciple relationship, the interactions between painters is an extremely important condition. Thus, as was the case among the Yuan masters, the social intercourse among members of the late Ming Songjiang school were incessant. For instance, Mo Shilong, a first-generation painter of the Songjiang school who made a great contribution to painting theory, frequently invited his friends to gather together to write poetry and drink in a totally relaxed atmosphere, and to engage in discussions of artistic matters. Not only were Mo's fellow-countrymen Gu Zhengyi (active ca. 1570–1596) and He Liangjun (1506–1573) invited, but the celebrated Suzhou scholars Wang Zhideng, Zhou Tianqiu (1514–1595), and Wang Shizhen also were his honored guests on frequent occasions. They seriously studied together and mutually influenced one another. Many of Mo Shilong's theoretical ideas were engendered in this way; moreover, the painting thought of Dong Qichang and Chen Jiru, who are considered the commanding figures of the Songjiang school, to a great extent actually originated in this way. Such elegant gatherings and literary parties among painters exerted a strong attraction, frequently breaking through regional boundaries and serving as a medium for interregional exchange. For instance, literati from elite Jiaxing families, such as Li Rihua and Xiang Shengmo, shared long and close friendships with Songjiang painters involving quite substantial social intercourse. They inscribed poetry and presented paintings to one another; they researched and investigated painting theory; they promoted one another's interests; and they appreciated one another's art. The paintings exhibited here are the best material evidence we have of this phenomenon. Records of the friendships between these artists include such works as the handscroll of poems in running script that Dong Qichang did for Chen Jiru (no. 11), the collaborative painting and calligraphy handscroll that Li Liufang and Lou Jian presented to Li Rihua (no. 21), and Xiang Shengmo's two paintings *Five Pines* (no. 17) and *Noble Hermit Amongst Forests and Streams* (no. 19). Xiang Shengmo's *Five Pines* is particularly in-

teresting. The painter had a dream in which he saw himself in the garden of Li Rihua, with whom he was admiring ancient pines and rare flowers. Amusing themselves and resting, they lingered. In the dream, Li Rihua's son, Zhaoheng, joined them. Hearing the pure tones of a far-away flute, the artist was greatly moved. Upon awaking, he painted the scene of his dream and presented it to Li Rihua. Xiang Shengmo painted the *Noble Hermit* handscroll for his friend Lu Dezhi. In his inscription on this painting, the artist employed moving language to describe his real affection for and friendship with Lu Dezhi. These painters all were able to treat people with sincerity, always responding with heartfelt admiration towards the success achieved by their painting friends and, moreover, offering unbiased, critical assessments. For example, Dong Qichang and Chen Jiru both were extremely respectful towards the Songjiang painter Zhao Zuo, who came from a commoner's background. Dong Qichang said, "Wendu [Zhao Zuo] is my esteemed friend." Dong made available artworks from his family's rich collection to provide Zhao Zuo with models for copying and practice. Dong Qichang's critical assessment of Xiang Shengmo also was very high. He recognized Xiang as a versatile painter of great technical skill who, at the same time, had not lost the uninhibited, elegantly untrammelled attitude of the literatus. He observed of Xiang, "The so-called scholar's spirit and professional's skill are all here." This kind of mutual promotion and praise not only created a good, artistically creative atmosphere in the painting world, but also generated a formative and permeating influence and had the effect of greatly stimulating the entire environment of contemporary painting and painting theory.

During the sixteenth century (in the Longqing and Wanli reigns) from after the founding of the Songjiang school by Mo Shilong, Gu Zhengyi, Sun Kehong and others to Dong Qichang and Zhao Zuo's time can be said to be a period that achieved vigorous development. Dong Qichang is the most outstanding representative. He not only brought about the opening of a new aesthetic realm in Chinese ink landscape painting, but he also contributed his general theory to traditional Chinese literati painting, leaving a rich legacy to later generations. During the seventeenth century, the Songjiang painting world achieved overwhelming supremacy in its competition with Suzhou, rapidly becoming the center of the late Ming painting world. Its style not only influenced the entire Jiangnan region of its day—when painters energetically pursued this current and competed in practicing the Songjiang style and imitating its art—but also caused the early Qing painting world to become its continuation. Cao Rong, a Jiaxing native of the early Qing said, "The painting and calligraphy of the entire Ming dynasty culminates in Dong Huating [Dong Qichang]; although Wen [Zhengming] and Shen [Zhou] were much celebrated in their time, compared with Dong they could but admire and weep." Although these words seem somewhat exag-

gerated, we can see from them the status of Dong Qichang and the Songjiang school in the late Ming painting world.

Owing to the historical causes discussed above, the Songjiang school in the main continued the traditions of Yuan painting. The painters all earnestly copied the works of the great Yuan masters, and they frequently took Yuan style to serve as their own criterion for judging artistic merit. Even painters outside the Songjiang school were no exception to this. For instance, Zhao Zuo, in the inscription to his landscape handscroll *Autumn Mountains Without End* (no. 14), tells us that in this work he is painting in the style of the great Yuan master Huang Gongwang. Similarly, Li Rihua inscribed his *Rivers and Mountains in My Dream* (no. 3) with the words "playfully imitating the spirit of Dachi's [Huang Gongwang's] brush."

The works of Xiang Shengmo, Li Zhaoheng, and others frequently invoke the names of the great Yuan masters, such as Huang Gongwang and Ni Zan. Compared with the realistic and detailed painting of the Song dynasty, Yuan painting clearly is relatively abbreviated; it attaches great importance to brush and ink, and to the expression of the artist's subjective taste and feelings. The Yuan artists extensively employed *Xuanzhi* (a kind of unsized, absorbent paper) for their painting, paying great attention to the use of moisture. Owing to the effects created by ink spread on the paper, the results were ones that could not have been achieved on silk. Song painters frequently depicted the steep and lofty mountain peaks of the North, while Yuan landscape painters almost always depicted the hills and level plains of Southern scenery. These special characteristics all were inherited by the works of the Songjiang school. From another point of view, they were also connected with the developmental history of the Wu school, which flourished during the middle Ming period. Traces of the style of Wen Zhengming and Shen Zhou can be sought also in the works of the Songjiang painters. However, the Songjiang painters abandoned the late-period Wu school habit of dry brushwork and its predilection for densely layered compositions. In terms of the abstraction and simplification of formal representation and the moist richness of ink rhythms, they went on to found a new artistic style. Dong Qichang once remarked: "If one were to compare my work with that of Wen Taishi [Wen Zhengming], each would have its strengths and weaknesses. Wen's refined detail is what I can't compare with; but, as for antique elegance and richness of ink, I go a little further." These words point out the difference between the styles of the two schools, Wu and Songjiang.

If we look at Chinese painting in terms of artistic style and aesthetic thought, we may divide it into two categories: academic painting and literati painting. The first refers to the style promoted by the imperial painting academy. Most of these artists were professional painters. They attached great importance to training in realistic painting skills; their technique was disciplined and fine, their colors gorgeous. Literati painting, on the other hand, was an artistic activity advanced by scholar-officials for the purpose of lodging their feelings in and diverting themselves through art. In contrast to academic painting, the scholars placed more emphasis on *li* (rule of nature) and made light of *fa* (painting technique). Their style was casual and elegant, free and easy, simplified and mild, tasteful and refined. Thus they created a unique kind of artistic style and aesthetic standard. Such formal distinctions begin from the Five Dynasties and Northern Song periods with the establishment of imperial painting academies. In fact, the origins of literati painting go back to much earlier times. Gu Kaizhi (346–407) of the Eastern Jin was an eminent literatus painter. In terms of theory and practice, however, it was Su Shi and Mi Fu tradition. By the Yuan period it had fully matured.

The style of the Songjiang school represents the continuation and further development of the Yuan literati painting tradition. In terms of painting thought, it advanced systematic exposition and general theory. Consequently, the painting theory of that day also developed to a considerable degree and lent impetus to creative practice among painters. Their painting was not like that of the academic school, which concerned itself with questions of the accurate description of the objective, natural world. Rather, the Songjiang painters emphasized projecting their own subjective feelings and taste into landscape, bringing into full play their brush-and-ink technique and particularly paying attention to using the brush techniques of calligraphy in painting. Dong Qichang remarked: "When the scholar paints, he ought to use the methods of the remarkable brushwork of the cursive and clerical scripts." Chen Jiru observed, "The painting of the literati is not a matter of pathways through ravines, but rather of brush and ink, [it] is not a matter of formal resemblance, but of using brush and ink to pursue expression." These artistic conceptions were consistently advocated in literati painting. They guided the artistic practice of the Songjiang painters and, moreover, exerted a decisive effect upon the formation of the period style of the late Ming painting world.

If we compare the late Ming scholar-painters with the painters of the Song academy, we find that few of these later men underwent a comparable kind of strict professional training. This, in fact, is precisely the inadequacy of these painters. It is for this reason that Dong Qichang always had sincere respect for really able painters. For instance, he characterized Xiang Shengmo as "a scholar and a professional"—a very high critical estimation. Dong Qichang also endlessly praised even those "painting artisans" who had no scholarly talents whatever but whose painting technique was brilliant, such as Qiu Shifu (Qiu Ying), one of the four Wu masters. However, the scholars proceeded to develop their own artistic style in another direction, emphasizing self-cultivation of the artist and visual expression of his personality and emotions

through painting. They stressed copying, and they emphasized the continuation of the painting styles and techniques of their illustrious predecessors, particularly the great Yuan masters. Compared with the painters of the Song period, when "taking nature as one's master" was the highest principle, the late Ming painters were more partial to the subjective side. Brush and ink and spirit-resonance became the most important criteria for evaluation, while the accurate description of nature was relegated to a subordinate position. These all came to constitute some of the common definitive characteristics of the late Ming style.

First was the intensification of painting stylization. Whether painting mountains or trees, the basic elements of formal representation were in most cases the same; they were merely recombined under the brush of various painters. These artists usually took their models from the works of the celebrated painters of earlier times, and frequently not directly from life. Thus, in terms of composition and formal representation, there was relatively less variety. For instance, there are differences between trees such as cypress and locust; their structures are entirely different from one another. However, under the late Ming scholar's brush, both were represented by nearly one kind of attenuated, upward-sprouting shoot, and their branch-work configurations were generally the same (as, for instance, in the foreground of Li Zhaoheng's landscape hanging scroll *Exquisite Scene of Lakes and Mountains*, no. 8). They never again made use of intricate artistry to express a sense of three-dimensionality and texture in their subjects. Rather, they caused the images in their painting to become flatter and flatter. Ink lines and ink dots became the primary means of formal representation. Frequently, they simply outlined the most important contours, leaving the fine details and subtle layers of the interior greatly diminished. Their use of texture strokes and dry washes was far less complex than that in Song painting; clearly their works were extremely abbreviated. Works such as Chen Jiru's *Dewdrops in Early Autumn* (no. 13) and Li Rihua's *Rivers and Mountains in My Dream* (no. 3) are highly typical examples. Dong Qichang had a very distinctive technique for painting trees: the trunks and branches were completely exposed, and the branches and leaves were not layered over one another, just as if they were seen in cross-section. This kind of flattening of the pictorial surface produced a very strong decorative and formal aesthetic effect. It gave people a feeling quite unlike that of real mountains and real water; instead, it was one of experiencing the artist's thought process and creating a new kind of form. These kinds of customary methods were employed over and over again by the late Ming painters in various kinds of painting, and they gradually came to form a kind of fixed system of symbolic representation. On the one hand, they opened up a new aesthetic realm in traditional Chinese painting, establishing critical painting standards that were different from those of the past. On the other hand, they

caused painters to become creatures of habit; and, at length, brought disastrous consequences to later painters who became accustomed to imitation and who lacked creativity.

Since most of these painters were scholars, they were capable of using the brush to write a fine hand, and they all were particularly concerned with using the brushwork of calligraphy to paint pictures. Because of the distinctive nature of the art of Chinese calligraphy, each line and each dot painted with the brush not only served as the basic means for delineating form, but also had independent aesthetic value in itself. This is fundamentally different from the contour line of Western painting. From the speed of his brush, the richness or dryness of his ink, his skillfulness or awkwardness, the squareness or roundness of his brushstrokes, and his dark and pale ink tonal modulations, one can readily comprehend the painter's technical ability, self-cultivation, and personality—even his very individuality. Therefore, these painters might paint in a very sketchy way, sometimes to the point of carelessly dashing off a few strokes, and the images that they depicted might not stick to the objective natural world. There still remained critical standards that clearly distinguished levels of quality among these works of art. In his *Huishi weiyan* (*Discourse on Matters of Painting*), Tang Zhiqi (1579–1651) discussed the characteristic difference between the Wu and Songjiang schools, noting, "The paintings of Suzhou show *li* [reason, order]. The paintings of Songjiang show *bi* [brushwork]." From this we can see that as Ming painting reached its late period of development, the use of the brush and the use of ink had become emphasized to the point of assuming a particularly important status. Excellent brushwork and the pure and understated use of ink were not merely distinguishing characteristics of the Songjiang school; they also became one of the characteristics of the late Ming painter's entire artistic environment.

Summing up our discussion, we can see that the Songjiang school was an important artistic current that greatly influenced the late Ming painting world. However, at that time people still had no way of assessing its full value. It was not until the Qing period that its profound and far-reaching influence finally became completely manifest. The style of the Four Wangs—Wang Shimin (1592–1680), Wang Qian (1598–1677), Wang Hui (1632–1717), and Wang Yuanqi (1642–1715)—who were considered the Orthodox school of Qing painting, in fact is the logical development of the late Ming Songjiang tradition. Even great masters of outstanding individuality and brilliance such as Zhu Da (1626–after 1705) had no way of avoiding the lingering shadow of Dong Qichang. The Songjiang school took up the Chinese scholars' ideas about painting and proceeded to advance aesthetic theory and practice to a new level of excellence, thereby confirming their unique position in Chinese painting history.

The Arts of Ming Woodblock-printed Images and Decorated Paper Albums

WANG QINGZHENG

CHINESE woodblock-printed images begin to appear during the Tang dynasty. The frontispiece of the Tang *Diamond* Sutra discovered at the Mogao Caves of Dunhuang is the earliest Buddhist printed image found to date. During the Tang and Five Dynasties periods, printed images—in addition to their function in propagating Buddhist doctrine—were used in other books, such as almanacs. Their function here was to serve as explanations of textual content to make it easier for the reader to understand the meaning of the book's written text.

During the Song dynasty woodblock-printed books flourished. In addition to their use in classical texts and historical writings, woodblock-printed images were also frequently appended as illustrations to practical treatises in widespread use among the people—such as the *Nongjing* (*Classic of Agriculture*), *Nongshu* (*Handbook of Agriculture*), *Canshu* (*Book of Sericulture*), *Jiupu* (*Wine Manual*), *Chalu* (*Monograph on Tea*), *Niujing* (*Book of Oxen*), *Hepu* (*Manual of Rice Cultivation*), *Yaoshu* (*Book of Medicine*), *Zhenjiujing* (*Book of Acupuncture and Moxibustion*)—where they served as supplementary explanations of the content of the book. The pictorial area of this sort of printed image often was placed at the upper portion of the page, occupying about one-quarter of the entire page, while the remaining three-quarters of the page below the picture was carved with written text. (In some cases, one-third was occupied by the image, two-thirds by text.) This produced the "picture above, text below" (*shang tu xia wen*) format. However, during the Song dynasty there already had emerged the phenomenon of using woodblock-printed images as the main part of some books. For instance, in the *Yingzao fashi* (*Manual on Architecture*), the sections on wood-structure types, wood carving, and colored ornaments depend to a great extent upon pictorial content to help the reader understand the meticulous and extremely elaborate open-work designs and the delicate carvings. During the Song dynasty there also appeared pictorial publications that entirely considered the woodblock-printed image as central. The *Meihua xishenpu* (*Manual of Flowering-plum Likenesses*) by Song Boren (active 13th cen-

tury), reprinted in 1261 and now in the Shanghai Museum collections, is epoch-making in this regard. This book is not a case of merely looking at pictures to understand text, or using pictures as a means of explicating written words, but rather employs one hundred printed images to manifest the myriad aspects of the flowering plum. Thus the woodblock-printed image already had started to become a kind of independent object for artistic appreciation. However, during this period this was an unusual phenomenon.

During the Yuan dynasty, with the flourishing of drama and fiction, woodblock-printed images were used to represent the content of the episodes that were the highlights of the plot, in order to enhance the reader's interest in the drama. The *Quan xiang pinghua wuzhong* (*Five Pinghua Texts with Full Illustrations*) of the Yus of Jian'an (modern Fujian province) that has come down to us today is typical of extant Yuan woodblock-printed illustrations of drama and fiction. Its carving is rough and bold, and its format is of the "picture above, text below" type.

WOODBLOCK-PRINTED IMAGES OF THE MING DYNASTY

The woodblock-printed images of the early Ming period still preserved the features of the late Yuan. In the past, specialists in the research of the history of woodblock-printed images unanimously considered that the Yuan type of "picture above, text below" format continuously lingered until the period between the Jiajing and Wanli reigns when it changed to "full-page illustration." This kind of change in format frequently was attributed as the contribution of the Jian'an booksellers of the Jiajing-Wanli period.

It was only in the 1970s that the excavation of a group of *shuochang ben* (texts of stories told in song and speech) from Ming tombs in the suburbs of Shanghai made people recognize that the change in format of Ming woodblock-printed illustrations ought to be placed earlier, in the period between the Chenghua and

Hongzhi reigns. These *shuochang ben* were printed by the Chenghua-period Yongshun bookstore of Beijing. There were twelve fascicles. Aside from the *Hua Guan Suo chushen zhuan* (*Illustrated Biography of Guan Suo*) that is displayed in this exhibition (no. 25), which preserves the Yuan format of "picture above, text below," the other eleven fascicles all have already changed to the "one page, two pictures" or the "full-page illustration" format.

Owing to the constraints of the "picture above, text below" format, the pictorial area of these woodblock-printed images was excessively narrow and small. One was unable to delineate full scenery, and often there was no way to depict fine details. In the illustrations of the *Bao daizhi chushen zhuan* (*Biography of the Early Years of Bao Zheng*) of the Chenghua-period *shuochang ben* there are two pictorial sections on one page. The carvers here have skillfully taken advantage of motifs such as billowing clouds, low railings, and roof ridges as a means of partitioning the page to show two scenes (fig. 1). Thus the plot of the story could be illustrated in greater detail. Other books went further, using "full-page illustration" as their dominant format (fig. 2). However, the Hongzhi-period printed edition of *Xixiang ji* (*Romance of the Western Chamber*) that comes down to us today still is of the "picture above, text below" type. From this we may infer that although woodblock-printed illustrations of the "one page, two pictures" or the "full-page illustration" type already had begun to come into currency during the Chenghua reign, it was only after the Jiajing reign that they finally became a set format.

From another point of view, we can see from the objects in this exhibition that the "one page, two pictures" or "full-page illustration" of the Chenghua period still were merely supplementary descriptions of a book's story plot. In the woodblock-printed images of this period, generally speaking, the carver was also the pictorial designer. The composition of the pictorial area is obviously crude, and although these images have a broadly-drawn, bold feeling, they frequently lack spiritual overtones and a comparatively deep artistic effect.

The period from the Jiajing and Wanli reigns to the Chongzhen reign at the end of the Ming was the period of rapid development of the art of the Chinese woodblock-printed images. The printing industries of Jinling (modern Nanjing), Hangzhou (in modern Zhejiang province), Huizhou (in modern Anhui province), and Jian'an were especially flourishing. During this time, owing to the widespread transmission of printed editions of plays and fiction, woodblock-printed illustrations also very naturally became even more developed. During this period, artists—as opposed to carvers—already had gradually come to design the compositions and personally paint the pictures for woodblock-printed images. Most of them could fully express the dramatic plot and, using very delicately carved lines,

could depict the inner feelings of the figures, accompanied by a suitable background to highlight the dramatic plot. The Wanli printed edition of *Pipa ji* (*Illustrated Story of the Lute*, no. 26), was produced by several members of the Huang family of Xin'an, Anhui province. The names of carvers recorded on these pictures include Huang Yibin, Huang Yikai (active 1573–1620), Huang Duanfu, and Huang Yifeng (*zi* Mingqi, b.1583). The copy of *Yanzi jian chuanqi* (*Illustrated Swallow Messenger of Love*, no. 28) was printed in 1643 at Wanling (modern Xuancheng, Anhui province) by Liu Guobao. Its principal carver was Xiang Nanzhou of Hangzhou. Compared with the work of the Wanli period, the woodblock-printed images of the Chongzhen period tended even more toward delicacy. The arrangement of architecture, trees and groves, mountains and rocks were even more precise and refined. The faces of the figures also were richer in emotional expression. From the woodblock-printed pictures exhibited here, one can see that the delineation of figures during this period already had changed from the earlier large-headed, short-bodied figures of dwarf-like appearance to better proportioned figures; the figures of the ladies are especially slender.

During this period, woodblock prints were mostly illustrations in ordinary books and plays or fiction, but they were also used in various kinds of specialized painting manuals. The most famous of these was the mid-Jiajing period *Gao Song huapu* (*Gao Song's Painting Manual*) by Gao Song (active 16th century) of Hebei province. It was divided into separate manuals on plum, orchid, bamboo, chrysanthemum, and birds, to which was appended a section on painting secrets. It was a primer for the novice painter and also a specialized artwork of woodblock-printing. Illustrated painting manuals of the Wanli period include the *Gushi huapu* (*Gu's Painting Manual*), which is, in fact, the celebrated *Lidai ming gong huapu* (*Album of Painting of Eminent Masters throughout History*), by Gu Bing of Hangzhou; the *Ji ya zhai huapu* (*Gathering-elegance Studio Painting Manual*), compiled by Huang Fengchi of Xin'an; and the *Shi yu huapu* (*Poetry Painting Album*), or *Cao tang shi yu huapu* (*Thatched-cottage Poetry Painting Album*), by the Wangs of Wanling. In addition to these are others such as *Xue hu huapu* (*Xuehu Painting Manual*) by Wang Huiren of Huiji (modern Shaoxing, Zhejiang province) and Zhou Lijing's *Huasou* (*A Collection of Paintings*).

The painting manuals that emerged at this time share the following points in common:

The pictorial area of the woodblock-printed images no longer was designed by carvers or common painting artisans but was from paintings done by painters. For instance Gu Bing was a disciple of Zhou Zhimian (active ca. 1580–1610) and in 1599 was summoned to serve at the palace as a court painter.

The pictorial area was not merely a supplement or explication of the written text or a direct illustration of the plot-line

face, as in modern embossed printing. The results were similar to steel printing. Using the *gonghua* method to represent the decorated surfaces of archaic jades, one could better reveal the substance and feel of the stone. In the depiction of landscapes, printers combined *gonghua* embossing with other techniques to create the effects of "cloud shadows and the glint of waves," so as to better represent the subject matter of the picture.

THE *SHIZHUZHAI JIAN PU* AND THE *LUOXUAN BIANGU JIAN PU*

Before the 1960s the scholars who researched the history of Chinese woodblock-printed images all regarded the *Shizhuzhai jian pu*, or *Ten Bamboo Studio Decorated Paper Album*, as China's earliest decorated paper album. The *Shizhuzhai jian pu* was printed by Hu Zhengyan (*zi* Ricong, active 1582–1672) in 1644, the last year of the Ming dynasty. Hu Zhengyan is the most celebrated master woodblock printer of the late Ming. In 1627 he printed the *Shizhuzhai shuhua pu* (*Ten Bamboo Studio Manual of Painting and Calligraphy*), whose "Bamboo Manual," "Plum Manual," and so forth were printed entirely using the *douban* color technique. It was always regarded as an incomparably great work in the history of woodblock-printed images. After these painting and calligraphy manuals, Hu went on to print the decorated paper album. In this album not only did he extensively employ *douban* color printing, but the *gonghua* embossing technique also appears. The world of woodblock-printing history consistently regarded this kind of *gonghua* technique as the unprecedented innovation of the *Shizhuzhai jian pu*. This viewpoint persisted until the 1960s when, after the discovery of the *Luoxuan biangu jian pu*, it finally was corrected.

The treasured edition of the *Luoxuan biangu jian pu*, or *Wisteria Studio Album of Stationery Decorated with Ancient and Modern Designs*, in the present exhibition (no. 27) was printed in 1626 at Jinling (modern Nanjing, Jiangsu province) by Wu Faxiang (b. 1578). In addition to its *xiaoyin* (preface), the book consists of 16 thematic sections comprising a total of 178 images: *Huashi* (Poetic scenes), 20 images; *Yulan* (Bamboo baskets), 12 images; *Feibai* (Flying-white), 8 images; *Bowu* (Scholar's objects), 8 images; *Zhezeng* (Gifts of cut flowers), 12 images; *Diaoyu* (Carved jade), 12 images; *Doucao* (Flowers and plants), 16 images; *Zagao* (Miscellaneous designs), 2 images; *Xuanshi* (Selected rocks), 12 images; *Yizeng* (Remembrances), 8 images; *Xianling* (Auspicious creatures), 8 images; *Daibu* (Con-

veyances), 8 images; *Shouqi* (Gathered rarities), 24 images; *Longzhong* (Dragons), 9 images; *Zeqi* (Choosing a perch), 11 images; and another *Zagao* section of 8 images. Among these, the images of the "Flying-white" and "Carved jade" sections are printed entirely in *gonghua* embossing. A minority of the "Poetic scenes" landscapes are monochromes; the remainder are in woodblock color printing. Its selection of subject matter, proceeding from the consideration of elegance, pursues the transcendence of worldly dust and casting off of all vulgarity. For instance, in the "Poetic scenes" section, printed images inscribed with phrases such as "Shadowy pagoda hidden by gathering clouds" (see upper right, no. 27), "Pliant willow wands, overhanging green on the river," and "Set amid dense bamboo, the mountain studio is chill" all show that the artist is able to take up the poetic image of the writer and describe it with the tip of the brush. Flowers and fruits, bamboo and rocks, birds and small animals, and the Four Treasures of the scholar's studio (paper, brush, ink, and inkstone) all are delineated with great skill. The use of color is marvelous, and the carving of the entire book is precise and skillful.

The completion of the *Luoxuan biangu jian pu* predates the *Shizhuzhai shuhua pu* by one year and the *Shizhuzhai jian pu* by eighteen years. To date, it is the earliest known decorated paper album to widely employ *douban* color printing and to innovate the *gonghua* technique.

During the 1920s the Japanese scholar Omura Seigai acquired a damaged copy of the *Luoxuan biangu jian pu*. Because its preface already had been lost, he did not know the date of its publication. Omura erroneously determined that it was printed during the Kangxi reign of the Qing dynasty by Weng Songnian (*hao* Luoxuan, 1647–1728). During the early 1960s, the late Xu Senyu, then director of the Shanghai Museum, first discovered the present complete edition of the *Luoxuan biangu jian pu*. The publisher of this book, Wu Faxiang, was broadly learned and multitalented; he was devoted to study, and those in his circle of friends all were famous contemporary artists. For instance, the *Luoxuan biangu jian pu* has a page of plum blossoms painted by his friend Wu Xiangru (*hao* Shiguan, active late 16th–early 17th century), a celebrated painter who sojourned in Nanjing during the late Ming. In 1627 Wu Xiangru, along with Wei Zhihuang (b. 1568) and others, participated in the *Shizhuzhai shuhua pu*, edited by Hu Zhengyan. Thus we can see that at that time the *Luoxuan biangu jian pu* and *Shizhuzhai shuhua pu* and the slightly later *Shizhuzhai jian pu* all were designed by a number of celebrated painters of the Nanjing area.

Fig. 1

Fig. 2

Catalogue Illustrations

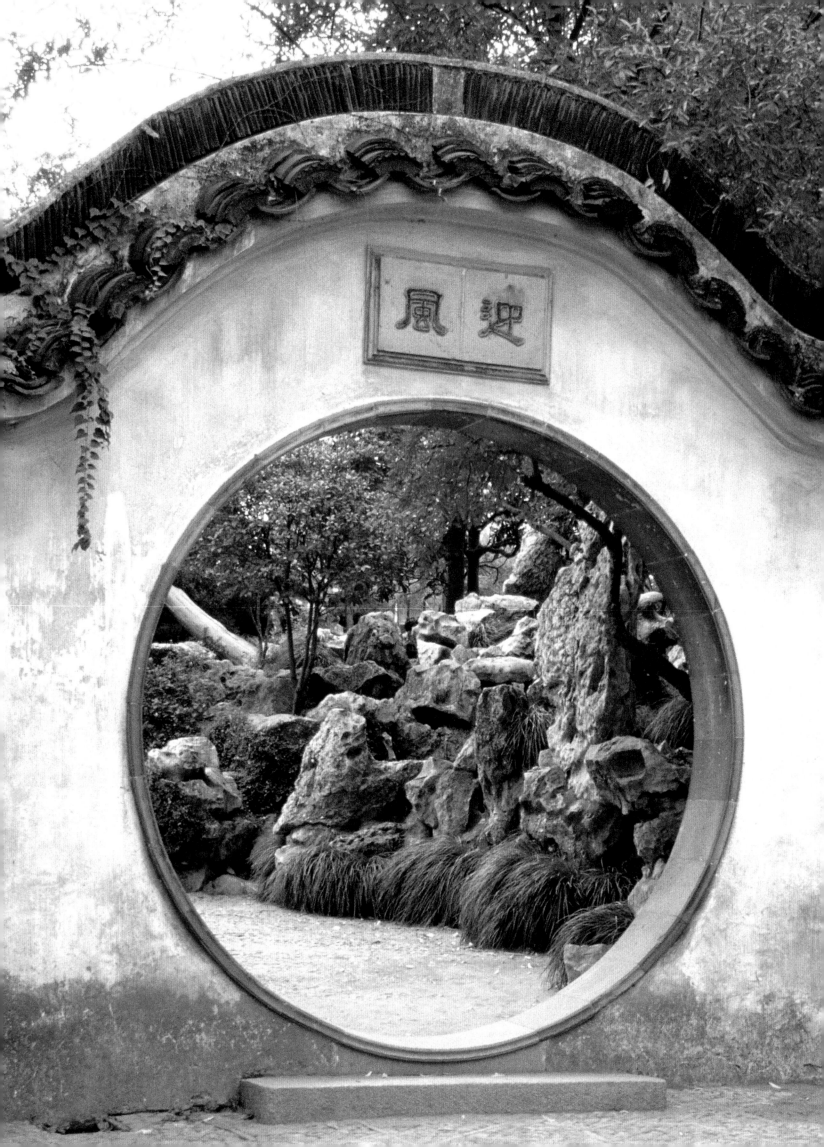

Painting and Calligraphy

Moon Gate, Suzhou

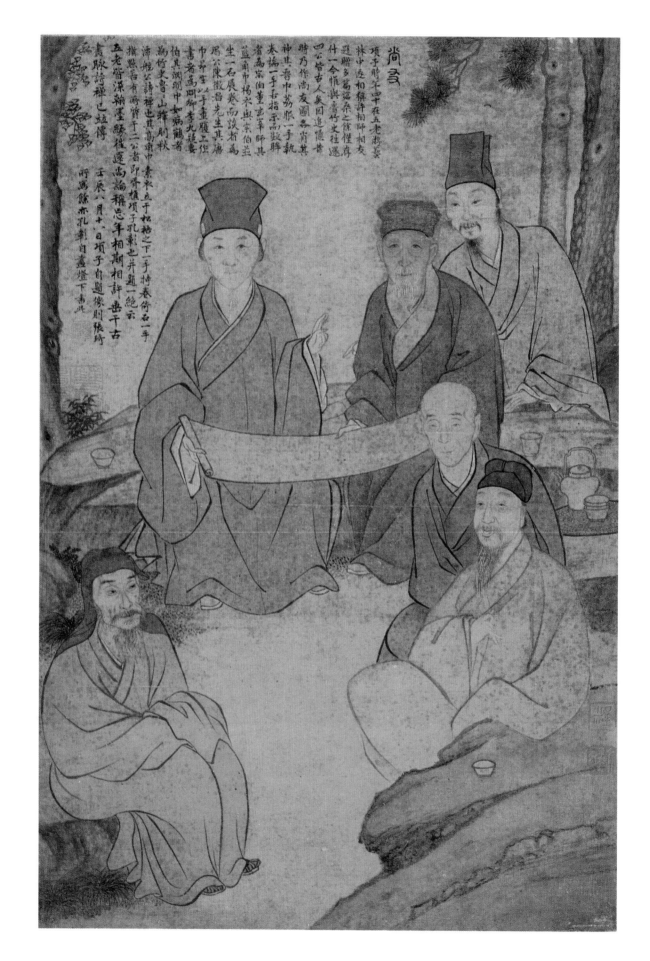

1. *Venerable Friends*, 1652

Xiang Shengmo, Zhang Qi
Hanging scroll, ink and colors on silk

2. *Portrait of Li Zhaoheng at Thirty-six sui*, 1627

Zeng Jing
Hanging scroll, ink and colors on silk
Li Zhaoheng inscription (detail)

2

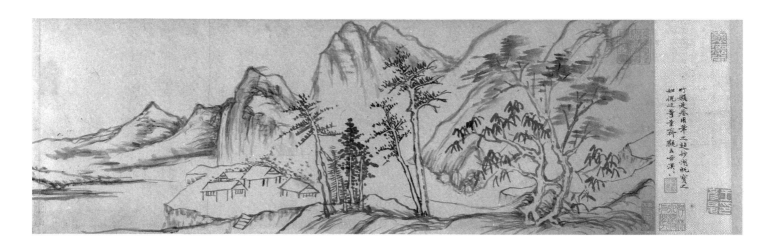

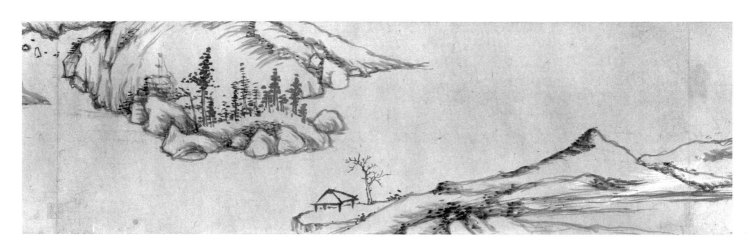

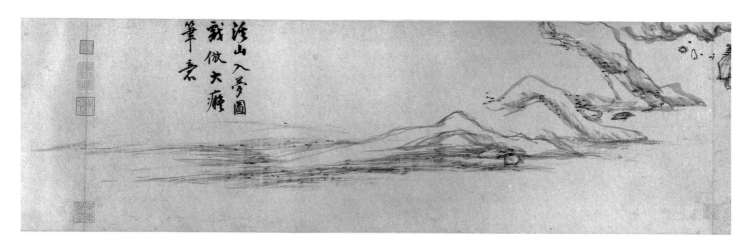

3. *Rivers and Mountains in My Dream*, 1625

Li Rihua
Handscroll, ink on paper

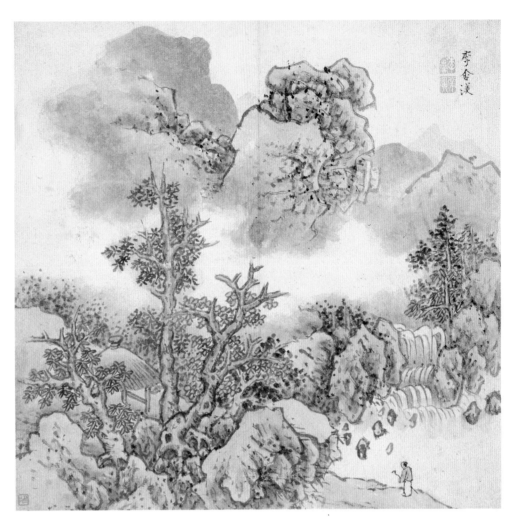

4 A

4. Three Leaves from *Painting and Calligraphy by Four Generations of the Li Family*, Ming-Qing

A. Li Hanmei
B., C. Li Rihua
Album, ink on paper and ink and light colors on paper

4 B

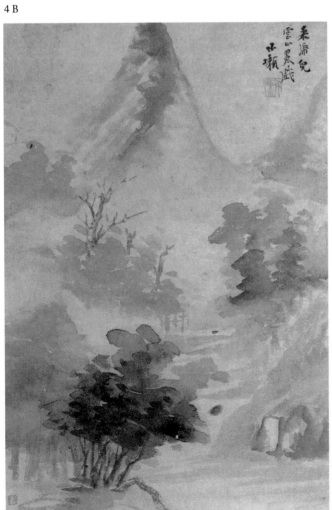

4 C

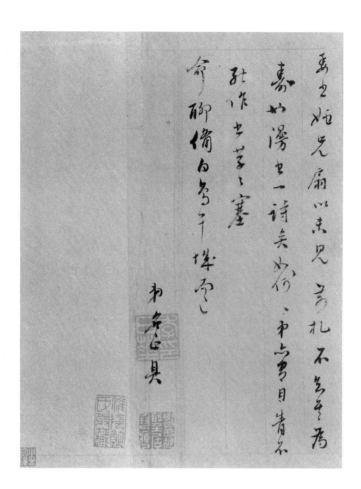

5. Two Letters from Album of Letters *Ming Xianshou ji ce*, ca. 1616–1620 (Leaves 17–19)

Li Rihua
Album, ink on paper

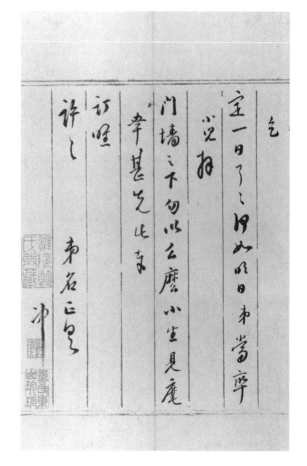

6. *Ten Views of Nancun Villa*, 1443

Du Qiong
Album, ink on paper and ink and light colors on paper

A. Bamboo Dwelling
B. Banana Garden
C. Studio of the Arriving Green
D. Peaceful Willow Hall
E. Mirror-dusting Pavilion
F. Luogu Cave
G. Luxuriant Flower Cottage
H. Crane Terrace
I. Fisherman's Retreat
J. Conch Room
K. Colophons by Zhu Taizheng, Li Rihua, Chen Jiru (reading right to left)

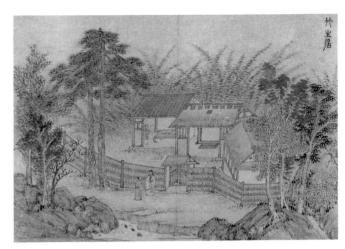

6 A

6 B

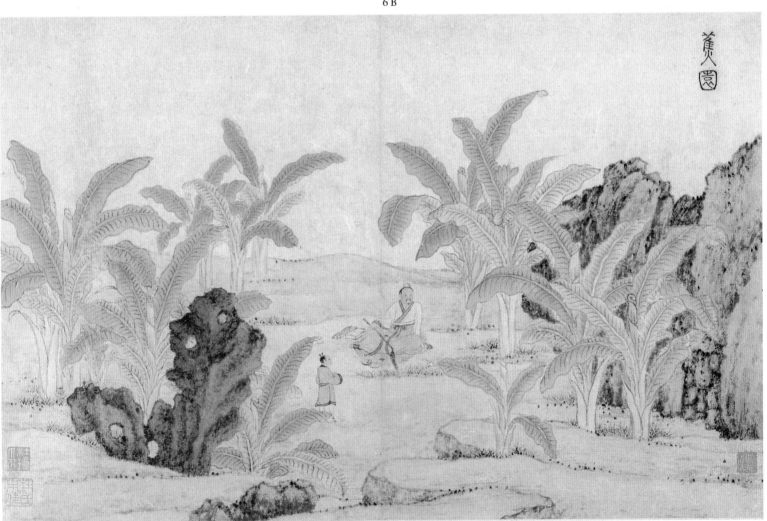

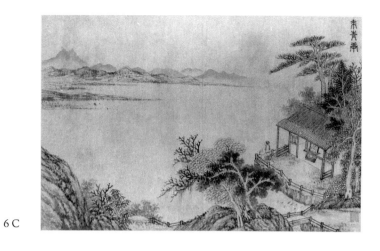

6 C

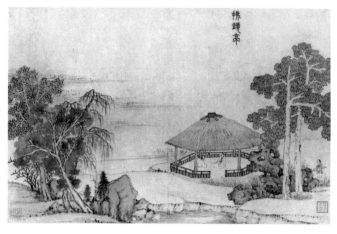

6 E

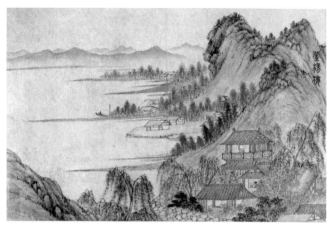

6 D

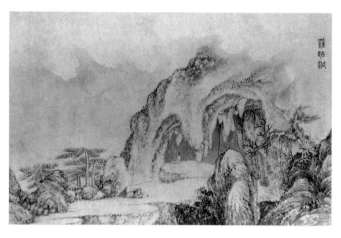

6 F

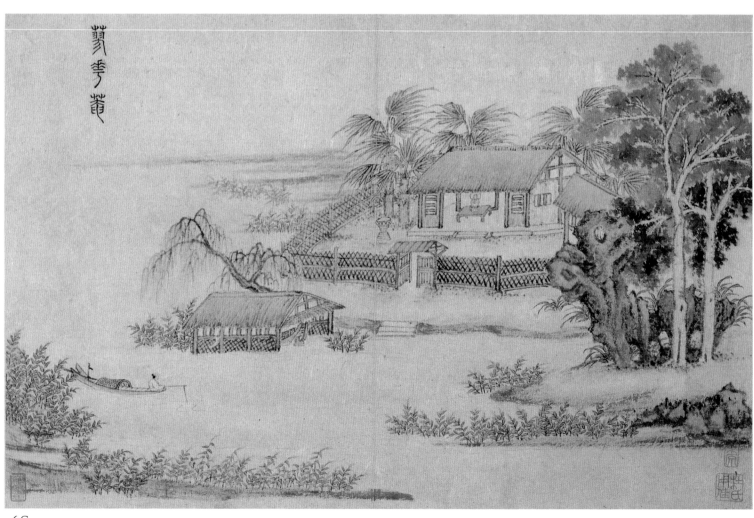

6 G

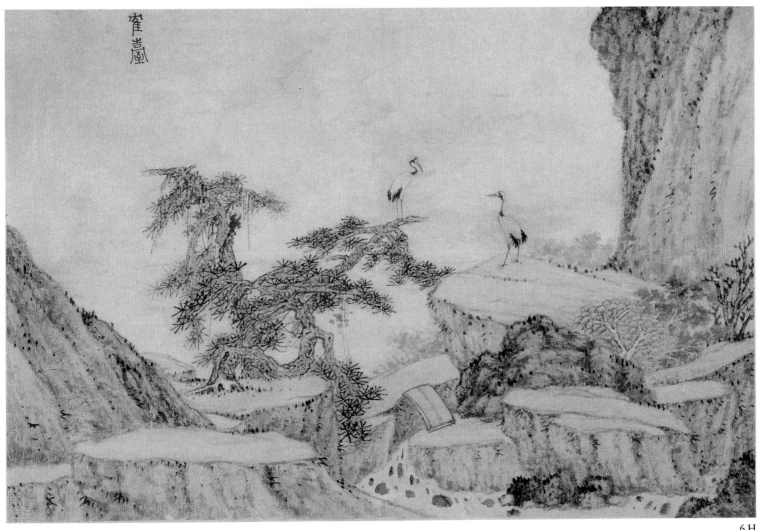

6 H

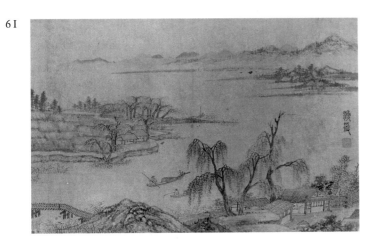

6 I

6 J

6 K

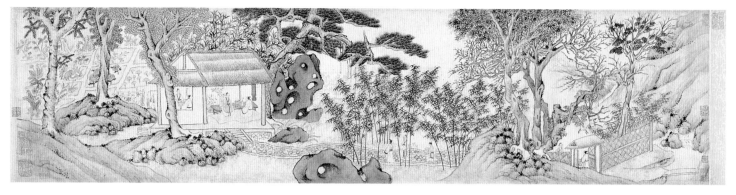

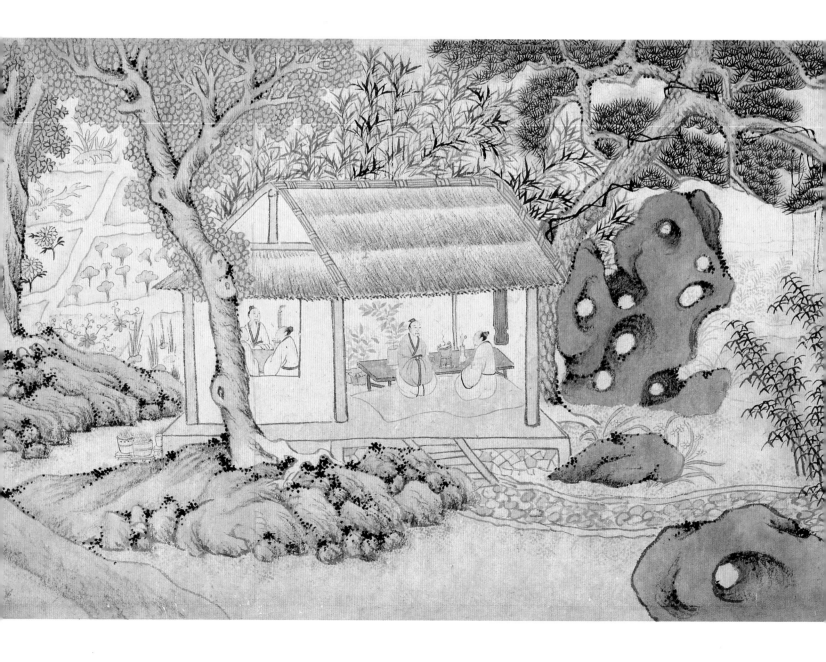

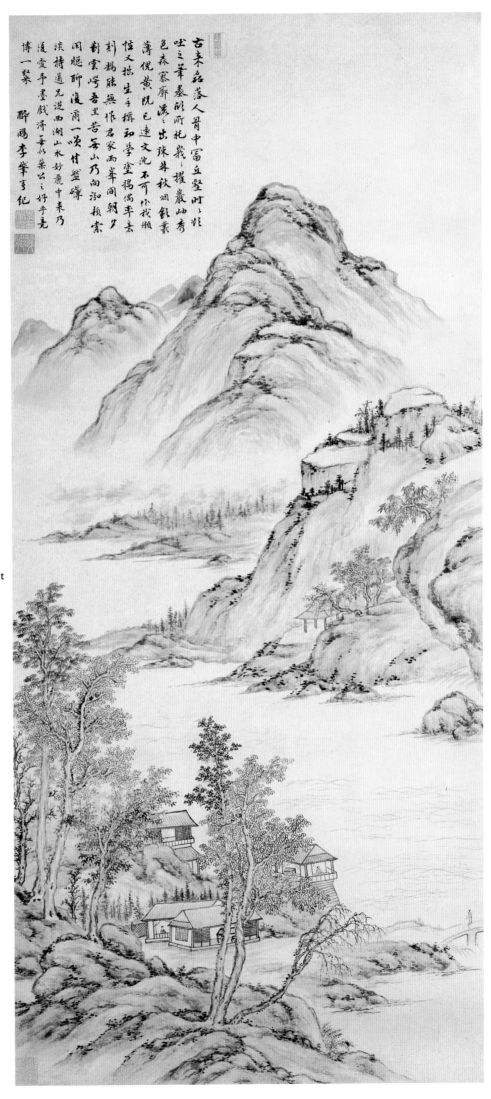

7. *Herb Mountain-Cottage,* **1540**

Wen Jia, Zhu Lang, Qian Gu

Handscroll, ink and light colors on paper
Chen Jiru and Li Rihua colophons (reading right
to left)

8. *Exquisite Scene of Lakes and Mountains,* **probably late 1640s or 1650s**

Li Zhaoheng

Hanging scroll, ink on paper

8

9. Two Leaves from *Album of Calligraphy and Landscape Paintings*, 1646

Li Zhaoheng
Album, ink on paper

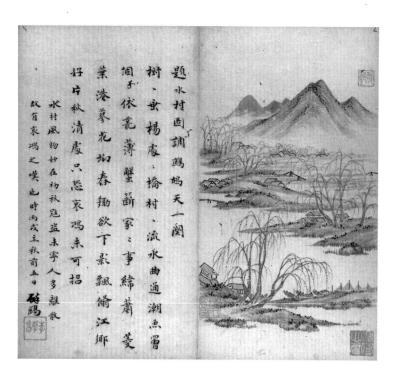

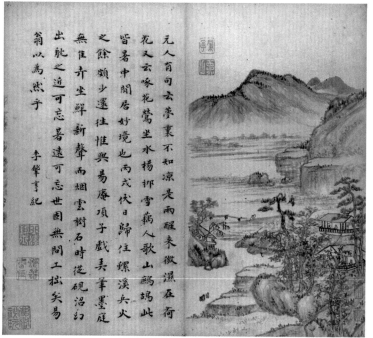

11

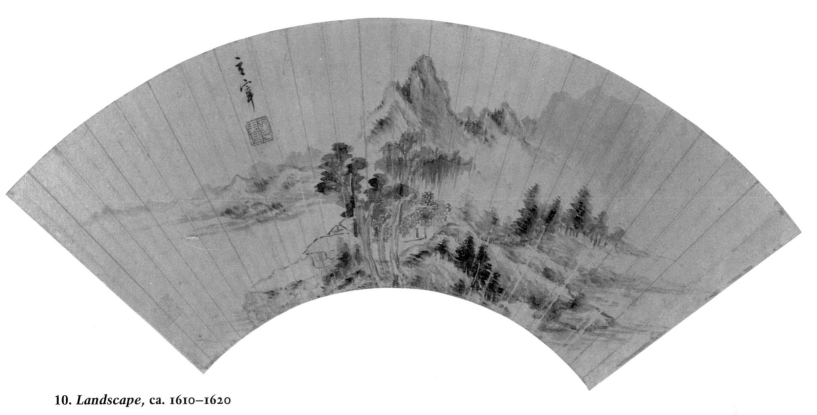

10. *Landscape,* ca. 1610–1620

Dong Qichang
Folding fan mounted as album leaf, ink and color on gold
paper

11. Two Poems from *Four Poems for Chen Jiru,* 1619

Dong Qichang
Handscroll, ink on "mirror-face" paper

12

12 E

12 D

12 C

12 A

12 G

12 F

12. Seven Leaves from *Record of the Old Huayan Monastery*, 1619

Chen Jiru

Album, ink on paper

A. Chen Jiru text (first page)
B., C. Dong Qichang title
D., E. Dong Qichang inscription and signature
F., G. Li Rihua colophon

12 B

13. *Dewdrops in Early Autumn*, probably 1620s or 1630s

Chen Jiru

Hanging scroll, ink and light colors on paper

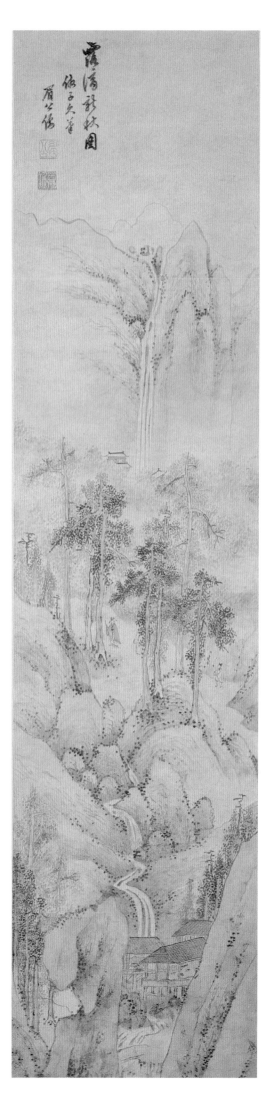

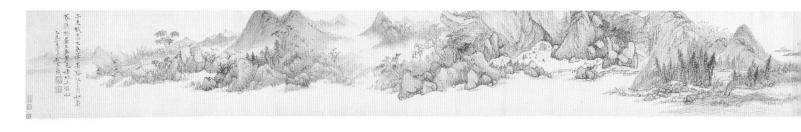

14

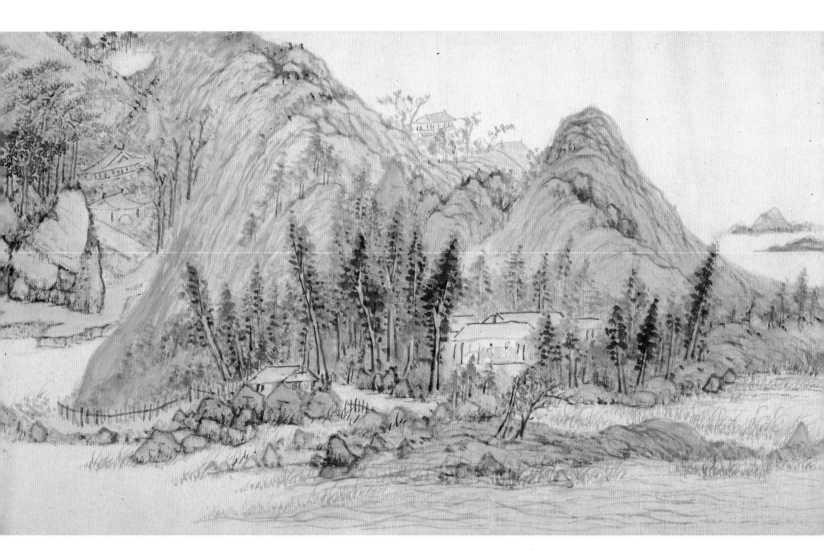

14. *Autumn Mountains Without End*, 1619

Zhao Zuo

Handscroll, ink and colors on "mirror-face" paper
Zhao Zuo inscription and Chen Jiru and Dong Qichang
colophons (reading right to left)

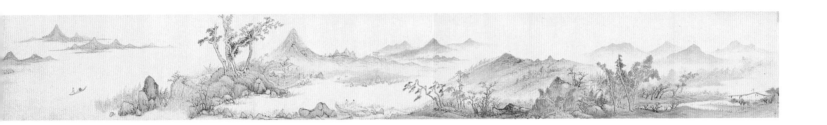

15. Four Leaves from *Illustrations to Poems by Wang Wei*, ca. late 1620s or early 1630s

Xiang Shengmo

Album, ink on paper
Li Rihua colophon (lower left)

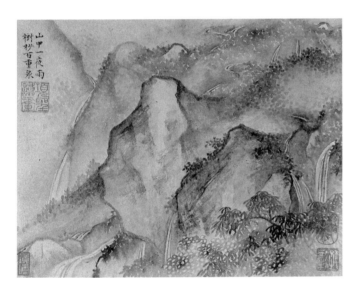

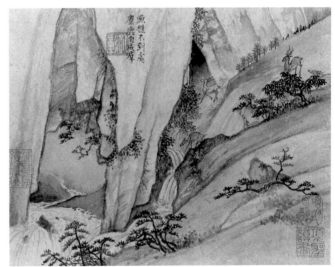

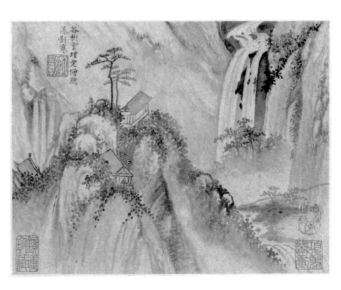

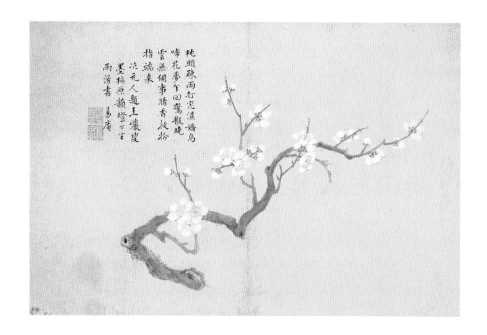

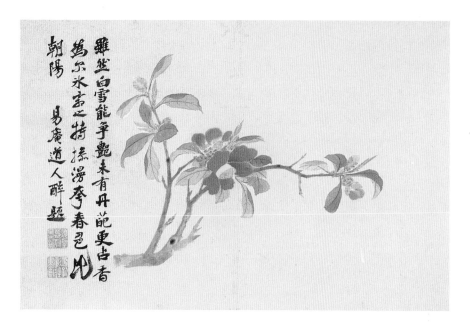

16. Three Leaves from _Album of Flowers_, 1643

Xiang Shengmo
Album, ink and colors on paper

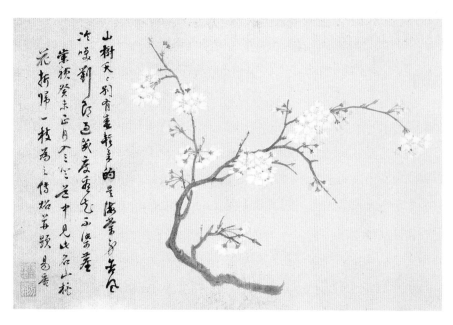

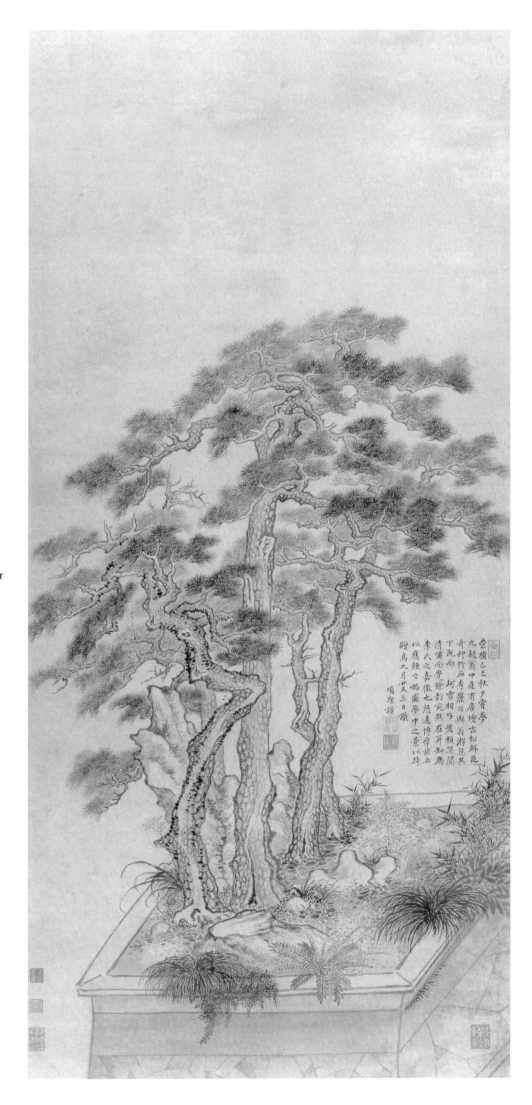

17. *Five Pines*, 1629

Xiang Shengmo
Hanging scroll, ink on paper

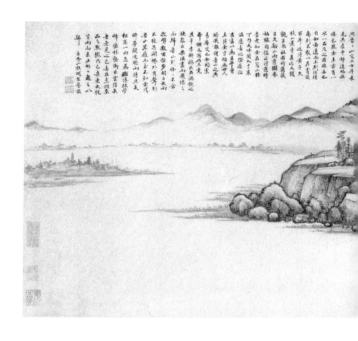

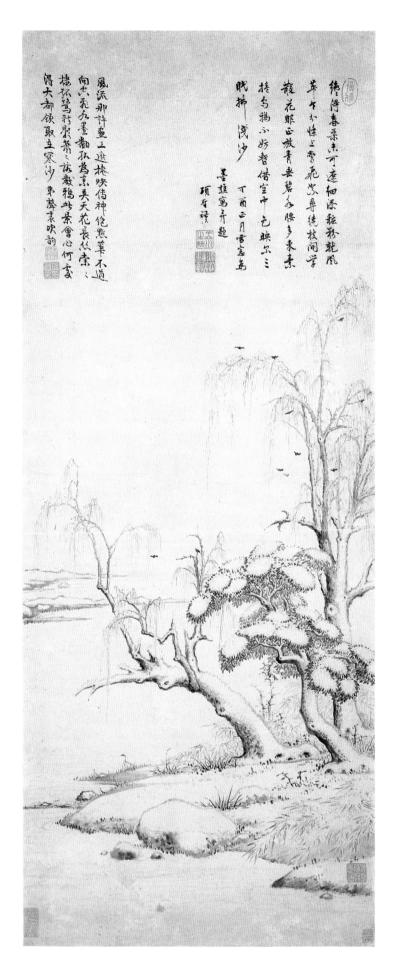

18. *A Scene of Cold Trees in Snow,* 1657

Xiang Shengmo
Hanging scroll, ink on paper

19. *Noble Hermit Amongst Forests and Streams,* ca. 1640

Xiang Shengmo
Handscroll, ink on paper

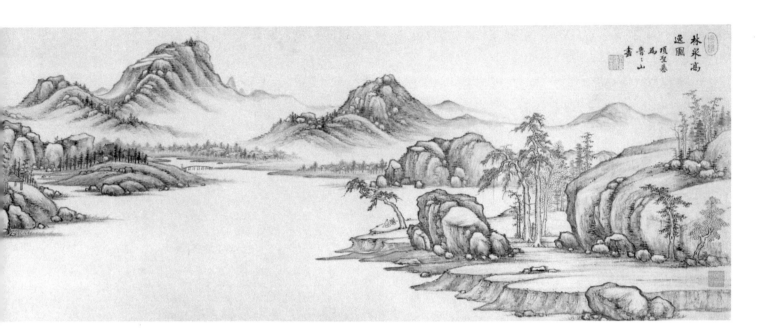

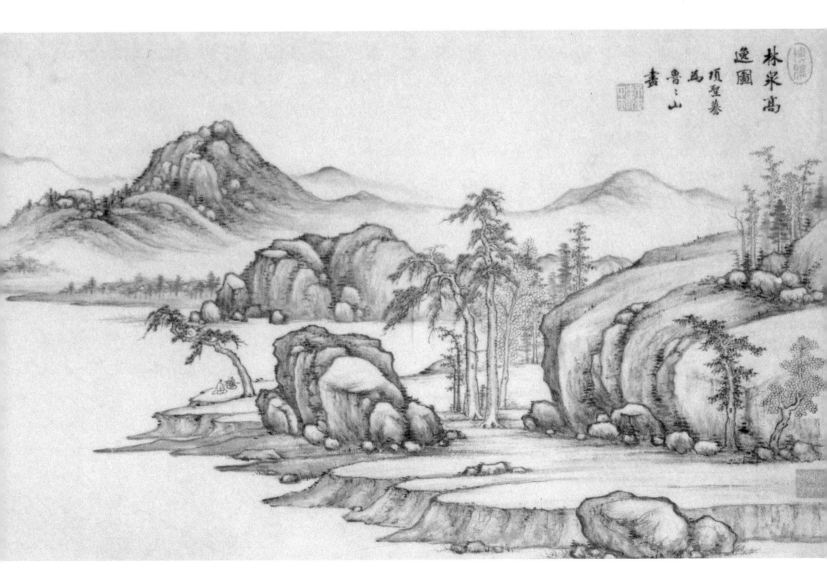

20. *Orchid and Rock Amidst a Clump of Bamboo,*
1660

Lu Dezhi
Hanging scroll, ink on paper

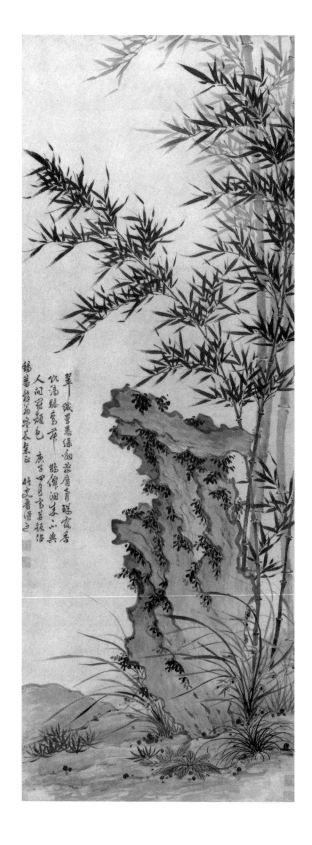

21. *Landscape* (from *Landscape* and *Poem by*
Du Fu), **1618**

Li Liufang
Handscroll, ink on paper

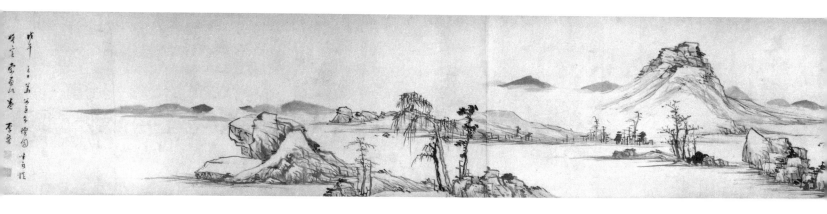

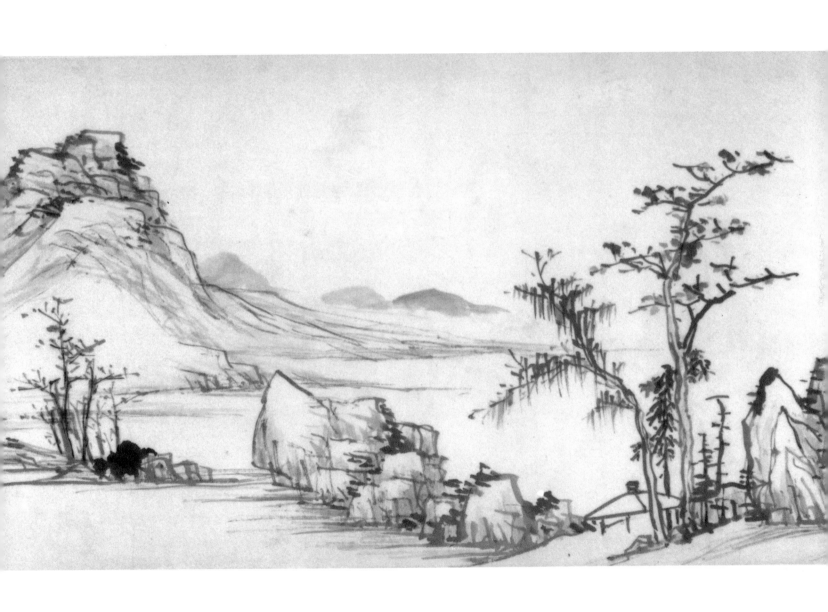

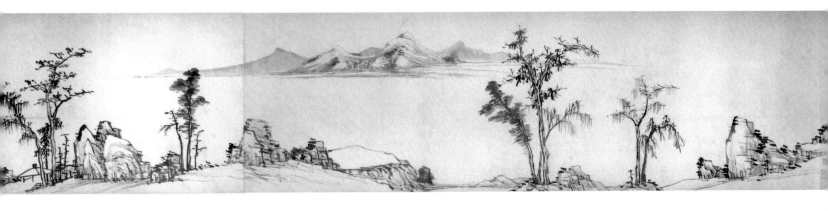

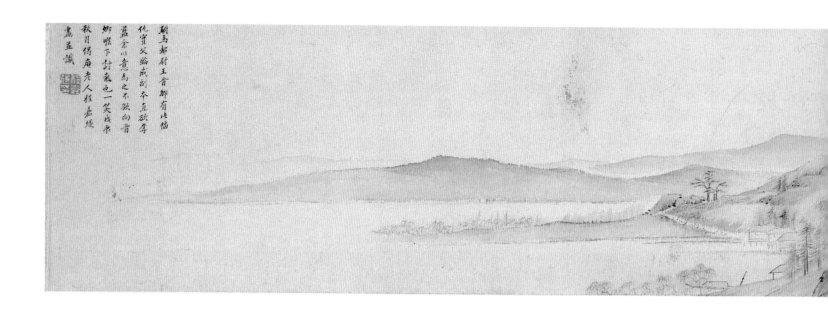

駙馬都尉王晉卿有此幅
優寶父臨成副本互欲存
蓋余以意爲之不欲向者
卿喉下討氣也一笑戊寅
秋月偶扇老人程嘉燧
爲孟識

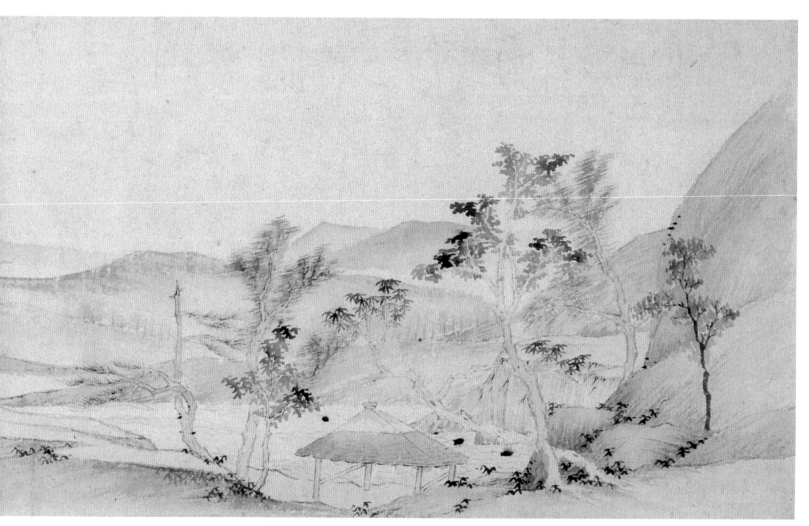

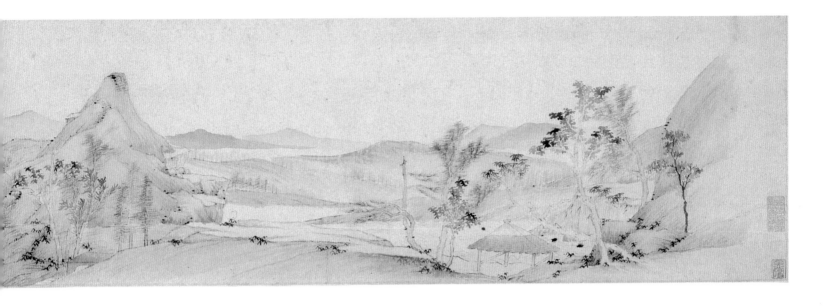

22. *Landscape after a Song Master,* 1628

Cheng Jiasui
Handscroll, ink and light colors on paper

23. *Paper Decorated with Two Flying Immortals,*
probably 14th–15th century

Handscroll, ink on paper

碑 圖
帖 書

Printed Books and Rubbings

Water Pavilion, Jiading

紫桃軒雜綴卷之一　　檇李李日華君實甫著

人從天台來貽余秋草一叢作花類桃而艷紫
可愛因植之雪窗峯下踰年遂滋蔓滿山趾余
未諳其性以修服食徒伴書籤承硯藩悅目雅
觀而巳因取以名我軒而日手綴雜所說於其
中

古人以杯為不落取其常飲則昏酣之流也以麵

24. One Page from *Miscellanea from the Purple Peach Studio*, ca. 1617

Li Rihua
Woodblock-printed book, ink on paper

25. Three Pages from *Newly Compiled, Fully Illustrated Biography of Guan Suo*, 1478

Woodblock-printed book, ink on paper
Page with dated printer's colophon (lower right)

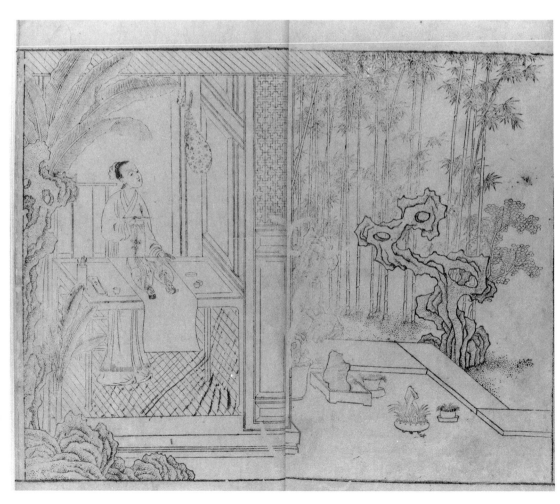

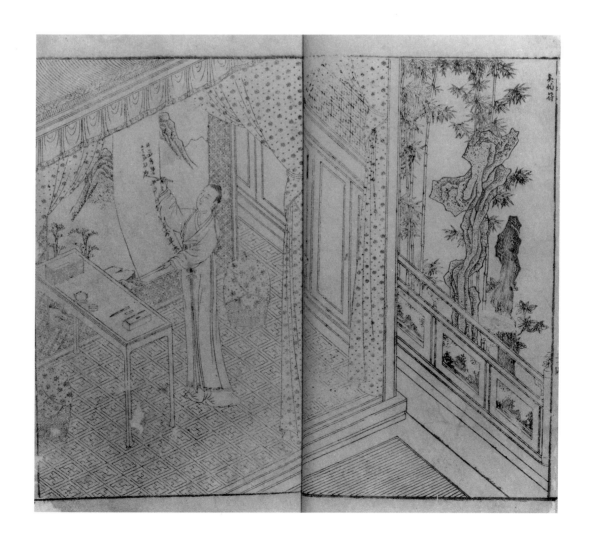

26. Seven Pages from *Illustrated Story of the Lute*, 1573–1620 edition

Gao Ming
Woodblock-printed book, ink on paper

塔影入雲巖

六國印
蘿軒珍藏

欲忘人之憂則贈之
以丹棘

27. Four Pages from *The Wisteria Studio Album of Stationery Decorated with Ancient and Modern Designs*, 1626

Wu Faxiang

Woodblock-printed book, ink, colors, and embossing on paper

28. Nine Pages from *Illustrated Swallow Messenger of Love*, 1643

Ruan Dacheng

Woodblock-printed book, ink on paper

28

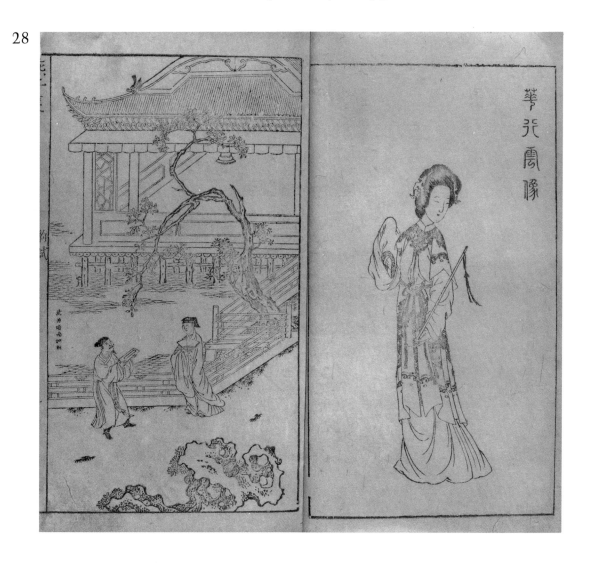

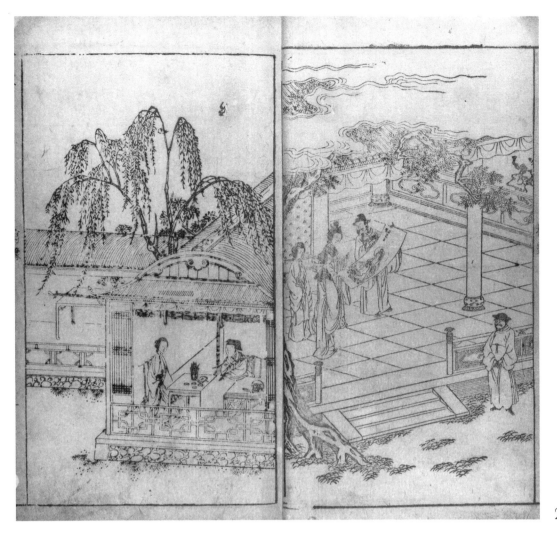

28

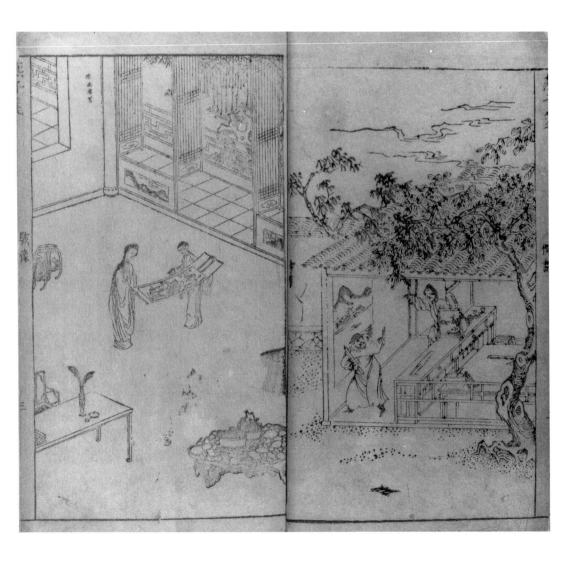

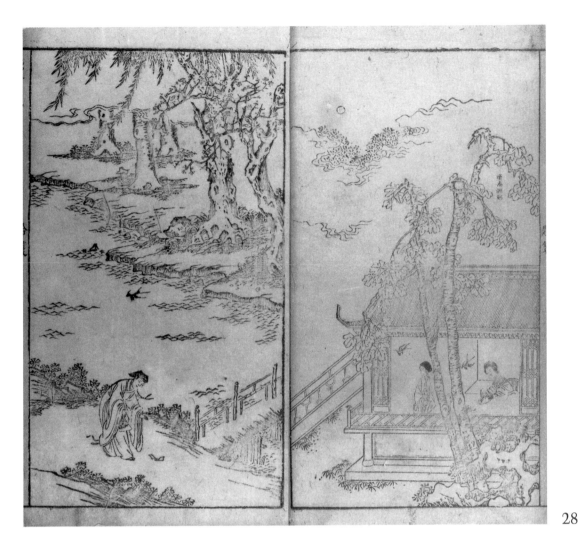

28

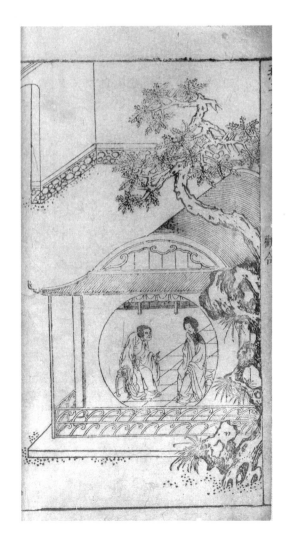

29. Three Leaves from *Rubbings of Selected Calligraphy from the Inkwell Hall*, 1602–1610

Album, ink on paper
Cover (lower right)

30. Three Leaves from *Rubbings from the Luxuriant Hill Studio*, 1611

Album, ink on paper

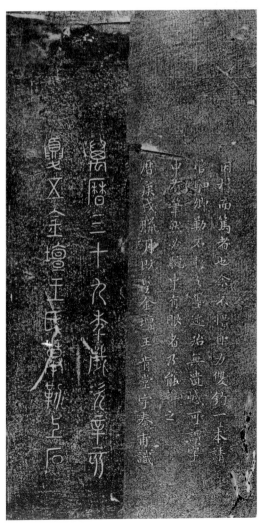

陶瓷

Ceramics

Bridge, Suzhou

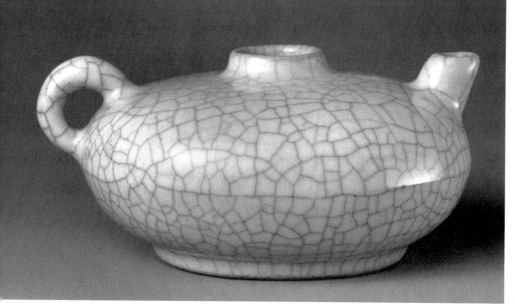

31

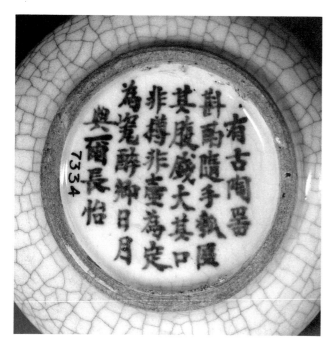

31. Winepot, probably 1573–1620

Porcelain, Jingdezhen *ge*-type ware
Poem inscribed on base (detail)

32. Melon-shaped Water Dropper, late 15th–early 17th century

Porcelain, Jingdezhen *ge*-type ware

33. Square Brushwasher, 16th–17th century

Porcelain, Jingdezhen *ge*-type ware

34. Foliate Brushwasher, 16th–17th century

Porcelain, Jingdezhen *ge*-type ware

35. Teapot, probably early 17th century

Shi Dabin

Earthenware, *Yixing* ware
Shi Dabin inscription on base (detail)

32

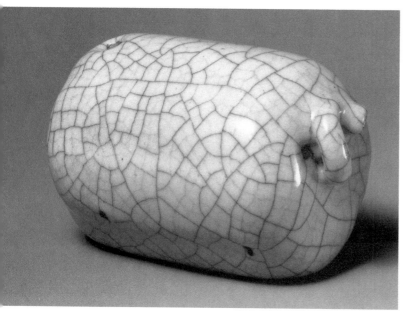

33

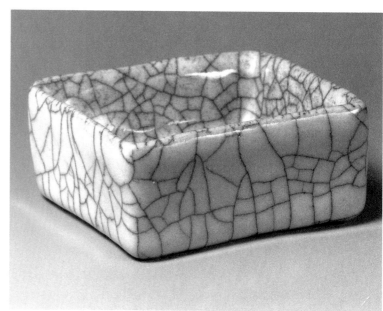

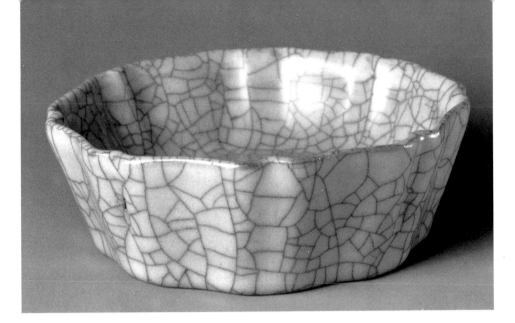

34

35

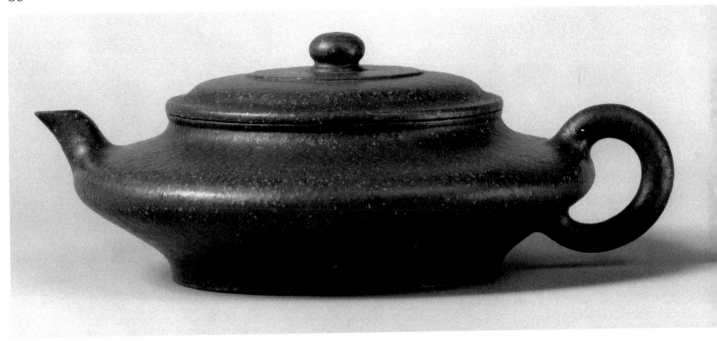

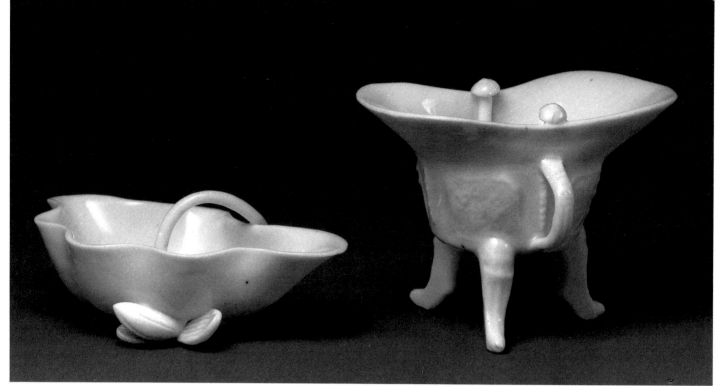

36

37

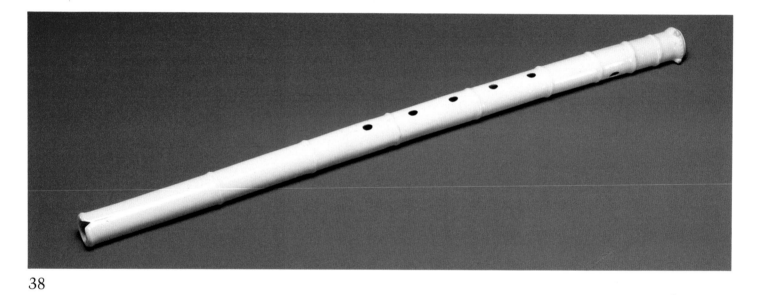

38

39

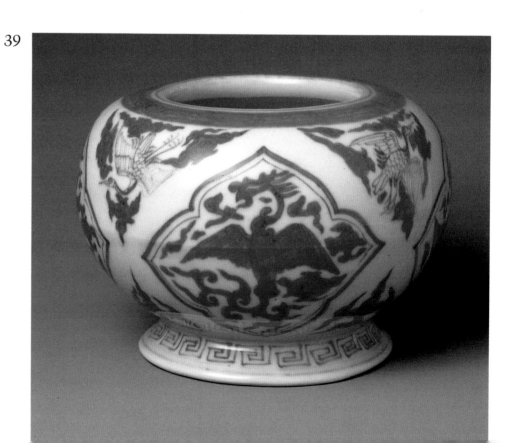

36. Lotus-leaf Brushwasher, 17th century

Porcelain, Dehua ware

37. *Jue*-shaped Tripod Cup, 17th century

Porcelain, Dehua ware

38. Vertical Flute, 17th century

Porcelain, Dehua ware

39. Waterpot, 1522–1566

Porcelain, Jingdezhen blue-and-white ware

40. Brush, probably 1573–1620

Porcelain, Jingdezhen blue-and-white ware

41. Brush Boat, 1573–1620

Porcelain, Jingdezhen blue-and-white ware

41

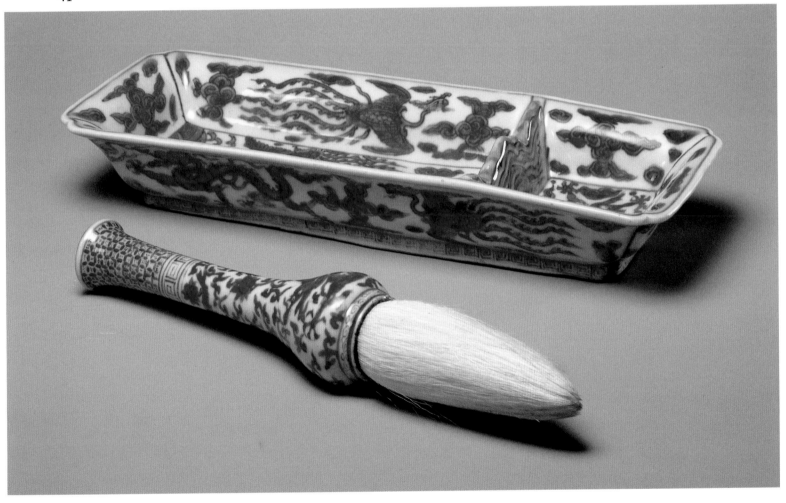

40

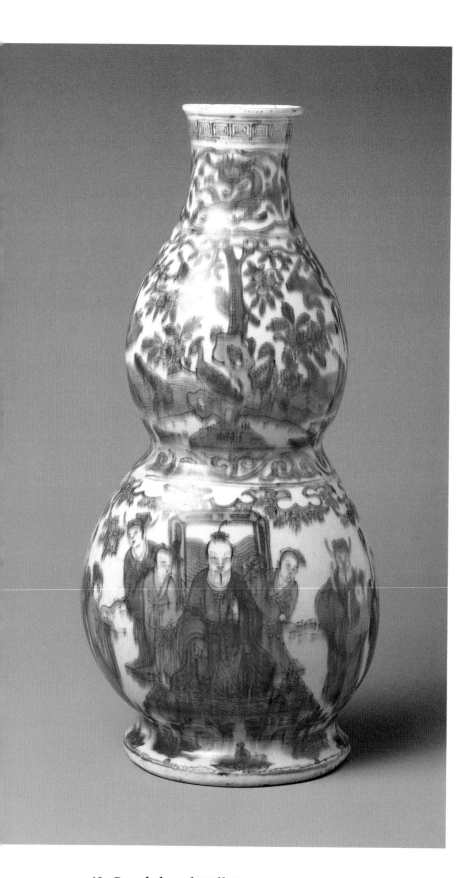

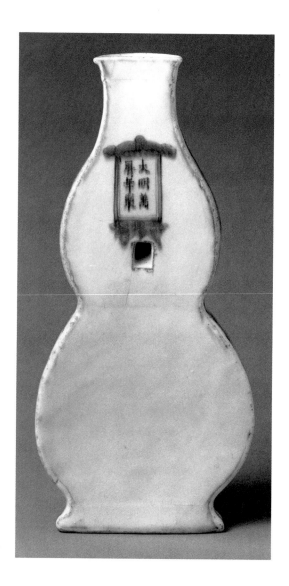

42. Gourd-shaped Wall Vase, 1573–1620

Porcelain, Jingdezhen blue-and-white ware
Back view with Wanli reign mark

43. Mountain-shaped Brushrest, mid-17th century

Porcelain, Jingdezhen blue-and-white ware

44. Cricket Container, probably 17th century

Earthenware inlaid with silver wire

43

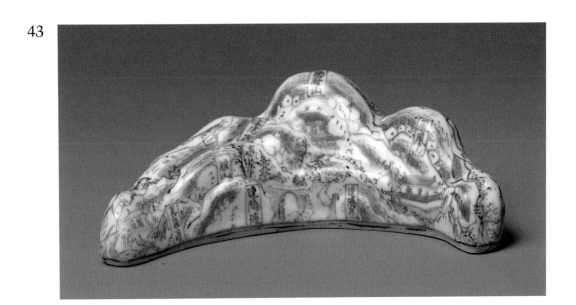

44

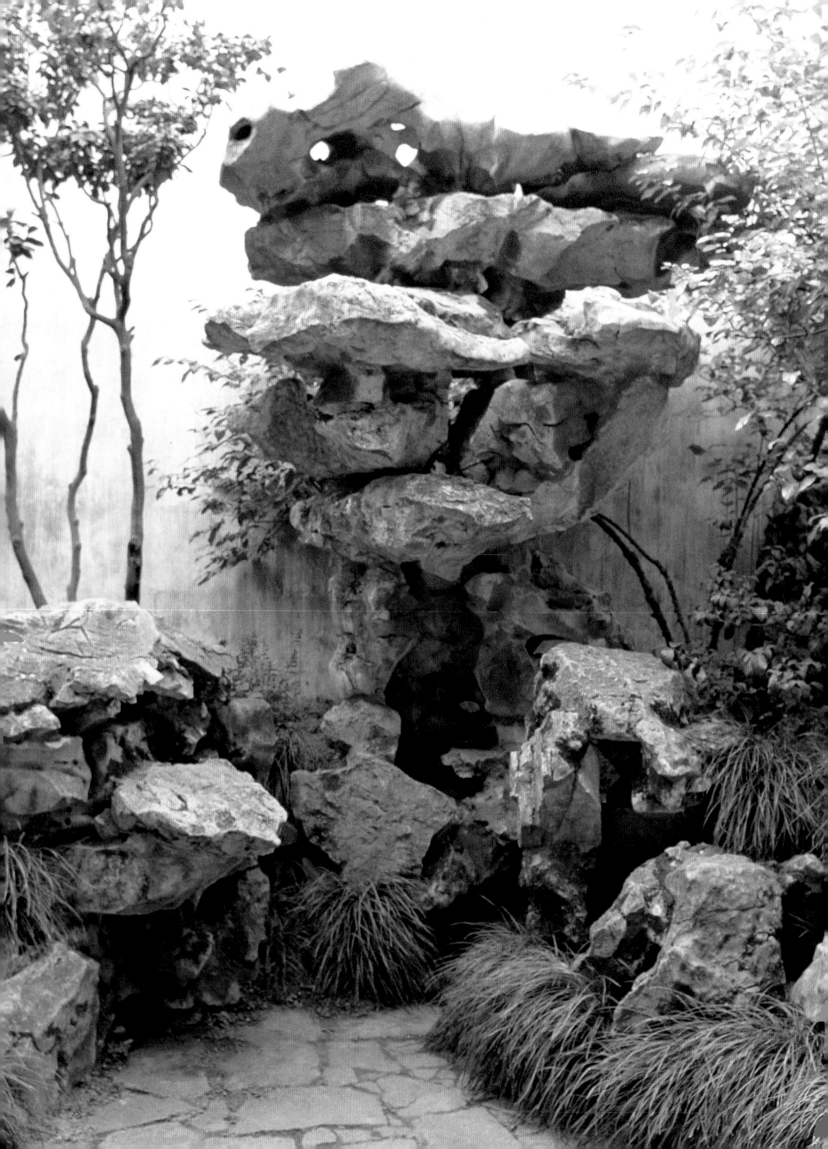

文玩

Decorative Arts

Lake Tai Rock, Suzhou

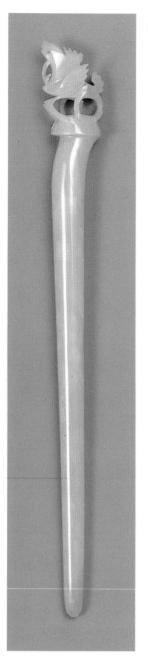

45

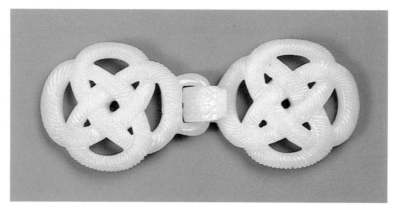

46

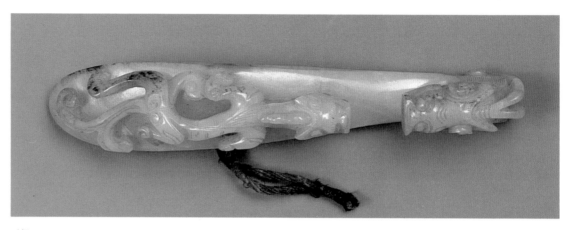

47

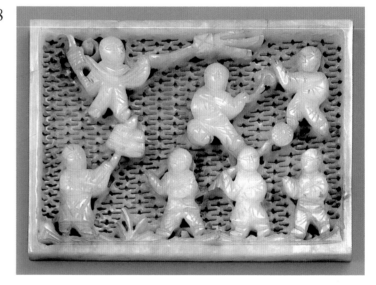

48

45. Hairpin with Phoenix Finial, 16th–early 17th century

Nephrite

46. Belt Buckle with Knotted Rope Decoration, 16th–17th century

Nephrite

47. Belt Hook with Dragon Head and *Chilong* Decoration, 16th–early 17th century

Nephrite

48. Belt Plaque with Decoration of Seven Boys, 16th–early 17th century

Nephrite

49. Fish and Lotus-leaf Pendant, probably mid-16th century

Nephrite

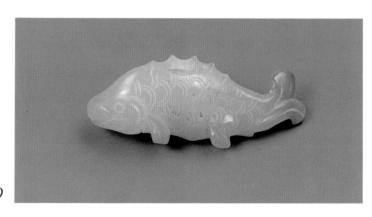

49

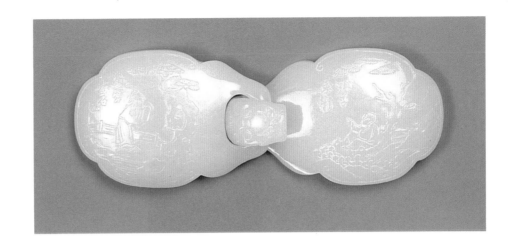

50. Belt Buckle with Scenes of Mi Fu and Zhang Qian, probably late 17th century

Nephrite

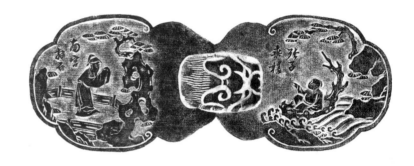

51. *Gui* Vessel with Knob Decoration, 16th–17th century

Nephrite

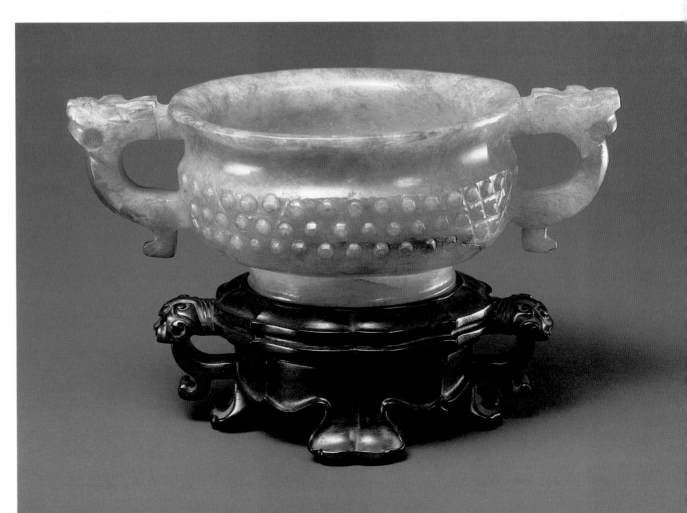

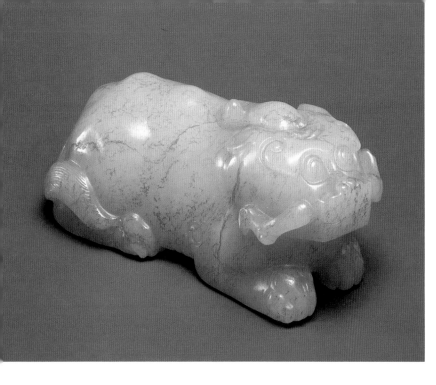

52. Recumbent *Bixie* Paperweight or Decorative Carving, 16th–early 17th century

Nephrite

53. Seated Bodhidharma (or Luohan), probably 17th century

Wei Rufen

Shoushan soapstone

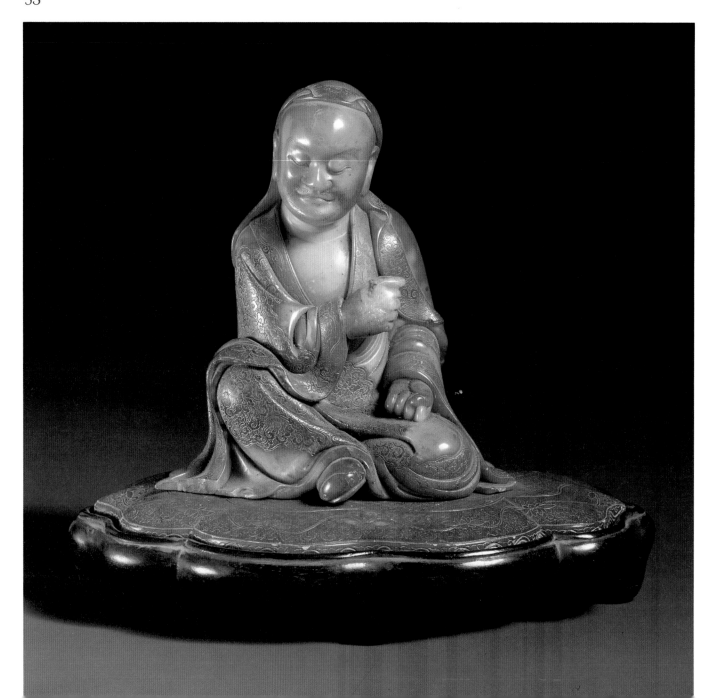

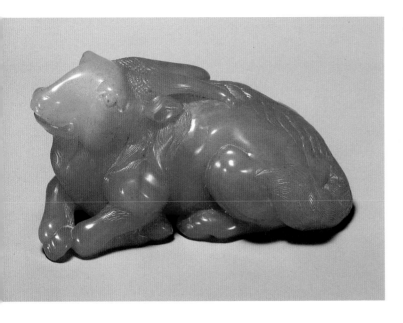

54

54. Recumbent Ram Paperweight or Decorative Carving, ca. late 17th century

Yang Ji

Tianhuang soapstone from Shoushan

55. Brushpot with Figures in a Garden, first half of 17th century

Shen Dasheng

Bamboo

55

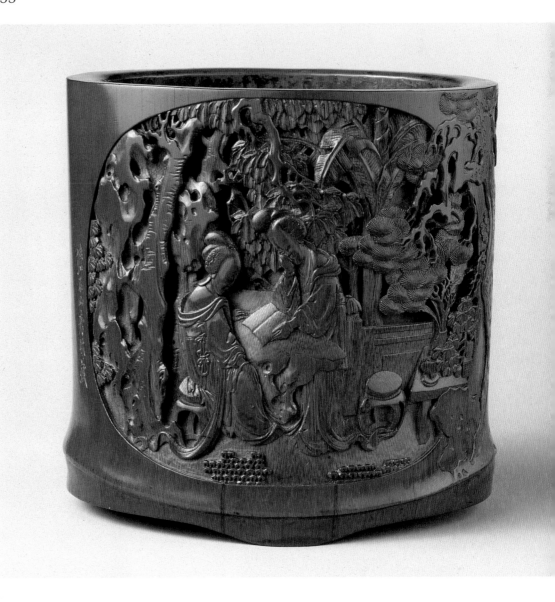

56

57

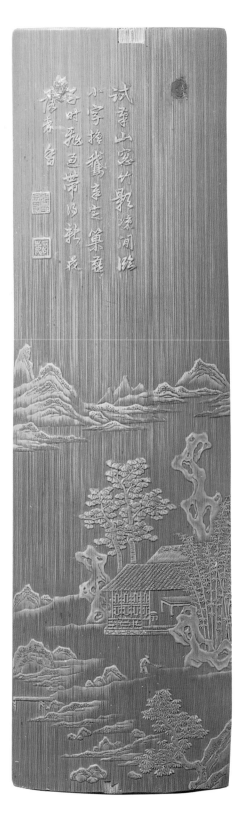

58

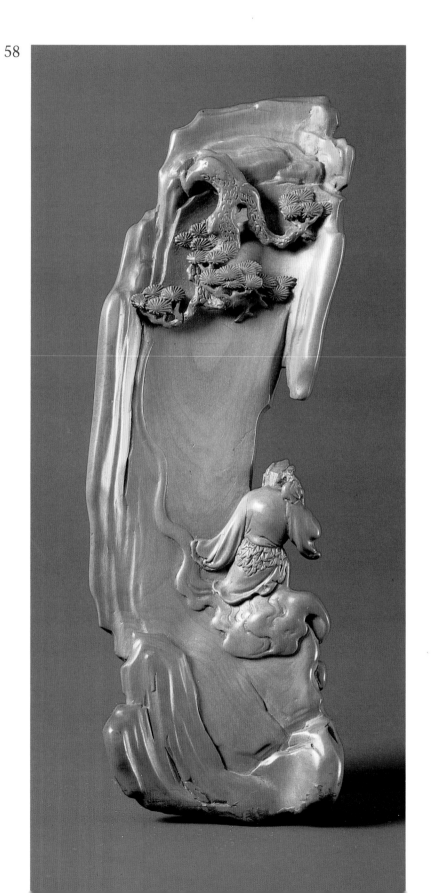

56. Waterpot with Pine Decoration, probably 17th century

Bamboo

57. Wrist Rest with Landscape Decoration, first half of 17th century

Zhang Xihuang
Bamboo, *liuqing* technique

58. Wrist Rest with a Scene of Dongfang Shuo, mid- to late 17th century

Boxwood
Two views

59. Luohan Seated on a Rock, 17th–early 18th century

Feng Xilu
Bamboo root-stem

59

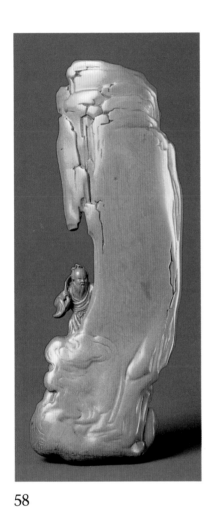

58

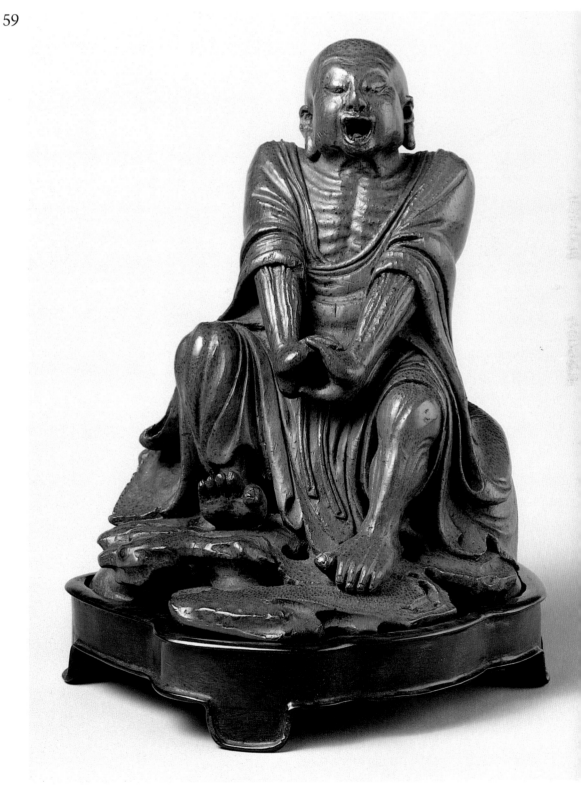

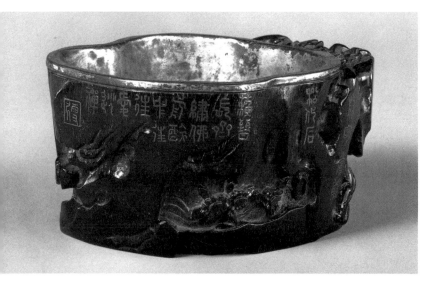

60

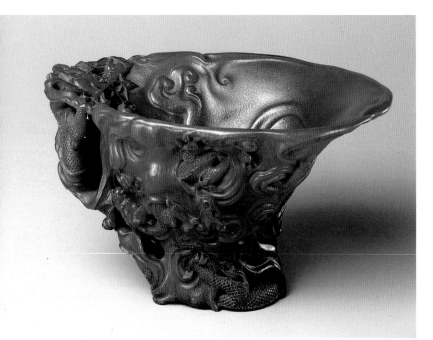

61

60. Wine Cup with a Scene of Tao Yuanming, late 16th–17th century

Meng Ren
Zitan wood

61. Cup with Six Dragons Amidst Clouds, probably 17th century

You Kan
Rhinoceros horn

62. Censer with Lotus, Narcissus, and Peony Decoration, late 16th–early 17th century

Hu Guangyu
Bronze with parcel gilding and silver inlay
Inscription on base (detail)

62

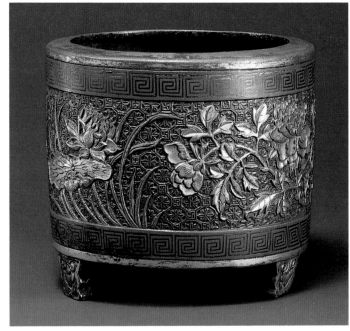

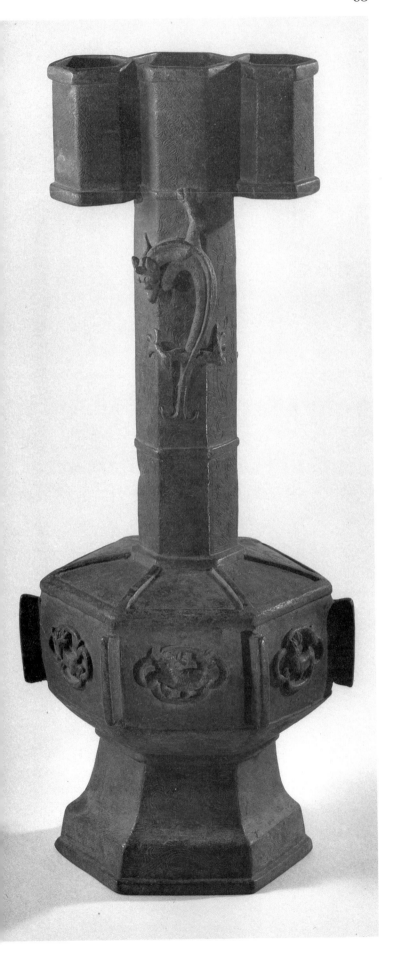

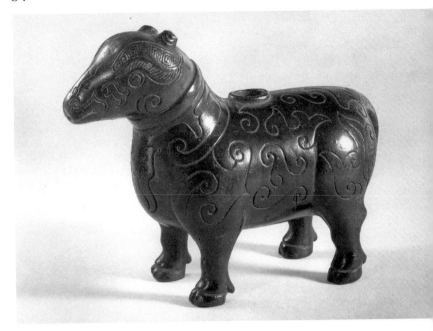

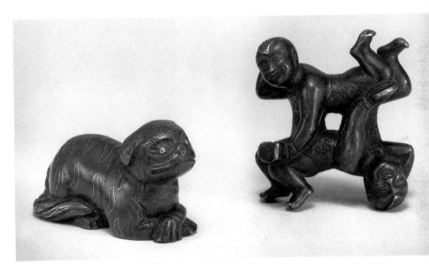

63. *Touhu* Vessel with *Chilong* Decoration, probably
first half of 17th century

Bronze

64. Animal-shaped Water Dropper, 16th–17th century

Bronze

65. Recumbent Feline Paperweight, 16th–17th
century

Bronze, inlaid with gold and silver

66. Paperweight with Boys Playing, 16th–17th
century

Bronze

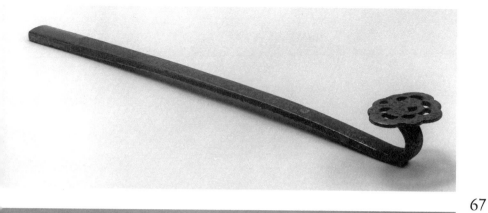

67

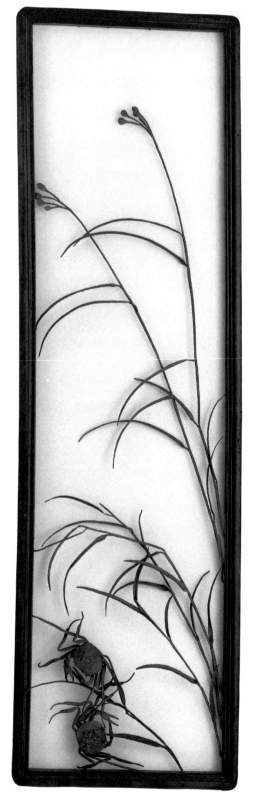

67. *Ruyi* Scepter with Decorative Inscription, first half of 17th century

Iron with cut sheet-silver and gold

68. Four Decorative Wall Hangings, 17th century

Iron with wooden frames

A. Crabs and Grasses
B. Rock and Branch of Blossoming Prunus
C. Rock and Branch of Fruiting Litchi
D. Rock and Blossoming Rose

68 A

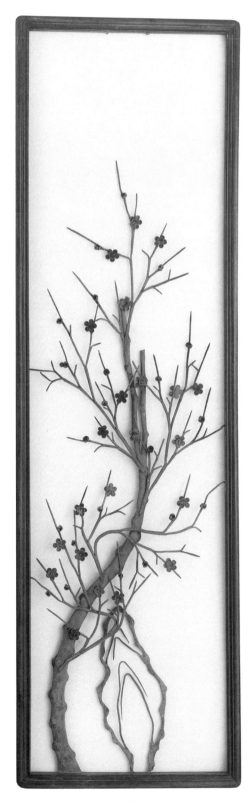

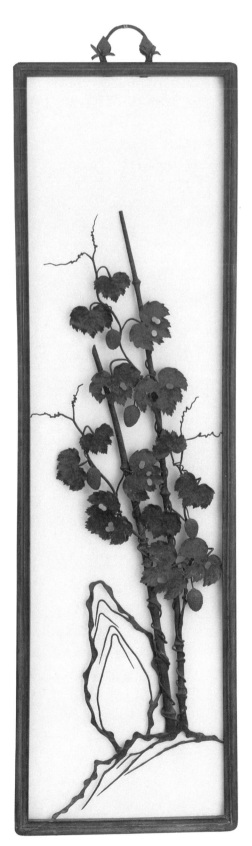

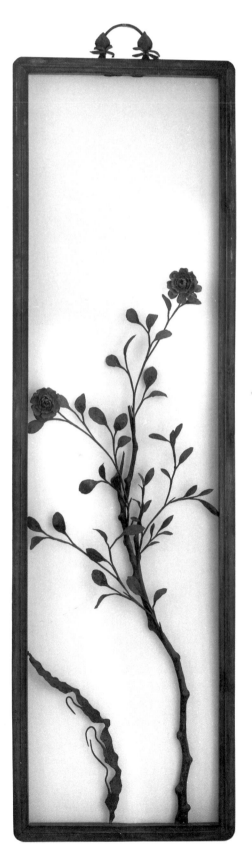

68 B

68 C

68 D

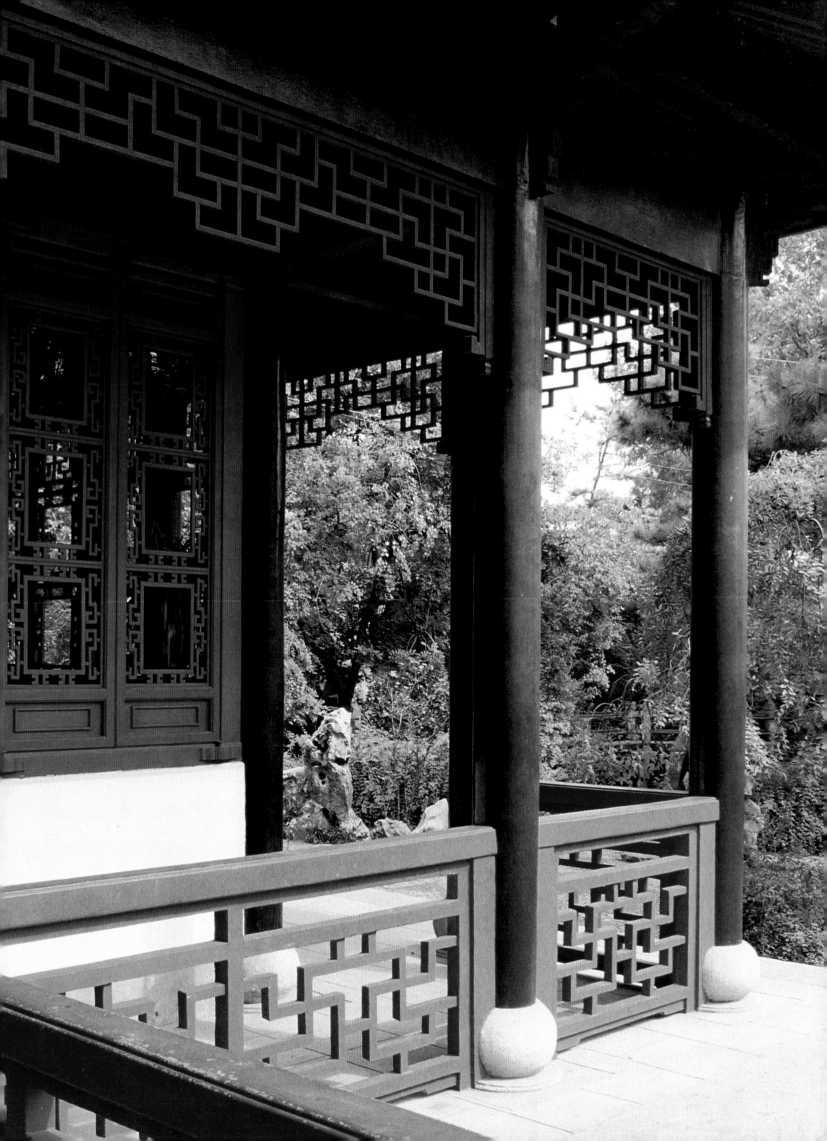

Scholar's Accoutrements

Porch of Studio, Jiading

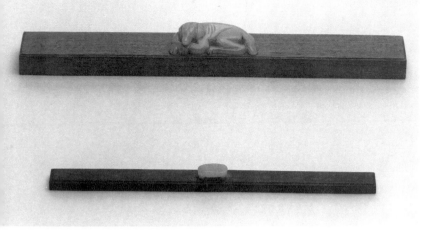

69 A B

69. Fourteen Scholar's Accoutrements, late 16th–early 17th century

A. Scroll weight with jade knob in the form of a recumbent dog
 Wood, nephrite

B. Scroll weight with pierced jade knob
 Wood, nephrite

C. Folding fan with net decoration
 Ink on gold paper, bamboo frame with lacquer decoration

D. Folding fan with net decoration
 Ink on gold paper, bamboo frame with lacquer decoration

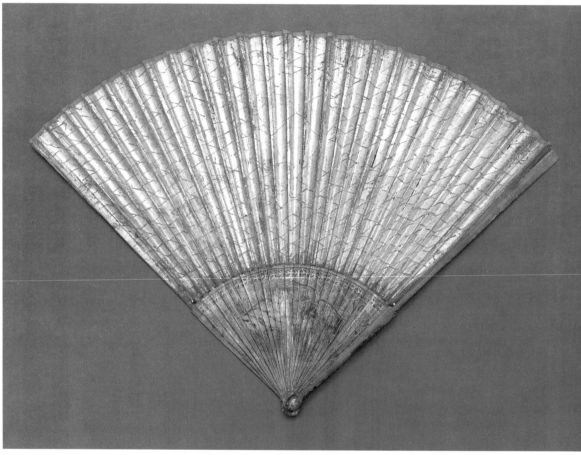

69 C

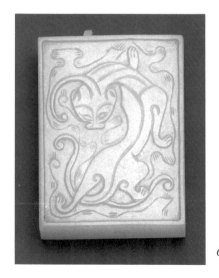

69 E

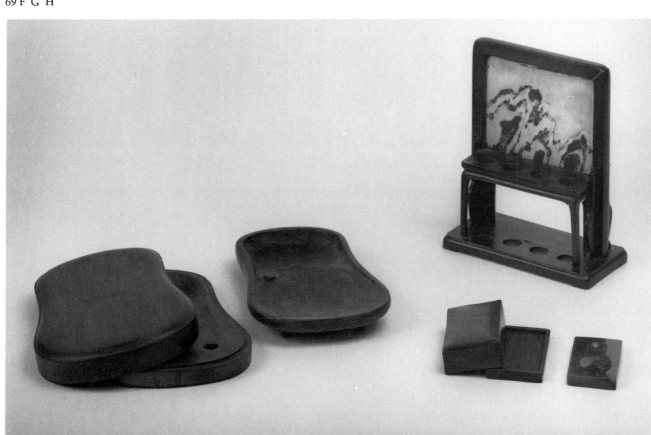

E. Plaque with *chi* dragon decoration
Nephrite

F. "Winnowing basket-shaped" inkstone with
contemporaneous fitted wood box
Duan stone

G. Table screen and brushrest with marble plaque
Wood with inset variegated marble

H. Rectangular palette for grinding pigments with
contemporaneous fitted wood box
Nephrite

69 F G H

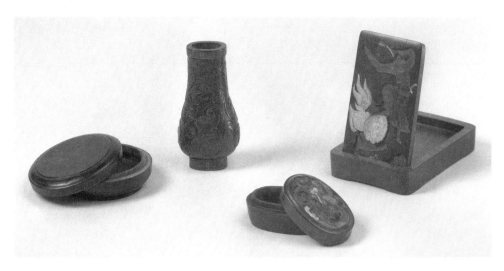

69 I J K L

I. Undecorated circular box and cover
Zitan wood

J. Pear-shaped vase with carved and inlaid decoration
Zitan wood inlaid with silver wire

K. Elliptical box and cover with inlaid decoration
Zitan wood with mother-of-pearl inlays

L. Flat rectangular object with hinged cover and inlaid lion decoration
Zitan wood with mother-of-pearl inlays

M. Undecorated rectangular stationery box
Hong wood

N. Undecorated cylindrical brushpot
Zitan wood

69 M N

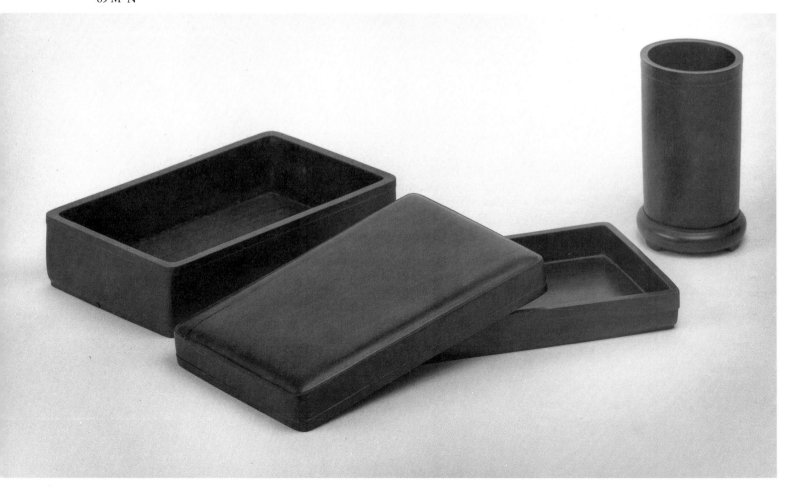

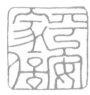

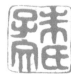

70 A 70 B 70 C

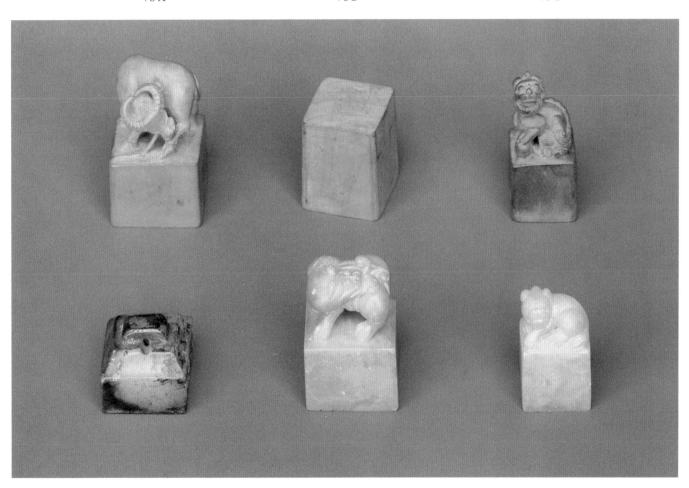

70 D 70 E 70 F

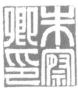

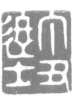

70. Six Seals, 16th century

A. **Square seal with water-buffalo knob**
 Boxwood

B. **Undecorated square seal**
 Boxwood

C. **Square seal with seated-lion knob**
 Boxwood

D. **Square seal with stepped-knob**
 Nephrite

E. **Square seal with standing-lion knob**
 Qingtian soapstone

F. **Square seal with recumbent *bixie* chimera knob**
 Qingtian soapstone

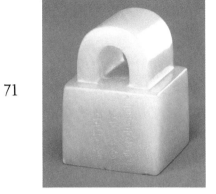

71

72

71. Square Seal with Bridge Knob, 1612

Gan Yang

Nephrite

72. Three Seals

Qingtian soapstone

A. Rectangular seal, 1624
 Gui Changshi

B. Square seal, 1604
 He Zhen

C. Square seal, 1604
 He Zhen

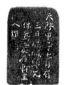

72 A

72 C

72 B

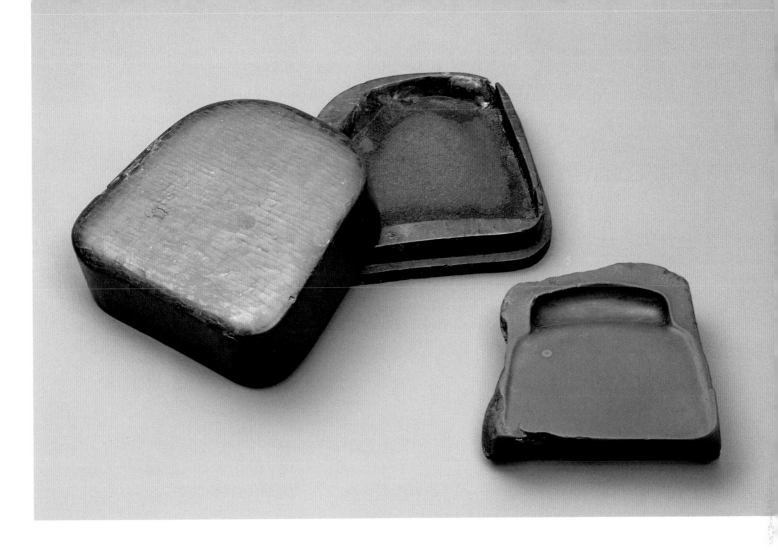

73

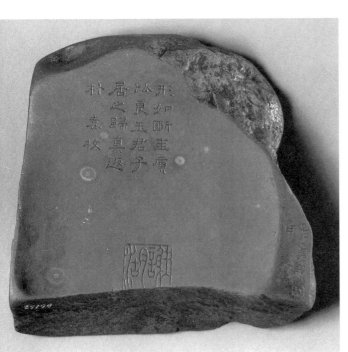

73. Inkstone with contemporaneous fitted lacquer box, probably mid-16th century

Duanzhou stone
Rubbings from head, side, and underside

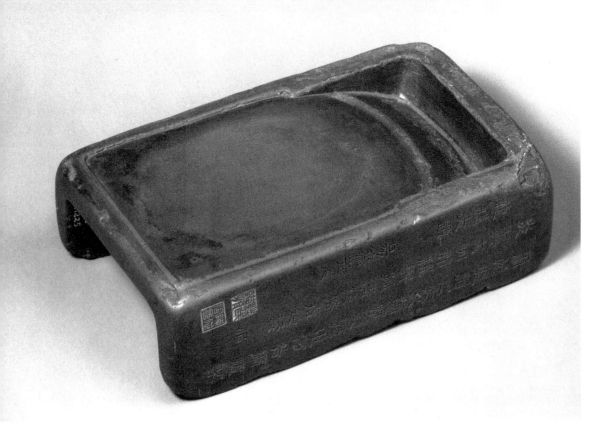

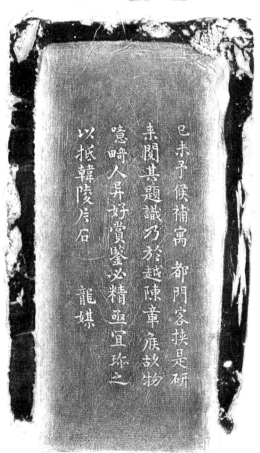

74. Inkstone, first half of 17th century

Duanzhou stone
Rubbings from head, side, and underside

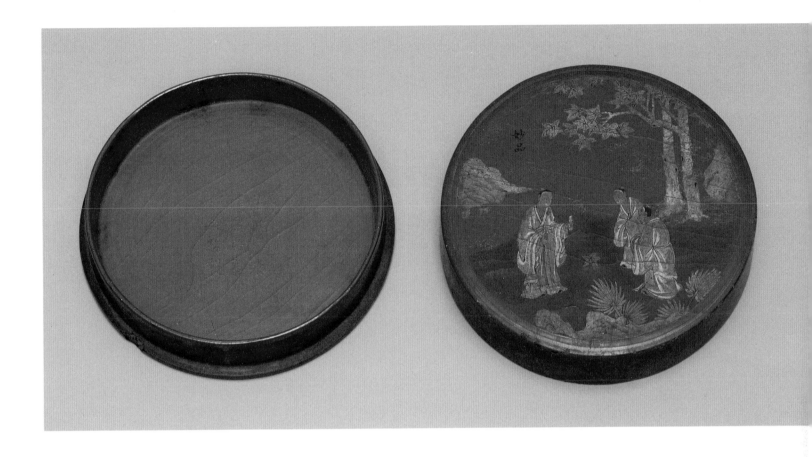

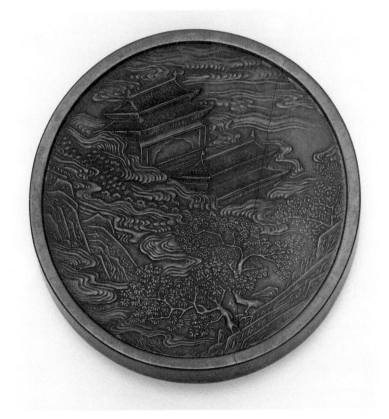

75. Ink Cake with contemporaneous fitted lacquer box, 1573–1620

Cheng Junfang
Molded pine soot and animal glue

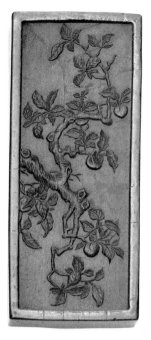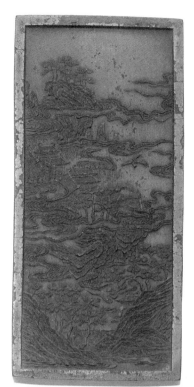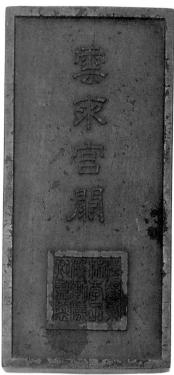

76. Inkstick, 1573–1620

Fang Yulu

Molded pine soot and animal glue

77. Inkstick, probably 1608

Wang Hongjian

Molded pine soot and animal glue

78. Brush and Cover with Figural Decoration, probably 1573–1620

Lacquered wood (or bamboo) with painted and inlaid decoration

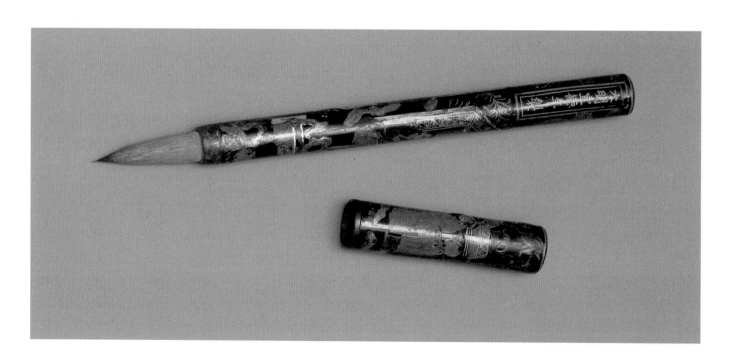

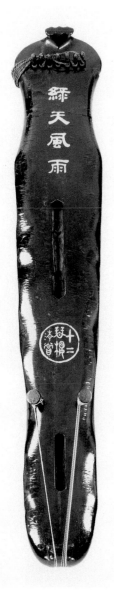

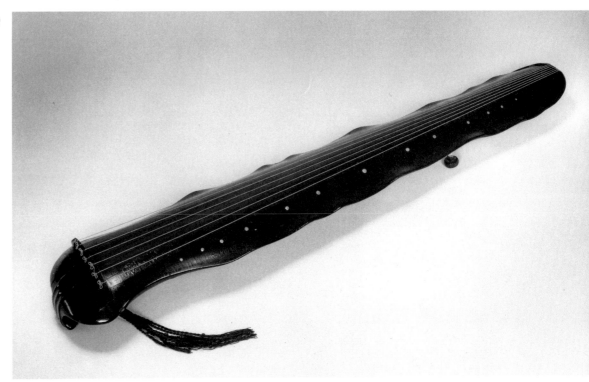

79. *Qin* (Zither) in the Shape of a Banana Leaf, 16th–17th century

Wood with lacquer and mother-of-pearl inlays
Two views

80. *Qin* (Zither), 1643

Zhang Jing(?)xiu
Wood with lacquer and mother-of-pearl inlays
Two views

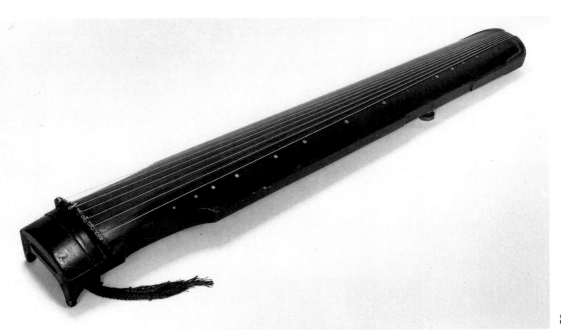

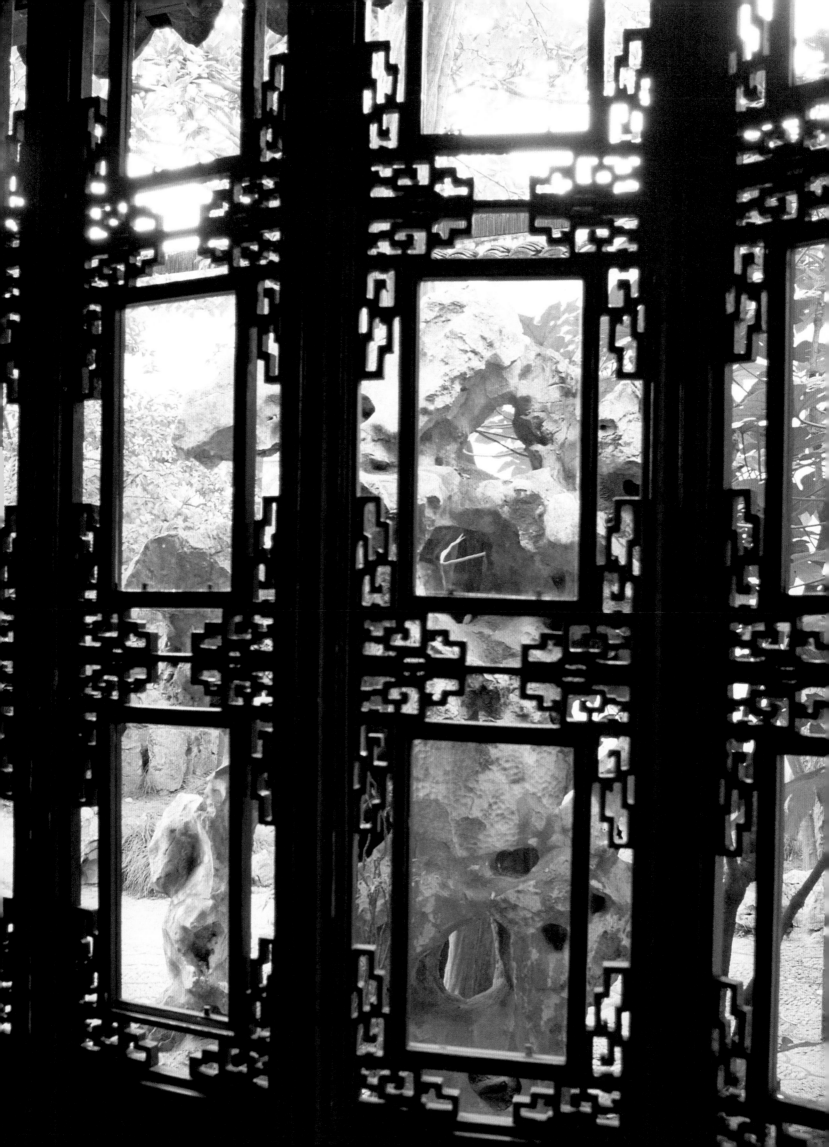

收藏

Collected Objects

View Through Studio Window, Jiading

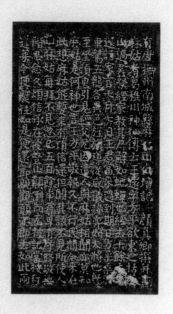

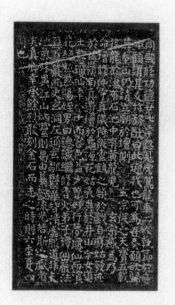
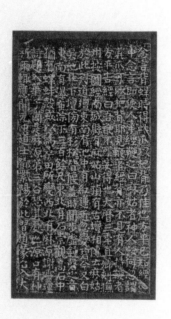

81. Leaves from Rubbing of Yan Zhenqing's
Small-character Record of the Altar to
the Immortal Magu, **album of Song**
rubbings assembled in 1595

Album, ink on paper

82. *Gu* Wine Vessel, 12th–11th century B.C.

Bronze
Rubbing of inscription on base

83. *Jue* Wine Vessel, 12th–11th century B.C.

Bronze
Rubbing of inscription under handle

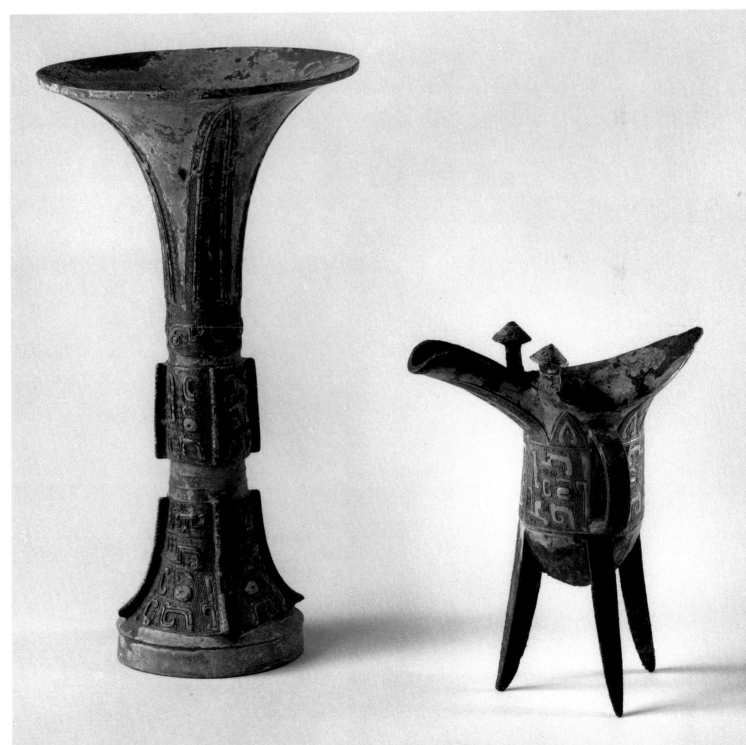

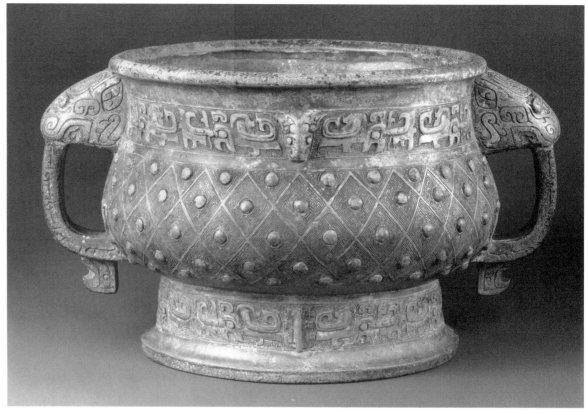

84

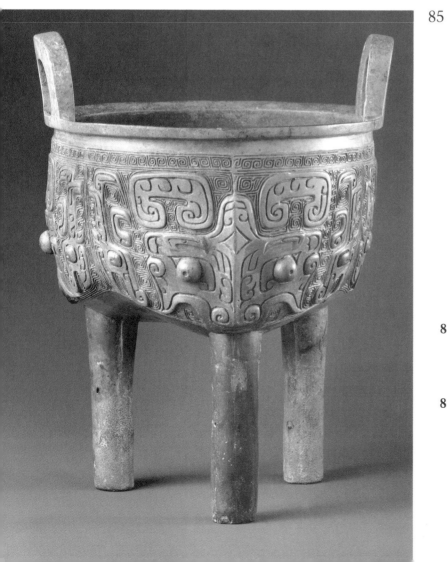

85

84. *Gui* **Food Vessel, 12th–11th century B.C.**

Bronze
Rubbing of inscription on interior floor

85. *Liding* **Food Vessel, ca. 11th–early 10th century B.C.**

Bronze

86. Chimera-shaped Water Dropper, probably 4th–6th century

Bronze

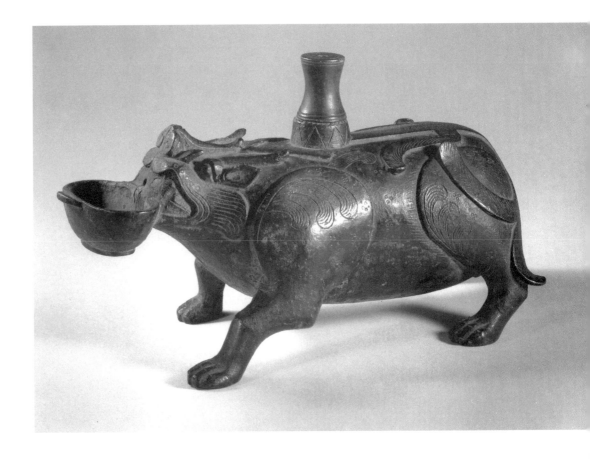

87. Four Seals

Bronze

A. Set of three nested square seals, 265–316
B. Set of two nested square seals, 206 B.C.–A.D. 9
C. Square seal with turtle knob, 222–265
D. Square seal with tile knob, 25–220

87 A 87 B 87 C 87 D

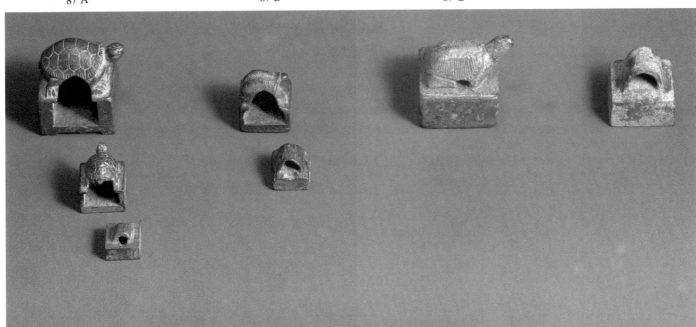

88. Vase, 13th–14th century

Stoneware, *guan* ware

89. Conical Bowl, 1465–1487

Porcelain, Jingdezhen *ge*-type ware
Inscription on base (detail)

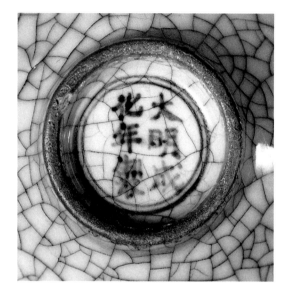

89

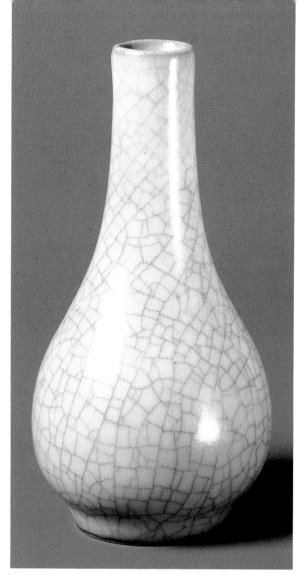

88

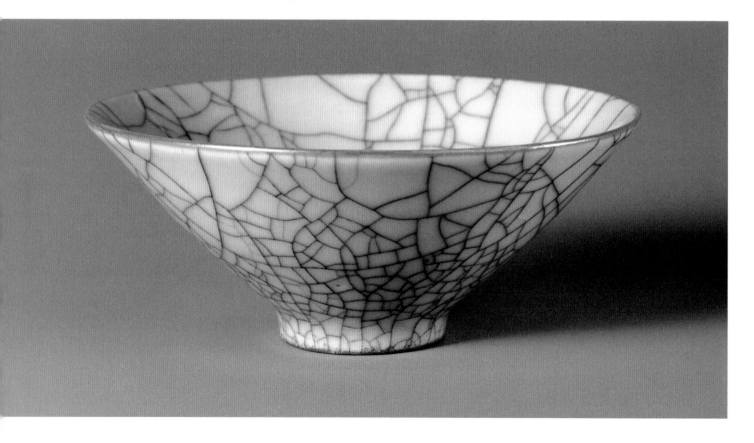

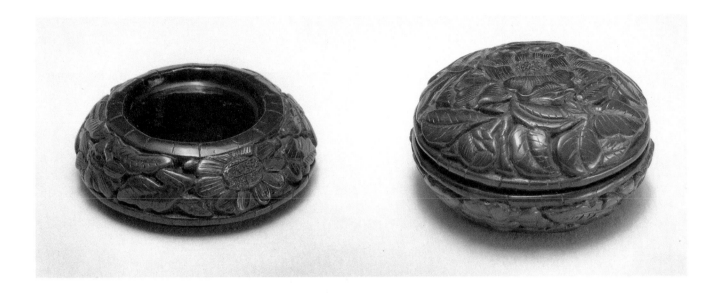

90. Two Covered Boxes with Floral Decoration, 1403–1424

Lacquer
Box on left showing inscription on base

91. Folding Fan with Net Decoration, late 16th–early 17th century

Ink on paper with bamboo frame

Painting and Calligraphy

1. Venerable Friends

Xiang Shengmo (1597–1658), *zi* Kongzhang, *hao* Yi'an, Xushan-qiao, Songtao Sanxian
Zhang Qi (active mid-17th century), *zi* Yuqi
Qing, dated to 1652
Hanging scroll, ink and colors on silk, with inscription, signature, and seals of Xiang Shengmo, 38.1 × 25.5 cm

THIS RARE GROUP portrait depicts the six most distinguished literati of the late Ming: (clockwise from the lower left) Lu Dezhi (1585–after 1660), Dong Qichang (1555–1636), Chen Jiru (1558–1639), Xiang Shengmo (1597–1658), Monk Qiutan (1558–1630), and Li Rihua (1565–1635). All were from Jiaxing or Songjiang in the Yangzi River delta, all were close friends, and all were poets, painters, calligraphers, and collectors. Li Rihua, Dong Qichang, and Chen Jiru, in particular, were the most respected connoisseurs of their day, and many of the masterpieces of Chinese painting and calligraphy bear their seals and colophons.

Venerable Friends is one of the earliest literati group portraits.[1] At the time it was painted, in 1652, only Lu Dezhi and Xiang Shengmo—the youngest members of the group—were still living, so this scroll is an imaginary portrait rather than a record of an actual literary gathering. As recorded in the inscriptions and colophons on works in this exhibition, life became difficult for those literati of the late Ming who saw their dynasty fall in 1644 and who then had to live under a new and foreign one, the Qing. Done just a few years after the founding of the Qing, this portrait reflects Xiang Shengmo's concern with earlier days, better times, and lost friends. In his inscription Xiang notes that the painting represents the time when he was forty (about 1635) and that it was done "to recapture the likeness and spirit of the group of friends."

This portrait was a collaborative effort by Xiang Shengmo and Zhang Qi. A professional portrait painter, Zhang Qi was a student and follower of Zeng Jing (1564–1647, no. 2). Like Xiang Shengmo, he was from Jiaxing and may well have been Xiang's friend. In any event, Zhang would have done the figures and Xiang the rest. Xiang Shengmo was a scion of a wealthy family and the grandson of Xiang Yuanbian (1525–1590), who had assembled the most distinguished private collection of painting and calligraphy during the Ming period. He was a literatus par excellence and an accomplished painter (nos. 15–19).

The setting is remarkably similar to that in a self-portrait that Xiang Shengmo did with Xie Bin (active mid-17th century, another follower of Zeng Jing) in the same year, a hanging scroll in the Jilin Provincial Museum entitled *A Carefree Immortal Among Waves of Pines*.[2] Although the setting of *Venerable Friends* is highly abbreviated, the pines that frame the composition and the configuration of rocks on which the figures sit are the same ones that appear in the Jilin Museum self-portrait. It is possible that the Shanghai Museum painting has been trimmed considerably in successive remountings; if it was indeed originally larger, the complete setting

might have been even closer to that of the Jilin Museum self-portrait.[3] The inscription on the Jilin Museum painting indicates that the area depicted in the painting was one of Xiang Shengmo's favorite places on his estate. Its reappearance here confirms that Xiang sought to evoke earlier and better times.

In addition to Xiang's *Carefree Immortal Among Waves of Pines* and his *Self-portrait in a Red Landscape*,[4] another self-portrait is known: a small hanging scroll in ink and light colors on paper in the collection of Wan-go H.C. Weng.[5] A likeness of the smiling, round-faced Li Rihua appears in an unsigned album of *Portraits of Eminent Men of Zhejiang Province* in the Nanjing Museum,[6] and a hanging scroll by Zeng Jing depicts *Chen Jiru with a Crane*.[7] An unpublished album leaf in the Shanghai Museum portrays Dong Qichang. In all these portraits, the figures are recognizable as the same ones that appear in the present work.

> Inscription translated in Chu-tsing Li's essay "The Literati Life" in this catalogue
> COLOPHON: Inscription and seals of Cheng Shifa (born 1921) on the mounting

2. Portrait of Li Zhaoheng at Thirty-six *sui*

Zeng Jing (1564–1647), *zi* Pochen
Ming, dated to 1627
Hanging scroll, ink and colors on silk, with inscriptions, signatures, and seals of Zeng Jing and Li Zhaoheng, 91.7 × 28.1 cm

THIS PORTRAIT depicts Li Zhaoheng (ca. 1592–ca. 1662), the only son of Li Rihua and a close friend of Xiang Shengmo. In the typical manner of seventeenth-century portraits, Li is presented against an unembellished background, as if floating through the air like an immortal (compare female portrait in no. 28).

Although he either did not take or did not pass the civil service examinations, Li Zhaoheng was an accomplished scholar and was much like his father in following literati pursuits. He was a talented calligrapher and painter (see nos. 8 and 9), well known for his landscapes and for his grapes done in a highly calligraphic style. He assisted in editing and publishing his father's writings and left several published collections of his own work, one of which is the *Xieshanlou jin'gao*, named after his Xieshanlou (Tower for Painting the Mountains) in Jiaxing. In 1645 invading troops of the new Qing government left much of Jiaxing in ruins, but the Xieshanlou seems to have escaped destruction.[1] Although Li apparently tried to resume the life of a literatus after the downfall of the Ming in 1644, he must have found it difficult, and following the lead of many Ming loyalist *yimin* (leftover subjects), he became a Buddhist monk sometime after 1646, taking the name Changying. He probably led the quiet life of

a literatus monk, like his friend the poet and Chan monk Qiutan (see no. 1).

The artist's inscription at the lower left states that the portrait was "Painted by Zeng Jing on a spring day of Tianqi *dingmao* [1627]." Li Zhaoheng notes in his own inscription at the upper right that "In *dingmao* [1627] Zeng Jing painted this portrait when I was thirty-six *sui*. Now, ten years later, in the early spring of *bingzi* [1636], [I] have opened it, appreciated it, and inscribed it. Zui'ou [Drunken Sea Gull, Li Zhaoheng]" (no. 2, detail). Since his date of birth is otherwise unrecorded, this work is an important document in establishing that Li was born about 1592. (At thirty-six *sui*, he would have been thirty-five years old by Western count.)

Zeng Jing was born in Putian, Fujian province, but spent his mature years in Nanjing.[2] He was the most famous and prolific portrait painter of his day and did likenesses of Chen Jiru and Dong Qichang, among others. Details of his background and training are obscure, but his portraits are clearly more realistic than any previously painted in China. In fact, seventeenth- and eighteenth-century Chinese writers frequently remarked that his portraits resemble "reflections of the models in a mirror." Many twentieth-century authors have suggested that Zeng Jing might well have been influenced by European pictures, which he could easily have seen in his native Fujian, a province that had long enjoyed trade with the Portuguese and Spanish, or in Nanjing, where a number of Jesuit missionaries were based. More traditional authors argue that his work is a logical outgrowth of the native Chinese tradition and that any similarity to Western paintings is coincidental. Proof for either case awaits the discovery of hard evidence, but Western influence seems likely. This portrait is typical of the work that Zeng Jing did in the 1620s and is similar to a *Portrait of Zhao Shi'e*,[3] also in the Shanghai Museum, which he painted in 1624.

With their open backgrounds and Jin-style caps, Zeng Jing's paintings have an antique flavor that recalls works of the Tang and early Song. Certain portraits, such as this one of Li Zhaoheng, resemble the figures in Wang Liyong's *Transformations of Laojun*,[4] now in the Nelson-Atkins Museum of Art, Kansas City. Whether or not Zeng Jing actually saw this twelfth-century handscroll is unknown, but it was in the collection of the distinguished Jiaxing connoisseur, Xiang Yuanbian. Although Zeng may not have had direct access to the Xiang family collection, perhaps one of the literati showed him the scroll (or one like it) and asked to be portrayed in the same manner.

Zeng Jing trained a number of followers, including Xie Bin and Zhang Qi (see no. 1). The group is usually termed the Pochen school after Zeng Jing's sobriquet; its members learned their mentor's style well and worked in an almost identical manner. Even twenty-five years after this portrait of Li Zhaoheng was done, elements of its style are discernible in works of Zeng's students. In the collaborative work *A Carefree Immortal Among Waves of Pines* by Xiang Shengmo and Xie Bin (see discussion, no. 1), for example, the tasseled ends of the figure's belt look much as they do in this portrait. Zeng's imprint was obviously indelible.

COLOPHON: Inscription and seals of Tao Yuan (Qing dynasty)

3. Rivers and Mountains in My Dream

Li Rihua (1565–1635), *zi* Junshi, *hao* Jiuyi, Zhulan Jushi
Ming, dated to 1625
Handscroll, ink on paper, with inscriptions, signature, and two seals of the artist, 23.4 × 253.3 cm

THE ARTISTS of Jiaxing, Songjiang, and Jiading eschewed the elegantly pleasing style of the Suzhou-based Wu school (see no. 7) in favor of a consciously awkward one that held appeal only for those who understood the formal, internal rhythms and art-historical references. Although they appreciated works by early masters of the Wu school, as evinced by their laudatory colophons (see nos. 6 and 7), they felt that the Wu school exponents of their own day created only formulaic works, pleasing to the eye but devoid of meaningful content. Thus, they rejected the easy grace of Wu school paintings—with their pastel colors and refined brushwork—and sought inspiration in works by masters of the Yuan, whose bold compositions and powerful brushwork they found invigorating. In particular they favored the Four Great Masters of the Yuan, Huang Gongwang (1269–1354), Wu Zhen (1280–1354), Wang Meng (1308–1385), and Ni Zan (1301–1374).

In his first inscription on this handscroll, Li Rihua mentions, for example, that he "playfully imitated the spirit of Dachi's brush," indicating that he was following Huang Gongwang, whose sobriquet was Dachi. While the freedom and spontaneity of this painting—and even the shape of the mountains at the beginning of the scroll—recall those of Huang Gongwang, the influence of other Yuan masters is also apparent. The ink-dot foliage of the trees clearly derives from works of Wu Zhen, and the empty kiosks, sparsely textured mountain surfaces, and generally dry brushwork owe their inspiration to Ni Zan. Through his exposure to the collection of Xiang Yuanbian, Li Rihua would have been familiar with original works by all these masters.

This painting is an original conception that makes art-historical allusions to the past and thus shows the artist's appreciation and understanding of earlier masters—a hallmark of literati style. With the combination of poetry, painting, and calligraphy, it is a happy marriage of the three "sister arts." The poem does not describe the painting but complements it by referring to fishing, thatched huts, and riverside trees. Written in the style of Wang Xizhi (321–379 or 303–361, see no. 29), the calligraphy makes its own allusions to the past.

Dated by inscription to the early autumn of 1625, this painting was done in Beijing not long after Li Rihua's arrival there for government service. The title, *Rivers and Mountains in My Dream*, indicates that it is not a specific—or even a real—landscape, but an imagined ideal one where the artist could find solace from the cares and frustrations of the mundane world. The aim was not formal likeness as would be expected in a portrait (compare no. 2), but the expression of personality through the manipulation of formal elements.

Second inscription translated in Chu-tsing Li's essay "The Literati Life" in this catalogue

COLOPHONS: Colophons and seals of Wu Dacheng (1835–1902) and Wu Hufan (1894–1968); 18 collectors' seals

4. Painting and Calligraphy by Four Generations of the Li Family

Ming–Qing

A. Li Rihua (1565–1635), 3 leaves of calligraphy comprising 1 letter, 2 paintings

B. Li Zhaoheng (ca. 1592–ca. 1662), *zi* Huijia, *hao* Kexue, Keyun, Shuangqi Diaoshi, Zui'ou, Buddhist name sometime after 1646, Changying, 1 painting dated to 1632

C. Li Qizhi (1622–after 1699), *hao* Qifeng, 2 paintings

D. Li Hanmei (active late 17th–early 18th century), *zi* Nanming, 3 paintings, 2 dated to 1692

Album of 11 leaves, ink on paper and ink and light colors on paper, with signatures, seals, and inscriptions by some of the artists, 30.4 × 25.0 cm (average)

AFTER LI RIHUA passed the *jinshi* examination in 1592, the Li family was accepted into the gentry and gained the respect and friendship of such eminent people as Xiang Yuanbian, Dong Qichang, and Chen Jiru, all of whom lived in Jiaxing or nearby Songjiang. Tutored by Zhou Lijing, and informally by members of the Xiang family, Li Rihua matured into a prolific author, talented painter, and distinguished connoisseur—in short, one of the most accomplished literati of the late Ming. His only son, Li Zhaoheng, did not take the civil service examinations but nevertheless pursued the literati life and continued his father's tradition of painting and scholarship, retreating sometime after 1646 to the security of the Chaoguo Temple in Songjiang as a monk. Of Li Zhaoheng's three sons little is known, but one, Li Xinzhi, passed the provincial *juren* examinations in 1642; a second son, Li Qizhi, became a painter well known for his landscapes and ink bamboos and plum blossoms. The fourth generation produced at least five recorded painters, of whom Li Hanmei, Li Rihua's great-grandson, is the best known.[1]

This album is important in illustrating the continuity of style from Li Rihua to Li Hanmei. Throughout there is an emphasis on sparse composition that recalls the work of the Yuan masters and expressive brushwork that evokes the spirit of Li Rihua's own paintings. Especially remarkable is the similarity of the trees, from the earliest works to the latest, constructed either with the "wet" horizontal foliage dots derived from Wu Zhen or with the drooping black strokes that appear in the opening sections of Li Rihua's *Rivers and Mountains in My Dream* (no. 3). Even the calligraphy is related. Such continuities reflect the filial respect of the successive generations as well as the identification of each individual with the family tradition.

A. The three leaves of calligraphy by Li Rihua comprise a poem of congratulation in honor of the seventieth birthday of one Baishi Daoren, who was most likely He Shi. A descendant of He Zhen (1322–1388), He Shi was a late Ming figure known for his paintings of orchids and of withering blossoms and dried leaves.[2] The poem suggests that Li Rihua and Baishi Daoren were about the same age, so it must have been written in the last years of Li's life, probably in the late 1620s or early 1630s.

Li's first painted leaf (no. 4 C) is undated but reveals the same compressed space, screen of trees, and Ni Zan-style kiosk and dry brushwork of *Rivers and Mountains in My Dream*, suggesting that it, too, comes from Li's mature period. The well-controlled washes of the second leaf (no. 4 B), enlivened with vigorous brushwork in the rocks and branches, show his interest in experimenting with the watery style of Mi Fu (1052–1107) and his son Mi Youren (ca. 1072–1151), perhaps as interpreted by the Yuan master Gao Kegong (1248–ca. 1310) or even the Ming painter Chen Shun (1483–1544). Li Rihua could well have known works by all these artists in the collection of Xiang Yuanbian.

B. In his only painting in this album, dated to the autumn of 1632, Li Zhaoheng typically draws on earlier models, combining the "hemp-fiber" texture strokes of Huang Gongwang with the schematic foliage of Wu Zhen. Following his father, he placed the river on a strong diagonal and overlapped the foreground trees and distant mountains to create a sense of spatial recession.

C. The son of Li Zhaoheng and grandson of Li Rihua, Li Qizhi was active in the mid-to late seventeenth century. Although his date of death remains unknown, a painting of plum blossoms dated to 1699 and bearing his signature indicates that he lived at least to the age of seventy-seven.[3]

Both of Li Qizhi's paintings in this album represent mountain vistas partially obscured by mist. The gentleness of these scenes and the use of a light blue wash in one of them to signal the most distant mountain peaks reveal a desire to please the eye rare in the works of the two previous generations of the Li family.

D. Perhaps a son of Li Xinzhi, and one of a group of cousins who were painters, Li Hanmei is the best known of the fourth and last significant generation of the Li family. His exact dates are unrecorded, but he must have been born in the mid-seventeenth century. Although the cyclical date (*renshen*) that appears on two of his three leaves in this album is the same as that on the leaf by Li Zhaoheng, it must correspond to 1692. The pleasing elegance of the scenes depicted in these leaves (no. 4 A) doubtless derives from works by Li Qizhi, but the preference for Yuan models and foliage types harks back to Li Rihua.

COLOPHON: Zhu Kuntian (1652–1699) facing one leaf by Li Qizhi

5. Two Letters from Album of Letters *Ming Xian shouji ce*

Li Rihua (1565–1635)
Ming, ca. 1616–1620
Four leaves (16–19) comprising two letters from an album of 32 leaves, ink on paper, one leaf with a seal of Li Rihua, 24.9 × 19.2 cm (leaves 16–17), 24.2 × 15.3 cm (leaves 18–19)
Gift of Mao Mingfen

ALTHOUGH these two letters by Li Rihua are undated, the mention of riots in Songjiang in the first one (leaves 16–17) probably refers to the two days of pillage that occurred on April 30 and May 1, 1616, in which Dong Qichang's home was

destroyed.[1] The calligraphic style of the second letter (leaves 18–19) is similar to that of the first, suggesting that the letters were written about the same time.

These very personal letters are elegantly written in a *xingshu*, or running script, derived from the master calligrapher Wang Xizhi (compare no. 29). Though more quickly and informally executed, the characters here resemble those in Li Rihua's inscriptions on *Rivers and Mountains in My Dream* (no. 3), especially in the long tails that swerve to the left in their downward descent. Such refined, graceful calligraphy is typical of the middle and late Ming and resembles that of Dong Qichang.

This album includes letters by fifteen prominent Ming literati of the fifteenth, sixteenth, and seventeenth centuries: Yu Qian (1398–1457), 2 leaves; Tu Jun (1497–1566), 2 leaves; Wang Ao (1450–1524), 1 leaf; Wen Jia (1501–1583), 2 leaves; Wang Shou (*jinshi*, 1526), 1 leaf; Ma Yilong (1499–1571), 1 leaf; Wang Zhideng (1535–1612), 1 leaf; Shen Xiang (16th century), 1 leaf; Xing Tong (1551–1612), 2 leaves, comprising 2 letters; Zeng Xian (1499–1548), 2 leaves; Li Rihua, 7 leaves, comprising 3 letters; Wang Siren (1575–1646), 1 leaf; Mi Wanzhong (1570–after 1628), 2 leaves; Ma Shiqi (1584–1644), 2 leaves; Zou Zhilin (*jinshi*, 1610), 5 leaves.

First letter translated in Chu-tsing Li's essay "The Literati Life" in this catalogue

COLOPHONS: Weng Tonghe (1830–1904; dated to 1889) and others

6. Ten Views of Nancun Villa

Du Qiong (1397–1474), *zi* Yongjia, *hao* Luguan Daoren, Dong-yuan

Ming, dated to 1443

Album of 16 leaves, including 10 painted leaves and 2 calligraphy leaves, ink on paper and ink and light colors on paper, each painted leaf with a title and one or two seals of the artist, calligraphy leaves with artist's inscription, signature, and transcription of poems by Tao Zongyi (1316–1403) on the Nancun Villa, 33.8 × 50.9 cm (average)

Gift of Gu Liu, Gu Duzhang, Gu Duqiu, Gu Fu, Gu Duxuan, and Shen Tongyue

DU QIONG was born into a wealthy family in the Taiping quarter of Suzhou.[1] He began his formal studies at the age of seven and shortly thereafter became a pupil of Chen Ji (1370–1434), the son of Chen Ruyan (ca. 1331–1371), a well-known official, poet, and literatus painter of the late Yuan. The precocious Du Qiong succeeded so brilliantly in his studies that Chen Ji chose him to teach his other tutees when he was summoned to government service in 1411. Du Qiong took his only trip to the north in 1420, when he accompanied his students to Beijing, the capital, so they could be examined on their ability to recite one of the emperor's exhortations on observance of the law. Du Qiong declined all offers of official position, preferring instead to remain in his native Suzhou, where he collected materials on local history for inclusion in imperial records and gained renown as a teacher, scholar, and author. His wealth seems to have increased over the years, for it is recorded that on several occasions he built new quarters, opened new gardens, and acquired more land. Although he sometimes is said to have studied with Tao Zongyi, Du

Qiong was born far too late to have had any but the most casual, childhood contact with that eminent scholar.

Few paintings by Du Qiong are extant and the histories mention virtually nothing about his artistic training. His father Du Yu (d. 1397) had an extensive library and collection of antiquities, indicating that the family was a learned one. It is likely that Du Qiong received his first instruction in painting and calligraphy from his teacher, Chen Ji, who no doubt perpetuated the artistic traditions of his father, Chen Ruyan. While Du Qiong claimed the tenth-century painters Dong Yuan (d. 962) and Monk Juran (active 960–980) as his models, his paintings are actually more closely related to those of the late Yuan masters, especially Ni Zan and Wang Meng—both close friends of Chen Ruyan—and Huang Gongwang. It is likely that he was a recognized connoisseur of his day, for his inscriptions and colophons appear on a number of ancient paintings.

Although Du Qiong was a painter of great accomplishment, history remembers him better as scholar and teacher, especially because he played such a crucial role in transmitting scholarship and literati ideals to the new culturally elite group then emerging in Suzhou, China's cultural and economic center in the early and mid-Ming.[2] With imperial patronage showered upon professional artists, the newly established literati tradition floundered in the early Ming and few artists chose to work in that mode. Du Qiong was thus vitally important in carrying forward the theory and practice of literati painting, an endeavor in which the painters Wang Fu (1362–1416), Liu Jue (1410–1472), and Yao Shou (1423–1495) also shared. The erudite Du Qiong was perhaps the most important among this group of painters, however, not only because of his scholarship but because he was one of the first to achieve a true synthesis of late Yuan literati styles. Many of the region's great scholars studied with Du Qiong in their youth, including the painter Shen Zhou (1427–1509) and the poet and calligrapher Wu Kuan (1436–1504); the latter contributed a colophon to this album in 1481. (In his colophon, Dong Qichang remarks that Shen Zhou's father, Shen Heng [*zi* Hengji, 1409–1477], studied with Du Qiong.)

Although there was a long tradition of representing generalized garden scenes in Chinese painting, and even of depicting such classical favorites as the Wangchuan Villa of Wang Wei (701–761) and the Longmian Garden of Li Gonglin (1049–1105/06), this album ranks among the earliest topographical works in Chinese painting, since it is based on an actual estate of the late fourteenth century. One of the most important works in the exhibition, it depicts ten views of Nancun Villa, the home of the scholar Tao Zongyi. Tao was one of the most famous literati of the late Yuan and early Ming, renowned for his poetry and historical writings. He lived most of his life in Songjiang, but after various contending troops ransacked the city in 1356 he moved to nearby Sijing, where he purchased a country house that became known as the Nancun caotang (Thatched Hall of South Village). The villa is well recorded in art and literature. Tao Zongyi himself composed a series of poems called "Nancun bieshu shijing yong" ("Songs on the Ten Views of Nancun Villa"), and it is these poems that Du Qiong illustrated in this album and transcribed on separate leaves at the end.

Du Qiong's genius, as seen in this album, lay in his ability to synthesize elements from preceding masters to form a new and highly original style, a quiet style that was at once vibrantly expressive and compellingly appealing. Too few

works by Du Qiong remain to permit a detailed study of his style and its development. In its varied brushwork, refined delicacy, light colors, and reliance upon Yuan models, however, the present album compares favorably with other works from his hand.

The title of this album was written by Zhou Ding (*zi* Boqi, 1401–1487) of nearby Jiashan, Zhejiang province. A scholar, calligrapher, and minor painter, Zhou may well have been a friend of Du Qiong.

Ten Views of Nancun Villa is important in the late Ming context of this exhibition because it includes colophons by Li Rihua, Dong Qichang, and Chen Jiru, among others, attesting their skill as connoisseurs and art historians. While it is often said that Dong Qichang and the members of his circle disliked paintings by Wu school artists, they did, in fact, admire works by its earlier masters, as indicated by their appreciative inscriptions here (see discussion, no. 3).

> Colophons by Li Rihua, Dong Qichang, and Chen Jiru translated in Chu-tsing Li's essay "The Literati Life" in this catalogue
> TITLE: Zhou Ding
> COLOPHONS: Zhou Jiazhou, Wu Kuan (dated to 1481), Yang Xunji, Wen Bi (Wen Zhengming, dated to 1507), Yang Longyou (Yang Wencong), Dong Qichang, Wang Duo, Zhu Taizhen, Li Rihua (dated to 1629), Chen Jiru (dated to 1629), Fei Nianci (dated to 1890)
> RECORDED: *Peiwenzhai shuhua pu, Liuyanzhai er bi, Guoyunlou shuhua ji*
> PUBLISHED: Shanghai bowuguan, *Shanghai bowuguan cang hua (Paintings in the Shanghai Museum)*, Shanghai: Renmin meishu chubanshe, 1959: no. 36
> Facsimile reprint (black-and-white) in album format by the Shanghai Museum

7. Herb Mountain-Cottage

Wen Jia (1501–1583), *zi* Xiucheng, *hao* Wenshui
Zhu Lang (active mid-16th century), *zi* Zilang, *hao* Qingqi
Qian Gu (1508–ca. 1578), *zi* Shubao, *hao* Qingshi
Ming, dated to 1540
Handscroll, ink and light colors on paper, with inscriptions and signatures of the artists (and others) on a separate sheet of paper following the painting, 28.3 × 114.8 cm (painting), 28.3 × 595.0 cm (with inscriptions)
Gift of Shen Tongyue

THIS MAGNIFICENT handscroll was a collaborative work by Wen Jia, Zhu Lang, and Qian Gu, all from Suzhou and all pupils and followers of Wen Zhengming (1470–1559), the celebrated genius who carried the Wu school to its zenith during the first half of the sixteenth century.[1] Since Wen Zhengming studied painting with Shen Zhou, the three painters of this scroll may be considered artistic descendants of Shen Zhou and of Shen's teacher Du Qiong (no. 6).

The second son of Wen Zhengming, Wen Jia learned poetry, painting, and calligraphy from his father as a youth. He worked very closely in his father's manner, as did the other two artists of this scroll, but he also sought inspiration in the exuberant compositions of Wang Meng and in the crisp, dry brushwork of Ni Zan. In its use of a dense, Wang Meng–style composition combined with texture strokes and dots derived from Wu Zhen, *Herb Mountain-Cottage* is typical of mid-sixteenth century Wu school works. It compares favorably

with other paintings by the same artists dated to the 1540s and 1550s, such as Wen Jia's *Blue and Green Landscape for Jin Menglan* of 1553 in the collection of C.C. Wang and Family, New York.[2] The fine drawing, light colors, sophisticated patterning, and high refinement seen in this painting are hallmarks of the Wu school and contrast markedly with the powerfully expressive brushwork of the later Songjiang school, which developed in the early seventeenth century and is the focus of this exhibition.

According to Wen Jia's inscription, this painting was done in 1540 at a literary gathering held on an autumn evening at Herb Mountain-Cottage. The participants composed poetry and, in addition, Wen, Zhu, and Qian did this painting, depicting the Herb Mountain-Cottage and the gentlemen who attended the gathering. Wen Jia further notes that Cai Shupin, the owner of the cottage, added the rocks and Shi Minwang the narcissus.

Such collaborative works were not uncommon among artists of the Wu school, whose styles were quite similar, and they underscore the almost familial relationships that existed among the literati in a given locale. Several other participants at the gathering were also Wu school artists but apparently did not contribute to this painting. Wen Jia's elder brother, Wen Peng (1498–1573), attended the event, for example, and composed one of the poems. In the context of this exhibition, Wen Peng is best remembered as the teacher of He Zhen (active Wanli period, 1573–1620), a famous literati seal carver (nos. 72 B and C).

The scholar's retreat was a typical subject of literati painting and was frequently portrayed by Wen Zhengming, Qiu Ying (1494/95–1552), and other artists of the Wu school. Herb gardens occasionally appear in their paintings, attesting an interest in plants and medicine on the part of the curious and learned literati.[3] In this painting the cottage—nestled amidst lush bamboo, fantastic rocks, a sculptured pine, and other trees—affords an idyllic retreat from the world. Inside, potted plants, a bronze *ding* incense burner (see no. 85), and a "hanging gall-shaped" *guan*-ware vase (see no. 88) establish the proper literati setting. An herb garden with chrysanthemums and other plants completes the scroll.

Following the painting are Wen Jia's inscription, the poems composed by the participants in the literary gathering, and colophons by Li Rihua and Chen Jiru. Chen discusses the gathering and compares it to other famous literary meetings; Li, on the other hand, discusses matters of connoisseurship and states that he had seen three forged versions of this painting. At the time Li and Chen saw it, the scroll must have been in the possession of Xu Renqing, a hermit-literatus of Jiaxing known for his poetry and calligraphy and for his art collection.

The *Herb Mountain-Cottage* handscroll, the Du Qiong album (no. 6), and the *guan*-ware vase (no. 88) are important in illustrating the late Ming love and understanding of antiquities. In addition, this scroll and the Du Qiong paintings portray the types of gardens and scholarly retreats in which Li Rihua, Dong Qichang, Chen Jiru, and the other artists of their circle must have enjoyed themselves and held literary gatherings of their own.

> Wen Jia's inscription and the colophons by Li Rihua and Chen Jiru are translated in Chu-tsing Li's essay "The Literati Life" in this catalogue
> INSCRIPTION: Wen Jia

POEMS: Wen Peng, Lu Zhi, Wen Jia, Peng Nian, Shen Damo, Zhou
Tianqiu, Shi Yue, Qian Gu, and Zhu Lang
COLOPHONS: Chen Jiru, Li Rihua, Cheng Tinglu (dated to 1858),
Zhang Qin, and Gu Wenbin (dated to 1862)
EX-COLLECTION: An Qi

8. Exquisite Scene of Lakes and Mountains

Li Zhaoheng (ca. 1592–ca. 1662)
Ming–Qing, probably late 1640s or 1650s
Hanging scroll, ink on paper, with inscription, signature, and two
seals of the artist, 112.5 × 51.1 cm

REFERENCES to Yuan painting abound in this hanging
scroll, which depicts a landscape near Lake Tai, northwest of
Jiaxing. The basic composition, with its foreground landmass
separated from distant mountains by a body of water, derives
from Yuan models, although the intrusion of a middle-
ground hill is a Ming innovation. In his inscription Li
Zhaoheng mentions both Ni Zan and Huang Gongwang, and
elements of their styles are clearly present. The delineation
of the foreground with dry brushstrokes accentuated with
"moss dots" relates to works by Ni Zan, for example, and the
"hemp-fiber" texture strokes and broad, rounded mountain
forms recall those of Huang Gongwang.

The lake and the foreground trees establish strong diago-
nals within the carefully balanced composition. As in the
works of Li Zhaoheng's father, Li Rihua, these diagonals im-
part great power and majesty to the composition. The mists
shrouding the base of the mountains not only clarify spatial
relationships but enhance the grandeur of the scene in their
suggestion of limitless space. The trees in this scroll echo
those of Li Rihua (no. 3), but in general the landscape is less
severe. In its dry brushwork, its atmospheric effects, and its
concern with grandeur, this painting also calls to mind works
by Xiang Shengmo (no. 19), not surprising in light of Xiang
and Li Zhaoheng's close friendship.

Although he is not well known today, Li Zhaoheng is said
to have competed in fame with Zhao Zuo (ca. 1570–after
1633, no. 14) in his day. Li Zhaoheng's works do not usually
bear a close stylistic resemblance to Zhao Zuo's atmospheric
landscapes, but this painting recalls a landscape hanging
scroll by Zhao in the Kurosawa Institute, Japan.[1]

Its thorough mastery of technique indicates that this excel-
lent landscape must have been painted in Li Zhaoheng's ma-
ture years, probably in the late 1640s or early 1650s, and
slightly later than the album dated to 1646 (no. 9). With its
large forms that interact with each other and with the inter-
vening open spaces, the composition is a fully mature one
that incorporates the hallmarks of the Songjiang school.

Inscription translated in Chu-tsing Li's essay "The Literati Life"
in this catalogue

9. Album of Calligraphy and Landscape Paintings

Li Zhaoheng (ca. 1592–ca. 1662)
Qing, 2 leaves dated to 1646
Album of 6 leaves, ink on paper, with inscriptions, signatures,
and seals of the artist, 25.3 × 28.3 cm

EACH OF THE SIX leaves in this album has a landscape
painting on the right and an inscription on the left. The in-
scriptions are largely autobiographical. The second leaf is of
special interest because it sheds light on the conditions of the
literati shortly after the fall of the Ming in 1644. Li writes
that he returned to live in his home in Luoxi during the
summer of 1646, indicating that he must have gone away
during the worst months of 1645 and 1646 when invading
Manchu troops looted Jiaxing and left much of it in ruins.
Sometime thereafter, Li became a Buddhist monk.[1]

Li Zhaoheng's discussions of paintings in his collection are
also enlightening. The most intriguing is his inscription on
the fourth leaf in which he refers to a manual of bamboo by
the Yuan master Wu Zhen in his collection and quotes six
lines of poetry that Wu had written on one of the leaves.
Those same six lines appear on the eleventh leaf of Wu
Zhen's most famous manual of ink bamboo—the one dated
to 1350 now in the Palace Museum, Taibei—indicating that it
is the one Li Zhaoheng owned. The appearance of Li's seals in
the Palace Museum manual confirms his ownership.[2] Such
information not only sheds light on Li Zhaoheng as a collec-
tor but enriches our understanding of the provenance of Wu
Zhen's manual of ink bamboo. In the same inscription Li
Zhaoheng further notes that Wu Zhen, also a native of Jia-
xing, had lived in the vicinity of his own home, which may
explain some of the Li family interest in imitating Wu's style.

In his inscription on the fifth leaf (no. 9, left) Li Zhaoheng
does not specifically refer to Zhao Mengfu (1254–1322) but
mentions a painting entitled *Water Village*, the most famous
version of which was done by Zhao Mengfu (now in the Pal-
ace Museum, Beijing). With its pointed mountains, leafless
willow trees, and wet marshy lands, the painting on the fac-
ing page recalls such works by Zhao as *Water Village* and *The
Autumn Colors on the Qiao and Hua Mountains*.[3] There is
an excellent chance that Li Zhaoheng was well acquainted
with these two famous scrolls since they had been in the
collection of Xiang Yuanbian and since Li Zhaoheng's father,
Li Rihua, had recorded *Water Village* in his writings.[4]

The paintings in this album, done for Xiang Shengmo,
compare favorably in style with others by Li Zhaoheng (nos.
4 and 8). Like the inscriptions, they evince the artist's inter-
est in exploring styles established by celebrated masters of
the Yuan. Although Li often combined the manners of sev-
eral different artists in his works, the style of a single master
usually predominates. In this album, for example, the chief
models were Huang Gongwang, Wu Zhen, Ni Zan, and Zhao
Mengfu. The other major master of the Yuan, Wang Meng,
seems not to have held great appeal as a model for members
of the Li family, perhaps because his works were too complex
for their taste. The mountain forms in the first leaf also recall
works by the Yuan artist Lu Guang (active mid-14th century).
Since Lu Guang's style was related to Huang Gongwang's and
since Li Rihua is known to have inscribed works by Lu
Guang,[5] the possibility of influence is very real.

This album is important not only for the content of its
inscriptions, but because it is dated. Done in the late summer
or early autumn of 1646, these leaves are about fourteen years
later than Li Zhaoheng's dated leaf in *Painting and Calligra-
phy by Four Generations of the Li Family* (no. 4) and reveal a
much more mature hand. Although there are still references
to his father's style, the album illustrates Li Zhaoheng's inde-
pendence in pursuing his own personal mode of expression.
The paintings show a preference for deep spaces, for example,

with clearly established spatial grounds that are often linked together with a body of water which recedes directly into the composition in a continuum from the foreground to the background.

> Inscription on leaf 2 translated in Chu-tsing Li's essay "The Literati Life" in this catalogue
> TITLE SLIP: Wu Hufan; 17 collectors' seals

10. Landscape

> Dong Qichang (1555–1636), *zi* Xuanzai, *hao* Sibai, Xiangguang
> Ming, ca. 1610–1620
> Folding fan mounted as an album leaf, ink and color on gold paper, with signature and seal of the artist, 21.5 × 48.5 cm

WELL KNOWN to all students of Chinese art, Dong Qichang (see no. 1) was the preeminent figure of the late Ming, and his style and theories have continued to shape the course of Chinese painting down to the present. Dong was equally talented as a painter, calligrapher (see no. 11), connoisseur, theorist, and art historian.[1]

Originally mounted on a folding-fan frame (compare nos. 69 C and D and 91), this painting depicts a mist-enshrouded landscape with distant mountains and foreground houses shaded by lakeside trees. To accommodate the challenging format, Dong Qichang concentrated the representational elements in the center of the composition, along the central vertical axis, and allowed the edges to melt into mist and water. Since the rounded promontory in the foreground strongly echoes the arc of the fan, the distant ground planes needed to curve only slightly to harmonize with the fan shape. The life of the painting stems not only from the vibrant brushwork on gold paper but from the counterbalanced diagonals at work in the well-planned composition.

The atmospheric effects of this painting derive ultimately from the tenth-century artist Dong Yuan, but the bold composition and marvelous brushwork were inspired by Yuan models. The brilliant harmony of format and landscape scene indicates that this is a fully mature work, probably done between 1610 and 1620. The attention given to tree leaves and surface textures, in particular, argues against a date after 1623, when Dong Qichang's works became their most free and spontaneous.

Although some artists of the late Ming modeled their paintings on the monumental landscapes of the Song period, Dong Qichang and the artists of his circle obviously chose to follow the masters of their newly defined Southern school. The paintings in this exhibition thus frequently allude to the styles of Dong Yuan and Monk Juran of the Five Dynasties and especially to Wu Zhen, Ni Zan, and Huang Gongwang of the Yuan. Northern school paintings are frequently followed, however, in contemporaneous three-dimensional arts which include pictorial scenes, inksticks (nos. 75 and 77) and bamboo wrist rests (no. 57), for example.

> PROVENANCE: One seal of Wang Ti reading *Xuzhai cangshan* at the left edge

11. Four Poems for Chen Jiru

> Dong Qichang (1555–1636)
> Ming, dated to 1619
> Handscroll, ink on "mirror-face" paper (*jingmianjian*), with inscription, signatures, and four seals of the artist, 25.9 × 113.0 cm

THROUGH NATURAL talent, disciplined study, and knowledge of genuine works by ancient masters gained through contact with the eminent Jiaxing collector Xiang Yuanbian, Dong Qichang matured into a seasoned calligrapher. By the time he received the *jinshi* degree in 1589, at the age of thirty-four, he was recognized as an accomplished master. In fact, he is counted as one of the Four Great Calligraphers of the late Ming, along with Xing Tong, Zhang Ruitu (1570–ca. 1641), and Mi Wanzhong.

As a child, Dong Qichang most likely learned to write in the manner of Zhao Mengfu, Zhu Yunming (1461–1527), and Wen Zhengming, the three calligraphers whose styles were the most influential in the mid-Ming period. By Dong's own admission, he committed himself to excellence in calligraphy at the age of sixteen, after learning that it was only his mediocre handwriting that kept him from taking first place in the annual prefectural examinations. He then began to practice calligraphy in earnest, imitating such Tang masters as Yan Zhenqing (709–785, no. 81) and Yu Shinan (558–638), mainly through the study of rubbings (compare nos. 29, 30, and 81). Later, he progressed to the styles of Zhong You (151–230) and Wang Xizhi (compare no. 29). From the study of works by these masters he developed his own distinctive style, which is bold and powerful yet mellow and graceful.

Like Li Rihua, whom he probably first met while working for Xiang Yuanbian in the late 1570s, Dong Qichang was a literatus who served as a government official. Also like Li Rihua, he retired during his most productive years—the fifties and sixties in Dong's case—which allowed him the freedom and leisure to digest his experiences, synthesize his knowledge, and evolve his distinctive styles and theories. In fact, the last years of his long retirement—especially the ones from 1617 to 1623—proved to be some of the most critical and productive ones of his artistic career.

This handscroll comprises four poems that Dong Qichang wrote in 1619 for his longtime friend Chen Jiru (see nos. 12 and 13). Written in the *xingshu*, or running script, for which Dong is best known, the characters combine the directness and clarity of Tang calligraphy with the characteristic grace and elegance of Song. In an inscription at the end of the second poem and in another at the end of the fourth, he states that all were written for Chen Jiru. A signature reading *Dong Qichang* follows the first inscription, and one reading *Qichang* follows the second. This is entirely typical, for Dong usually signed his calligraphic works with his formal name and his paintings with his sobriquet *Xuanzai*.[1] The calligraphy of these poems compares favorably in style with two other examples of Dong's calligraphy in the exhibition that were done about the same time, the title inscribed for Chen Jiru's *Record of the Old Huayan Monastery* (no. 12) and the colophon for Zhao Zuo's landscape handscroll (no. 14).

These poems are four of thirty recorded ones that Dong Qichang wrote in honor of Chen Jiru, commenting on his personality, character, and talent as an author. In typical late

Ming style, all employ the same rhyme scheme and are replete with obscure allusions that reflect Dong's vast knowledge. Some of the allusions refer to Chan Buddhism, others to Daoism, and yet others to ancient history and literature. All thirty of the poems for Chen Jiru appear in Dong Qichang's *Rongtai ji*.[2]

Dong Qichang used "mirror-face" paper (*jingmianjian*) for this handscroll, as Gao Shiqi (1645–1703) noted in his colophon. The term refers to a very smooth paper that is heavily sized so that the ink does not penetrate easily. The brushstrokes are thus sharp and distinct with absolutely no blurring of edges. "Mirror-face" paper was not common in the late Ming, but it was used occasionally by Dong Qichang and members of his circle (compare no. 14).

Dong Qichang enjoyed great fame as a painter (see no. 10) and calligrapher during his lifetime. After his death his fame increased, not only because of the excellence of his work but because the Kangxi and Qianlong emperors imitated his calligraphic style. In 1705, on his fifth tour of the south, the Kangxi emperor wrote an essay on Dong's work and had a commemorative tablet erected in Dong's temple in Songjiang. The Qianlong emperor not only wrote and painted in Dong's style but also collected a large number of his works.

COLOPHONS: Colophon and three seals of Gao Shiqi (dated to 1698); colophons by Zhang Yurui (dated to 1773) and Wu Hufan (dated to 1953); 19 collectors' seals

12. Record of the Old Huayan Monastery

Chen Jiru (1558–1639), *zi* Zhongsun, *hao* Meigong, Migong, Midaoren, Xuetang, Boshiqiao, Pinwai Jushi
Title written by Dong Qichang (1555–1636)
Ming, dated to 1619
Album of 30 leaves (including title and colophons), ink on paper, with inscription, signature, and seals of the artist, 30.0 × 37.5 cm
Gift of Zhang Gongyu

A NATIVE OF Songjiang, Chen Jiru (see no. 1) was a lifelong friend of Dong Qichang and is regarded as one of the Seven Most Talented Men of Letters of the late Ming.[1] Although he was a man of great learning and a prolific author who wrote with elegant clarity, he never advanced beyond the licentiate degree in the civil service examinations. An exemplar of the hermit type of literatus, he withdrew from society to concentrate on his research and writing and supported himself largely by teaching.

From at least the Tang period onward there was a tradition among scholars of writing records of temples in elegant calligraphy. The celebrated Tang calligrapher Yan Zhenqing is well known for his *Record of the Altar to the Immortal Magu* (no. 81), for example, and Zhao Mengfu's *Record of the Miaoyan Temple*, now in the John B. Elliott Collection at The Art Museum, Princeton University, ranks among his calligraphic masterpieces.[2] In the present work Chen Jiru briefly describes the history of the Old Huayan Monastery.

Written in *xingshu*, or running script, the calligraphy of this album is bold yet refined and graceful (no. 12 A). The style derives from works by Song masters, especially Su Shi and Mi Fu, and is closely related to that of Dong Qichang. It

compares favorably with the colophon that Chen Jiru wrote on the handscroll by Zhao Zuo (no. 14).

Dong Qichang inscribed the title of this album (no. 12 B–E), and a number of prominent late Ming literary and political figures—some of whom were active in the Donglin movement—wrote colophons for it. Dated to 1624, Li Rihua's colophon (no. 12 F and G) shows strong similarity in calligraphic style to other works from his hand in the exhibition (nos. 3–5).

TITLE: Dong Qichang
COLOPHONS: Zhao Huanguang, Bi Longding, Tang Shiji, Zhu Guozhen, Wen Zhenmeng, Qian Shishu, Fan Yunlin, Shi Zhixian, Fang Gongqian, Hou Tongzeng, and Li Rihua

13. Dewdrops in Early Autumn

Chen Jiru (1558–1639)
Ming, probably 1620s or 1630s
Hanging scroll, ink and light colors on paper, with title, inscription, signature, and seals of the artist, 121.0 × 29.6 cm

CHEN JIRU is best known as an author and calligrapher (no. 12), but as this lyrical scene indicates, he was also an accomplished painter. Although Chen was a man of humble means who led a reclusive life, he was able to collect on a modest scale and amassed a large library. Through his visits to the Jiaxing collector Xiang Yuanbian, beginning in the late 1570s, he developed a firm understanding of the history of Chinese painting and calligraphy and sharpened his keen eye. Chen matured into a distinguished connoisseur, and many of the greatest Song and Yuan paintings bear his seals or colophons along with those of Dong Qichang and Li Rihua.

Little is known of Chen Jiru's early artistic training. He could well have studied with his fellow townsmen Gu Zhengyi (active ca. 1570–1596) and Mo Shilong (1539?–1587), the same two literati with whom Chen's friend Dong Qichang studied. *Dewdrops in Early Autumn*, however, shows stylistic affinities to works by Song Xu (1525–ca. 1607) and Sun Kehong (*hao* Xueju, 1532–1610), indicating that Chen Jiru may have studied with one of them or at least learned from their works. A well-known local painter, Song was apparently born in Jiaxing but moved to Songjiang; he was active in poetry and painting circles there and attracted a number of students and followers, including Zhao Zuo (no. 14). A native of Songjiang, Sun Kehong was a scholar-official (see discussion, no. 60); he was also a well-known painter in his own day and his works resemble those of Song Xu in style.

In his inscription in the upper left corner of this hanging scroll, Chen Jiru states that he has imitated the manner of Huang Gongwang. In fact, the theme, rock forms, autumnal trees, "hemp-fiber" texture strokes, and densely packed composition all have more to do with the style of the tenth-century monk-painter Juran than with Huang Gongwang. Perhaps the mention of Huang in the inscription is to be interpreted as a reference to artistic lineage since Huang also followed the manner of Juran. *Dewdrops in Early Autumn* bears some similarity to *Mountains and Woods*,[1] one of several hanging scrolls in the Palace Museum, Taibei, associated with Monk Juran. Since it was Dong Qichang who first at-

tributed this unsigned to work to Juran, it is possible that Chen Jiru also saw it.

Although Chen shared many views on painting theory with Dong Qichang, their styles could be quite different as revealed by this work. Here, Chen Jiru has followed the lead of Song Xu and created an attenuated, densely packed composition that assumes a high vantage point, in this case level with the distant, hilltop temple. He has also tried the novel experiment of focusing on the middleground, where the scholar waits for his servant to catch up. Since Chinese hanging scrolls are customarily read from the bottom up—with the higher portions of the composition representing areas ever further away from the viewer—the effect of this painting is somewhat unsettling at first glance, but it is ultimately successful. Obviously aware of the viewer's possible initial confusion, Chen framed the immediate foreground with steep cliffs which help to locate the proper vantage point.

In his willingness to challenge established principles of compositional organization, Chen was an active participant in the late Ming search for new modes of expression within a highly traditional framework. Unlike Li Rihua (no. 3), who employed a sparse composition with shifting vantage points, Chen Jiru created a densely packed composition with a single vantage point, but the interest of these two artists in transforming standard conventions into something entirely new is closely related. In pushing the scene to the borders of the composition, *Dewdrops in Early Autumn* is akin to Lu Dezhi's *Orchid and Rock Amidst a Clump of Bamboo* (no. 20); in its use of compressed space it relates to Li Rihua's *Rivers and Mountains in My Dream* (no. 3). While later artists tended to base their works on ones by Dong Qichang, with the result that works by other late Ming painters have become less well known, these fascinating experiments by Li Rihua and Chen Jiru reveal the tremendous intellectual and creative vitality of the late Ming.

14. Autumn Mountains Without End

Zhao Zuo (ca. 1570–after 1633), *zi* Wendu
Ming, dated to 1619
Handscroll, ink and colors on "mirror-face" paper (*jingmianjian*), with inscription, signature, and two seals of the artist, 28.3 × 424.2 cm

ZHAO ZUO was born in Songjiang and spent most of his life there, although he moved his home to Tangxi in his last years to be near the captivating scenery of West Lake, Hangzhou.[1] He was known as both a poet and a painter, but little of his poetry survives, save a few lines inscribed on paintings. He lived most of his life in poverty and probably relied upon the sale of paintings for his livelihood. Like the members of Dong Qichang's circle, with whom he was well acquainted, Zhao Zuo was also an art theorist and author. Although his ideas, as expounded in his brief *Hualun* (*Discussions on Painting*), are not as revolutionary as those of Dong Qichang, his writings evince his concern with, and participation in, the profound reshaping of Chinese painting that was occurring in the late Ming.

One of Zhao Zuo's finest works, *Autumn Mountains Without End* represents the lightly colored, atmospheric landscape style for which the artist is best known. In his *Hualun*, Zhao Zuo emphasized representational goals, stating that bridges, figures, villages, and temples should all be included in paintings. They not only appear in abundance in this painting but are set exactly as Zhao prescribed: villages partially concealed in groves of trees, pebbles and boulders in recessed stream beds, faraway trees rendered indistinctly, and supplementary trees grouped together.[2] Although Zhao Zuo espoused selected theories expounded by Dong Qichang and the members of his circle, his paintings are usually less severe than ones by artists of the Songjiang school, who typically worked in monochrome ink and who seldom depicted figures or buildings other than the Ni Zan-style kiosk.

The compositional organization of this beautiful handscroll is remarkably similar to that of Li Rihua's *Rivers and Mountains in My Dream* (no. 3). In his inscription, dated to 1619, Zhao Zuo indicates that *Autumn Mountains Without End* was done in the manner of Huang Gongwang, as was Li Rihua's handscroll, which was painted only six years later, in 1625. The references to Huang Gongwang include the compositional arrangement, tree types, rounded mountain forms, and "hemp-fiber" strokes which texture the mountain surfaces. More than anything else, they allude to the painting's spontaneity and lively brushwork. While Huang Gongwang worked mainly in tones of pure ink, Zhao Zuo added his own interpretation through the use of soft colors.

Autumn Mountains Without End reflects the high quality of Zhao Zuo's mature works. The painting is freer and more relaxed than some of his earlier handscrolls, such as *Streams and Mountains Without End*, of 1612, in The Metropolitan Museum of Art, New York.[3] It compares favorably in style with a handscroll depicting a *Summer Landscape*, dated to 1620 and in the Kurosawa Institute, Japan.[4] The calligraphy of the inscriptions in the Shanghai Museum and Kurosawa Institute scrolls is also very similar: elongated *kaishu* (standard script) characters that, in their slightly mannered way, border on *lishu* (official script).[5] Zhao's interest in *lishu* had already expressed itself in the inscription on the Metropolitan Museum scroll of 1612.[6]

Both Dong Qichang and Chen Jiru wrote colophons for this handscroll. Though undated, the colophons were probably done in 1619, the year of the painting itself, or shortly thereafter. The calligraphy of the colophons agrees with other calligraphic works of similar date by Dong Qichang and Chen Jiru in this exhibition, namely, Dong's *Four Poems for Chen Jiru* (no. 11) and Chen's *Record of the Old Huayan Monastery* (no. 12). Both the painting and Dong Qichang's colophon were executed on "mirror-face" paper (see discussion, no. 11).

Artist's inscription and the two colophons translated in Chu-tsing Li's essay "The Artistic Theories of the Literati" in this catalogue
COLOPHONS: Colophons and seals of Chen Jiru and Dong Qichang; 8 collectors' seals

15. Illustrations to Poems by Wang Wei

Xiang Shengmo (1597–1658)
Ming, ca. late 1620s or early 1630s (before 1635)
Album of 12 leaves, ink on paper, each leaf with poetry by Wang Wei (701–761) and a seal of the artist, 12.1 × 15.6 cm

ALTHOUGH Xiang Shengmo obviously studied the classics as a youth in preparation for a career in government service, he gave up the pursuit of office at an early age, and, like Chen Jiru, aspired to the life of a hermit.[1] He decided as a young man to devote himself to painting and had already become a talented and accomplished master by his late twenties. Little is known of his artistic training, but he likely received his earliest instruction from his father, Xiang Deda,[2] and his uncles who painted orchids, rocks, and bamboo, and occasionally small landscapes. Traditional sources state that he practiced assiduously as a youth which enabled him to learn painting merely by copying the old masters and by drawing from nature.

Whatever his training, Xiang Shengmo's earliest works were done in the manner of Wen Zhengming—a manner that he continued to explore throughout his life. Although Xiang was close to Dong Qichang and Li Rihua, his works reveal little influence of the Songjiang school. Xiang is best known for his elegant but meticulous draftsmanship which led some critics to categorize his works as "combining the excellence of the literati with the consummate skill of the professional."

The twelve leaves of this intimate album illustrate lines of poetry by Wang Wei, the celebrated poet-painter of the Tang dynasty. All depict landscapes, but the individual scenes range from river views with birds and tall trees, to thatched cottages concealed in dense groves, to precipitous mountain peaks with tumbling waterfalls. Though the pleasures of solitude and reclusion are apparent throughout, the moods and seasons depicted vary considerably, some leaves portraying the lush vegetation of spring and summer and others the sparse foliage of autumn and winter. Atmospheric effects also differ, from mist-enveloped vistas to crystal-clear panoramas. An early and very personal work, this album includes not only a range of styles and manners but a degree of spontaneity seldom encountered in Xiang Shengmo's more formal compositions (compare nos. 17–19).

A poet himself, Xiang Shengmo must have felt a special kinship to Wang Wei, whose poems speak of the beauty of nature, the rewards of reclusion, and the pleasures of friendship. Xiang probably took Wang Wei as a model, since by Ming times Wang's poetry and paintings were said to be interchangeable. Later critics would say the same of Xiang Shengmo's own compositions. In addition, because Dong Qichang and his circle regarded Wang Wei as the patriarch of their hallowed Southern school, no other poet's work could have been more appropriate as the theme for a series of paintings.

This small album reflects Xiang Shengmo's tremendous creativity, as he sought not only to suggest varied effects but to explore the styles of a number of ancient masters. Xiang drew upon a wide range of sources for these paintings, often imitating Wu Zhen's trees, Ni Zan's dry brushwork, Huang Gongwang's "hemp-fiber" texture strokes, and Ma Yuan and Xia Gui's "axe-cut" strokes. The compositions are even more varied, some deriving from Ni Zan, others from Ma Yuan (active 1190–after 1225) and Xia Gui (active early 13th century), and yet others from the Wu school; many, however, are purely of his own invention. Interestingly, some of the more dense compositions that expansively crowd their borders assume high vantage points, recalling works by Song Xu, Sun Kehong, and Chen Jiru (no. 13).

Although this album is undated, the crowded compositions and the interest in caves and other unusual landscape features point to a relatively early date, as do the angular rock forms and the hard-edged washes reminiscent of Ma Yuan and Xia Gui. All these elements find parallels in Xiang Shengmo's first scroll of the series entitled *Calling for Reclusion*,[3] dated to 1626 and now in the Los Angeles County Museum of Art. In any event, since it includes an appreciative inscription by Li Rihua, the album must have been painted before 1635, the year of Li's death.

COLOPHONS: Inscriptions and seals of Dong Qichang, Chen Jiru, Li Rihua, and Ding Yuangong; 23 collectors' seals
TITLE SLIP: Wu Hufan

16. Album of Flowers

Xiang Shengmo (1597–1658)
Ming, 1 leaf dated to 1643
Album of 10 leaves, ink and colors on paper, each leaf with inscription, signature, and one or two seals of the artist, 28.0 × 43.0 cm

EXQUISITELY PAINTED in delicate colors, each of the ten leaves in this album depicts a solitary branch in full bloom against an open background. A short poetic inscription accompanies each branch, identifying the flower and suggesting a context. The inscription on the ninth leaf bears a date that corresponds to 1643.

The quiet colors and sparse compositions of these paintings embody the subtle, refined taste of the late Ming literati and recall their preference for delicately colored ceramics such as *ge* and *guan* wares (nos. 31–34, 88 and 89). Although Dong Qichang and other artists of the Songjiang school seldom used color in their works, Xiang Shengmo, like Zhao Zuo (no. 14), was of a more independent mind and occasionally employed pigments when exploring the style of a past master known for his use of color. In addition, he was partial to Wen Zhengming and other members of the Wu school, in whose works subtle colors played an important role (see nos. 6 and 7).

Although the depiction of single flowering branches had already begun in the late Northern Song and flourished in the Southern Song, in true late Ming literati fashion Xiang Shengmo alludes to a Yuan model in this album, most likely to Qian Xuan (ca. 1235–after 1301), who was known for his quiet scenes of flowering branches. Xiang could not have known it in 1643 when he painted this album, but the scholarly, reclusive Qian Xuan would in fact prove a perfect model for him since Qian also saw the collapse of his native Song dynasty and had to live his remaining years as an *yimin* under the foreign Yuan (Mongol) dynasty.

Among Qian Xuan's few surviving works, one stands out as a possible prototype for the leaves in the present album: the short handscroll depicting a branch of blossoming pear formerly in the Percival David Collection, London, and now in The Metropolitan Museum of Art, New York.[1] Since the scroll bears two seals of Xiang Yuanbian, it may have been in his collection and Xiang Shengmo might have studied it. If not, he must have known similar paintings.

Both the Qian Xuan handscroll and the Xiang Shengmo album leaves eschew outlines, relying instead upon soft brushwork and fine texture strokes to describe the branches and upon the hard edges of carefully controlled washes of

color to define the leaves. In addition, both Qian Xuan and Xiang Shengmo occasionally used red pigment to indicate leaf veins. The styles are not identical, however. In Ming fashion, Xiang considered his poems an integral part of the composition and thus placed them near the flowering branches; following earlier convention, Qian inscribed his poem at the end of the scroll. Another difference lies in the concept of the flowering branch. Qian Xuan regarded his branches as still growing, a vital part of a larger living entity; as such, they almost always push through the lower border of the composition, implying that the larger plant is just out of sight. Xiang Shengmo, by contrast, definitely saw his branches as cut, decorative arrangements, ready to be placed in a vase, as indicated by the small wisps of bark that sometimes trail at the cut. In the same way that late Ming landscape painters imitated the styles of Yuan masters, Xiang Shengmo here has reinterpreted the manner of a Yuan painter for his flowers.

These beautiful album leaves show Xiang's considerable talent as a colorist. They also compare favorably with selected leaves from an album that he did in 1645–1646, now in the Palace Museum, Taibei.[2]

prominently in his paintings (see no. 19). Because of his skill in depicting them he came to be known as Xiang Song, or Xiang the Pine. The ones in this painting derive ultimately from the Li Cheng–Guo Xi tradition of the Northern Song, but they are no doubt actually based on Yuan interpretations of Song models. In their stern, morally upright character, they recall pines in the works of such Yuan masters as Wu Zhen, Luo Zhichuan (d. before 1330), and Li Kan (1245–1320) and his son Li Shixing (1282–1328). The major difference is that Xiang Shengmo's pines have been tamed and domesticated, relegated to a garden planter; in Yuan paintings pines often stand as noble guardians at the head of a valley.

The pines in this painting are remarkably detailed, in keeping with the early date of the scroll. They are extremely close in style to those in another painting that Xiang did in the same year, a long landscape handscroll entitled *A Hermit Among Soughing Pines*,[1] now in the Museum of Fine Arts, Boston. The pines in both these paintings contrast with his later, simplified manner, as seen in a leaf from the *Album of Studies from Nature*[2] done in 1645–1646.

Inscription translated in Chu-tsing Li's essay "The Literati Life" in this catalogue

17. Five Pines

Xiang Shengmo (1597–1658)
Ming, dated to 1629
Hanging scroll, ink on paper, with inscription, signature, and seals of the artist, 107.3 × 50.7 cm

TAIHU ROCKS sitting atop white marble pedestals and pines growing in splendid planters appear in paintings of the Song dynasty, but usually as details of a much larger garden scene. What is new in the theme of this Ming painting is the concentration on one small segment of a garden; in this it shows a kinship to bamboo painting, which often focuses on a single stalk or clump of bamboo at the side of a weathered rock (compare no. 20).

Also new is the dreamlike quality of the scene; in fact in his inscription Xiang Shengmo mentions that this painting is a visual description of one of his dreams. In the dream he and Li Rihua were enjoying themselves in Li's courtyard under several pines growing on a terrace. As they were talking, Li Zhaoheng joined them, and shortly thereafter they heard a clear whistle, which Xiang interpreted as an auspicious omen for the Li family. Dreams and their analysis became an important subject of discussion in the late Ming (compare the title of no. 3), and Xiang Shengmo occasionally refers to them in his inscriptions.

At the end of the inscription Xiang states that because of the auspicious nature of his dream, he painted this scene for Li Rihua and his son, Li Zhaoheng. All three men lived in Jiaxing and all were very close. In fact, Xiang Shengmo was a protégé of Li Rihua and was Li Zhaoheng's best friend. Xiang was also related to them by marriage since his wife was a cousin of Li Zhaoheng. Xiang traveled widely as a young man and in 1628, just a year before this painting was done, had traveled north to Beijing on the Grand Canal with Li Rihua.

Xiang Shengmo was especially fond of pines, which figure

18. A Scene of Cold Trees in Snow

Xiang Shengmo (1597–1658)
Qing, dated to 1657
Hanging scroll, ink on paper, with inscription, signature, and two seals of the artist, 87.0 × 36.0 cm
Gift of Gu Liu, Gu Duzhang, Gu Duqiu, Gu Fu, Gu Duxuan, and Shen Tongyue

THIS ELEGANT painting depicts a winter scene with three trees on a river bank, their graceful forms silhouetted against the misty sky above and the river and distant shore below. Snow scenes had long been popular with Chinese artists and, according to tradition, had been depicted at least as early as the Tang dynasty, in the works of the poet-painter Wang Wei. Cao Zhibo (1271–1355) of the Yuan and Wen Zhengming of the Ming were well known for their snowy landscapes, and it is probably from such sources that Xiang Shengmo drew inspiration for *A Scene of Cold Trees in Snow*. The sparse composition and simplified brushwork of the distant shore, however, recall Ni Zan.

When the Manchu armies crushed Nanjing in 1645, Xiang Shengmo and his family were forced to flee their home and live as refugees further south. When Xiang returned to Jiaxing in late 1645 or 1646, he found his home in ruins, his grandfather's collection dispersed, and his family wealth vanished. He lived his remaining years in comparative poverty and, according to some accounts, had to sell his paintings to support himself and his family.

Although Xiang's earlier works are highly personal and self-analytical, those done after his return to Jiaxing tend to be nostalgic and symbolic (compare no. 1). His style also became freer and his compositions less complex in his later works, a change some authors see as a response to his newfound poverty: since he had to rely on the sale of his paintings to support his family, he had to work quickly to produce a greater number.

Dated to 1657, this painting was done when Xiang Sheng-mo was sixty years old, just a year before his death. Typical of his works after 1645, the composition is simpler and less contrived than those of his earlier paintings (compare nos. 15, 17, and 19). His love of detail still found expression, however, in the meticulous rendering of the snow-covered leaves of the center tree. The intricate patterning of the leaves recalls works by Ding Yunpeng (1547–ca. 1621), who had lived for a few years in Songjiang.

COLOPHON: Inscription and seals of Xiang Shengbiao, perhaps a younger brother or, more likely, a cousin of Xiang Shengmo
PUBLISHED: *The Pageant of Chinese Painting*, Tokyo: Ohtsuka-Kohgeisha, 1959: plate 750

19. Noble Hermit Amongst Forests and Streams

Xiang Shengmo (1597–1658)
Ming, ca. 1640
Handscroll, ink on paper, with title, inscription, signature, and four seals of the artist, 33.6 × 126.2 cm

IN HIS INSCRIPTION Xiang Shengmo notes that he painted this handscroll for Lu Lushan (Lu Dezhi, nos. 1 and 20). He states that after twenty years of friendship, Lu mentioned that he did not have one of Xiang's paintings. Xiang had never done a painting for Lu because he felt his works were not sufficiently accomplished; after looking at some paintings by Huang Gongwang in the family collection, however, he felt he had made some progress, so he consented to do this one. He further comments that while he was working on this scroll at Li Zhaoheng's Xieshanlou (see discussion, no. 2), Li Zhaoheng came in and they shared some wine. The inscription not only shows the strong bonds of friendship between these gentlemen, but indicates that the collection assembled by Xiang Shengmo's grandfather, Xiang Yuanbian, still existed, at least in part, when this scroll was done.

The carefully delineated shoreline in the opening passage recalls works by Ni Zan, as do the dry brushstrokes, general clarity of the scene, and meticulously placed, horizontal dots that enliven the edges of rocks and mountains. The "alum-head" rocks that punctuate the distant mountains, on the other hand, may allude to Wu Zhen and, by extension, to Monk Juran. The combination of these elements and their arrangement into a zigzag composition are purely Xiang Shengmo, however, as is the precise, formal mode of depiction. The schematized but varied foliage types, seen especially in the trees in the opening passage, are also characteristic of Xiang's paintings but find precedent in the works of the Yuan artist Tang Di (ca. 1286–1354).

Although undated, this scroll was most probably done in the early 1640s, a short time before the cataclysmic fall of the Ming dynasty which engendered the great changes in Xiang Shengmo's life and painting style. *Noble Hermit Amongst Forests and Streams* is more precise and detailed than Xiang's late works, but not so contrived as his landscapes done in the 1620s and 1630s, such as the *Calling for Reclusion* series[1] or *Illustrations to Poems by Wang Wei* (no. 15). The description of the towering mountain in the central section of this painting is close to that of the distant mountain in his *Self-portrait*

in a *Red Landscape*,[2] which probably dates to 1645 or 1646. Reference to the family collection in Xiang's inscription, however, indicates that *Noble Hermit Amongst Forests and Streams* was done before the dispersal of the collection in 1645. The central section of this handscroll also compares favorably with Li Zhaoheng's *Exquisite Scene of Lakes and Mountains* (no. 8), not far removed in time from the present scroll.

COLOPHON: Feng Wenwei (dated to 1892); 3 collectors' seals

20. Orchid and Rock Amidst a Clump of Bamboo

Lu Dezhi (1585–after 1660), original name Shen, *zi* Lushan, Kongsun, *hao* Qianyan
Qing, dated to 1660
Hanging scroll, ink on paper, with inscription, signature, and seals of the artist, 231.4 × 85.4 cm

THIS LARGE, HANDSOME hanging scroll was painted by Lu Dezhi (see no. 1), a native of Qiantang (modern Hangzhou) who moved to Jiaxing and became a pupil of Li Rihua. Only about seven years older than Li's son, Zhaoheng, Lu Dezhi became a close friend of both father and son and actually lived with the Li family for a year or so. Through them he met Xiang Shengmo (see discussion, no. 19).

Lu Dezhi considered himself a specialist in bamboo painting, as indicated by his signature on this scroll reading *Zhushi Lu Dezhi* (Lu Dezhi, the Recorder of Bamboo). He was also well known as a calligrapher and painter of orchids and pines. Li Rihua regarded him as his star pupil and one of the greatest painters of the time. In fact, Li composed poems for so many of Lu Dezhi's paintings that they were later collected by another of Li's students and published in a volume entitled *Zhulan Mojun tiyu* (*Li Rihua's Inscriptions on Mojun's [Lu Dezhi's] Paintings*). Lu Dezhi's date of death remains unknown, but the present scroll and another that he painted for Wang Hui (1632–1717) in 1660 indicate that he lived to be at least seventy-five years old.[1]

The association of ink bamboo painting with the literati began in the Northern Song with such masters as Su Shi (1037–1101) and his distant cousin, Wen Tong (1018/19–1079). In bamboo these artists found an ideal vehicle for the expression of feelings through descriptive but highly calligraphic brushwork. In addition, bamboo was thought to reflect the virtues of the *junzi*, or Confucian gentleman, so it was the perfect symbol for the literati.

Ink bamboo painting rose to prominence during the early Yuan in the works of such painters as Zhao Mengfu and Li Kan, and had become a fully established idiom by the closing years of the dynasty.[2] In the Ming period this interest in bamboo not only led a number of artists to specialize in bamboo painting but also sparked the desire for scholars' accoutrements crafted in bamboo (see nos. 55–57 and 59).

Like landscape artists, bamboo painters of the late Ming sought inspiration in works by the Four Great Masters of the Yuan—Huang Gongwang, Wu Zhen, Ni Zan, and Wang Meng. Lu Dezhi, in particular, preferred to work in the manner of Wu Zhen with occasional references to the Northern

Song literati masters Su Shi and Wen Tong. Since Li Rihua and his family also liked and collected works by Wu Zhen (see discussion, no. 9), Lu was doubtless able to study original examples.

In *Orchid and Rock Amidst a Clump of Bamboo*, a fully mature work by Lu Dezhi, the combination of rock and bamboo clearly derives from the tradition of Zhao Mengfu and Wu Zhen, and ultimately of Wen Tong and Su Shi. The rocks in most Yuan paintings of bamboo are relatively small, but the larger one here finds precedent in a tall, slender one with angled surfaces—perhaps a Lingbi stone—in a hanging scroll entitled *Bamboo and Rock* by Guan Daosheng (1262–1319), Zhao Mengfu's wife.[3] The reference to Wu Zhen in Lu Dezhi's paintings usually lies less in the specific composition and more in the handling of brush and ink—the creation of relatively broad leaves with virile, calligraphic brushwork. The absolute clarity of the scene, with each leaf beautifully defined and its relationship to its neighbors carefully specified, must also have been inspired by Wu Zhen's paintings. Another bamboo hanging scroll by Lu Dezhi, in a private collection in Japan,[4] follows Wu Zhen prototypes more closely, and appears as if it might have been inspired by a leaf from Wu Zhen's *Zhupu* (*Manual of Bamboo*), which Li Zhaoheng owned and Lu Dezhi must have known.

The slightly tremulous quality of the calligraphy in Lu Dezhi's inscription is typical of a mannered style that was popular in the late Ming. It is also seen in the works of Fu Shan (1607–1684) and other seventeenth-century calligraphers.

21. Landscape *and* Poem by Du Fu

Painting: Li Liufang (1575–1629), *zi* Mouzai, Changheng, *hao* Xianghai, Pao'an, Shenyu Jushi, Tanyuan, and others
Calligraphy: Lou Jian (1567–1631), *zi* Zirou
Ming, painting dated to 1618, calligraphy dated to 1620
Handscroll, ink on paper, with inscriptions, signatures, and seals of the artists, 42.7 × 430.1 cm (painting), 42.8 × 279.1 cm (calligraphy)

BOTH THE PAINTING by Li Liufang and the calligraphy by Lou Jian in this handscroll were done for Li Rihua, who probably had them mounted together. Li Liufang and Lou Jian lived in Jiading, not far from Jiaxing and Songjiang, and were friends of Li Rihua, Dong Qichang, and the members of their circle.

Known as a poet, painter, and calligrapher, Li Liufang was born in Jiading but came from a family that had moved there from Shexian, Anhui province, only a few generations before.[1] He studied the classics as a youth in anticipation of a career as an official and took the *juren* degree in 1606. He twice traveled to Beijing to sit for the *jinshi* examinations, but did not pass the first time and arrived too late to try the second time. By the early 1620s he had abandoned hope of a government career, deciding instead to pursue his literary and artistic interests. Li made a home for himself and his

mother in Nanxiang, not far from Jiading, where he built his famous garden, Tanyuan, and entertained such close friends as Cheng Jiasui (1565–1644, no. 22) and Qian Qianyi (1582–1664).

Like many other scholars of his day, Li Liufang was a seal carver. Little acknowledged in the literature of art is the fact that Li was also a noted amateur bamboo carver,[2] not surprising since Jiading was one of the principal centers of the craft. He was a friend of the celebrated carver Zhu Ying and is said to have studied with his friend's father, Zhu He, the reputed founder of the Jiading, or Lianshui, school of bamboo carving (see discussion, no. 55). No such works by Li Liufang are known today.

As a painter, Li Liufang is best remembered for his sketchy landscapes whose vigorous brushwork and varied ink tones impart liveliness and spontaneity. In painting style and theory he was a close follower of Dong Qichang; along with Cheng Jiasui, he is included among the Nine Friends of Painting, a select group composed of Dong Qichang and eight younger associates. Like Dong Qichang, he was one of the more radical members of the Songjiang circle of painters and was fascinated by the expressive potential of pure brushwork, which he explored to the full in his works. Unfortunately, his promising development as an artist was cut short by his early death at the age of fifty-four.

In this painting, Li Liufang employed a type of composition that had become standard by the seventeenth century, a simplified version of that seen in works by Li Rihua (no. 3), Zhao Zuo (no. 14), and Xiang Shengmo (no. 18). He has infused it with new life, however, by concentrating on the foreground with its interesting rock and tree forms. As an associate of Dong Qichang, Li naturally followed such Southern school models of the Yuan as Wu Zhen (for the "wet" foliage dots on the trees), Ni Zan (for the dry brushwork, angular rock forms, and black horizontal texture dots), and Huang Gongwang (for the general composition, texture strokes on the dominant mountain, and ink washes used for the distant hills). The combination of the styles of these artists is characteristic of Li Liufang's work and he used it to full advantage in this scroll.

According to most sources, Li Liufang's earliest extant painting dates to 1610 and his last to 1628, so the present landscape (of 1618) falls midway, chronologically, in his oeuvre. Though less casual, this innovative scroll compares favorably, in its emphasis on foreground elements, with another landscape handscroll, dated to 1616, now in the collection of George J. Schlenker, Piedmont, California.[3] Li's later works, more under the influence of Dong Qichang, display greater adherence to standardized conventions. This landscape handscroll ranks among his very finest pieces and shows him to have been an accomplished master of brush and ink.

Dated to 1618, Li Liufang's inscription at the end of this handscroll dedicates the painting to Li Rihua. Li comments that Li Rihua came to visit him at the Tanyuan where they sat in the Shenyushi (Prudent Entertainment Room) while he painted this river scene. Given the similarity of the brushwork and the foreground rocks and trees, this painting might have influenced Li Rihua's own *Rivers and Mountains in My Dream* (no. 3), done a few years later in 1625.

Following the painting, on a separate sheet of paper, is a

transcription of a poem on painting by Du Fu (712–770), which Lou Jian[4] copied in 1620 especially for Li Rihua. A noted poet and calligrapher, Lou Jian was a friend of both Li Liufang and Li Rihua. Written in bold *kaishu*, or standard script, Lou's calligraphy recalls that of the Northern Song master calligrapher Su Shi, but also reflects the influence of Dong Qichang.

COLOPHONS: Xi Gang, Chen Yuzhong, Chen Can, and Guo Lin; 6 collectors' seals

22. Landscape after a Song Master

Cheng Jiasui (1565–1644), *zi* Mengyang, *hao* Jie'an, Songyuan Laoren, Songyuan Shilao
Ming, dated to 1628
Handscroll, ink and light colors on paper, with inscription, signature, and seal of the artist, 21.6 × 129.7 cm
Gift of Gu Liu, Gu Duzhang, Gu Duqiu, Gu Fu, Gu Duxuan, and Shen Tongyue

CHENG JIASUI was born in Xiuning, Anhui province, but spent most of his life in Jiading, where he became well acquainted with Li Liufang, Lou Jian, Li Rihua, Dong Qichang, and other members of their group.[1] As a youth he studied in preparation for a career in government service, but after failing the official examinations he turned to poetry, music, and painting. He was already recognized as a poet of great caliber by the age of thirty, and he is now best remembered for his numerous literary works. Few of Cheng's paintings are extant, but Dong Qichang lauded his works and forgers reportedly copied them all too frequently, indicating that they were highly esteemed in the seventeenth century.

Cheng Jiasui subscribed to the principles of Dong Qichang and the Songjiang school in his paintings, but beyond the preference for Yuan models, the powerful influence of that group is less apparent in his works than in those of Li Liufang (no. 21). Cheng typically worked in the manner of Ni Zan, painting elegant river landscapes with delicate brushwork, sometimes with washes of light color.

Executed with fine lines, soft colors, and graded tones of ink, this landscape handscroll is an excellent example of Cheng's rare works. In his inscription, Cheng states that he took inspiration from a painting by the celebrated Northern Song master Wang Shen (ca. 1048–ca. 1103), a friend of Su Shi and Wen Tong and a brother-in-law of Emperor Shenzong (r. 1067–1085). Although Cheng further comments that Qiu Ying had made a copy of the Wang Shen scroll that was almost better than the original, he emphasized that he himself was not trying to copy the original, or even compete with Qiu Ying, but was simply seeking to convey something of the spirit of Wang Shen's work. The use of color in this painting is especially appropriate since Wang Shen was known for his

landscapes in the blue-and-green manner of Li Sixun (653–718) and his son Li Zhaodao (ca. 670–730).

With the seventeenth-century emphasis on taking masters of the Yuan—particularly those designated by Dong Qichang as members of his Southern school—as models, it is unusual to find Cheng Jiasui following a Song prototype. Dong Qichang himself, however, had done a monochrome ink landscape that he said was inspired by the reappearance of a lost Wang Shen scroll. Dong's painting, *Misty Rivers and Layered Peaks* (ca. 1604) in the Palace Museum, Taibei, is remarkably similar in compositional organization to a blue-and-green handscroll by Wang Shen, *The Isle of the Immortals*, also in the Palace Museum. Since Dong Qichang wrote the title slip and a colophon for the Wang Shen painting at some time before 1614, it is likely the same work that inspired his *Misty Rivers and Layered Peaks*.[2] Since it also bears seals of both Li Zhaoheng and Xiang Dushou (1521–1586), Xiang Yuanbian's elder brother, the Wang Shen handscroll was obviously in the Jiaxing-Songjiang area in the early seventeenth century and could also have inspired this painting by Cheng Jiasui.

Even if nominally painted in the manner of Wang Shen, this delicate landscape reflects the strong influence of the Yuan master Ni Zan. An interesting feature of this painting is its use of soft colors in combination with the Ni Zan manner. Although he is best known for his ink landscapes with dry brushwork, Ni Zan did a few works in light color, of which one survives: *Empty Grove after Rain*, a hanging scroll dated to 1368 and now in the Palace Museum, Taibei.[3] An inscription by Dong Qichang and a seal of the Huang family of Huating (modern Songjiang) indicate that the scroll was in Songjiang at some point in the early seventeenth century. Li Rihua records that he saw it in Nanjing in 1628, the very year that Cheng Jiasui painted this river landscape.[4] Whether or not Cheng also saw this colored Ni Zan painting and took inspiration from it is unknown, but it is an intriguing possibility.

Following the painting is a short colophon by Li Liufang written on a separate sheet of paper decorated with gold flecks. Although gold-flecked and gold-surfaced papers had been popular for fan paintings since the early Ming (see no. 10), artists began to use them for calligraphy and for larger painted compositions only in the late Ming. Like "mirror-face" paper (see discussion, no. 11), such decorated papers were usually virtually nonabsorbent and thus required consummate mastery of brush and ink. With their emphasis on expression through pure brushwork, Dong Qichang and the artists of his circle were among the first to explore the use of these less absorbent papers for painting and calligraphy.

Cheng Jiasui is known to have journeyed frequently to his birthplace in Anhui province, and Li Liufang also probably went occasionally to Anhui to visit his ancestral home. With their simplified painting styles and their continuing contacts with Anhui province, it is not surprising that these two artists should have been influential in the development of the Anhui school of painting that rose to prominence as the older members of Dong Qichang's circle passed on.

COLOPHONS: Colophons and seals of Li Liufang and Gu Wenbin (dated to 1873)
TITLE SLIP: Li Liufang

23. Paper Decorated with Two Flying Immortals

Artist unknown
Ming, probably 14th–15th century
Handscroll, ink on paper, 47.8 × 122.9 cm

DECORATED PAPER enjoyed a long history in China; small sheets were often used for letters and poetry (see no. 27), while larger ones were occasionally mounted at the beginning of a handscroll as the *yinshou*, or frontispiece, on which the title of the scroll could be written. According to its eighteenth-century title slip, this sheet of decorated paper was already mounted as the *yinshou* on the *Panshibian* handscroll of calligraphy by Huang Tingjian (1045–1105) when it was received into the imperial collection of the Qianlong emperor on November 27, 1779. Other documentation[1] states that this paper was removed from the Huang Tingjian scroll and mounted separately, in its present form, sometime after it left the palace in the early years of the Republic following the collapse of the Qing dynasty in 1911.

The paper is embellished with two flying female immortals who face each other and whose outstretched arms almost touch. Their long sleeves trail behind them and their scarves and ribbons flutter in the air, imparting a sense of graceful movement. An elaborately wrought border frames the scene; at first inspection the border motif resembles a scrolling-cloud pattern, but it actually is composed of a series of linked *chilong* dragons seen from above. Since the artist presumably decorated this paper specifically to serve as the frontispiece to a handscroll, the designs were executed in tones of gray; had the title of a scroll been inscribed over the celestial figures, the calligraphy would have been done in rich black ink to make it readily distinguishable from the painted decoration.

Flying figures, generally known as *apsaras*, frequently appear in the colorful Buddhist wall paintings of the Northern Wei and Tang periods. The presentation of this pair of figures, however, shows greater affinity to the flying immortals that embellish the walls of Yonglegong, a fourteenth-century Daoist temple in southern Shanxi province.[2] The treatment of the hair and broad oval faces of these immortals is also close to that seen in the figured handles of a jade cup in The Cleveland Museum of Art that has been assigned to the Yuan period.[3] Although the scene relates closely to fourteenth-century works, the border of linked *chilong* dragons points to an early Ming date for this piece.

The linear style derives ultimately from works by Wu Daozi (active ca. 710–ca. 760) and his later follower Wu Zongyuan (d. 1050), both of whom were known for their striking Buddhist and Daoist figures rendered in powerful, calligraphic brushwork.

The paper itself is probably *Xuanzhi*, a fine, soft-white paper made in Xuanzhou (modern Xuancheng, Anhui province).[4] Xuan paper was first mentioned as tribute in Tang documents and has been the most preferred for painting and calligraphy since that time. Prepared from the bark of the *qingtan* tree, Xuan paper has always been made in very large sheets for artistic use; the normal size was eight by twelve feet, but examples measuring up to fifty feet in length are known. Individual sheets were prepared with one, two, or even three layers, depending upon the thickness and strength desired.

At the time it entered the Qing palace collection in 1779, this sheet of paper was assumed to be contemporaneous with the accompanying Huang Tingjian calligraphy, and its decoration was ascribed to the Northern Song Painting Academy. As shown above, however, the decoration most likely dates to the early Ming, although the paper itself could be older. The literati of the Ming liked to write on Song paper and often used old temple and sutra papers for special occasions. This sheet thus would have been treasured by the literati as a rare antique. It was probably mounted together with the Huang Tingjian calligraphy in the Ming period.

Printed Books and Rubbings

24. Miscellanea from the Purple Peach Studio (*Zitaoxuan zazhui* and *Zitaoxuan youzhui*)

Li Rihua (1565–1635)
Introduction to *Zitaoxuan zazhui* by Wang Qilong
Ming, *Zitaoxuan zazhui*, ca. 1617; *Zitaoxuan youzhui*, ca. 1623
Woodblock-printed book, ink on paper; *Zitaoxuan zazhui*, 2 volumes, 3 *juan*; *Zitaoxuan youzhui*, 1 volume, 3 *juan*. Page: both works, 8 columns per page, 19 characters per column (introduction, 5 columns per page, 13 characters per column). Block size: H. 20.4, W. 26.8 cm

A WELL-EDUCATED MAN, Li Rihua was a prolific author. Although he considered himself primarily an artist, he is much better known today for his numerous publications than for his paintings (nos. 3 and 4), which are extremely rare. He probably kept a diary for most of his life, but only the entries written between 1609 and 1616 survive, published under the title *Weishuixuan riji* (*Diary of the Water-tasting Studio*). His several collections of miscellaneous notes, such as the *Zitaoxuan zazhui* (ca. 1617) and *Zitaoxuan youzhui* (ca. 1623), however, were probably culled from his diaries. As such, they are important historical documents that give insight into the everyday life of a late Ming official in retirement.[1]

These volumes of miscellanea cover a broad range of topics, but many of the notes reflect Li Rihua's interest in matters concerning art and taste. They describe, for example, numerous works of art—inkstones and ceramics as well as scrolls of painting and calligraphy—that dealers brought for him to examine. They also reflect his thoughts and opinions on individual artists and specific works of art. In addition, they record technical processes for preparing paper to be used in tracing works of art, and other such matters of great interest to connoisseurs.

The woodblocks used for printing these volumes were

beautifully carved with a highly regularized *kaishu*, or standard script, arranged in a formal layout. The style is typical of the late Ming and contrasts markedly with the more informal style seen in the popular literature of earlier periods (compare no. 25). The austere pages bespeak the authority of the text and the erudition of its author. In this script style, the individual characters are slightly elongated; thick vertical strokes balance exceptionally thin horizontal ones, with only the diagonal strokes showing any modulation in width.

In traditional manner, each sheet of paper was printed with a single woodblock and then folded in half to form the front and back of a page. The fold appears at the outside edge of each page with the loose ends sewn to form the spine. The narrow space on either side of the fold is called the *banxin*, or block heart, because it corresponds to the center of the printing block.[2] The title of the book and the page number are typically designated in this space. In the present work the *banxin* includes the five characters of the title at the top, followed by the *juan* (chapter) number below a single, V-shaped, black mark known as a "fish tail" (*yu wei*). Further down appears the number of the page within the *juan*. On the back side of most pages, at the bottom of the *banxin*, is indicated the total number of characters on the page, presumably noted by the carver to assist in calculating the total amount to be charged for preparing the blocks.

25. Newly Compiled, Fully Illustrated Biography of Guan Suo in Four Parts (*Xinbian quanxiang shuochang zuben Hua Guan Suo chushen zhuan deng si zhong*)

Ming, dated to 1478
Woodblock-printed book, ink on paper, 1 volume, 4 *ji*, with a Song-style printer's colophon reading *Chenghua wuxu zhongchun Yongshun shutang chongkan* (Reprinted in the second month of spring in the *wuxu* year of Chenghua [1478] by the Yongshun Bookstore [Beijing]) in two columns within a double rectangular border at the end of the first *ji*. Page: woodblock illustrations at top, text below; 19 columns per page, 23 (occasionally 24) character-spaces per column. Excavated in 1967 from a Wanli period (1573–1620) tomb in Jiading xian, Shanghai. Block size: H. 18.2, W. 23.2 cm
Facsimile edition published by the Shanghai Museum

IN 1967 THE EXCAVATION of a Wanli period tomb in Jiading yielded a small group of woodblock-printed books dating from the Chenghua period.[1] These illustrated books number among the earliest extant examples of printed popular literature and shed light not only on the evolution of the illustrated book[2] but on the development of secular dramas and *chuanqi*, or tales of the miraculous.

This book is a romanticized account of various exploits of the fictional warrior-hero Guan Suo. The work evolved from the oral storytelling tradition of the Tang and Song and details four separate episodes about Guan Suo. Though related in theme, the stories were no doubt originally recounted one by one by a professional storyteller and later were assembled to form a book. Such literary "building by accretion" led to the creation of the novel in the Ming. In fact, in its emphasis

on romanticized heroics, the *Biography of Guan Suo* anticipates such Ming novels as *Shuihu zhuan* (*The Water Margin*) and *Sanguozhi yanyi* (*Romance of the Three Kingdoms*).

The illustrations in this work appear at the tops of the pages above the text, an arrangement characteristic of the earliest type of Chinese illustrated book. In this format, the *Biography of Guan Suo* agrees with the handful of other known early illustrated editions, including ones from the Yuan. The printer's colophon at the end of the first section (no. 25, lower right) notes that the book is a reprint—which has led some scholars to speculate that it might have been printed with old blocks, perhaps ones from the Yuan.

The illustrations depict poignant scenes described in the text; their subjects range from Guan Suo's first bath as a newborn baby to equestrian warriors in full armor engaged in combat. Since the story arose in popular literature, action-packed scenes of battles and jousts naturally predominate. Although some illustrations are discrete units on the front or back of a page, most of those in the *Biography of Guan Suo* continue uninterrupted from the front around to the back. A short caption in the form of a vertical column of characters appears at the right of each illustration.

In pictorial style, emphasis is on the figures. The settings indicate the location of the scene but leave much to the imagination. The figures are highly stylized, as in Chinese theatrical productions, and are recognizable more by the clothing or armor they wear than by their specific facial types. All illustrations concentrate on the foreground, with only the briefest reference to a background if a vast panorama or mountainous setting is intended.

The illustrations give insight into details of daily life in the Yuan and early Ming. A "hanging gall-shaped" bottle (see no. 88) holding flowers is shown on either side of a censer, for example, clearly indicating that such pieces were used as vases, sometimes in a religious context on an altar table. The *touhu* variant of the bottle is also pictured with flowers, showing that it too was used as a vase. With their large figures and sparse backgrounds, some of these illustrations recall scenes on fourteenth-century blue-and-white wares, confirming speculations that some of the earliest porcelain decorative motifs derive from illustrated books.

By the mid-fourteenth century two different styles of script were in common use for printed books.[3] One was an austere but elegant hybrid of old styles inherited from the Song and used for formal writing (see no. 24). The other was an informal script derived from the style of the Yuan painter and calligrapher Zhao Mengfu. The *Biography of Guan Suo* clearly employs the latter. The two characters that appear at the center of the *banxin* between a pair of V-shaped, black "fish tails" are an abbreviation of the title and the *ji* (part). The page number within the *ji* is given a few spaces below.

Although stories such as the *Biography of Guan Suo* arose from humble origins in popular literature, they found great popularity in the Ming, even among the literati, as authors began to explore new literary genres. Accustomed to the exquisitely printed volumes of their own day (nos. 24 and 26–28), scholars of the late Ming must have delighted in the antique charm of earlier works such as this one.

PUBLISHED: Zhao Jingshen, "Tan Ming Chenghua kanben 'shuochang cihua,'" ("A Discussion of the Ming Chenghua Editions of 'shuochang cihua'"), *Wenwu* (Beijing) no. 11 (1972): 19–22

Shanghaishi wenwu guanli weiyuanhui daoguzu, comp., "Shanghai faxian yipi Ming Chenghua nianjian keyin de changben, chuanqi ("A group of Ming Chenghua-period Woodblock-printed *Changben* and *Chuanqi* Books Discovered in Shanghai"), *Wenwu* (Beijing) no. 11 (1972): 67

Wang Qingzheng, "Gai wenxue, xiqu he banhua shishang di yici zhongyao faxian ("An Important Discovery that Revises the History of Literature, Drama, and Woodblock Printing"), *Wenwu* (Beijing) no. 11 (1973): 58–67

Facsimile reprint by the Shanghai Museum: *Ming Chenghua shuochang cihua congkan: Shiliu zhong fu baitu ji chuanqi yi zhong*, vol. 1, *Xinbian quanxiang shuochang zuben Hua Guan Suo chushen zhuan deng si zhong*, Shanghai: Shanghaishi wenwu baoguan weiyuanhui and Shanghai bowuguan, 1973

Shanghaishi wenwu baoguan weiyuanhui, comp., *Shanghai gudai lishi wenwu tulu (An Illustrated Catalogue of Ancient Cultural Objects from Shanghai)*, Shanghai: Jiaoyu chubanshe, 1981

26. Illustrated Story of the Lute (*Xiuxiang dianban pipa ji*)

Gao Ming (ca. 1305–after 1368), *zi* Zecheng
Ming, Wanli period (1573–1620)
Woodblock-printed book, ink on paper, 3 volumes, 3 *juan*. Page: 10 columns per page, 22 characters per column, 39 illustrations interspersed with the text. Printed in Xin'an, Anhui province. Block size: H. 20.7, W. 27.0 cm

ALTHOUGH Gao Ming's *Pipa ji* was probably first published in the mid-fourteenth century, few, if any, of the earliest editions are extant. It has enjoyed continuous popularity since its first appearance and has been published in numerous editions. This copy, representing the refined but intricately complex style of the late Ming, ranks among the finest examples of Wanli period printing.

The story is one of human suffering, marital infidelity, and heroic sacrifice. The principal character, Cai Bojie, leaves his devoted wife, Wu Niang, with his parents to prepare for the civil service examinations in the capital. After taking highest honors in the palace examination, Cai Bojie is pressured to marry the daughter of Prime Minister Niu, which he does with great reluctance. At home, conditions are desperate and despite Wu Niang's struggle to find food for them, the old parents eventually die of hardship and starvation. The devoted Wu Niang cuts off her long, lustrous hair—her only possession of any value—and sells it in order to give her parents-in-law a proper burial. With her lute (*pipa*) and a painting of her in-laws in hand, she sings her way to the capital to seek her husband. Wu Niang eventually locates Cai and is accepted as a member of the household. In storybook fashion Cai Bojie and his two wives live happily ever after. Confucian audiences are deeply touched by Wu Niang's filial piety and by the kind, accommodating nature of the second wife.[1]

An instrument of foreign—perhaps Central Asian—origin, the *pipa*, or lute, was imported into China during the Han and had become popular by the Tang, when it was occasionally used as a symbol of sadness and parting. The celebrated poet Bai Juyi (772–846) wrote movingly of the instrument in his "Pipa xing" ("Lute Song") of 816.[2] Since the *Story of the Lute* involves the sad parting of husband and wife, it is logical that the author, Gao Ming, should have chosen the *pipa* as the play's principal symbol.

Gao Ming was born into a highly literate family in Ruian, Zhejiang province. He received the *juren* degree in 1344 and the *jinshi* a year later. After serving in several official posts he retired in 1356. His *Pipa ji* may well be a product of the next several years; it is thought to have first been published in 1367.[3] A strict Confucian, Gao emphasized filial piety and heroic sacrifice in his play to ensure poetic justice and establish a model for his audience in the right conduct of life.

Gao Ming is regarded as the greatest dramatist of the Southern school during its formative period in the fourteenth century, and his *Pipa ji* is considered one of the five great masterpieces of early Southern drama. The play is often classified as a *chuanqi* (tale of the miraculous), a popular literary form that rose to prominence in the south in the Yuan period. As the Northern stories and plays (*zaju*) declined in the Ming, the *chuanqi* found favor with the literati, who elevated them to a high art form.

In this edition of the *Pipa ji*, the illustrations are interspersed with the text; each scene is spread across two facing pages. As in illustrated books of earlier periods (compare no. 25), emphasis is on the figures, but here the settings are lavishly described, leaving little to the imagination. A more refined type of drama than the earlier tales of heroic combat, the *Story of the Lute* depicts cultivated people in elegantly appointed settings. Gentlemen appear in discussion in magnificent gardens with banana trees and fantastic rocks. Women carry folding fans and stand before hanging scrolls and painted screens. Articles from the scholar's studio appear throughout, from brushes and inkstones to censers and paperweights, to "hanging gall-shaped" vases in crackled *guan* ware holding peacock feathers. A scholar plays a *qin* (zither) (compare nos. 79, 80) in one scene, and in another, a small potted pine sits on a ledge between two *penjing* (miniature rockeries). The artists attempted to convey a sense of personality—some characters appear timid, others wise, others virtuous—and were particularly successful in portraying psychological relationships through placement, gestures, and glances.

The intricate geometric designs that decorate the floors and garden terraces are closely related to the diaper patterns on late Ming lacquers and bronzes (compare nos. 62, 63, and 67), underscoring the unity of style in the decorative arts of the late sixteenth and early seventeenth centuries. With their exquisite surfaces, these printed books were meant to appeal as much to the eye as to the mind.

Two sizes of characters have been used for the written word: larger ones signal the main text while smaller ones indicate annotations. Small circles that function as periods were inserted in the main text and commentaries, but were omitted from the sections that are to be sung. The arrangement of the *banxin* is extremely simple, with the *juan* designation at the top and the page number within the *juan* appearing about two-thirds of the way down the edge.

The exquisite draftsmanship bespeaks accomplished designers and consummately skilled woodblock carvers. Printed signatures of the carvers, including those of Huang Bofu (Huang Yingrui), Huang Yibin (b. 1586), and Huang Duanfu (Duanfu is possibly a *zi* of Huang Yibin), appear on several of the illustrations. Members of the famous Huang family of woodblock carvers, they were active during the Wanli period in Xin'an, Anhui province. It was the distinguished work of this clan, among others, that elevated the printing of Xin'an to preeminence during the Ming.[4]

27. The Wisteria Studio Album of Stationery Decorated with Ancient and Modern Designs (*Luoxuan biangu jian pu*)

Wu Faxiang (b. 1578), *hao* Luoxuan
Introduction by Yan Jizu
Ming, preface dated to 1626
Woodblock-printed book, ink, colors, and embossing on paper, 2 volumes, 178 images. Page: bordered woodblock stationery designs. Printed in Jinling (modern Nanjing). Block size: H. 21.3, W. 30.4 cm
Facsimile edition published by the Shanghai Museum

THIS EXQUISITE ALBUM of decorated stationery is one of the earliest examples of woodblock printing in multiple colors. Each of the designs pictured would originally have embellished sheets of ornamental paper that would have been stored in an elegant stationery box (compare no. 69 M) and used for notes, letters, and poetry.[1] After creating a number of designs that must have been very popular, the artist, Wu Faxiang, published them together as an album, in the same manner that Cheng Junfang (1541–ca. 1616) and Fang Yulu (active Wanli period, 1573–1620) published manuals of their inkstick designs (see nos. 75 and 76).

In addition to its preface, this album comprises 178 pictorial leaves arranged in 16 thematic sections: *Huashi* (Poetic scenes), 20 leaves; *Yulan* (Bamboo baskets), 12 leaves; *Feibai* (Flying-white), 8 leaves; *Bowu* (Scholars' objects and antiquities), 8 leaves; *Zhezeng* (Cut flowers), 12 leaves; *Diaoyu* (Carved jade), 12 leaves; *Doucao* (Flora), 16 leaves; *Zagao* (Miscellaneous designs), 2 leaves; *Xuanshi* (Selected rocks), 12 leaves; *Yizeng* (Remembrances), 8 leaves; *Xianling* (Auspicious creatures), 8 images; *Daibu* (Palanquins and other conveyances), 8 leaves; *Shouqi* (Collected rarities), 24 leaves; *Longzhong* (Dragons), 9 leaves; *Zeqi* (Choosing a perch), 11 leaves; and *Zagao* (Second section of miscellaneous designs), 8 leaves.

Wild geese (*yan*) in flight are a favorite theme in this work and in decorated stationery in general; in fact, letters are often poetically referred to as *yanbo*, or wild-goose silk. The connection between letters and wild geese derives from a famous story about the Chinese general Su Wu, who, while held hostage by the barbarian Xiongnu in the early first century B.C., clandestinely sent a letter written on silk to the Han emperor Wudi (r. 141–87 B.C.) by tying it to the leg of a wild goose, knowing that the goose would likely be shot if it flew over the imperial gardens (see discussion, no. 28).[2]

This album includes patterns done in single as well as multiple colors. Some pages are embellished with embossed designs, others with printed designs, and yet others with a combination of embossed and printed ones. Many designs have a title or a short inscription, sometimes followed by printed seals, added in imitation of painted album leaves. The full title of the album, *Luoxuan biangu jian pu*, appears in six characters at the top of the *banxin* of each page.

The technique employed in printing the multiple colors in this album has occasioned some scholarly debate. Until recently it was argued that the book was printed with the single-block technique, in which the printers applied the various colors for each page to a single block, blending the pigments and working the necessary gradations of tonality on the block itself.[3] It now seems likely, however, that the album was created with the multiple-block technique, in which the various colors were printed successively with a series of woodblocks.[4] In either case, the *Wisteria Studio Album* represents the earliest known printed work that employs multiple colors extensively;[5] if it was printed with multiple blocks, the album also represents the earliest known use of that technique, since it predates both the *Ten Bamboo Studio Manual of Painting and Calligraphy* (*Shizhuzhai shuhua pu*) of 1627 and *The Ten Bamboo Studio Album of Stationery* (*Shizhuzhai jian pu*) of 1644. In addition, this album includes the earliest embossed designs (*gonghua*), achieved by pressing the paper firmly against a carved but uninked woodblock.

In 1923, in reproducing the second volume from an incomplete set of this work, a Japanese publisher mistakenly ascribed it to Weng Songnian[6] (1647–1728), a landscape painter from Zhejiang province whose *hao*, like that of Wu Faxiang, was Luoxuan. The *Wisteria Studio Album* thus languished for many years in the twentieth century under a misattribution to the Kangxi period because of this misunderstanding of the identity of Luoxuan. Discovered in Shanghai in the early 1960s,[7] the present complete set includes the preface in the first volume, which records that it was done by Wu Faxiang of Nanjing in 1626.

RECORDED: Zhang Zongxiao, *Qingqizhai shumu, juan* 2, 1843.
PUBLISHED: Omura Seigai, comp., *Zuhon Sōkan*, Tokyo, 1923 (reproduces the second volume of an incomplete set and attributes it to the Kangxi period)
Shen Zhiyu, "Ba Luoxuan biangu jian pu ('A Postscript to the 'Wisteria Studio Album of Stationery Decorated with Ancient and Modern Designs'"), *Wenwu* (Beijing) no. 7 (1964): 7–9
Facsimile Reprint, Shanghai: Shanghai Museum
Wang Fang-yu, "Book Illustration in Late Ming and Early Qing China," in Sören Edgren, et al., *Chinese Rare Books in American Collections*, New York: China Institute in America, 1984: 39
Tsien Tsuen-hsuin, *Paper and Printing*, vol. 5, part I in Joseph Needham, ed., *Science and Civilisation in China*, Cambridge: Cambridge University Press, 1985: 95, 286

28. Illustrated Swallow Messenger of Love, Xueyuntang Edition (*Xueyuntang bidian yanzi jian*)

Ruan Dacheng (ca. 1587–1646), *zi* Jizhi, *hao* Yuanhai, Shichao, Baizi Shanqiao
Preface by Gu Na
Ming, preface dated to 1643
Woodblock-printed book, ink on paper, 2 volumes, 2 *juan*. Page: 9 columns per page, 24 characters per column (introduction, 4 columns per page, 8 characters per column), 18 illustrations at the beginning of the first volume. Printed in Wanling (modern Xuancheng), Anhui province, by Liu Guobao; illustration designer, Lu Wuqing; principal carver, Xiang Nanzhou. Block size: H. 20.1, W. 24.4 cm

DATED TO 1643, this copy of the *Illustrated Swallow Messenger of Love* is the latest printed book in this exhibition, in both date of composition and date of printing. The illustrations reflect the new pictorial style of the mid-seventeenth century and foreshadow the development of the Qing style.

The play elaborates a popular story of a love triangle involving a handsome young scholar and two beautiful women—one, a proper and talented young lady of good family, and the other, a faithful courtesan. The story resolves itself happily in a marriage brought about through the help of a swallow who carries a love-letter. The author, Ruan Dacheng, based this play on an earlier one, *Swallow Messenger*, written in the early Ming.[1]

The swallow has traditionally served as a symbol of marital happiness in China, since swallows usually fly and play in pairs. Although written with different characters, "swallow" (*yan*) and "wild goose" (*yan*) have the same pronunciation in Mandarin Chinese, suggesting a play on words: the wild goose, which pairs with only one mate, is also regarded as a symbol of marital fidelity. The related roles of swallow and goose are further reinforced in this play by the fact that a swallow carries a letter, recalling the well-known story of the wild goose that carried Su Wu's letter to the Han emperor Wudi in the first century B.C. (see discussion, no. 27).

Ruan Dacheng was born around 1587, probably in Huaining, Anhui province. A poet, dramatist, and politician, he came from a family of wealth and influence but of unsavory reputation. He received the *jinshi* degree in 1616 and thereafter served in several official posts. He lived in retirement from 1629 to 1644, first in his home district and then in Nanjing, and it was during this time that he composed the several dramas for which he is now best known. It is said that Ruan presented the *Swallow Messenger of Love* to Zhu Yousong (d. 1645), the Prince of Fu, as his contribution to the celebrations surrounding the coronation of the prince as emperor of the Southern Ming dynasty in 1644.[2] Of Ruan's nine plays, only four are extant.

As a dramatist, Ruan was a follower of Tang Xianzu (1550–1616), a mid-Ming author whose Linchuan school emphasized lively, imaginative content and seemingly spontaneous language over stylized form and predetermined rhythm, the chief characteristics of the rival Wujiang school established by Shen Jing (1553–1610). Still frequently per-

formed, Ruan's works are romantic and sentimental dramas based on imaginary incidents rather than on historical events. They usually rely on Buddhistic, supernatural, or somewhat contrived devices to bring about a denouement. Ruan wrote his plays in the *kunqu* style, an elegant and highly literary form of the *chuanqi*[3] (see discussion, nos. 25 and 26).

All the illustrations in this edition appear at the beginning of the first volume, immediately following Gu Na's preface. Each single-page illustration is unrelated in composition to the one it faces. The first two illustrations depict the two principal female characters, who are shown with elaborate coiffures and elegant gowns. Each is given a full-page illustration and silhouetted against a blank background, recalling traditional Chinese portraiture (compare no. 2). Of the remaining sixteen scenes, some are set indoors and others out-of-doors, but virtually all include broad vistas so that the figures are relatively small in proportion to the composition. This is typical of mid-seventeenth century style and stands in marked contrast to works of the earlier Wanli period (see no. 26). In addition, large areas of the composition are left open and unembellished, unlike the intricately patterned scenes characteristic of the finest Wanli period illustrated books. Because the illustrations portray broad vistas, less attention was given to the numerous objects that enlivened seventeenth-century interiors. Still, there are depictions of crackled *guan*-ware bottles, and in one scene, a small table screen with an inset marble plaque sits on a table (compare no. 69 G).

The female figures display the large heads set on narrow shoulders that became standard in mid-seventeenth century depictions. In typical fashion, their faces are true ovals with tiny, pointed chins (compare no. 55). The scattered grasses and wispy, outlined clouds recall those seen on blue-and-white porcelains of the mid-seventeenth century, a hallmark of the transitional period from Ming to Qing.

The bold characters of the main text resemble those of the Shanghai Museum edition of the *Illustrated Story of the Lute* (no. 26). The characters used for the annotations are the same size as those of the main text, but they were cut with much thinner lines so that they are readily distinguishable from the main text. The *banxin* has the three characters of the title, *Yanzi jian*, at the top, with a single V-shaped, black "fish tail" near the center just above the *juan* number. The page number within the *juan* appears in the *banxin*, about one-third of the way up from the bottom. Except for the first two illustrations, whose titles are conceived as part of the compositions, each illustration has a two-character caption at the center of the *banxin*, just outside the border.

Printed signatures on several of the leaves indicate that the woodblocks were carved by Xiang Nanzhou from Wulin (modern Hangzhou). One of the most renowned engravers of the early and mid-seventeenth century, Xiang also transferred Chen Hongshou's painted illustrations for the *Romance of the Western Chamber* (*Xixiang ji*) to woodblocks for printing.[4] Another printed signature indicates that the illustrations were designed by Lu Wuqing, a noted painter active in the Wanli and Chongzhen periods.

The title page of the first volume notes that this is the Xueyuntang edition of the *Yanzi jian*, which according to the preface was published in 1643. However, the title on the first page of text states that it is the Huaiyuantang edition, an-

other seventeenth-century version whose printing blocks were also carved by Xiang Nanzhou. The single borders of the illustrated pages are identical to those of the preface and table of contents, confirming that the illustrations come from the Xueyuntang edition. The pages of the text, however, have double borders at the top and bottom, which, like the title, may signal that they come from a different edition.

PUBLISHED: Guo Weiqu, *Zhongguo banhua shilüe* (*A Short History of Chinese Woodblock Prints*), Beijing: Zhaohua meishu chubanshe, 1962: plate 32

tioned. The stone engravings from which these rubbings were taken, however, are regarded as the most beautifully carved ones from the Ming period. They faithfully reproduce not only the texts of the originals but the seals affixed by collectors of various periods, including ones by Emperor Huizong (r. 1100–1126) of the Northern Song.

The rubbings were done in the *wujin ta* (black-gold) technique, so that the pages are evenly covered with an extremely dark black ink, resembling those of a printed book.[2] The album ends are covered with Ming period brocade, the interlocked geometric designs of which compare favorably with the diaper patterns on contemporaneous works in bronze, lacquer, and other materials (see nos. 62, 63, and 67).

29. Rubbings of Selected Calligraphy from the Inkwell Hall (*Mochitang xuantie*)

Commissioned by Zhang Zao (b. 1547), *zi* Zhongyu
Ming, individual volumes dated between 1602 and 1610
Album of rubbings from stone engravings, ink on paper, 5 *juan* in 5 volumes, *wujin ta* (black-gold rubbing) technique; album ends covered in Ming period brocade. Single page: H. 28.5, W. 13.8 cm

THESE RUBBINGS were conceived as a source book for the study of calligraphy and include examples by famous calligraphers of the Jin, Sui, Tang, Song, and Yuan periods, from Wang Xizhi and his son Wang Xianzhi (344–388) through Zhao Mengfu.[1] Zhang Zao (better known by his *zi* Zhongyu) commissioned the original stone engravings as well as the rubbings. In a few cases the models might have been original works of calligraphy, but since so many of the works reproduced in the albums are ancient ones, most of the models presumably were earlier rubbings (compare no. 81) or brush-written copies.

This work, entitled *Mochitang xuantie*, begins with a table of contents that was engraved in stone and presented as a rubbing. The works of calligraphy follow in chronological order; appended to many of them are notes by Zhang Zao discussing the importance of the text and recording the date of the stone engraving.

Zhang Zao was a son of the well-known calligrapher and stone engraver Zhang Wen (active 16th century) of Changzhou (modern Suzhou). Zhang Zao learned both arts from his father and doubtless participated in the actual engraving of the stones from which the Mochitang rubbings were prepared.

By the Ming period many different versions of ancient calligraphic masterpieces were known from rubbings, brush-written copies, and purported originals. The merits and demerits of each version were much debated and questions of authenticity naturally arose. In commissioning new stone-engravings, such connoisseurs as Zhang Zao and Wang Kentang (b. 1553, no. 30) were establishing which versions they felt were authentic (by inclusion) and which were spurious (by omission).

Although the texts included in the *Mochitang xuantie* are generally very good, the authenticity of a few has been ques-

30. Rubbings from the Luxuriant Hill Studio (*Yugangzhai momiao*)

Commissioned by Wang Kentang (b. 1553, *jinshi* 1589), *zi* Yutai
Stone engravings by Guan Chiqing (active Wanli period, 1573–1620)
Ming, dated to 1611
Album of rubbings from stone engravings, ink on paper, 10 *juan* in 10 volumes, *chanyi ta* (cicada-wing technique). Single page: H. 28.0, W. 14.3 cm

LIKE THE *Mochitang xuantie* (no. 29), this group of rubbings preserves the work of famous calligraphers, including ones from the Wei, Jin, Tang, and Song periods. Although not so carefully arranged in chronological order as the *Mochitang xuantie*, this work captures the nuances of calligraphic style better than other rubbings because the stone engravings were based primarily on original works of art rather than on brush-written copies and earlier rubbings.[1] It faithfully reproduces the collectors' seals as well as the texts and calligraphic styles.

Done in the *chanyi ta*, or cicada-wing, technique, the rubbings show the text in white characters against a lightly inked, mottled-gray background.[2] Although small red circles were sometimes used for punctuating classical Chinese texts, Wang Kentang added the ones here to indicate characters he thought were especially well written.

From Jintan, Jiangsu province, Wang Kentang was a recognized scholar of his day and held a number of official posts. He was a noted calligrapher and was especially well versed in medicine.[3]

Ceramics

Guan, Ge, and Ge-type Wares (nos. 31–34, 88, 89)

Southern *guan*, or official, ware first appeared during the Southern Song period. The 1929 discovery of a kiln site south of Hangzhou, Zhejiang province, confirmed that *guan* pieces were produced there, but similar wares may have been made at other sites as well, especially at the Longquan kilns, Zhejiang. *Guan* ware typically exhibits a thin body in dark gray clay—although light gray and buff are not unknown—covered with a thick, semi-opaque, grayish-green glaze. The glaze tends to thin at the mouth, so that the lip appears dark, and iron compounds in the exposed body-clay of the footring fire a purplish-rust color. Traditional sources thus describe *guan* ware as having a "brown mouth and iron foot." Decoration seldom appears on these wares; rather, they rely upon beauty of glaze and tautness of form for their aesthetic appeal. The crackle patterns formed in the glazes during the cooling process after firing were exploited for their decorative effect. In Song pieces the crackle lines are usually light gray or brown, and in some cases they are quite long, echoing the shape of the vessel (no. 88).

Although classical *ge* ware resembles *guan* ware in its aesthetics, there are distinct differences. The glaze of *ge* ware is typically grayish-blue and is fully opaque with an almost matte finish. Its crackle pattern is exaggerated, often standing out in bold black. Like *guan* ware, the color of the body-clay can range from slate gray to buff. Chinese and Western scholars have traditionally ascribed examples of classic *ge* ware to the Southern Song, but that practice is now frequently challenged. Many specialists believe *ge* ware may not have evolved until the very late Southern Song or, more likely, the Yuan; its precise place of manufacture is still debated.

The taste for *ge* ware persisted into the Ming, old pieces being collected and new ones created. Although blue-and-white porcelain had become the official court ware by the early fifteenth century, many Ming imperial princes preferred the aristocratic *guan* and *ge* wares of earlier days, as did the culturally conservative literati. The seventeenth-century cataloguer of taste, Wen Zhenheng (1585–1645), heaped praise on *guan* and *ge* wares, preferring them to all other ceramics, especially for brushwashers and water droppers.

Virtually all writers agree that Ming *ge*-type wares were produced at Jingdezhen, Jiangxi. Although Ming *ge*-type wares resemble Song or Yuan *ge* pieces, the substitution of a white porcelain body distinguishes them as later wares, as does a range of new shapes, particularly ones appropriate for the scholar's studio. Their glazes also tend to be thinner and more lustrous. To simulate the "brown mouth and iron foot" of literary descriptions, a brown or butterscotch slip was often applied to the mouth before glazing, and a purplish-rust one to the bottom of the footring.

Since few *ge*-type vessels with Ming reign marks (no. 89) have survived to serve as guideposts, specialists have been reluctant to attribute pieces to the Ming: classical examples of *ge* ware are assigned to the Southern Song or Yuan, and *ge*-type examples are typically ascribed to the Qing, especially to the Yongzheng and Qianlong eras when marked pieces were produced in abundance. The literati preference for *ge* and *ge*-type ware suggests that numerous pieces must have been produced in the Ming, however, and that many current attributions should be reassessed. The four examples below are proposed as candidates for attribution to the Ming.

31. Winepot

Ming, probably Wanli period (1573–1620)
Jingdezhen *ge*-type ware, porcelain body with crackled grayish-blue glaze and with underglaze cobalt-blue inscription on the base, H. 5.4, D. 10.9 cm

THE REFERENCE to intoxication in the inscription on its base leaves no doubt that this piece was a winepot, not a teapot or water dropper:

There is an old pottery vessel
[From which one can] pour and drink anytime.
Its belly is like a gourd,
Its mouth as big as a coin.
It's not a *zun* and it's not a *hu*;
Is it Ding [ware] or is it porcelain?
[I] shall enjoy forever the time
Spent in the land of inebriation with you.[1]

The Chinese were certainly brewing alcoholic beverages, primarily from millet through fermentation, in the Shang dynasty and probably even as early as the late Neolithic period. Techniques of distillation (mainly using sorghum grains) were learned in the twelfth or thirteenth century, so that by the Ming a variety of alcoholic beverages, commonly called "wines," was available.[2] It is difficult to ascertain exactly what type of wine might have been served in this small ewer, but it was perhaps a fine one made in Fenzhou, Shanxi, which the eighteenth-century poet and connoisseur Yuan Mei (1716–1798) considered the best.[3]

The development of small wine vessels, such as this one, derived in part from the change in manners and social customs toward the more intimate during the Ming period. In the mid-fifteenth century it was customary when entertaining guests at a banquet to seat them at one large table for eight and to serve the wine in two large cups, which would be used in turn by the guests. By the late fifteenth century it had become the practice to provide separate table settings for two persons at one small table.[4] It was at this time that potters began making small wine ewers appropriate for two people. The reduction in the size of winepots was doubtless also a function of the increasing popularity of distilled beverages; as the alcohol content of wines and spirits increased, the size of winepots diminished.

The calligraphic style of the inscription and the tonality of the cobalt (see detail, no. 31) correspond to inscriptions on pieces securely dated to the Wanli period (compare nos. 41 and 42). This, combined with the straight line of the handle,

lip, and spout, lends credence to the Wanli period attribution. A cover, now lost, would originally have completed this piece.

32. Melon-shaped Water Dropper

Ming, late 15th–early 17th century
Jingdezhen *ge*-type ware, molded porcelain body with crackled, grayish-blue glaze over incised and molded decoration, H. 4.8, L. 7.5, D. 4.4 cm

THE SHAPE of this elegant water dropper for the scholar's desk imitates a melon with a small section of the vine curling at one end. In adding water to the inkstone (see nos. 69 F, 73, and 74) drop by drop, the scholar could easily regulate the tonality of ink.

The melon most likely entered the repertory of Chinese shapes during the Tang dynasty, when chilled watermelon was much prized at the court in summer.[1] Covered, melon-shaped boxes crafted in gold and silver during the Tang and Song distantly foreshadow the shape of this water dropper.[2] Melon-shaped vessels of various sorts appear in abundance during the Song, and in the Yuan melons are sometimes portrayed in both scroll painting and ceramic decoration.[3]

The attribution of this water dropper to the Ming rests on the similarity of the glaze and its crackle patterns to that of the winepot discussed above (no. 31). Qing examples are often more complex, with several leaves and sections of curling vine large enough to serve as a handle.[4] In his *Zhangwu zhi* of 1637 Wen Zhenheng notes that among ceramic water droppers, melon-shaped ones of *guan* and *ge* ware are the best, indicating that these were available in the early seventeenth century.[5]

This water dropper is fully glazed and was fired on four small spurs; the spur marks, visible on the slightly flattened base, were dressed with a dark slip in imitation of classical *ge* ware of the Southern Song and Yuan. The body was most likely created with a double-faced press-mold in sections that were luted together before the glaze clay was applied. An evenly distributed crackle pattern of medium density appears in a slate-gray color, with a subsidiary pattern in a light buff.

33. Square Brushwasher

Ming, 16th–17th century
Jingdezhen *ge*-type ware, molded porcelain body with crackled, grayish-blue glaze, H. 2.9, W. 6.8 cm

AS SCHOLARS came to prefer *ge*-type ware for their desks, objects such as brushwashers and water droppers took on new shapes that departed from the models of the Song and Yuan. Square brushwaters lack clear classical antecedents, but the shape reflects the Ming interest in volume and geometric form.

A dense, slate-gray crackle pattern permeates the grayish-blue glaze of this brushwasher. While the dating of such pieces is notoriously difficult, the formalized shape is spiritually akin to that of jade and lacquer articles of the sixteenth century.[1]

34. Foliate Brushwasher

Ming, 16th–17th century
Jingdezhen *ge*-type ware, molded porcelain body with crackled grayish-blue glaze, H. 3.6, D. 12.3 cm
Gift of Wu Yunrui

THE SEVENTEENTH-CENTURY connoisseur Wen Zhenheng preferred jade brushwashers for the desk, but remarked that among ceramic ones *guan* and *ge* pieces are the best. He particularly favored foliate brushwashers and ones with scalloped rims.[1]

Chinese potters had already begun to imitate floral shapes in their wares in the late Tang dynasty. Vessels in gold, silver, and lacquer exerted a strong influence on ceramic shapes beginning in the early Song[2] and continuing through the Qing. The flat floor and complex walls of this brushwasher clearly indicate a relationship, however distant, with metal forms.

The even, regular shape and the angular articulation of the walls indicate that this vessel was not shaped on a potter's wheel but with a double-faced press-mold, a technique that had gained currency by the late fourteenth century. A thick, lustrous, grayish-blue glaze covers the entire vessel and exhibits the expected crackle pattern; in this case, the pattern is denser on the interior, looser on the exterior. Six evenly spaced spur marks punctuate the glaze of the base. They were dressed to fire dark gray, and the lip was dressed with a slip to fire a butterscotch color.

The traditional attribution of this piece is to the Yong-zheng period of the Qing dynasty. The similarity of the glaze and crackle pattern to the previous example (no. 33), combined with Wen Zhenheng's mention of foliate brushwashers in *guan* and *ge* ware, however, suggests an earlier dating. In light of the marked Xuande and Chenghua period examples of the Ming (see no. 89), the entire category of *ge*-type wares awaits reexamination, and many unmarked pieces currently ascribed to the Qing may in fact qualify for attribution to the Ming.

35. Teapot

Shi Dabin (active Wanli period, 1573–1620)
Ming, probably early 17th century
Yixing ware, rust-brown earthenware with incised 7-character *kaishu* inscription and signature reading *Yuanyuantang cang Dabin zhi* on the base, H. (including knob) 6.5, D. 14.2 cm
Gift of Gu Yan

THE SIGNATURE on the base (see detail, no. 35) indicates that this pot was made by Shi Dabin, the most famous Yixing potter of the Wanli period. Born in Yixing in southern Jiangsu province, Shi Dabin was a son of Shi Peng, one of the four great Yixing masters of the early Wanli era. Tradition recounts that in his earlier works Shi Dabin followed the manner of Gongchun (active Zhengde period, 1506–1521)—the purported inventor of Yixing pottery—in making large teapots, but after a visit to the Songjiang area, where he discussed the formalities of tea with Chen Jiru (see nos. 1, 12,

and 13), he began making small teapots. Shi Dabin is indeed best known for his small teapots like this one. It is said that he was an austere, elegant man and that his works reflect his personality; this teapot would seem to confirm that statement.[1]

Until recently the origin of Yixing ware was uncertain. Although a few old literary records mention the existence of this type of ware in the Song period, most pieces bearing pre-Ming attributions have been discredited and authors have traditionally assigned the earliest activity at the Yixing kilns to the sixteenth century. In 1976, however, workers at the kilns excavated a large quantity of shards at the nearby site of Yangjiaoshan. Archaeologists now regard the rather coarse, unglazed, purplish-red fragments as the forerunners of "classical" Yixing ware, dating the earliest ones to the mid-Northern Song and the most advanced to the Southern Song.[2] Though archaeologists have now confirmed that the Yixing kilns were active in the Song, it was probably not until the sixteenth century that the "classical" ware began to be produced and to attract the attention of the literati. Perhaps it was Gongchun who created the refined pots that appealed to the literati and thus gained fame as the purported inventor of the ware.

The introduction of the teapot reflects a major change in the manner of preparing tea. The earliest generations of tea-drinkers—perhaps people of the Late Zhou and Han periods—boiled the leaves in a kettle, often with grain and other ingredients. By the Tang the customary manner of preparing the beverage was to whisk powdered, dried leaves with hot water in a tea bowl, akin to the method used in the Japanese tea ceremony today. It was only in the Ming that the Chinese began to brew tea by steeping whole leaves in boiling water, a practice that led to the invention of the teapot.

The Yixing teapot, in particular, was preferred because its small size and unglazed walls were believed to enhance both the bouquet and the flavor of the tea. Each time tea was prepared, the vessel's slightly porous earthenware walls would absorb a bit of the brew. Although the pot was rinsed with clean water or cool tea after each use, it was never scrubbed, so tea deposits naturally built up on the interior surfaces; in time, the user was really making tea *in* tea, so there was no extraneous taste from the pot itself. Cultivated scholars of the Ming also must have delighted in the perfect craftsmanship, geometric shapes (compare nos. 33 and 34), and unglazed surfaces suggestive of the humble raw materials, all typical characteristics of Yixing ware.

Although members of literati circles seldom fraternized with artisans and craftsmen, the potters of Yixing were an exception, as were bamboo and seal carvers (see nos. 55–59 and 72). The association of the literati and Yixing potters probably began in the sixteenth century. Mutual admiration between the scholars and the Yixing potters allowed the status of Yixing ware to rise from utilitarian object to work of art. Because of these circumstances a number of these pots were inscribed, dedicated, and signed, so that we know the names of many potters.

It is often said that Chen Jiru, a connoisseur and bon vivant, conceived the idea of brewing tea in small pots. In fact, Chen very likely inherited the idea from an earlier generation and merely persuaded Shi Dabin to make small teapots,[3] for there had already begun in the late fifteenth century a trend toward smaller vessels appropriate for more intimate table settings (see discussion, no. 31).

Wen Zhenheng acclaimed Yixing ware as the finest for brewing tea, but unlike the literati of Songjiang, he did not find Yixing shapes pleasing. Also differing with his peers in Songjiang, he felt that Shi Dabin's teapots were too small.[4]

Shi Dabin's inscription on the base of this teapot indicates that it was made for one Yuanyuantang. The user of that sobriquet has yet to be identified.

36. Lotus-leaf Brushwasher

Ming, 17th century
Dehua ware, porcelain with molded decoration, H. 3.9,
 W. 11.5 cm

IF THE *JUE*-SHAPED cup (no. 37) illustrates the formal, archaistic style of Dehua porcelains, this brushwasher exemplifies the naturalistic style. It was molded in the shape of a lotus leaf with upturned, scalloped edges, imparting an elegant but irregular foliation to the lip. Like its more geometrically shaped *ge*-ware counterparts (nos. 33 and 34), this small monochrome-glazed vessel would have served as a brushwasher for the scholar's desk. Such pieces may also have been used to hold fresh water for preparing ink, with the water either poured directly onto the inkstone from one of the foliations in the lip or transferred with a tiny spoon.[1]

As many scholars have remarked, the walls of Dehua porcelains are relatively thick, much thicker than one would expect in a piece of similar size and shape from Jingdezhen. Dehua clay tends to warp in firing, and one way of minimizing such unwanted changes of shape was to increase the thickness of the walls.

With their flawless craftsmanship, antique overtones, and lack of association with the imperial court, the monochrome wares of Dehua appealed strongly to the literati of the late Ming. Although the depiction of the ceramics in *Venerable Friends* (no. 1) is too cursory to permit exact identification, the pieces might well be from Dehua. Their elegantly simple shapes and unadorned surfaces are typical of wares produced there in the late Ming.[2]

37. *Jue*-shaped Tripod Cup

Ming, 17th century
Dehua ware, porcelain with molded decoration, H. (including
 posts) 7.3, W. (across spouts) 10.8 cm
Gift of the Jietuo Studio (Jietuoan Zhu)

ANTIQUE IN FLAVOR, this small, sturdy cup is a hybrid form of the archaic bronze *jue* (no. 83) and the *jue*'s close relative, the *jiao*.[1] A very rare vessel type, the *jiao* has two matching triangular spouts, similar in shape to the winglike projection that balances the single spout of the *jue* vessel. In creating this Dehua cup, the potters combined the strict, bilateral symmetry of the *jiao* with the spout shape of the more typical *jue*. The proportions differ radically: bronze *jue* and *jiao* vessels are elegantly elongated, while the Dehua imitations tend to be squat and heavy.

Bronze *jue* and *jiao* vessels were used for heating and drinking wine. This Dehua cup was probably also used for drinking wine, but it might occasionally have served as a small water-pouring vessel for the scholar's table.

Best known in the West as *blanc de Chine*, the porcelains of Dehua rank among the finest ceramics ever produced in China.[2] An ivory-toned glaze covers the pure white porcelain body, giving the pieces a warm feeling. The vast majority are decorated with molded designs.

Ceramic production must have begun at the Dehua kilns, in central Fujian province, during the Song, but the cream-white porcelain we call Dehua today probably did not evolve until the early Ming. A marked improvement in the quality of the ware became apparent at the turn of the sixteenth century, due largely to changes in kiln construction and technology. Although the earliest wares from Dehua were produced mainly for the export trade,[3] the high-quality wares of the late Ming and Qing periods appealed to the home market, especially the wealthy of the Jiangnan area.

38. Vertical Flute

Ming–Qing, 17th century
Dehua ware, molded porcelain, L. 57.6, D. 3.0 cm

SINCE BOTH vertical and transverse flutes were usually crafted in bamboo, porcelain examples from Dehua were typically segmented to resemble that natural material. The tiny circles at the bottom of the instrument suggest the lowest node of a bamboo plant where the stalk joins the underground root stem; the knobs represent root buds, and the circles the stubs of roots that have been removed.[1]

Tradition asserts that the flute, or *xiao*, was invented at the time of the legendary Yellow Emperor, but was refashioned and improved by Jiu Zhong during the reign of the Han emperor Wudi. Representations of Han flutes are known from decorated tomb tiles, and an eighth-century bamboo example has been preserved in the Shōsō-in, Nara.[2] Although the popularity of bamboo flutes never waned, some flautists preferred porcelain models because the smoothness of the internal surfaces enhanced the clarity of the sound. In addition, since ceramic ware is unaffected by fluctuations in humidity, porcelain flutes never went out of tune with changes in the weather.

The production of Dehua porcelain flutes was already well established by the late Ming. Since these flutes are crafted to simulate their bamboo cousins in form, they are all similar in appearance, so their dating is problematic. It has been suggested that flutes of the Ming have their fundamental in d′ and those of the Qing in f′.[3] This flute has traditionally been dated to the Qing dynasty.

The only "requisite" musical instrument for the late Ming scholar was the *qin*, or zither (nos. 79 and 80). Many musically talented scholars played other instruments as well, however, the *xiao* foremost among them. Native Chinese instruments were always preferred to those of foreign origin, such as the *pipa*, or lute, which were considered appropriate only for professional musicians.

39. Waterpot

Ming, Jiajing period (1522–1566)
Jingdezhen blue-and-white ware, porcelain with decoration in underglaze cobalt blue and with underglaze cobalt-blue mark reading *Da Ming Jiajingnian zao* on the base, H. 8.7, D. 13.3 cm

FRESH, CLEAN WATER played an important role in the scholar's studio, not only for brewing tea (see no. 35) but also for preparing ink and cleansing the brush. This vessel would have held an abundant supply of water for the desk, to be fed into a water dropper (nos. 32, 64, and 86) or ladled into a brushwasher (nos. 33, 34, and 36). Its shape perhaps derives from a Buddhist alms bowl.[1] A few similarly shaped waterpots sport covers, but the majority seem to have been made without them.[2]

Four ogival panels emblazon the walls of this waterpot, each with a *fenghuang*, or phoenix, with wings spread in flight amidst clouds. Cranes and clouds, arranged in triangular configuration, decorate the interstices. Although decorations of dragons and phoenixes appear in blue-and-white ware of all periods, cranes and other Daoist emblems of immortality were particularly common during the reign of the Jiajing emperor, who was an ardent Daoist. The subject matter and the purplish blue of the cobalt make this waterpot a typical work of the Jiajing period. A virtually identical example appears in the collection of the Palace Museum, Taibei.[3]

40. Brush

Ming, probably Wanli period (1573–1620)
Jingdezhen blue-and-white ware, porcelain with decoration in underglaze cobalt blue, L. (with brush head) 27.6, D. 4.7 cm

THE INVENTION of the pliable brush in China must date at least as far back as the Neolithic period, for Yangshao burnished pots give every indication of having been painted with the brush. Porcelain-handled brushes probably made their appearance relatively late, sometime in the late fourteenth or the early fifteenth century. Early Ming porcelain brush handles, especially ones from the Xuande period, tend to have relatively straight sides, but ones of the sixteenth and early seventeenth centuries, such as this example, often exhibit an elongated-bottle shape. Porcelain handles of blue-and-white ware were favored during the fifteenth and sixteenth centuries, but ones with decoration in overglaze polychrome enamels began to dominate in the late sixteenth century. Porcelain never replaced wood and bamboo as the most preferred material for brush handles, but it was used for the occasional luxury piece, as were jade and ivory.

The dragon-and-floral arabesque, visible on the lower portion of this brush handle, matured as a decorative motif in the early decades of the fifteenth century, but it was frequently employed in later periods as well. Elaborate diapering, like that at the top of the handle, was especially popular in the late fifteenth and sixteenth centuries. The use of an archaistic dragon and floral-scroll motif combined with the

diaper pattern and rich blue of the cobalt suggests an attribution to the early years of the Wanli period, or even the closing years of the Jiajing reign. A virtually identical—and like this one, unmarked—brush in the Palace Museum, Taibei, has been attributed to the Wanli period.[1] A blue-and-white brush of similar shape but slightly different decoration in the Percival David Foundation, London, exhibits a Wanli mark.[2]

The soft animal hairs of the head of this brush are doubtless not the original sixteenth-century ones, but they are not necessarily modern. The head would have been replaced from time to time as the bristles became worn through use.

41. Brush Boat

Ming, Wanli period (1573–1620)
Jingdezhen blue-and-white ware, porcelain with decoration in underglaze cobalt blue and with underglaze cobalt-blue mark reading *Da Ming Wanlinian zhi* within a double rectangle on the base, H. 4.8, L. 31.2 cm

A MOLDED vertical panel at roughly two-thirds the length divides the interior of this brush boat into two compartments. Such vessels were typically used as a temporary receptacle for a brush when a painter or calligrapher was alternating among several brushes for variation in width, texture, or expressive effect of line. The mountain-shaped panel could support one or two brushes in its indentations, the handle of the brush (see no. 40) resting in the longer compartment and the smaller compartment catching any ink that might drop from the saturated head.

In typical Wanli fashion, the vessel is decorated with flying *fenghuang*, or phoenixes, and spiked dragons that stride rapidly but effortlessly over the surfaces. The phoenixes, with five-plumed tails, symbolize the *yin*, or female, forces of nature, while the dragons represent the *yang*, or male, forces. Although use of the five-clawed dragon is often said to have been the prerogative of the imperial family, that association is certain only with the so-called Mandarin squares, or embroidered badges of office and rank; the exclusive identification of this dragon with the imperial family in ceramic decoration is less certain.

Dragons have long been paired with clouds and water in Chinese ceramic decoration,[1] but it was not until the Jiajing period that the convention of representing a dragon above a wave-washed rock gained currency.[2] By the Wanli period the motif was firmly established and frequently occurs in ceramic, lacquer, textile, and architectural decoration.

This brush boat and its congeners may well have been produced with a double-faced press-mold, as indicated by the gently rounded corners indented at the lip, the even curvature of the walls, and the engaged struts on the base. The vertical brushrest panel was most likely molded separately and inserted while the clay was still moist, before the piece was decorated and glazed.

The shape, subject matter, rich dark cobalt-blue color, and style (with small, almost lace-like design elements) all point to a Wanli date for this brush boat, a fact confirmed by the mark on the base. The brush boat is rare among Chinese ceramics, and most examples date to the Wanli period. Blue-and-white brush boats are exceptionally rare, overglaze enamel ones occurring more frequently.[3]

42. Gourd-shaped Wall Vase

Ming, Wanli period (1573–1620)
Jingdezhen blue-and-white ware, porcelain with decoration in underglaze cobalt blue and with underglaze cobalt-blue mark reading *Da Ming Wanlinian zhi* in a cartouche on the back, H. 31.6, W. 15.1 cm

ALTHOUGH THIS *guaping*, or hanging vase, might have been used to display a bouquet of flowers, its brilliant color alone would have been sufficient to enliven a studio wall. Simulating a calabash (*hulu*) in shape, the rounded front of the vase displays two principal registers of decoration, one on each of the swelling forms. The lower scene depicts a group of gentlemen in a garden, with the central figure seated before a screen and the others respectfully standing. The abstract pattern of the cobalt wash suggests that the screen might include an inset marble plaque, a larger version of the miniature screen in this exhibition (no. 69 G).

The Chinese were traditionally fond of gourds, and in the Ming and Qing they often shaped and decorated growing gourds with molds.[1] During the Song they would sometimes carve seals so that the legend was configured in the shape of a gourd. It is thus not surprising that by the late Southern Song or Yuan the "double gourd" had entered the repertory of ceramic shapes.[2] Gourd-shaped bottles proliferated during the Jiajing reign of the Ming,[3] but the hemispherical, gourd-shaped wall vase probably first appeared during the Wanli era.

Unlike the highly stylized dragon-and-phoenix pattern of the contemporaneous brush boat (no. 41), the two principal registers of decoration on this wall vase are strongly pictorial. Chinese ceramic decorators had been experimenting with the representation of recession into pictorial space since the late fourteenth century,[4] but it was only in the Wanli period, in works such as this one, that ceramic painters achieved tightly knit, unified compositions with relatively level ground lines. This accomplishment paved the way for the ubiquitous pictorial designs of the seventeenth century.

The underglaze cobalt-blue reign mark on the back is contained within a rectangular cartouche resting on an open lotus blossom and surmounted by a lotus leaf seen in profile (back view, no. 42). In this piece, the cobalt was diffused through the glaze, so that the mark and some of the designs are slightly blurred.

A virtually identical wall vase with the same lotus-cartouche mark is in the collection of the Musée Guimet, Paris.[5]

43. Mountain-shaped Brushrest

Ming–Qing, mid-17th century
Jingdezhen blue-and-white ware, porcelain with decoration in underglaze cobalt blue, H. 4.0, W. 12.3 cm

THE USE OF ceramic material for brushrests dates to at least as early as the Tang dynasty. With the Chinese love of rocks and the important role that mountains play in both Chinese thought and painting,[1] it is only natural that brushrests should have been fashioned in the shape of mountains.

This brushrest depicts prominent topographical features of Fuliangxian, Jiangxi province, the area around the ceramic production center of Jingdezhen. Small groups of buildings are tucked in mountain valleys to indicate towns and villages, and specific place names are inscribed in the rectangular cartouches. Although more conservative Ming scholars preferred monochrome glazed ceramics in Song style (compare nos. 31–34 and 88–89), ones of more liberal taste did not object to high quality blue-and-white pieces. A brushrest like this one might well have appealed to Li Rihua who was sent to Jingdezhen early in 1598 to supervise the selection and packing of porcelain to be shipped to Beijing.[2]

Although the Chinese had been making maps for centuries—and a few specific mountains had long attracted the attention of Chinese painters—it was only in late Ming painting that the representation of individual localities became common.[3] About the same time, lacquer artists began to depict specific areas in their works, especially in those pieces with inlaid mother-of-pearl decoration. The subject matter of this brushrest can be viewed as part of that larger phenomenon.

The light color of the cobalt, the extensive use of graded washes, and the scalloped edges of the clouds suggest that this brushrest dates to the mid-seventeenth century.

This container was likely to have been used to house a cricket during the summer months, when crickets were kept in pottery containers to afford a measure of protection from the heat. During the winter months they were kept in molded gourd containers which were warmer to the touch. Many of the pottery containers were outfitted with tiny porcelain dishes for feeding the crickets as well as small clay vessels in which the insects could sleep. A painting in the Field Museum of Natural History, Chicago, depicts a group of young boys playing with crickets, apparently transferring a newly captured one from a trap to a ceramic container similar in shape to this example.[3]

The impressed mark reading *Huzhou Zhang Shunji yinhua* indicates that the silver inlay work was done by Zhang Shunji from Huzhou, Zhejiang province. The pot itself was probably made in Lumu, a suburb of Suzhou, well known in Ming and Qing times for the manufacture of pottery cricket containers. Suzhou potters, like their counterparts at Yixing (no. 35), often impressed seals on their works, naming the individual or kiln that produced the pots.

Decorative Arts

44. Cricket Container

Ming–Qing, probably 17th century
Molded black earthenware, probably produced in the Lumu suburb of Suzhou, with decoration of stylized characters in inlaid twisted silver wire and with impressed mark reading *Huzhou Zhang Shunji yinhua*, H. 7.8, D. 11.4. cm

THIS CYLINDRICAL cricket jar has a flat cover with a metal ring handle in the center. Bordered above and below by a *leiwen* collar, the principal band of decoration features sixteen variants of the auspicious character *shou* (longevity). The *guwen*, or archaic-style script, recalls the script on inscribed bronzes of the Shang and Zhou periods (nos. 82–84). All the decorative motifs have been inlaid with twisted silver wire, which offers a subtle contrast to the slate-gray earthenware body. Now tarnished, the silver wire would originally have been much brighter.

Perhaps more than any other people, the Chinese have been intrigued by the insects about them. The chirping of crickets is frequently mentioned in the *Shijing* (*Book of Songs*), the classical anthology of poetry whose roots in oral tradition stretch as far back as the Shang. Succeeding generations must have continued to enjoy the sound of crickets, and during the Tang individuals began to keep crickets in cages. By the Song dynasty the sport of cricket fighting had evolved and, along with it, a veritable cult of the cricket.[1] In the thirteenth century, the official Jia Sidao (1213–1275), a cricket fancier, wrote a treatise entitled *Cuzhi jing* (*Book of Crickets*) describing different varieties of crickets and discussing their care and treatment.[2] Following his lead, scholars of the Ming and Qing contributed significantly to the literature on crickets.

45. Hairpin with Phoenix Finial

Ming, 16th–early 17th century
Pale greenish-white nephrite, excavated in 1970 from a Ming tomb at Dongchang lu, Huangpu qu, Shanghai, L. 18.4 cm

LONG, SLENDER pins like this one were intended mostly for men. They were sometimes used alone but other times with a barrel-shaped hair ornament in metal or jade. Lu Zigang (see no. 50), the most renowned jade carver in Chinese history, who was active in Suzhou during the mid- to late sixteenth century, is said to have fashioned such hairpins in jade.[1] Although this piece is not signed, it is close in date to Lu Zigang and reflects his style. Numerous pins and other small carvings in similar style have survived above ground as heirloom pieces; this one is particularly important, however, for it was excavated from a Ming tomb, confirming its Ming date. A related piece—a small sculpture in white jade with openwork designs depicting egrets amid lotuses—was excavated from a Ming tomb in Nanjing, Jiangsu province.[2]

Hairpins of jade and bone have been excavated from Shang burial sites, evincing their long history in China. Phoenix finials had definitely been added to hairpins by the Tang dynasty and remained an often-used ornament thereafter. In the British Museum there is a tenth- to twelfth-century silver-gilt appliqué ornament in the shape of a flying bird with outstretched serrated wings and a long tail that could well be a distant forebear of the phoenix finial on this jade hairpin.[3]

The stone of this piece is excellent. The color is so pale that it would easily have been considered white, the most preferred color for jade in the late Ming and early Qing.

46. Belt Buckle with Knotted Rope Decoration

Ming, 16th–17th century
Pale greenish-white nephrite, excavated in 1967 from a Ming
tomb in Longhua xiang, Shanghai xian, L. 10.6, W. 4.2 cm

JADE BELT BUCKLES have a long history in China, having appeared at least as early as the Warring States period. The earliest examples comprise but one part—a shaft, often elegantly curved, with a hook at one end and a knob on the reverse for attaching the belt (compare no. 47). Two-part buckles like this one have been found at Yuan and Ming archaeological sites, indicating that they had appeared by the fourteenth century.[1]

A handsome, symmetrical form appropriate for a buckle, the knotted-rope design is regarded as a symbol of immortality since it lacks both beginning and end. Its popularity in the late Ming may have been inspired by the so-called mystic knot, one of the Eight Buddhist Emblems frequently seen on decorative arts of the Ming and Qing.

The use of diagonal fluting on jade to simulate rope probably began late in the Zhou dynasty, and a number of Warring States period bracelets with such decoration have survived.[2] Openwork designs simulating knotted rope had matured by the Song, as a marvelous pendant in the collection of Dr. Paul Singer attests.[3] The pattern continued to be fashioned throughout the Ming and Qing, sometimes with a loss of vitality, but the present example illustrates that lapidary artists of the late Ming were still willing to bring fine craftsmanship to bear in reworking this old motif.

The Ming date of this buckle is confirmed by its recovery from a Ming tomb. The stone, like that of the phoenix hairpin (no. 45), is of high quality and light enough in color to be termed white.

are not uncommon. The use of small *chi* dragons as surface ornament, especially on pierced disks and scabbard furnishings, gained currency during the Han.[1] The single-piece belt hook is one of the most characteristic forms among post-Han jades, and it was in almost continuous use until the Qing.[2]

Although these jade hooks were designed so that they could be used, by Ming times most were simply enjoyed as decorative objects whose archaistic forms symbolized continuity with the hallowed past. Scholars admired them for their beauty and craftsmanship, and perhaps occasionally used them as paperweights on the desk. The erudite cataloguer of taste Wen Zhenheng noted that inlaid bronze belt hooks of the Han and earlier periods could be attached to the studio wall and used for hanging paintings, elegant dusters, or feather fans.[3] Jade belt hooks of the mid-Ming presumably often served a similar function.

This hook and the white jade fish of no. 49 were excavated from the Pan family tombs near Shanghai. To that prominent Shanghai family belonged the scholar-official Pan Yunduan (1526–1601),[4] who built the Yuyuan, one of the few classical Ming gardens extant in Shanghai. The tombs date to the Jiajing and Wanli periods, and this jade belt hook is probably contemporaneous.

Important features of style to note in the design of this hook are the implied relationship between the *chilong* and the larger dragon head, and the groove that encircles the edge of the spatulate body. This type of groove frequently appears on the footring of Ming jade vessels and evinces the care with which jade workers practised their craft. Not all Ming pieces display this feature, but it is far more common than among Qing examples. The slender neck that links the spatulate body and dragon-head hook of this piece is also a Ming characteristic. The mottled stone of this buckle is more typical of Ming jades than is the flawless, almost white stone of nos. 45, 46, and 50; the high surface polish of this piece, however, is unusual among Ming jades.

47. Belt Hook with Dragon Head and *Chilong* Decoration

Ming, 16th–early 17th century
Mottled grayish-white nephrite, excavated in 1976 from the
Pan family tombs of the Jiajing (1522–1566) to Wanli
(1573–1620) periods at Longhua xiang, Shanghai xian, L.
15.5, W. 3.5 cm

THE ARCHED BODY of this belt hook is of flattened spatulate form. The narrow end of the body curves back on itself to form the dragon-head hook that would have received the jade or metal ring attached to the other end of the belt. A small horned *chi* dragon appears in full relief on the surface; its body arranged in an elaborate S-curve, it creeps stealthily toward the larger dragon head, like a baby playing with a parent. The flat, quatrefoil-shaped button on the back would have been used to fasten the piece to the belt.

Jade and bronze garment hooks with animal heads had appeared by the Warring States period. Feline heads predominate among belt hooks of that early date, but dragon heads

48. Belt Plaque with Decoration of Seven Boys

Ming, 16th–early 17th century
Mottled grayish-white nephrite, excavated in 1981 from a
Wanli period (1573–1620) tomb at Dongchang lu, Huangpu
qu, Shanghai, L. 7.6, W. 5.3 cm

BELTS INSET with jade plaques probably originated in Central Asia but had been introduced into China by the sixth century. Examples from the Tang and Song dynasties usually present single figures in low relief against a solid ground. Although plaques with pierced backgrounds appeared in the Tang, openwork grounds did not gain currency until the fourteenth century when they typically occur in combination with a much more complex style of decoration. Ming belt plaques typically present a variety of subjects—birds, flowers, dragons, deer—and give the illusion of numerous intertwined levels of carving. This piece is somewhat conservative in style, retaining the human figure as its principal subject matter and employing only two levels of carving, the

figures and background. It was originally part of a set that perhaps included as many as nineteen pieces.[1]

Scenes of young boys playing were common during the sixteenth century, especially during the Jiajing reign, when they occurred on countless examples of blue-and-white porcelain. The children in this scene play with a variety of toys, including parasols and other trappings of officialdom. Apart from being an amusing and cheerful theme, the motif was intended as an auspicious wish that the viewer might have many sons who would attain positions of power and prestige (compare no. 66).

This plaque was excavated from a Wanli period tomb in Shanghai. Among other articles recovered from the tomb was a folding fan (compare nos. 69 C and D and 91) bearing the cyclical date *bingwu* (1606), allowing the tomb to be dated to the Wanli period.

49. Fish and Lotus-leaf Pendant

Ming, probably mid-16th century
Mottled white nephrite, excavated in 1976 from the Pan family tombs of the Jiajing (1522–1566) to Wanli (1573–1620) periods at Longhua xiang, Shanghai xian, L. 5.1, W. 2.0 cm

DAOISTS CONSIDERED jade the stone of immortality, and Confucius (551–479 B.C.) not only praised it as the noblest of materials but likened its virtues to those of his *junzi*, or Superior Man.[1] With such symbolic overtones, jade was cherished by the Chinese, and no proper gentleman would have been without a few prized pieces to carry about on his person. This small fish pendant has a single perforation in the center of the dorsal fin that allowed it to be suspended on a silken cord. A lotus leaf appears in low relief on the reverse.

The fish was particularly favored for these pendants as the word for fish in Chinese, *yu*, is a homonym for the word "abundance." In addition, *he*, or lotus, is a homonym for "harmony," so this small pendant is an auspicious wish to the viewer for both harmony and abundance. Such visual rebuses are common in jades of the Ming and Qing. By the Shang dynasty, lapidary artists had created the jade fish pendant, the distant ancestor of this example. The pairing of fish (usually the carp) and lotuses as a decorative motif probably began in the Northern Song or Jin,[2] but did not gain widespread currency until the Yuan, by which time it was firmly established.[3] The motif reached the height of its popularity during the Jiajing era of the sixteenth century when large numbers of porcelain vessels were decorated with lotus-and-goldfish designs in colorful overglaze enamels.

The simple, naturalistic treatment of this piece—particularly the presentation of the lotus leaf without a long stalk—suggests an early to mid-sixteenth century attribution. A very similar example was recently excavated from the tomb of the eminent Ming essayist and scholar Lu Shen (d. 1544), lending credence to the attribution given here.[4] Later pendants tend to be both more elaborate and more stylized, with a lotus stalk passing through the fish's mouth and often encircling its body as well.[5]

Like the jade belt hook of no. 47, this pendant was excavated from the Pan family tombs near Shanghai.

50. Belt Buckle with Scenes of Mi Fu and Zhang Qian

Qing, probably late 17th century
Pale greenish-white nephrite, excavated in 1967 from a Qing tomb at Gonghe xinlu, Zhabei qu, Shanghai, L. 12.3, W. 4.5 cm

THE SHORT INSCRIPTION reading *Nangong baishi* on the left panel of this jade belt buckle identifies the scene as "Mi Fu Saluting a Rock." A famous scholar-official of the late Northern Song, Mi Fu was also a celebrated painter, calligrapher, and connoisseur. He cherished fine garden rocks, especially ones of unusual shape from Taihu. Legend recounts that one day upon discovering a rock more magnificent than any other he had ever seen, Mi Fu bowed before it and addressed it as "Elder Brother." That occasion, represented here, held special appeal for the literati of the late Ming who admired and shared Mi Fu's eccentric elegance.

The inscription reading *Zhangzi chengcha* identifies the scene on the right panel as "Master Zhang Riding the Raft." Zhang Qian (2nd century B.C.) was an explorer of the Western Han who sought the source of the Yellow River, said to flow from the Milky Way. At some point the story of Zhang Qian was combined with the tale of a magic raft that could carry people through the four seas, the heavens, and the Milky Way. With its overtones of both adventurous travel and Daoist magic, the legend found great favor in the late Ming.

The two scenes depicted here are unrelated except that both were popular in the late Ming and early Qing. The theme of "Mi Fu Saluting a Rock" frequently appears in Chinese painting of the seventeenth century, and depictions of "Master Zhang Riding the Raft" occur in numerous seventeenth-century examples of silver, jade, blue-and-white porcelain, and carved rhinoceros horn.

With its naturalistic surface decoration suggestive of a painting on paper, this buckle is in a style usually associated with Lu Zigang (compare no. 45). The shape of the rocks and the treatment of the trees point to an early Qing date for this buckle, however. The ribbonlike clouds that waft through so many scenes on jades and blue-and-white porcelain of the mid-seventeenth century are noticeably absent here, and the calligraphy is close in style to that on jades assigned to the Kangxi period,[1] suggesting a late seventeenth-century date for this buckle. The excavation of this piece from a Qing tomb confirms its antiquity but does not aid in dating it precisely.

51. *Gui* Vessel with Knob Decoration

Ming, 16th–17th century
Mottled brownish-gray nephrite, H. 5.1, D. 9.7 cm

SMALL JADE VESSELS in the shape of archaic ritual bronzes were favorite objects in the scholar's studio. The *gui*, *ding* (compare nos. 84 and 85), and *zun* were the most commonly imitated shapes in Ming times, but by the Qing, imitations of the *gu*, *jue* (compare nos. 82 and 83), and *jia* had come into vogue as well. Such Qing pieces were probably mere orna-

ments to grace a desk or bookshelf. The function of Ming pieces is less certain, but since bowl and jar shapes predominate, they may have served as cups, incense burners, or water vessels for the scholar's table. In any event, the interest in archaistic shapes and decoration reveals the late Ming scholar's deep involvement with the past through collecting and the study of art, literature, and history.

Precise dating of these small *gui*-shaped vessels within the Ming period is problematic. Vessels of the Ming—this one included—can often take on relatively simple forms with sparse decoration alternating with smooth surfaces. Jade *gui* vessels with other types of decoration—vertical ribbing or *taotie* masks, for example—are even more difficult to date and have sparked much scholarly debate. With its well-modeled footring, its interest in geometric form, and its contrast between decorated and undecorated surfaces, the Shanghai Museum jade *gui* typifies the mid- to late Ming style.

Bronzes decorated with bosses had evolved by the late Shang (see no. 84), but knobs, or bosses, probably did not appear on jades until the Eastern Zhou.[1] The jade bosses were not strictly regimented into rows and columns until the very late Eastern Zhou, or even early Western Han.[2] Once established, that regimentation usually prevailed in boss-decorated pieces of later periods, probably for ease in carving.

52. Recumbent *Bixie* Paperweight or Decorative Carving

Ming, 16th–early 17th century
Greenish-white nephrite mottled with rust-brown, H. 4.1, L. 9.4 cm

LIKE THE CARVED ram by Yang Ji (active 17th century, no. 54), this small jade sculpture may have ornamented a scholar's desk or bookshelf, but it could also have served as a paperweight. Perhaps an importation from Persia, the *bixie* chimera—an imaginary creature resembling a winged lion—rose to prominence in the arts of the Han dynasty.[1] The typical Han *bixie* is a fully self-assured beast that strides forward proudly, its head held high, its mouth open and growling, its tail curled with nervous energy. Large sculptures of *bixie* chimeras were associated with the royal tombs of the Southern Dynasties during the Six Dynasties period. Their exact meaning remains unclear, but their ferocious demeanor suggests a tutelary function. By the Ming period artists tended to present these creatures more as docile, domesticated pets than as ferocious guardians. In fact, the combination of bulging, staring eyes with closed mouth and passive posture makes the Ming examples seem, by contrast, timid and diffident.[2] The static quality and simplicity of design are typical of Ming carvings.

This chimera holds a branch of auspicious *lingzhi* fungus in its mouth, so that it symbolically bears good tidings. The interest in pairing elements for their symbolic meaning is also seen in the white jade fish pendant (no. 49). The tendency to embellish is especially characteristic of the middle and late Ming, signaling a sixteenth-to-seventeenth-century date for this piece.

The bottom of this piece is completely finished and the surface is smooth and well modeled, lacking the hard, lustrous polish of Qing pieces. The stone is mottled throughout with rust-brown markings, some of which may have been artificially achieved through staining.[3]

53. Seated Bodhidharma (or Luohan)

Wei Rufen (probably 17th century)
Ming–Qing, probably 17th century
Mottled brownish-green soapstone from Shoushan, Fujian province, with traces of gilding and with a signature reading *Wei Rufen zhi* carved on the base in *lishu*, H. 10.7, W. 12.9 cm
Gift of Hu Ruizhi

LITERATI PAINTINGS of the seventeenth century frequently depict small Buddhist images among the accoutrements of a scholar, along with ink and inkstones, *ge*-type ceramics, and archaic bronzes used as flower vases or water pots.[1]

Although this sculpture has traditionally been identified as a luohan, it most likely represents Bodhidharma (Chinese, Damo), an Indian sage who, according to Chinese legend, traveled to China in the sixth century and founded the Chan sect of Buddhism. Bodhidharma is usually depicted with a large head and foreign features, including a beard or moustache; in addition, he is typically presented with a red robe and with a shawl over his head. The stone of this sculpture is of variegated color, but it does have large red splashes on the back, especially near the figure's proper left shoulder. Luohans, on the other hand, are usually shown in the patchwork variety of monastic garb, and they are almost always depicted with the head bare, the shaven pate fully exposed (compare no. 59).

Paintings of Bodhidharma were especially popular in the Songjiang area during the sixteenth century.[2] If this sculpture was produced in that area—as its finesse suggests it could have been—the connection with painting could be revealing in terms of iconography.

The name Wei Rufen, carved on the underside of the flat stone base, is not recorded in the literature, so details of the artist's life remain unknown. This sculpture bears some similarity to a small soapstone figure of a seated luohan with a signature of Yang Ji (compare no. 54), particularly in the description of the large, round head and the treatment of the wide eyes and soft drapery folds.[3] The styles vary significantly enough to signal different hands, but the similarities are great enough to imply that Wei Rufen and Yang Ji were active about the same time and perhaps knew each other's work.

Shoushan stone, a variety of soapstone, or steatite, comes from Shoushan xiang, a suburb of Fuzhou in Fujian province. It occurs in a range of colors, from white (called *tianbai* and yellowish-orange (*tianhuang*, no. 54) to light green, dark brown, and even black; the colors are often variegated as in this small sculpture. In addition to its beautiful colors, Shoushan stone is extremely fine-grained, so that it can be given a subtle surface finish, smooth and delicate to the touch. Although some Shoushan stones bear a superficial resemblance to jade, the finest examples—especially *tianbai*

and *tianhuang*—are even more translucent. Soapstone gained respectability, as it were, among the literati during the Ming. As scholars accepted the soft stone for seals (see discussion no. 70), they came to hold it in high regard for carvings as well, not in place of jade but in addition to it.

The unusual coloring of this piece suggests that the stone may well have been artificially stained, a technique common in later jade carving.[4] In particular, that portion of the flat base directly under the figure is a light grayish-green, similar in color to the figure's exposed chest; the light color of this part of the base contrasts so markedly with the deep brown surrounding it that staining of the darker area is suspected. If this is indeed the case, only scientific examination can reveal how much of the color is natural and how much is artificial. As soapstone sculptures are studied in more detail, color enhancement will no doubt be found common. The figure's proper right hand is a replacement. It is uncertain whether the original was carved integrally with the sculpture or, like the base, was carved separately and attached.

PUBLISHED: Shen Zhiyu, ed., *The Shanghai Museum of Art*, New York: Harry N. Abrams, 1983: 282 and 324, no. 208

54. Recumbent Ram Paperweight or Decorative Carving

Yang Ji (active 17th century), *zi* Yuxuan
Qing, ca. late 17th century
Tianhuang soapstone from Shoushan, Fujian province, with a signature reading *Yuxuan* incised on the proper right front shoulder, H. 4.5, L. 8.6 cm

A SUPERB WORK of art, this sculpture must rank among the very finest soapstone carvings of any period. The body is naturalistically modeled, and in typical seventeenth-century style, almost every surface displays concave-convex movement so that the piece is alive with energy. The underside is as beautifully and completely wrought as the top. All surfaces are smoothly finished, the various parts blending harmoniously without the fine points and sharp angles so typical of the Qianlong period.

Yang Ji, better known by his sobriquet Yuxuan, was the most famous—and probably the finest—soapstone carver of the seventeenth century. From Zhangpu, Fujian province, he is said to have excelled in carving seal knobs (compare no. 70) and figures of humans and animals.

The quality of the stone matches perfectly the quality of the sculpture, for it is a surpassing example of the translucent, yellowish-orange *tianhuang* soapstone, the most famous variety of Shoushan soapstone (see discussion, no. 53). A relatively soft stone, *tianhuang* yields easily to the carver's knife, and one expects it to be meticulously sculpted with a beautifully finished surface. In general, white jade has been the most prized of stones throughout most of Chinese history, but there was a taste for yellow jade during the Yuan, Ming, and early Qing.[1] The popularity of the rare white and yellow jades doubtless accounts for the ranking of *tianbai* and *tianhuang* above other types of Shoushan stone.

55. Brushpot with Figures in a Garden

Shen Dasheng (active first half of 17th century), *zi* Zhongxu, Yumen, *hao* Yuchuan
Ming, first half of 17th century
Bamboo, with incised signature reading *Yuchuan Shen Dasheng zhi* and incised collector's inscription reading *Danshi Shanju zhencang*, H. 14.2, D. 13.4 cm

DURING THE MING two important centers of bamboo carving arose, one in Nanjing (the Jinling school) and the other in Jiading (the Lianshui school). In general, the Jinling school was noted for its shallow-relief carving, the Lianshui school for its high-relief carving and three-dimensional sculptures.[1]

A native of Jiading, Zhu He (*hao* Songlin, active 16th century) was the purported founder of the Lianshui school. His son Zhu Ying (*hao* Xiaosong) and grandson Zhu Zhizheng (*hao* Sansong, active 1620–1645) were also renowned carvers; each generation supposedly did even finer work than the preceding one so that Zhu Zhizheng is regarded as the most accomplished of the three.[2] Collectively, the Three Zhus are considered the greatest masters in the history of Chinese bamboo carving. Their works set the tone for all later carvings done in Jiading, and virtually all later masters from that area are said to have studied the manner of the Three Zhus.

The signature on this brushpot indicates that it was carved by Shen Dasheng. A well-known artist of the late Ming, Shen was a native of Jiading who followed the style of Zhu He. He was also a poet and an accomplished painter. Few facts about Shen's life are recorded, but traditional sources state that he studied medicine and that he lived into the early Qing period as one of the *yimin*, or Ming loyalists, who refused to accept the legitimacy of the new dynasty. A small sculpture of a toad by Shen Dasheng in the Brian S. McElney Collection, Hong Kong,[3] has an inscribed signature and a date that corresponds to 1623, showing that the artist was active in the early part of the seventeenth century. Since he was already working in the 1620s, he most likely knew Li Liufang (no. 21) and Zhu Zhizheng, and could even have studied with Zhu Ying. Few works by Shen Dasheng are extant in any medium. The inscription on the back of this brushpot was added by the nineteenth-century painter and connoisseur Ji Fen (*hao* Danshi Shanju, 1783–1846) and indicates that he once owned the piece.

During the Ming, brushpots were made in a variety of materials, including bamboo, wood, jade, and porcelain. It is possible that the vessel type originated in bamboo and was imitated in other materials. The pictorial scene on this brushpot is highly narrative in character and relates closely to designs in printed books of the late Ming. The densely packed composition and the emphasis on the foreground, in particular, find parallels in book illustrations (see nos. 26 and 28). Examples of bamboo carving are known in which the designs are virtually identical to ones in printed dramas popular at the time.[4]

The style of this elliptical brushpot is typical of the late Ming, especially in its tendency to intrude upon well-defined borders (compare no. 63) and its contrasting of decorated and undecorated areas. The figure types are also late Ming in style, especially the elliptical faces with relatively broad chins. Figures in late seventeenth-century works, by contrast, often have heads that are extremely large in proportion

to the bodies and faces that are distinctly oval with a tiny, pointed chin. All these traits suggest an early seventeenth-century date for this piece.

This Shen Dasheng brushpot is closely related in style to the aromatics container by Zhu Ying recovered in 1966 from a Wanli period tomb and to a seventeenth-century bamboo brushpot formerly in the collection of Dr. Ip Yee.[5]

PUBLISHED: Shen Zhiyu, ed., *The Shanghai Museum of Art*, New York: Harry N. Abrams, 1983: 276 and 321, no. 199

56. Waterpot with Pine Decoration

Ming–Qing, probably 17th century
Bamboo, probably bamboo root-stem (*zhugen*), with a carved seal reading *Zhiyan* on the base, H. 3.9, W. 7.4 cm

RESEMBLING an ovoid section of hollow pine trunk with scaly bark and clustered needles, this small but exquisite waterpot was doubtless intended more as an ornament for the scholar's desk than as a functional vessel. Its style and subject matter derive from works by Zhu He (see discussion, no. 55). A rare bamboo brushpot in the Nanjing Museum bears Zhu's signature and the cyclical date *xinwei* (probably 1571).[1] The boldly carved brushpot was fashioned in the form of a section of weathered pine trunk with gnarled branches and clustered needles. This type of brushpot spawned countless imitations in both bamboo and jade and was the inspiration for numerous wrist rests and waterpots, including this piece.[2]

The stylistic connection with Zhu He—including the shape and subject matter as well as the high-relief carving with openwork designs—clearly reveals the Jiading origin of this waterpot. Its subtle surface finish distinguishes it from the Zhu He brushpot in the Nanjing Museum, however, and suggests that it is probably later by several generations. With its complex shape, irregular form, heavily scaled branches, and fully finished base, the Shanghai Museum waterpot shows greater affinity to the late Ming or early Qing. Small vessels of this type were made over a long period of time with little change in style, however, so dating is notoriously difficult.[3]

The seal on the base reading *Zhiyan* would otherwise identify the carver as Zhou Hao (*hao* Zhiyan, 1686–1773), but most connoisseurs believe the seal is a later addition to this fine but probably anonymous seventeenth-century piece. A native of Jiading, Zhou Hao was a gifted poet and painter who specialized in bamboo scenes but who also carved bamboo.[4] He is better known for a linear style of carving that resembles engraving rather than for one employing openwork and high relief as in this piece. It is possible that Zhou once owned this waterpot, however, and added his seal as a collector's mark.

The Chinese used almost all parts of the versatile bamboo plant. In their carvings, craftsmen employed the hollow stalk, or culm, as well as the nearly solid root-stem (*zhugen*), the underground portion of the plant that connects the stalk and roots.[5] The irregular form and the relatively thick walls indicate that this waterpot was most likely carved from a section of root-stem rather than from a segment of stalk.

57. Wrist Rest with Landscape Decoration

Zhang Xihuang (active 17th century), formal name Zonglüe
Ming–Qing, first half of 17th century
Bamboo, carved in *liuqing* technique, with a carved poem at the top followed by two carved square seals reading *Zhang Zonglüe yin* (intaglio) and *Xihuang* (relief), L. 19.3, W. 5.8 cm

USED TO SUPPORT a painter or calligrapher's wrist while doing fine or meticulous work with the brush, the wrist rest was one of a host of new accoutrements that appeared in the Ming and soared to popularity in the seventeenth century. Though usually crafted in bamboo, ones of wood (no. 58) and jade are not uncommon.

Composed in four seven-character lines, the poem at the top of the landscape composition reads:

> The bamboo shadow is cool by the window where I try my new brush.
> At leisure I copy the essay in small characters that was exchanged for the geese.
> The nesting swallow flies by from time to time,
> Bringing fragrance in the form of new blossoms that drop on my paper.

In the best tradition of literati painting, the poem does not describe the scene but complements it. The "essay in small characters that was exchanged for the geese" refers to the *Huangtingjing* scripture that Wang Xizhi, China's most celebrated calligrapher, copied in small characters for a Daoist priest in exchange for a flock of rare geese. (A rubbing of the *Huangtingjing* appears in the *Mochitang xuantie*, no. 29.)

The seals at the end of the poem indicate that this superb wrist rest was carved by Zhang Xihuang, one of the most renowned bamboo carvers of the late Ming. The upper seal reveals that the artist's formal name was Zonglüe, Xihuang being a studio name. A brushpot by Zhang in the Museum of Fine Arts, Boston, displays identical seals, as do two additional brushpots in the Freer Gallery of Art, Washington, D.C.[1]

Although his date and place of birth are unrecorded, Zhang Xihuang is said to have been from Jiangyin, Jiangsu province. He must have been a literatus, as attested by the harmony of poem and pictorial scene in the Shanghai Museum wrist rest. He is regarded as the first great Ming master of *liuqing* (retaining the green) carving, which achieves its effects through contrasting colors rather than through relief work or linear engraving.

In the *liuqing* technique the green skin is left in place when the bamboo stalk is being prepared for carving. In working the designs the bamboo craftsman removes the skin from the background areas, then articulates the pictorial motifs in the skin that remains in the other areas. As the bamboo dries, the "retained green" skin matures to a golden yellow and the woody stalk to a warm brown with fine grains. Although *liuqing* carving originated as early as the Tang dynasty, it did not rise to prominence until the late Ming. Zhang Xihuang's particular genius lay in his ability to achieve gradations of tonality in the retained skin by varying its thickness through deft shaving and scraping. Aesthetically, his *liuqing* pieces are similar to monochrome ink paintings.

Virtually all of Zhang Xihuang's extant works, which number fewer than twenty, depict landscapes with trees, rocks, mountains, and buildings. Conventional wisdom asserts that he imitated paintings of the Tang artists Li Sixun and Li Zhaodao in his carvings; with their grand palaces, distant mountains, vast expanses of water, and elevated points of view, many of his works do bear a resemblance to Tang paintings. Closer parallels, however, can be found in paintings by Wang Zhenpeng (active late 13th–14th century) of the Yuan and his follower Li Rongjin (active 14th century). The calligraphy of the inscriptions usually follows the manner of Zhao Mengfu. Since Zhang must have been a literatus, his attraction to Yuan painting and calligraphy is not surprising.

The Shanghai Museum wrist rest and the two brushpots in the Freer Gallery also show some similarity to early Ming literati paintings, for their garden scenes with cottages and studios are related, at least in some details, to the intimate scenes pictured in Du Qiong's album, *Ten Views of Nancun Villa* (no. 6). The styles vary widely, but the spirit is akin.

Even in its minutest details—the tiled roof, the lattice wall, the tiny figure, the individual characters and seals of the inscription—this wrist rest exhibits the same deft hand as other works securely associated with Zhang Xihuang. In addition, the beautifully rendered Taihu rocks find parallels in Wanli period lacquers and seventeenth-century jade carvings,[2] corroborating the late Ming date of this piece and illustrating the essential unity of style among the decorative arts of the late Ming.

carver Wu Zhifan (active second half of the 17th century).[3] The treatment of the figure with soft modeling and gently rounded contours is remarkably close to the Wu Zhifan piece, as is the scale of the figure to the mountainscape and the handling of the broad expanses of vertical cliff face. Given its superb quality and its similarity in style to the Palace Museum brushpot, there is reason to believe that this wrist rest was also carved by Wu Zhifan. Active in Jiading, then later in Tianjin, Wu Zhifan was well known for his carvings in relatively low relief that give the impression of great depth.

Although bamboo and wood had been used in China since remote antiquity for functional articles as well as musical instruments, their appropriation as materials for the decorative arts came only in the Ming. The literati's attraction to bamboo as a material was no doubt sparked by their interest in bamboo painting (compare no. 20). With its Confucian overtones, its relationship to painting, and its warm monochrome color, bamboo was a logical material for the host of new scholars' accoutrements that appeared in the Ming. A taste for beautifully colored, fine-grained woods also soon developed. As such costly woods were also used for furniture and garden architecture, studio objects crafted in them harmonized well with their surroundings.

PUBLISHED: Shen Zhiyu, ed., *The Shanghai Museum of Art*, New York: Harry N. Abrams, 1983: 287 and 325, nos. 214 and 215

58. Wrist Rest with a Scene of Dongfang Shuo

Qing, mid- to late 17th century
Boxwood (*huangyangmu*), L. 15.6, W. 5.4 cm

ALTHOUGH CONCEIVED as a wrist rest, this marvelous carving may have served more as a decorative than as a functional piece. Designed to be viewed from both sides, it has been fashioned in the form of a soaring, craggy precipice. A precariously placed gentleman, dressed in flowing robes and cloth cap, stands on a small ledge, peering around one side of the vertical cliff. The peach that he holds in his right hand identifies the elderly, bearded gentleman as Zhang Shaoping (b. 160 B.C.), better known to history as Dongfang Shuo.[1]

A courtier, humorist, and prankster, Dongfang Shuo became the subject of numerous myths and legends. The episode depicted here refers to his theft of the peaches of immortality from Xiwangmu, Queen Mother of the West. He supposedly stole the famous peaches, which ripen only once every three thousand years, on three separate occasions. The story was a popular subject for painting and the decorative arts from the mid-Ming period onward. Such pieces were often presented as birthday gifts because of their auspicious suggestions of immortality.

The angular rocks, the elongated, rectangular composition, and the sparse, almost minimalist style reflect the influence of paintings by Monk Hongren (1610–1664) and of printed books from Anhui province.[2] An even closer parallel, however, is a carved boxwood brushpot in the Palace Museum, Beijing, that bears a signature of the celebrated bamboo

59. Luohan Seated on a Rock

Feng Xilu (active Kangxi period, 1662–1722), *zi* Yihou, *hao* Lianchi
Qing, 17th–early 18th century
Bamboo root-stem (*zhugen*), with an inscription reading *Feng Xilu zaoxiang* incised on the side, H. 14.9, W. 12.2 cm

LUOHANS ARE enlightened beings who are striving to attain the final stage of spiritual awareness. They are not deities but are reverently regarded as disciples or worthies of the Buddha. They were originally sixteen in number, but eighteen have generally been recognized in China from the tenth century onward, though groups of five hundred are often portrayed in Chinese Buddhist art as well.

Luohans entered the vocabulary of Chinese art with the arrival of Buddhism in the first and second centuries. By the Song period luohans were often depicted in groups, but separately from the Buddha and other deities. Still treated with seriousness, they were, however, sometimes shown engaged in such mundane tasks as tending laundry to emphasize their humanness.[1] In the late Ming, luohans became favored subjects of secular sculptors, less as votive images than as simple reminders of the spiritual realm (compare no. 53). Scholars appreciated these small sculptures in which the luohans are humorously presented and often look more like mere humans than like revered disciples of the Buddha. Their bony chests and slightly foreign-looking features are all that distinguish them from depictions of monks, unless a lion or other wild beast lies tamely nearby, revealing the immense power of their Buddhist *dharma*.

Born into a Jiading family of bamboo carvers, Feng Xilu[2] distinguished himself through his small sculptures. His dates are unknown, but he and his brothers, Feng Xizhang and Feng Xijue, were summoned to Beijing in 1703 to serve in the palace, indicating that he was active in the Kangxi period. He was employed in the imperial workshops there for a time, but later returned to Jiading because of ill health. Literary records state that Feng excelled in carving figures from bamboo root-stem and that he was fond of portraying monks and Buddhas in strange poses and unusual forms. He was well known for the naturalistic drapery and relaxed attitudes of his figures.

Feng Xilu's works are exceedingly rare; this is one of the few signed pieces that can be considered genuine. It accords well with literary descriptions of his work and compares favorably with a bamboo sculpture of an old monk that Wang Shixiang has tentatively attributed to his hand.[3]

PUBLISHED: Shanghaishi wenwu baoguan weiyuanhui, comp., *Shanghai gudai lishi wenwu tulu* (*An Illustrated Catalogue of Ancient Cultural Objects from Shanghai*), Shanghai: Jiaoyu chubanshe, 1981

sion, no. 13). He may have commissioned the cup or added his seal as a collector's mark. The inlaid silver seal on the base reading *Meng Ren shouzhi* (Handmade by Meng Ren) indicates that the cup was carved by Meng Ren, who is otherwise unrecorded. The seal script of the mark, mostly correct and partly invented, is typical of the Ming.

The irregular shape, the relatively high relief of the carving, and the preference for openwork designs displayed in this wine cup compare favorably with those of bamboo carvings from Jiading dated to the late Ming (compare no. 56). Also characteristic of the late Ming are the gentle modeling and rounded contours seen in the seated figure (compare no. 58). The detailed finishing of the base, with its irregularly shaped, angular rock forms and its whirlpool segmented by ridges, evinces ties with mid-Ming carving styles,[1] but suggests a date in the late Ming period. Amidst the ebbing of traditional values in the sixteenth and seventeenth centuries, Tao Yuanming, who left official life after only a few weeks to return to the simple life on his farm, was a favorite subject of Chinese painting and the decorative arts.[2]

60. Wine Cup with a Scene of Tao Yuanming

Meng Ren (probably active late 16th–17th century)
Ming, late 16th–17th century
Zitan wood inlaid with a poem in silver wire, the interior lined with brass, with a seal inlaid in brass reading *Xueju* following the poem and a seal inlaid in silver reading *Meng Ren shouzhi* on the base, H. 5.7, W. 10.9 cm

OF IRREGULAR ovoid shape, this handsome *zitan* wine cup is carved in the form of a lakeside cliff. A gentleman in traditional scholar's robe and informal cloth cap sits in a grotto on one side of the handle, gazing toward a distant view. Around the cup from the figure several chrysanthemums grow on a small ledge at the water's edge.

The inscription comprises three separate and seemingly unrelated units. The first, nearest the seated figure, is a column of four characters reading *Yuanming shangju* (Yuanming enjoying chrysanthemums). It identifies the gentleman as the poet Tao Yuanming (Tao Qian, 365–427), whose love for chrysanthemums is well known. The second unit is a column of three characters reading *Song hua shi*. The third unit is composed of two seven-character poetic lines:

Su Jin ate vegetarian meals before a brocaded Buddha.
When intoxicated he often liked to escape in meditation.

The poem, which does not seem to relate to either Tao Yuanming or the scene depicted, may have been a favorite line of the person for whom the cup was made, or it may have been merely a reference to the pleasures of wine. The inlaid brass seal reading *Xueju* at the end of the poem perhaps refers to Sun Kehong (*hao* Xueju), the Songjiang painter (see discus-

61. Cup with Six Dragons Amidst Clouds

You Kan (probably active 17th century)
Ming–Qing, probably 17th century
Rhinoceros horn, with a carved seal reading *You Kan*, H. 9.3, W. 11.5 cm

THE RHINOCEROS has been known in China since antiquity and is represented in bronzes and jades of the Shang and Early Western Zhou periods.[1] It was valued for its hide, which was used to fabricate armor. It is uncertain when the Chinese began to use the horn—actually a solid mass of agglutinated hair rather than true horn—but the fourth-century writer Ge Hong credited it with the valuable power of detecting and neutralizing poison. As medicinal and aphrodisiacal properties were also ascribed to it, the rhinoceros horn quickly entered the vast Chinese pharmacopoeia.

The earliest extant articles of secure date carved in rhinoceros horn are ones from the eighth and ninth centuries in the Shōsō-in, Nara.[2] Among the items preserved there are rhino horn belt plaques and *tanbing*, or early *ruyi*-type scepters (see no. 67). Vessels of the Song and Yuan periods have yet to be sorted out from the wealth of later material, but discussions in Cao Zhao's *Gegu yaolun* of 1388 confirm their existence.[3] Numerous examples of Ming and Qing date are known, many late Ming ones with Wanli period reign marks. Wen Zhenheng notes that it is appropriate to have an old rhino horn cup on the desk, along with a jade one, but he does not specify a particular shape or attribute magical properties to it.[4]

The seal script signature indicates that this cup was carved by You Kan, the most famous of the handful of rhinoceros horn carvers whose names are known.[5] Although You Kan is said to have come from Wuxi, Jiangsu province, his dates are

unrecorded. A few authors place him in the Ming period, but most assign him to the Kangxi reign of the Qing dynasty. He purportedly excelled in crafting pieces from ivory and stone as well and is said to have been so talented in doing fine and meticulous work that he was able to carve Su Shi's entire "Ode to the Red Cliff" ("*Chibi fu*") on a bead.

Traditionally associated with water and rain, the dragon is often paired with clouds in Chinese decorative arts. The motif of multiple dragons sporting amidst clouds is an ancient one whose lineage stretches back to Han times.[6] Here the dragons are engaged in a playful romp, in typical late Ming fashion.

The well-carved base and the implied relationship among the dragons point to this cup's late Ming origins (compare no. 47). More than anything else, it is the perfectly conceived and executed surface finish that signals a seventeenth-century date.

Rhinoceros horn should be smooth and mellow and have a translucency like fine jade or *tianhuang* soapstone, which gives the material an inner life. Newly harvested rhinoceros horn is grayish yellow in color; the rich, warm chestnut-brown preferred in carvings results from years of handling and polishing. Raw material of lesser quality was apparently stained to achieve the desired color.

62. Censer with Lotus, Narcissus, and Peony Decoration

Hu Guangyu (active late 16th–first half of 17th century)
Ming, late 16th–early 17th century
Bronze, with parcel gilding and silver inlay and with a 9-character gilded mark on the base reading *Yunjian Hu Wenming nan Guangyu zhi* (Made by Guangyu, son of Hu Wenming of Yunjian) in seal script, H. 9.3, D. 10.6 cm
Gift of Li Yinxuan and Qiu Hui

SECULAR INCENSE BURNERS in the form of ancient ritual bronze vessels evolved in the Song, inspired by renewed interest in antiquities. The shape of this censer derives ultimately from bronze *zun*, or wine-warming vessels, of the late Warring States and Han periods. Potters of the Song dynasty particularly liked this shape and employed it for incense burners. Most Song ceramic examples are undecorated, but by the Yuan, potters were embellishing the exterior walls with scrolling floral decoration.[1] Perhaps the closest ceramic parallels to the present incense burner are the Jizhou-ware lamps or incense burners from the Southern Song; their barrel forms, inverted lips, *leiwen* borders, and scrolling lotus decoration all anticipate the Ming bronzes.[2]

The mark on this censer clearly indicates that it was made by Hu Guangyu (see detail, no. 62). Little is recorded about the artist himself, but his father Hu Wenming,[3] the most famous bronze caster in the late Ming, worked in Yunjian (modern Songjiang), an important center of bronze manufacture. Hu Wenming is best known for his archaistic censers inlaid in gold and silver; they were said to have been very costly in their day and referred to as *Hu lu* (literally, Hu censers).

To date, only two other works bearing the mark of Hu Guangyu have been published, both of them *gui*-shaped censers.[4] Each has a nine-character mark identical in content and similar in style to that of the Shanghai Museum censer. It is on the basis of these marks that we know Hu Guangyu to be the son of Hu Wenming. The use of the father's name in the mark suggests that Hu Guangyu succeeded his father as head (or possibly owner) of the workshop and played on his father's name as a trademark. The *gui*-shaped censers by Hu Guangyu are remarkably similar in style to those with marks of Hu Wenming, and would be indistinguishable from them without the marks. This Shanghai Museum censer is virtually identical to one by Hu Wenming recently published for the first time.[5] Until additional pieces come to light, we cannot know whether Hu Guangyu worked exclusively in his father's style or whether some of the pieces bearing his father's mark were actually made by Hu Guangyu. (Some specialists interpret the seal-script characters of the artist's given name to read Guanghan; in any event, he was a son of Hu Wenming.)

The late Ming interest in bright colors manifests itself here in the contrast between bright gold and warm copper. Although parcel gilding had been used in the decoration of Ming copper and bronze vessels at least since the Xuande period, earlier pieces lack the visual force of this censer. Also typical of the late Ming is the naturalistic treatment of combined floral groups, picked out in parcel gilding. The diaper pattern of the background finds parallels in lacquers of the period.[6]

Unlike the archaic bronzes (nos. 82–85) which were cast with the piece-mold technique, most post-Han bronzes were cast with the lost-wax process. Although the *leiwen* borders above and below the principal register of decoration were inlaid through the traditional method of fitting silver wires into prepared recesses, the gold overlay was most likely effected through the use of mercury, or parcel, gilding. In this technique, the areas to be gilded would have been painted with an amalgam of powdered gold and liquid mercury after the censer had been cast, and then the vessel would have been heated lightly. As the mercury evaporated it left behind a thin but even layer of gold. This technique often produces slightly irregular edges in the gilded areas. In addition, since the layer of gold is exceptionally thin, it wears easily.

Wen Zhenheng recommended that ceramic censers be used in the summer months and bronze ones in the winter. Although one might have many incense burners, only one should be used at a time in the studio. The censer must not be randomly placed nor should it be set on the table for paintings; rather, it is to be kept on a stand reserved for its use.[7] Wen criticized certain types of censers made by Hu Wenming but recommended his incense tongs. The humble scholar Tu Long (1542–1605), who among others composed a treatise on incense, also praised Hu Wenming's incense tongs.[8]

Delicate fragrances, whether of flowers or of incense, figure prominently in Chinese poetry. The incense burner, along with the incense and the tongs for handling it, was an important part of the studio. The Japanese cult of incense has been well recorded and studied; Chinese customs, on the other hand, have yet to be explored in detail.

63. *Touhu* Vessel with *Chilong* Decoration

Ming, probably first half of 17th century
Bronze, H. 48.5, D. 21.3 cm

THE *touhu*, or pitch pot, was used as the target in the arrow game, an aristocratic drinking game in which two contestants (or teams) tossed arrows at the mouth of the vessel.[1] The side that pitched the greatest number of arrows into the *touhu* won and celebrated its victory by serving penalty drinks to the vanquished. This ancient game is mentioned in the *Zuozhuan* (*Zuo Commentary on the Spring and Autumn Annals*, attributed to Zuoqiu Ming, ca. 5th–6th century B.C.), and its rules and etiquette are set down in some detail in the *Liji* (*Book of Rites*), one of the Confucian classics.[2]

Its antiquity and its mention in classical literature made the arrow game popular in literati circles. A Han tomb relief from Nanyang, Henan province, depicts two figures engaged in a game of *touhu* and an eighth-century painted leather guard from a musical instrument, now in the Shōsō-in, Nara, is decorated with a group of gentlemen in a setting that includes a *touhu* vessel.[3] The social status of the men in the Han relief is uncertain, but the figures in the Shōsō-in painted guard are clearly scholars, as indicated by their robes and caps. From the Song onward, the *touhu* pot and its accompanying arrows were frequently depicted in paintings of scholars at their leisure.[4] The Song scholar-statesman Sima Guang (1019–1086) authored a treatise on the game entitled *Touhu xinge*, confirming the literati interest in the sport.

An eighth-century bronze *touhu* vessel has been preserved in the Shōsō-in.[5] The arrows that accompany the pot have round padded balls at the tip. According to the *Liji*, the arrows should be made of mulberry wood, or of zizyphus, with the bark intact. The material of the vessel is not specified, but bronze was doubtless the most commonly used.

The decorative style of *touhu* vessels varies with the period of manufacture, the only requisites being the long neck and the two ears, or tubular appendages, near the mouth. The style of this *touhu* is very much that of the Ming period. Interest in geometric forms, here accentuated by ridges and flanges, is a Ming characteristic (see no. 33), as is the tendency to establish a rule of form, then break it; here, for example, the *chi* dragon not only playfully violates the strict bilateral symmetry of the design, but interrupts the strict borders defined by the angles of the faceted neck. In similar fashion the small dragons in the rectangular panels of the belly intrude upon their borders. The intricately worked linear background pattern of this *touhu* also recalls the style of late Ming lacquers.

A 1647 edition of Sima Guang's *Touhu xinge*, mentioned above, includes a woodblock illustration of two hexagonal *touhu* pots almost identical in appearance to this one.[6] In reprinting old books, new woodblocks were often prepared; if the book was to be illustrated, it was customary to depict current manners and tastes. If that is the case with the 1647 edition of *Touhu xinge*, the vessels illustrated doubtless represent the early to mid-seventeenth century style. The remarkable similarity of the Shanghai Museum piece to those illustrated in *Touhu xinge* allows a tentative attribution to the first half of the seventeenth century.

64. Animal-shaped Water Dropper

Ming, 16th–17th century
Bronze, H. 10.1, L. 14.2 cm
Gift of Gu Lijiang

THIS WATER DROPPER has been fashioned in the shape of a standing, hoofed quadruped, perhaps a tapir. Water was poured into the interior cavity through the circular opening in the back, then dropped onto the inkstone through the small hole in the nose. A stopper, now lost, may have fitted into the opening in the back (compare no. 86).

Ming scholars were fond of playful water droppers, especially those with antique overtones. This small vessel finds its antecedents in the tapir-shaped bronzes of the Eastern Zhou. Vessels of that early date usually have long ears, absent here. The linear surface patterns and *leiwen* brows are clear references to the decorative styles of antiquity. It is traditional to depict animals of this type with a collar; even the Eastern Zhou examples often have a distinct pattern of lines about the neck that resembles a stylized collar, and many also have bands surrounding the belly that suggest belts or harnesses.[1]

The Shanghai Museum piece is remarkably similar, in both size and appearance, to a bronze water dropper, inlaid with gold and silver, published in the catalogue of the Seligman Collection. Of uncertain date, the Seligman dropper was said to be in the style of the late Zhou but of later manufacture.[2] In all probability it, too, dates to the Ming. Its decoration suggests that the surface patterns on the Shanghai vessel might once have sported gold and silver inlays (compare no. 65).

The small eyes, alert countenance, and dark color of the Shanghai Museum water dropper are standard characteristics of the early Ming. The linear surface ornament, however, points toward a mid- to late Ming date for this piece.

65. Recumbent Feline Paperweight

Ming, 16th–17th century
Bronze, inlaid with gold and silver, H. 3.8, L. 7.5 cm
Gift of Gu Lijiang

THE REPERTORY of Chinese decorative animal sculpture is replete with creatures, such as this one, uncertain in identity. Some are purely mythical, drawn from legends and fabulous tales. Others are animals that the sculptor had only heard about or seen in paintings, so that his understanding of the basic, identifying characteristics was tenuous at best. Still others are whimsical creations, the happy products of active imagination and artistic license. Yet others were probably very real but so stylized that we do not recognize them.

Animals such as this one, seemingly feline and perhaps a tiger, have been portrayed in Chinese art at least since Tang times. The convention of crossed paws apparently entered the vocabulary of sculptors during the Song. With its clean

outlines, overall simplicity of form, and rather timid expression, this small animal is wholly in the Ming idiom (compare no. 52).[1] The use of copper or a light brown bronze—in this case enlivened with inlaid gold and silver wires—reflects the growing interest in color in the late Ming.

Wen Zhenheng's comments on paperweights[2] indicate that at least some small animal-shaped bronzes from the early Ming were prized in the late Ming. Presumably, late Ming bronzes would not have been considered too inelegant for the studio as long as they had an antique flavor.

66. Paperweight with Boys Playing

Ming, 16th–17th century
Bronze, L. 6.4, W. 6.0 cm

THIS PAPERWEIGHT, roughly square in overall configuration, has been cast in the form of a visual pun that can be read two ways. Vertically, two boys appear back to back—one crouching, the other standing on his head. Horizontally, the sculpture can be read as a second pair of boys, the lower one doing a backstand and the upper one supporting himself with his left hand while resting his knees on the raised arm of the lower figure. In each set the boys are identical in appearance and posture, only their orientations having been reversed.

As early as the Song, painters such as Su Hanchen (12th century) had specialized in the depiction of children at play.[1] By the mid-Ming, scenes of young boys at play were common in all the decorative arts (compare no. 48). It is possible that the objects the children hold here are a coin and a silver ingot, the wish being that the viewer not only have many sons, but also wealth.

The use of rebuses and visual puns was standard in the mid- and late Ming periods (compare no. 49). Although a cleverly designed scene that can be read as either two or four boys might be sufficiently amusing for some, the play on images actually goes much deeper, for the pun refers to a line in the Daoist classic, the *Daodejing*, that would have been familiar to all men of learning:

The *Dao* gave rise to the One; the One gave rise to two; two gave rise to three; [and] three gave rise to the ten thousand things [i.e., everything].[2]

According to traditional Chinese explanation, this visual pun finds an even more explicit *locus classicus* in the *Dazhuan*, or *Great Commentary*, on the *Yijing* (*Book of Changes*):

Therefore there is in the Changes the Great Primal Beginning [*taiji*]. This generates two primary forces. The two primary forces generate four images. The four images generate eight trigrams.[3]

Although the words for "primary forces" (*yi*) and "boys" (*er*) are pronounced differently in Mandarin Chinese, they had similar pronunciations in ancient Chinese.[4] By substituting the almost homonymic "boys" for "primary forces" in the *Yijing* commentary, the statement becomes:

Therefore there is in the Changes the Great Primal Beginning [*taiji*]. This generates two boys. The two boys generate four images.

The interest in visual puns with classical overtones, in itself, suggests a late Ming date for this paperweight, as does the animation of the boys at play. In addition, the small triangular tuft of hair became popular in the sixteenth and seventeenth centuries; earlier representations usually showed boys with topknots.

67. *Ruyi* Scepter with Decorative Inscription

Ming, first half of 17th century
Iron, with cut sheet-silver and gold, L. 57.1 cm

DURING THE Qing *ruyi* scepters were often given as birthday presents or New Year's gifts because of the auspicious character of the name *ruyi*, meaning "as desired" or "as [you] wish." At certain times they were even conferred by the emperor as presentation pieces. Its exact significance in earlier periods is less clear, but the *ruyi* was definitely considered an appropriate accoutrement of an elegant and learned man. Old paintings, for example, often depict a scholar holding a *ruyi* scepter while engaged in conversation. In his *Zhangwu zhi* of 1637, Wen Zhenheng mentions that the *ruyi* was used for "giving directions."[1] This remark can be interpreted literally to mean that it was used, like a marshal's baton, to point the way, or figuratively to mean that it was held, like a wand, during learned discussions. Wen Zhenheng further remarks that iron ones could be used for personal defense.

The *ruyi* scepter is now thought to have evolved from the *tanbing*, or discussion wand, that was in use by the Six Dynasties period[2] and that was held during discussions, where it conferred the right to speak. In a fifth-century depiction of the *Seven Sages of the Bamboo Grove and Rong Qiqi* that decorates a tomb at Xishanqiao, near Nanjing, Wang Rong sits between a ginkgo tree and a willow, holding in his raised right hand a long wand that must be a *tanbing*;[3] the scene evinces the antiquity of the scepter and its early association with the literati. The Bodhisattva Mañjuśrī (Chinese, Wenshu Pusa)—the Buddhist Deity of Transcendent Wisdom—often holds a *tanbing* or *ruyi* when engaged in discourse with the sage layman Vimalakīrti (Chinese, Weimojie), who typically holds a fan. Since the Bodhisattva Mañjuśrī can hold a variety of other symbols, including a sword and a deer or yak tail, it is possible that the ancient Chinese symbol of discussion was appropriated specifically to indicate the intellectual debate between Mañjuśrī and Vimalakīrti.[4] In any event, both the *ruyi* and the fan became marks of cultivated gentlemen.

Several bronze *ruyi* or *tanbing* of eighth-century date have been preserved in the Shōsō-in, Nara. The modern type of *ruyi* with well-defined head probably evolved in the Song. A scepter intermediate in shape between the Shōsō-in examples and the modern type appears in *The Thirteen Emperors* scroll attributed to Yan Liben (d. 673) in the Museum of Fine Arts, Boston.[5]

In the Song most *ruyi* scepters were made of wood; by the Qing they were crafted in a variety of materials, from coral and jade to gold and gilt bronze. Iron *ruyi* are associated mainly with the late Ming, though Qing examples are known. Iron seems an unlikely choice of materials for scholars' objects. Perhaps its use derives from a particular incident or anecdote (possibly involving integrity) unrecorded and now forgotten; or perhaps it was used, as Wen Zhenheng stated, simply to make the *ruyi* heavy enough to be used for defense.

It is recorded that Zhao Nanxing (1550–1628), a minister of state celebrated for his integrity, had a number of iron *ruyi*, all made by one Zhang Aochun. Zhang is little mentioned in the literature and had no recorded followers, so information about him is scant. Although unsigned, the Shanghai Museum scepter is similar to three others, all dated to 1622, that bear the signature of Zhang Aochun and a poem by Zhao Nanxing.[6] Many of the characters in the Shanghai *ruyi*'s inscription have been effaced, but enough remain to determine that the inscription is not the poem by Zhao Nanxing that appears on the other pieces (see detail, no. 67).

The Shanghai Museum piece accords well with literary descriptions of seventeenth-century iron *ruyi* scepters, and it compares favorably with the examples dated to 1622 mentioned above. In addition, the *leiwen* diapering on the back corresponds to similar patterns in Ming textiles and the diapering on the front relates to that on late Ming carved lacquers, confirming the early seventeenth-century date of this piece. Whether it was made by Zhang Aochun cannot yet be determined.

These several iron scepters are closely related in technique of manufacture. They are not inlaid in the traditional manner, in which gold and silver wires are set into prepared recesses (compare no. 65). Rather, the iron was scored with a fine network of hatched lines so that the thin pieces of gold and silver would adhere to the roughened surface when hammered into place. Given the delicacy of the seal-script characters and exquisite finishing of the edges, it is possible that the entire scepter was first enveloped in sheet silver, and the background areas then cut away.

The individual design elements of these iron pictures were cut from sheet metal and hammered into the desired configuration, then secured to the wooden frame. Elements of the composition are often linked for structural support, but they are not secured to a common ground or backdrop. A variety of techniques was used for linking the elements, from twisted wires and interlocking parts to rivets and perhaps solder, all clearly visible from the back but cleverly concealed in the front.

The art of imitating ink painting in forged iron is of comparatively recent origin, having evolved only in the seventeenth century with Tang Peng (*zi* Tianchi).[1] Tradition asserts that Tang was a neighbor of the famed Anhui painter Xiao Yuncong (1596–1673) in Wuhu xian, Anhui province. Although a painter, Tang Peng supposedly took up depictions in forged iron after discovering that his paintings were less highly esteemed than Xiao's. This story is difficult to confirm, but Tang and Xiao are both known to have lived in Wuhu xian, and an inscribed date corresponding to 1687 on an iron calligraphy by Tang suggests that they were contemporaries.[2] Tradition also usually links Tang Peng with Liang Yingfeng (*zi* Zaibang),[3] another artist skilled in crafting iron pictures. Signed works by Liang are rare and autographed ones by Tang are almost unknown, so a specific attribution to either hand is virtually impossible.

The subject matter of these wall hangings accords well with that of works from early in the iron-picture tradition. Comparison with painting styles also suggests that a seventeenth-century date for these works is acceptable, but an attribution to a specific artist awaits further research.

Scholar's Accoutrements

68. Four Decorative Wall Hangings

Ming–Qing, 17th century
Forged iron with wooden frames
A. Crabs and Grasses, H. 140.5, W. 41.7 cm
B. Rock and Branch of Blossoming Prunus, H. 140.0, W. 41.9 cm
C. Rock and Branch of Fruiting Litchi, H. 139.7, W. 41.9 cm
D. Rock and Blossoming Rose, H. 141.3, W. 41.6 cm

SIMILAR IN STYLE and subject matter to literati hanging scrolls in the bird-and-flower genre, these wall hangings—called *tiehua*, or iron pictures—would once have graced a scholar's studio. They relied on the contrast between the dark metal of the designs and the whitewashed walls of the studio for visual effect, simulating monochrome ink paintings on white paper. The consistency of style, size, and technique indicates that these four hangings made up a set or were part of a set.

69. Fourteen Scholar's Accoutrements

Ming, late 16th–early 17th century
Excavated in 1966 from the Wanli period (1573–1620) tomb of Zhu Shoucheng in Gucun zhen, Baoshan xian, Shanghai

A. Scroll weight with jade knob in the form of a recumbent dog, *huanghuali* wood with pale greenish-gray nephrite ornament (jade ornament could date to the Song), H. 3.2, L. 28.4, W. 2.9 cm
B. Scroll weight with pierced jade knob, *zitan* wood with pale greenish-white nephrite ornament, H. 1.5, L. 22.1, W. 1.5 cm
C. Folding fan with net decoration, ink on gold paper, bamboo frame with lacquer decoration, W. 46.0 cm
D. Folding fan with net decoration, ink on gold paper, bamboo frame with lacquer decoration, W. 56.5 cm
E. Jade plaque with *chi* dragon decoration, white nephrite, L. 2.6, W. 3.4 cm
F. "Winnowing basket-shaped" Duan inkstone accompanied by a contemporaneous fitted wood box, lavender-tinged brown Duanzhou stone from Duanzhou, Guangdong province, with one iridescent eye, H. 3.0, L. 22.0, W. 13.8 cm

G. Table screen and brushrest with a marble plaque resembling a mist-enveloped mountain landscape, *zitan* wood with inset white marble with green and black markings, H. 20.1, W. 17.4 cm

H. Rectangular jade palette for grinding pigments accompanied by a contemporaneous fitted wood box, sea-green nephrite, H. 1.0, L. 8.7, W. 4.6 cm

I. Undecorated circular box and cover, *zitan* wood, H. 2.8, D. 7.1 cm

J. Pear-shaped vase with carved and inlaid decoration, *zitan* wood inlaid with silver wire, H. 8.9, W. 4.9 cm

K. Elliptical box and cover with inlaid decoration, *zitan* wood with mother-of-pearl inlays on the cover, H. 2.8, L. 5.8, W. 4.1 cm

L. Flat rectangular object with hinged cover and inlaid lion decoration (perhaps a clip, paperweight, or wrist rest), *zitan* wood with mother-of-pearl inlays on the cover, H. 2.0, L. 11.0, W. 7.1 cm

M. Undecorated rectangular stationery box with cover and removable tray, *hong* wood, H. 9.0, L. 26.7 cm

N. Undecorated cylindrical brushpot, *zitan* wood, H. 15.5, D. 10.0 cm

THE DISCOVERY OF this group of scholar's accoutrements among the artifacts in the tomb of Zhu Shoucheng is extremely important for the study of such materials. On the basis of a deed recovered from the adjacent grave of Zhu Shoucheng's wife, archaeologists have dated this tomb to the Wanli period, so these materials can date no later than the early seventeenth century. Although numbers of implements for the scholar's desk from the late Ming and Qing have survived above ground, their simplicity, conservative styles, and lack of reliably dated inscriptions have made it difficult to establish a chronology of stylistic evolution. With these excavated pieces as guideposts, we can begin to establish a chronological framework for scholar's objects.

An elegant simplicity informs all these pieces, seen especially in the smooth edges, polished surfaces, and subtly rounded corners. The works tend to be small and unostentatious, but were exquisitely crafted from fine materials. These are the essential characteristics of objects produced for the scholar's studio in the late Ming.

A and B. *Scroll weights*. Although weights of this type might occasionally have been used for papers on the desk, the long, narrow form indicates that they were designed to hold a handscroll open to a desired section. Weights of this form had evolved at least as early as the Song and examples in bronze from the Yuan are known.[1] During the Ming period such weights were copied in jade. Wen Zhenheng mentions wooden weights with old jade knobs in his *Zhangwu zhi* of 1637, indicating that they must have been common at the time. Wen's term for such pieces is *yachi* (press rule), which suggests that they might also have been used as uncalibrated rulers or straightedges.[2] The ornament on the larger of these two pieces reflects the typical interpretation of a dog in small Chinese sculptures, with a long narrow muzzle and protruding ribs. The animal's flattened form and crossed front paws suggest that it might well date to the Song.

Characteristics to be observed in these pieces are the meticulous craftsmanship, seen especially in the indented edges along the top, and the preference for old jade knobs. The careful articulation of the top edge was also copied in the Ming jade versions.

C and D. *Folding fans*. See no. 91 for a discussion of folding fans with abstract "net" decoration. These two fans are so similar in style and appearance to no. 91 that they could have been painted by the same artist.

E. *Jade plaque*. This small pendant is perhaps the most exquisite jade in this exhibition. The stone is the pure white mutton-fat jade so prized by connoisseurs over the centuries. (Mutton fat, *yangzhi*, is the Chinese term for nephrite that has the whiteness and translucency of lard.) Each side is beautifully carved with a *chi* dragon that curves gracefully to complement the rectangular form of the plaque. The dragons recall those seen on jades of the Warring States period, but in their playful attitude they are wholly Ming. They are almost identical to the ones that embellish the top and bottom of the bamboo aromatics container carved by Zhu Ying (see discussion no. 55) and recovered from the same tomb as these scholar's accoutrements.[3] The bottom and sides of the plaque are finished with abstract scrolls set against a cross-hatched ground; the top sports a small jade loop that would have allowed the pendant to be suspended from the belt by a silk cord.

F. *Duan inkstone*. This fine Duan inkstone was fashioned in the "winnowing-basket shape," which made its first appearance during the Tang. Because of its resemblance to the outline of the ideograph for *feng* (wind), the shape is popularly called *fengzi xing* (wind-character-shaped); the term had already been applied to the shape in the Song by the connoisseur Mi Fu, who wrote a treatise on inkstones.

Although this inkstone most likely dates to the Ming, its archaic shape suggests that it could date as early as the Song. Inkstones were already being embellished with sculpted decoration in the Ming, but the absence of such decoration on this piece (and on the other two inkstones in this exhibition, nos. 73 and 74) indicates a preference for undecorated ones among the Ming literati. The Duanzhou stone of this ink palette sports one iridescent eye, preserved atop a short post.

The undecorated wood box that accompanies this inkstone is also a marvel of craftsmanship; its appearance here confirms that the custom of preparing fitted boxes for cherished items had definitely begun by the late Ming. The box not only protected the inkstone from damage but shielded it from dust, which could diminish its ink-grinding properties.

G. *Table screen*. The Chinese have long prized pieces of white marble with green and black markings suggesting mountain peaks enveloped in clouds, in the manner of a misty landscape by Mi Fu. Cut into a square or rectangular shape, such pieces were framed in beautiful wood and hung in the studio. The Tang poet Wang Wei mentions a decorative marble plaque in one of his poems, but information about early pieces is scant. Since the material is natural and requires no embellishment other than cutting, polishing, and framing, the dating of these plaques has proved elusive. This excavated example confirms the existence of such pieces in the late Ming. In its shape and its combination of a small table screen with a brushholder, this piece compares favorably with porcelain examples of similar date. Depictions of small table screens often appear in printed books of the late Ming (see no. 28), and a fifteenth-century handscroll depicting scholar-officials in a garden includes a detail of such a screen.[4] Wen Zhenheng mentioned that such screens can be used as long as they are small enough to sit on a table, indicating that there must have been large ones in the late Ming as well.[5]

H. *Rectangular jade palette.* This small palette was used for grinding vermillion for punctuating and proofreading texts.

I. and K. *Covered boxes.* Like the early fifteenth-century carved lacquer boxes in this exhibition (no. 90), these undecorated boxes might have been used for incense pellets, for the red seal paste in common use since the Song, or for a variety of other materials. Scientific analysis could reveal whether they were used as seal-paste boxes, as traces of the oils and pigments would almost certainly remain. Most of the mother-of-pearl inlay is now missing from the cover of the elliptical box so it is impossible to read the design.

J. *Pear-shaped vase.* This small vessel could have served as a water bottle, but it was more likely used as a vase to hold incense tongs or joss sticks. The dragon designs on its surface recall those on carved jade and rhinoceros horn of the late Ming. The interest in wooden pieces decorated with silver inlays was doubtless inspired by inlaid bronzes (nos. 62 and 65). The technique, which produced a luxurious effect in contrasting colors, was especially popular in the late Ming and was occasionally used for ceramic decoration as well (no. 44). Now tarnished, the silver wire would originally have been much brighter. The finest wooden stands of the Ming and early Qing were also often inlaid with silver wire.

L. *Flat rectangular object.* Small hinged objects like this one are common among scholars' accoutrements of the seventeenth century.[6] They might have been used as paperweights, wrist rests, or clips, or perhaps they were merely decorative objects. The partly missing, partly calcified mother-of-pearl inlay of this piece originally represented a lion and a dancing figure.

M. *Rectangular stationery box.* This box would have been used to contain letter paper (see no. 27), brushes, and other writing implements from the scholar's desk.

N. *Cylindrical brushpot.* The cylindrical walls of this undecorated brushpot rest in a small circular base that resembles a swelling node on a bamboo stalk (compare no. 55); although the base with its short legs looks something like a stand, it is, in fact, the lower portion of the brushpot. In wooden brushpots of the Qing the base and vessel were often integrally carved from the same block of wood to alleviate problems of warping and splitting; in such pieces the knotty, sap-filled center of the flat base was usually removed and the resulting hole fitted with a wooden spigot. In this late Ming example these problems were solved by setting the cylindrical portion of the vessel into a slightly larger base rather than by attempting to fit a flat, wooden plate into the bottom. In Qing examples, the walls often curve gently inward towards the waist, but in this brushpot the walls are straight, which is appropriate for a piece with an elaborate base. Wen Zhenheng mentioned that brushpots of *zitan* wood, ebony (*wumu*), and *huali* wood could occasionally be used, alternating with ones of other materials.[7]

SELECTED ITEMS PUBLISHED: Shanghaishi wenwu baoguan weiyuanhui, comp., *Shanghai gudai lishi wenwu tulu (An Illustrated Catalogue of Ancient Cultural Objects from Shanghai)*, Shanghai: Jiaoyu chubanshe, 1981

70. Six Seals

Ming, 16th century
Excavated in 1969 from the 16th-century tomb of Zhu Chaqing in Liyuan lu, Huwan qu, Shanghai

A. Square seal with water-buffalo knob, and with intaglio legend reading *Ding chou jin shi* (*Jinshi* degree in 1517), boxwood (*huangyangmu*); this seal belonged to Zhu Bao, the father of the tomb occupant, who received his *jinshi* degree in 1517, the twelfth year of Zhengde, which corresponds to *dingchou*, H. 4.0, W. 2.4 cm

B. Undecorated square seal, with relief legend reading *Ping an jia xin*, boxwood; this seal could have belonged to either Zhu Bao or Zhu Chaqing, H. 2.7, W. 2.2 cm

C. Square seal with seated-lion knob and with relief legend reading *Zhu shi Zi wen* (Mr. Zhu Ziwen), boxwood; this seal belonged to Zhu Bao, whose *zi* was Ziwen, H. 3.8, W. 1.8 cm

D. Square seal with stepped-knob and with intaglio legend reading *Zhu Cha qing yin* (Seal of Zhu Chaqing), mottled grayish-white nephrite; this seal belonged to Zhu Chaqing, H. 1.8, W. 2.2 cm

E. Square seal with standing-lion knob and with intaglio legend reading *Ding chou jin shi* (*Jinshi* degree in 1517), carved by Zhou Jing (active 16th century), amber-colored Qingtian soapstone from Zhejiang province, with a *biankuan* inscription reading *Zhou Jing zhuan* finely incised on one side; this seal belonged to Zhu Bao, H. 3.3, W. 2.0 cm

F. Square seal with recumbent *bixie* chimera knob and with relief legend reading *Qing gang zhi yin* (Seal of Qinggang), greenish Qingtian soapstone from Zhejiang province; this seal belonged to Zhu Bao, H. 2.8, W. 1.7 cm

THESE SIX SEALS were excavated from the tomb of Zhu Chaqing, a native of Huating (modern Songjiang). Some of the seals belonged to Zhu Chaqing himself and others were used by his father, the scholar-official Zhu Bao (*zi* Ziwen, *hao* Qinggang Jushi, 1481–1533). Zhu Bao received the *jinshi* degree in 1517, a fact recorded in historical sources as well as in these seals. He served in several official posts, including one in Fuzhou, and left a book entitled *Zhu Fuzhou ji*. His son, Zhu Chaqing (*zi* Bangxian, *hao* Xianggang), authored a book entitled *Zhu Bangxian ji*. Zhu Chaqing is recorded to have died in 1572.

In composition and calligraphic style the legends on these seals clearly reflect the influence of classical Han seals (compare no. 87 B and D). Since these seals date to the sixteenth century, they are contemporaneous with seals carved by Wen Peng and perhaps early ones carved by He Zhen (no. 72 B and C). The use of the Han style for an antique flavor was inspired by Wen Peng's return to classical prototypes.

Some of these seals are unornamented, but others have knobs in the form of animals. A variety of creatures is represented, usually in a lively style and often with some openwork. In style and subject matter, the animal-shaped knobs compare favorably with decorative carvings in jade and soapstone of the late Ming (no. 54). In most cases the knobs were carved by professional sculptors, such as Wei Rufen and Yang Ji (nos. 53 and 54), so the similarity in style is expected. Literati seal carvers did only the legends and the *biankuan*, or side inscriptions, leaving the preparation of the stone and the embellishment of the knob to professional carvers.

In appraising seals, connoisseurs first examine the design and calligraphy of the legend, for that is the raison d'être of

the seal and its impress is the mark seen on documents and works of art. They then turn to an examination of the material, the calligraphy of the *biankuan* inscription, and the carving of the decorative knob.[1]

Bronze and jade were the materials most commonly used for seals before the Yuan dynasty. Neither of these was appropriate for the literati to work, however, as jade is too hard for anyone but a professional to carve, and bronze requires the use of foundry equipment to cast. Although Zhao Mengfu and other early literati seal carvers worked in ivory, soapstone quickly became the preferred material after its merits were discovered by the plum-blossom painter Wang Mian (1287–1359).

Tianbai and *tianhuang* soapstones (see discussion, no. 54) were considered the very best materials for literati seals. Other soapstones from Shoushan (in Fujian province) were also prized (see no. 53) as was the famed *jixue*, or chicken blood, stone from Changhua (near Hangzhou) whose name derives from its dark red splashes. Soapstone from Qingtian in southern Zhejiang province was the most widely used material for literati seals during the Ming. As accoutrements in bamboo and wood gained popularity among scholars, boxwood also came to be used for seals (compare no. 58).

71. Square Seal with Bridge Knob

Gan Yang (active Wanli period, 1573–1620), *zi* Xufu, *hao* Yindong

Ming, dated to 1612

Greenish-white nephrite, with relief legend reading *Dong hai qiao gong bi gu hou fu yin* and a *biankuan* inscription reading *Wanli renzi zhi yu yanguan gongshe Shangyuan Gan Yang* (Made in Wanli *renzi* [1612] at the Salt Bureau [by] Gan Yang of Shangyuan) finely incised on one side. Excavated in 1969 from a Ming tomb in Chuansha xian, Shanghai, H. 4.5, W. 3.5 cm

THIS SEAL is undecorated except for the beautifully finished handle on the top. Although handles of this shape are usually termed tile knobs (*wa niu*), after their resemblance to roof tiles, ones of this proportion are often called bridge knobs (*qiao niu*), after their size. The clean, unembellished calligraphic style of the legend finds its origins in seals of the Qin and Han (see no. 87), and the use of a dated *biankuan* inscription on the side reflects the influence of Wen Peng and He Zhen (see discussion, no. 72). The elegantly simple surfaces embody the purest literati taste of the period and compare favorably with the scholar's accoutrements excavated from the tomb of Zhu Shoucheng (no. 69).

The *biankuan* inscription indicates that this seal was carved by Gan Yang of Shangyuan (an area of modern Nanjing). A well-known seal carver of the Wanli period, Gan was also the author of several treatises on the art, including *Ganshi yinzheng* (1597) and *Yinzhang jishuo*. The incised date corresponding to 1612 and the seal's recovery from a Ming tomb confirm the late Ming date of this piece.

Seal scripts, legends, and styles have long been studied from impressions on documents and works of art. The study

of seals as objects, however, has been hindered by a paucity of securely dated examples. Problems of dating have been further complicated by the practice of shaving legends from old seals to accommodate new ones. Unless a seal was treasured as a collector's item, it might well have served several successive masters, each of whom removed the previous legend and added his own. A seal might thus be much older than its most recent legend. Excavated seals will enhance the understanding of the history of literati seal carving.

72. Three Seals

Ming, Wanli (1573–1620)—Tianqi (1621–1627) periods

A. Rectangular seal, carved by Gui Changshi (1573–1644, *zi* Wenxiu, *hao* Jia'an), dated to 1624, brown Qingtian soapstone with intaglio legend reading *Yong zhuo cun wu dao* (Using awkwardness to preserve my *dao*) and a *biankuan* inscription reading *Tianqi jiazi shiyi yue you san ri Lucheng Gui Wenxiu wei Aishixuan zhuren zuo* (Made on the third day of the eleventh month of Tianqi *jiazi* [1624] by Gui Wenxiu of Lucheng for the Master of the Rock-loving Studio) finely incised on one side, H. 3.5, W. 2.4 cm

B. Square seal, carved by He Zhen, dated to 1604, brownish-green Qingtian soapstone with intaglio legend reading *Yan po gou sou* (Old fisherman in misty waves) and a *biankuan* inscription reading *Jiachen dong zhi wei Jingdun xiansheng He Zhen* (Made in the winter of *jiachen* [1604] for Mr. Jingdun [by] He Zhen) finely incised on one side, H. 6.2, W. 2.7 cm

C. Square seal, carved by He Zhen (active Wanli period, *zi* Zhuchen, *hao* Changqing, Xueyu), dated to 1604, black Qingtian soapstone from Zhejiang province, with intaglio legend reading *Jiao chuang ye yu* (Banana-tree window night rain) and with a *biankuan* inscription reading *Jiachen dongri zhi He Zhen* (Made on a winter day of *jiachen* [1604] [by] He Zhen) finely incised on one side, H. 4.8, W. 2.5 cm

WITH THE RISE of literati painting in the Yuan, many artists began to carve their own seals, concerned as they were with any vehicle that expressed their taste and personality. Among literati seal carvers of the Ming, Wen Peng, He Zhen, and Gui Changshi are the most renowned. Wen Peng and He Zhen were the first to take seals of the Qin and Han periods (see no. 87 B and D) as models. Their works possess an antique elegance and a studied awkwardness much prized by the literati. Wen Peng and He Zhen also began the practice of carving *biankuan* inscriptions on the seal giving the carver's name, the date of the seal, and sometimes a few words of dedication.

A native of Wuyuan, Jiangxi province, He Zhen had close connections with literati circles in Suzhou and studied seal-carving with Wen Peng (see discussion, no. 7). He was an accomplished painter, especially of bamboo, but is much better known for his seals. The carvers of the slightly later, Anhui school of seal carving took works by He Zhen as their models, so that he is often regarded as the founder of that school. The squared, angular characters, the simple but forceful calligraphy, and the highly ordered compositions of

the two He Zhen seals in this exhibition reveal that they were inspired by Han seals. Each seal has a *biankuan* inscription dated to 1604 followed by He Zhen's signature.

Gui Changshi was born in Kunshan, Jiangsu province, but moved to nearby Changshu. A grandson of the well-known Suzhou scholar Gui Youguang (1506–1571), Gui Changshi was born into the literati world and distinguished himself as a poet, painter, and calligrapher. He based his calligraphy on works by masters of the Jin and Tang (compare nos. 30 and 81) and excelled in *caoshu*, or draft script. Unlike He Zhen, who was primarily a seal carver, Gui Changshi was a literatus who was also known for his seals. He found inspiration in seals of the Qin and Han, but also experimented with even earlier styles, as seen in this example, that relate more closely to ancient bronze inscriptions (compare nos. 82–84).[1] He Zhen and Gui Changshi were almost certainly well acquainted with many of the other literati represented in this exhibition. In fact, Gui Changshi was designated one of the Three Talents (Sancai), along with Wang Zhijian and Li Liufang (no. 21).

It is not known for whom these three seals were carved. The legends are poetic ones and would have had a very personal meaning to the individuals who used the seals. All three seals have *biankuan* inscriptions giving the carvers' names and the dates. Two of the inscriptions include studio names of the scholars for whom the seals were carved, but they cannot yet be paired with specific individuals.

Ming scholars were not particularly interested in epigraphical studies *per se*, so the forms of their seal-script characters are not always technically correct (compare signature, no. 60). The Ming literati took special delight in ancient bronze seals, whose inscriptions had been carved rather than cast; often prepared in haste—usually for an official about to depart on a new assignment—the legends of such seals display a rugged forcefulness. Ming gentlemen also appreciated the deterioration seen in ancient bronze seals and sometimes added hints of "damage" to the legends of their own newly carved ones in an attempt to evoke the feeling of antiquity.

Duan Inkstones (nos. 73, 74)

Of the four treasures of the scholar's studio—brush, ink, paper, and inkstone—more attention was lavished on the selection of the inkstone than any other. Not only was a fine stone essential for preparing ink, it was the most visible of the principal objects on the desk and thus stood as a tangible symbol of the scholar's taste.

Inkstones come in many shapes and sizes, but they must possess two elements: a smooth, relatively flat area, or bed, for grinding ink and a depressed area, or well, for holding excess liquid. Although the inkslab—both stone and ceramic—had appeared by the Han, the history of later Chinese inkstones begins with the Tang, when the basic shapes and materials preferred in all subsequent periods were introduced. "Winnowing basket-shaped" inkstones (no. 69 F) evolved during the Tang, quickly supplanting the earlier, circular ones in popularity; the rectangular shape appeared in late Tang and gained prominence in the Song. The three most

prized materials for inkstones were also discovered in the Tang: Duanzhou stone from Duanzhou (Guangdong province), Shexian stone from Shexian (Anhui), and grayish-green Chengni clay from Jiangzhou (Shanxi); the latter produced the best ceramic ink palettes.

Of all these materials, Duanzhou stone, a variety of slate, has invariably been the most prized from the Tang to the present. Although Duanzhou stone comes in a range of colors from black and gray to green and white, the rarest, and thus most celebrated, is the *zi Duan*, or lavender, stone. Duanzhou stone often displays natural markings, called eyes, which are concentric rings of contrasting, iridescent colors. Connoisseurs have classified these markings according to appearance, giving them such descriptive names as "mynah bird eyes" and "peacock eyes." In addition, Duanzhou stone can sport numerous other markings, perhaps the most famous of which is the reddish splash referred to as *huona* (fiery mark or scorched patch).

The resonant properties of inkstones were carefully considered by connoisseurs, who would often suspend a stone on a string and thump it with a knuckle. It was important, however, that the stone not emit sound when ink was being ground. In his *Zhangwu zhi* of 1637, Wen Zhenheng states, "Natural stones that are warm and moist [in appearance] like jade, that grind ink soundlessly, and that do not damage the brush are rare treasures." In general, the most important property of any stone used for inkslabs is that it be sufficiently abrasive to grind the ink to a fine, smooth consistency, yet delicate enough not to damage or weaken the fragile hairs of the brush tip. It should also be non-porous so the ink does not dry too quickly in summer or freeze in winter.

That Duanzhou stone possesses all of these characteristics in abundance is well attested by the laudatory remarks it has elicited from connoisseurs over the centuries and by its popularity among master painters and calligraphers. In the words of the poet and calligrapher Chen Gongyin (1631–1700), "Other inkstones are so coarse that they quickly wear down the inkstick or they are so smooth that they fail to grip it at all. [Duanzhou stones] are not so; they are smooth and jade-like in appearance and they are soft to the touch. If one adds water and grinds an inkstick, the ink flows luxuriantly, as if the inkstick and water have a natural affinity for each other; the harder the inkstick, the stronger the affinity" (Zhu Jialian, "Shuo yan," *Wenwu*, Beijing, 1954, no. 12: 18–20).

73. Inkstone

Ming, probably mid-16th century
Lavender-brown Duanzhou stone, from Duanzhou, Guangdong province, with iridescent eyes and with incised inscriptions by Yuan Mei (1716–1798) and Ting Shou (probably Qing period) and an incised seal of Yuan Jiong (1495–1560) reading *Xiehu*, accompanied by a contemporaneous fitted box in purplish-black lacquer. Inkstone: H. 2.5, L. 9.5, W. 9.9 cm

THIS MAGNIFICENT inkstone displays the cherished purplish-brown color of the very best Duanzhou stone. It sports a number of eyes over the surface, particularly on the underside. The irregularly shaped sides retain the black inner

layers of skin of the small boulder from which it was carved. Scholars of the Ming especially prized Duanzhou stones that were just the appropriate size for an inkstone.[1] Whenever such stones were found, the carver would carefully design the inkstone to employ the natural shape of the stone and incorporate as much of the skin as possible. Such stones were greatly preferred to large boulders, which would be fashioned into many inkstones. The same aesthetic prevailed among jade carvings, where elements of the golden-brown skin of a small stone were cleverly worked into the design whenever possible (compare no. 52).

At the foot of the underside is a carved seal in *zhuanshu*, or seal script, reading *Xiehu*. This name was used by the mid-Ming scholar Yuan Jiong and indicates that the inkstone once belonged to him. Also on the underside, and carved in *lishu*, or official script, is an inscription by the distinguished eighteenth-century poet Yuan Mei, in four poetic lines of four characters each:

> Its shape like a broken jade *gui* [tablet],
> Its material comparable to fine jade,
> A scholar acquires it,
> And returns to his true self.

A second, and later, inscription by Yuan Mei appears on the proper left side of the stone, carved in *kaishu*, or regular script. It reads:

> This inkstone belonged to my distant relative Shangzhigong Xiecaotang [Yuan Jiong]. [One of his] tenth-generation grandsons joyously bought it and asked me to inscribe it.
> Inscribed again by [YUAN] MEI

On the proper right side, near the foot, is a short inscription by Ting Shou carved in *zhuanshu* and reading *Zisun yong baoyong* ([May] sons and grandsons treasure and use [this] forever), a phrase that often occurs in early bronze inscriptions (compare nos. 82–84); its appearance here, in conjunction with the ancient seal script, signals the link with the past and the importance of this beautiful inkstone. On the head of the stone appears a short inscription reading *Wu yan zhi san* (Third of five inkstones), in the same *lishu* and by the same hand as Yuan Mei's poem. This inscription might indicate that the inkstone was once part of a set of five; on the other hand, it might mean "Third of five [great] inkstones" or "Third of [my] five inkstones."

Although seals and names had been carved on inkstones in earlier periods, the custom of adding full inscriptions arose in the Ming. A similar phenomenon occurred in painting and calligraphy, with both artists and collectors inscribing their works. Inscriptions on fine inkstones frequently compare the material to jade. The reference is less to the appearance of the stone than to the Confucian virtues that jade symbolizes. Such inscriptions thus impute high moral character to the inkstones.

A plain purplish-black lacquer box, of Ming date, accompanies the inkstone. According to Wen Zhenheng's comments on boxes for inkstones, this example could not be more perfect:

> [I] recommend using boxes of purple or black lacquer. Covers of the five metals must not be used as metal can dry and parch the stone. *Zitan*, ebony, and carved red and polychrome lacquers are all vulgar and should not be used [for boxes].[2]

74. Inkstone

Ming, first half of 17th century
Lavender-tinged dark gray Duanzhou stone, from Duanzhou, Guangdong province, with iridescent eyes and one greenish-yellow diagonal mark, and with incised inscriptions by Chen Congzhou (probably 18th century) and Chen Hongshou (1599–1652), H. 4.8, L. 16.5, W. 10.2 cm
Gift of Jiang Zhenru and Jiang Zutong

THE STONE of this rectangular inkslab is a lavender-tinged charcoal color. It boasts at least one eye on its right side as well as one diagonal mark in greenish-yellow. Its shape and proportions derive from classical models of the late Tang and Song. The slope of the flat bed is much gentler than that of early examples, however, and the inkwell is proportionately shallower.

The proper right side of the base bears an inscription by the late Ming painter Chen Hongshou (*hao* Laolian) in *xingshu*, or running script. The inscription, in two poetic lines of seven characters each, is followed by Chen's signature, reading *Laolian*. The inscription, worded as if spoken by the inkstone itself, translates:

> I give myself to you
> To be treated like jade.
> To place me amongst gold and
> grain would be to insult me.

On the head of the hollow, plinthlike base is a five-character inscription in *kaishu*, or regular script, reading *Xiangguang zhuzhe yan* (Inkstone of the Master of Fragrant Brilliance); although unsigned, it is in Chen Hongshou's distinctive hand. *Xiangguang* (Fragrant Brilliance) was a name used by Dong Qichang, but its use here could be coincidental. Since the five characters are incised on the head of the base, the inscription could also represent the name of the inkstone. On the proper left side is a long inscription in *lishu*, or official script, followed by a signature and two carved seals of Chen Congzhou, indicating that he once owned the piece. A second, and later, inscription by Chen Congzhou appears on the underside in *kaishu*.

Ink (nos. 75–77)

Chinese ink is traditionally prepared in the form of dry sticks or cakes that must be ground against a moistened inkstone to produce the liquid used for painting and calligraphy. In grinding his own ink, the scholar maintained complete control over texture, quality, and appearance. This thorough mastery of material, combined with consummate skill in applying ink to paper, led to the subtle variations in tonality whose highly expressive effects are reflected in the phrase "the five colors of ink."

The essential components of the best inks are pine soot and animal glue. Soot, collected under carefully controlled conditions, imparts the blackness and durability so esteemed

in Chinese ink. Water-soluble animal glue, made by boiling bones and hides, binds the solid ink together and fixes the ink to the paper or silk. Some recipes call for over a thousand additional ingredients—ranging from egg white and raw lacquer sap to gambage and crushed pearls—to improve the color, luster, fragrance, and consistency. The thick, raw ink paste is shaped into sticks with wooden or copper molds which can also impress designs.

The invention of ink is traditionally ascribed to Wei Dan (179–253), but since inks of much earlier date have been discovered, he was perhaps merely the first to record a formula for making it. Excavations at Neolithic sites reveal that early Chinese were already using a black carbonaceous material as a pigment. The oldest surviving inkstick—a cylinder-shaped one—was excavated in the 1970s from a third century B.C. tomb in Hubei province.

From the late Tang onward, the names of numerous inkmakers have been recorded, the most famous of whom was Li Tinggui (active 950–980). A native of Hebei province, Li moved to Shexian, Anhui province, where he served as the official in charge of inkmaking at the Southern Tang court. Since Li's time, Shexian has been the most important center in China for the manufacture of ink.

The zenith of the art of inkmaking came in the late Ming with the scholars Cheng Junfang and Fang Yulu, both of whom lived in Shexian. Cheng Junfang (1541–ca. 1616) began making ink in his youth, his establishment then known as the Baomozhai, or Studio of Precious Ink. Fang Yulu (active Wanli period, 1573–1620) learned the craft from Cheng.

In 1588 Fang Yulu published the first edition of the famous *Fangshi mopu*, an album of his inkstick designs. The nearly four hundred illustrations were prepared by two well known artists of the time, Ding Yunpeng (1547–ca. 1621) and Wu Tingyu. Eighteen years later, in 1606, Cheng Junfang followed suit with his *Chengshi moyuan*. Cheng also persuaded Ding Yunpeng to furnish the bulk of the nearly five hundred illustrations for his compendium. The *Chengshi moyuan* also includes three essays by the Jesuit missionary Matteo Ricci (1552–1610), whom Cheng met in the early 1600s, as well as copies of four Biblical pictures that were given to Cheng by Ricci. Most remarkably, in a small number of copies of the album a few pages were printed in color using the single-woodblock printing technique.

The Chinese had begun to collect inksticks by the late Tang and Song. Although in theory all inksticks could be used, by the late Ming many were made specifically as presentation pieces or collector's items and were accompanied by fine lacquer storage boxes. By the Qing the interest in collecting had led to the production of large sets of inksticks, often with elaborate wooden or lacquer chests, indicating that the inksticks were to be appreciated but not used.

75. Ink Cake

Cheng Junfang (1541–ca. 1616), original name Dayue, *zi* Junfang, Youbo, Shifang, *hao* Xiaoye
Ming, Wanli period (1573–1620)
Molded pine soot and animal glue, with a palace scene on one side and a molded title reading *Yunli dicheng shuangfeng que* (Amidst the Clouds, the Double Phoenix Gate-tower of the Imperial City) on the other, and with a signature molded in the shape of a seal reading *Junfang* on the title side, accompanied by a contemporaneous fitted lacquer box. Box: H. 3.3, D. 14.6 cm; Ink cake: Wt. 270.0 g

THE TITLE inscribed on this circular ink cake recalls the low-relief scene of a palace amidst trees, clouds, and flowing streams on the reverse.[1] The composition of the scene is similar to that of late Ming printed book illustrations, and the style compares favorably to that of carved lacquer and bamboo of the same period. The swirling clouds are of a type frequently seen in late Ming and Transitional period ceramics and jades. The design of this ink cake is illustrated in Cheng Junfang's album *Chengshi moyuan* of 1606, where the title in seal-script characters appears above the palace scene.[2]

A native of Yanzhen, Shexian, in Anhui province, Cheng Junfang was one of the most famous inkmakers of the Ming period.[3] Cheng Junfang and Cheng Dayue were at one time thought to be two different people and are so listed in the *Siku quanshu* catalogue and *Shexian zhi* (Shexian Gazetteer); they are now known to be the same person, Dayue being Cheng's original name and Junfang one of his several *zi*. Little is known of Cheng's boyhood, but his early interest in ink may indicate that he came from a family of inkmakers. He was an avid collector and connoisseur of inksticks.

The fitted lacquer box that accompanies this ink cake depicts several gentlemen in a landscape with pines, water, and distant mountains. The style of the painting, particularly the proportion of the figures to the landscape, relates closely to that of Wanli period painted lacquers,[4] indicating that the box is contemporaneous with the ink cake. The preparation of a fine box at the time of manufacture suggests that this ink cake was not made to be used, but merely to be enjoyed and appreciated by connoisseurs.

76. Inkstick

Fang Yulu (active Wanli period, 1573–1620) *zi* Jianyuan
Ming, Wanli period (1573–1620)
Molded pine soot and animal glue, with a branch of fruiting prunus on one side and a molded title reading *Biao you mei* (Falling are the Plums) on the other and with a molded inscription reading *Fang Yulu hua yi mo* (Fang Yulu painted [this] ink[stick]) and a seal-type inscription reading *Changshou wannian* on the title side, L. 13.6, W. 6.0 cm, Wt. 170.0 g

THIS RECTANGULAR inkstick is presented in a hanging scroll format with a branch of fruiting *mei* (prunus). The title, "Falling are the Plums," is the first line of a poem from the *Shijing*, the ancient poetry classic. The poem translates:

Falling are the plums,
Seven are left.
You young men who seek me,
Seize the auspicious time!

Falling are the plums,
Three are left.
You young men who seek me,
Seize the present moment!

Falling are the plums,
With slanting baskets we scoop them.
You young men who seek me,
Seize the chance to speak up![1]

The ripening plums are usually said to be an image of a girl reaching maturity, and the diminishing number of plums on the tree, a reference both to passing time and to the girl's increasing impatience. Since the title here is followed by a seal inscription that reads *Changshou wannian* (Longevity 10,000 years), it is possible that the reference to falling plums is merely an allusion to passing time. Although the blossoming plum is frequently represented in Chinese art, depictions of the fruiting plum are rare. The scene on this inkstick was clearly designed to accompany the poem. The lustrous edges of this piece suggest that black lacquer may have been applied to the sides and borders for protection.

A short inscription on the front indicates that Fang Yulu is the artist. Like Cheng Junfang, Fang was a native of Shexian, Anhui province, the famous center for ink manufacture.[2] Fang was born in Jiangling, where his father was engaged in business, but moved to neighboring Yanzhen, where Cheng lived. Tradition asserts that Cheng Junfang befriended the destitute Fang Yulu and taught him the art of inkmaking, including his trade secrets. At some point Fang and Cheng had a serious falling-out—reputedly over a concubine—and became bitter rivals, with Fang Yulu establishing his own workshop. Fang was a noted poet as well as a publisher and inkmaker. He was a pupil and close friend of his fellow townsmen Wang Daoguan (d. 1592) and Wang's brother Wang Daokun (1525–1593), at one time the Senior Minister of War.

77. Inkstick

Wang Hongjian (active 17th century)
Ming, dated to the year *wushen*, probably 1608
Molded pine soot and animal glue, with a palace scene on one
 side and a molded inscription reading *Yun lai gong que* (Approaching-Cloud Palace Gate-tower) on the other and with a molded inscription reading *Wu shen nian tai zi zhong hai* on the top and a seal-type inscription reading *Haiyang Sanglin jizi Hongjian Yiqing jianzhi* (Made under the supervision of Hongjian Yiqing, youngest son of Sanglin of Haiyang) on the title side, L. 15.8, W. 7.7 cm, Wt. 274.0 g

THE TITLE on the front of this rectangular inkstick, "Approaching-Cloud Palace Gate-tower," describes the scene on the reverse. The seal-type inscription below the title refers to Hongjian Yiqing, who is Wang Hongjian, an inkmaker active in the seventeenth century in Xiuning, Anhui province. This inscription indicates that he was the youngest son of (Wang) Sanglin, a native of Haiyang. Both father and son were dis-

tinguished inkmakers of the late Ming.[1] Wang Hongjian is now much better known than his father; he may have been a relatively young man when he produced this inkstick, however, since he seems to have been playing upon his father's name as a trademark, in the same manner that Hu Guangyu used Hu Wenming's name in his inscriptions (see discussion, no. 62). Wang Hongjian's own son also became a well-known inkmaker.

The inscription on the top of the inkstick dates the piece to the cyclical year *wushen*, which most likely corresponds to 1608. Both the landscape and the calligraphic styles accord well with an early seventeenth-century date. Although based on alleged Tang prototypes, the mountain scene recalls paintings by seventeenth-century Anhui school masters, especially in the construction of mountain and rock forms with overlapping parallelograms. The interpretation of the design relates to scenes that Ding Yunpeng did for Cheng Junfang's album of ink cake designs, the *Chengshi moyuan*.[2]

78. Brush and Cover with Figural Decoration

Ming, probably Wanli period (1573–1620)
Lacquered wood (or bamboo), with painted and inlaid decoration and with an inscription reading *Da Ming Xuandenian zhi* in a cartouche on the handle, L. 23.4 (with brush head) D. 1.9 cm

THE CHINESE had invented the art of lacquering by the Neolithic period and were fashioning exquisitely painted examples at least as early as the Warring States. Lacquer inlaid with silver had appeared as early as the Han dynasty, and examples with inlays of mother-of-pearl and of thin sheets of gold and silver had evolved by the Tang.[1] Literary sources mention that lacquer inlaid with mother-of-pearl was revived, with different effect, in the Song, and such pieces frequently appear in paintings of that period. Few pre-Yuan inlaid lacquers survive, however. Although carved cinnabar lacquer is the type most commonly associated with the Ming (see no. 90), artisans in southern coastal China produced colorful pieces in painted and inlaid lacquer in the late Ming, particularly in the late Jiajing and Wanli periods.[2]

As with the Yixing (no. 35) and Dehua (nos. 36–38) kilns, which also entered a period of florescence in the sixteenth and seventeenth centuries, the local lacquer workshops in the south began to produce exceptionally well-crafted objects of great beauty to appeal to wealthy clients in the Jiangnan area. While the literati tended to prefer monochrome ceramics and hardstones, they doubtless enjoyed the note of contrast that a brightly colored brush or lacquered basket would provide.

Perhaps made in one of the many lacquer workshops in Fujian province, this brush probably dates to the Wanli period. Its bright and varied colors accord well with the exuberant use of color that became widespread in the late sixteenth century. With its elongated figures that are relatively large in proportion to the composition, the style compares favorably to that seen in Wanli period lacquered baskets with painted decoration. In its shape, proportions, and general appearance, this lacquer brush resembles a carved bamboo brush with a Wanli period mark in The Cleveland Museum of

Art. A slightly earlier brush of the Jiajing period with lacquer decoration exhibits stouter proportions.[3]

Although the mark claims that the brush was made during the Xuande reign, no inlaid and painted lacquer pieces in similar style are known from the early fifteenth century. The Yongle and Xuande periods were celebrated for their blue-and-white porcelains, cloisonné enamels, and carved cinnabar lacquers; for the sake of prestige, later artists frequently added marks of those periods to their works, even to ones that had absolutely no relation to early fifteenth-century styles.

Qin (Zither) (nos. 79, 80)

A long, rectangular instrument, the *qin* is essentially an unfretted zither usually with seven strings. It is one of the most ancient of Chinese musical instruments and was most likely in use as early as the Shang dynasty. Confucius (551–479 B.C.) was fond of playing the *qin* and frequently remarked on the salutary effects of its music. Its association with eminent scholars also dates from antiquity: two of the greatest players recorded in the history of *qin* were Cai Yong (133–192) and Xi Kang (223–262). The latter, who composed a poetical essay on the *qin*, was one of the prototypical literati, a member of the Seven Sages of the Bamboo Grove. In the depiction of the *Seven Sages of the Bamboo Grove and Rong Qiqi* from the fifth-century tomb at Xishanqiao, Nanjing, both Xi Kang and Rong Qiqi are shown playing the *qin*. With its Confucian overtones and its associations with early scholars, the *qin* naturally became the favored musical instrument of later literati.

The most famous recorded *qin*-makers were members of the Lei family of the Tang dynasty. Their instruments were revered even by Song times and the emperor Huizong (r. 1100–1126) is said to have possessed a number of them. (Among the literati of the Ming, the greatest feat would have been to acquire a *qin* made by the Lei family and once owned by Huizong. The next best thing would have been to find any *qin* collected by Huizong.) Although some Ming literati commissioned their *qin*, many made their own, concerned as they were with the craftsmanship and aesthetic effect of any vehicle used to express their personalities. Due to the large number of literati living in the Hangzhou-Suzhou-Songjiang area, that region became famous for the number of great instruments it produced.

Although an accomplished *qin* player, the seventeenth-century connoisseur Wen Zhenheng had relatively little to say about the instrument in his *Zhangwu zhi* of 1637, aside from comments on its appearance and remarks on famous makers since the Tang. For the *qin* table, he especially recommended ones made from large, old bricks from Zhengzhou, Henan province, because the bricks are hollow and thus naturally amplify the sound. Such tables are still to be seen today in the classical gardens of Suzhou.

79. *Qin* (Zither) in the Shape of a Banana Leaf

Ming, 16th–17th century
Wood, with dark brown lacquer and mother-of-pearl inlays and with one inscription reading *Lütian fengyu* (Wind and rain in the green season) and another reading *Shi'er qin lou qing shang* on the base, H. 11.0, L. 119.0, W. 20.3 cm
Gift of Wu Jinxiang

ALTHOUGH the *qin* is, by necessity, always long and rectangular, subtle variations occur in the interpretation of the shape.[1] This *qin*, for example, was fashioned in the form of a banana leaf, a shape especially popular in the late Ming. The banana tree was an essential element of any Ming garden, and it is frequently represented in paintings and bamboo carvings of the period (see no. 55). Stylized banana leaves also embellish the borders of many late Ming blue-and-white porcelains. The invention of the banana-leaf *qin* is traditionally ascribed to Zhu Haihe of the mid-Ming.

The leaf-shape interpretation of this *qin* finds antecedents in the depiction of *The Seven Sages of the Bamboo Grove and Rong Qiqi* from the fifth-century tomb at Xishanqiao, Nanjing.[2] The *qin* that the scholar Xi Kang plays in that scene is leaf-shaped, though not specifically in the form of a banana leaf.

80. *Qin* (Zither)

Zhang Jing(?)xiu (active late Ming)
Ming, dated to 1643
Wood with black lacquer and mother-of-pearl inlays and with a carved inscription on the interior reading *Chongzhen guiwei Zhang Jing(?)xiu zhi Guyu Ji Yuanru fujia cang* (Made by Zhang Jing(?)xiu in the *guiwei* year of Chongzhen [1643]; collected by Ji Yuanru of Guyu), and a carved seal reading *Qin yin yuan* (Garden of the Qin Recluse) and an inscription on the exterior by Tang Yusheng, H. 11.3, L. 121.9, W. 18.8 cm
Gift of Wang Ruhua

THIS *qin* was crafted in the classical form that the Chinese term *Zhongni xing* (literally, Confucius-shaped). Zhongni was one of the names that Confucius used; since he was supposed to have played a *qin* of this shape, his name has been given to the type. It is the simplest of the several variants and has the cleanest lines. *Zhongni*-shaped *qin* of eighth-century date have been preserved in the Shōsō-in, Nara.[1]

The inscription on the interior indicates that this instrument was made for Ji Yuanru by Zhang Jing(?)xiu, who lived in the late Ming. The inscriptions on the exterior were added by Tang Yifen (*hao* Yusheng, 1778–1853). Prized *qin* were collected and inscribed in the same manner as paintings and inkstones.

Collected Objects

81. Rubbing of Yan Zhenqing's *Small-character Record of the Altar to the Immortal Magu* (*Xiaozi Maguxiantan ji*)

Song, album assembled in the late Ming and dated to 1595
Album of rubbings from stone engravings, ink on paper. Page:
H. 33.0, W. 35.3 cm

YAN ZHENQING was a famous calligrapher of the Tang whose style influenced the development of later calligraphy. His calligraphic style was also the model for the most important of the traditional Chinese printing typefaces, *lao Song ti*, or Old Song style[1] (compare no. 24). The characters of this rubbing are written in *kaishu*, or regular script, each one roughly the same size and each in its full, formal form.

These rubbings were prepared in the Song and mounted in their present album format in the late sixteenth century. By the Ming period, Song rubbings were often mounted in slender vertical strips, as seen in this work, with several of the narrow columns glued side by side to form a page. The page with the brush-written inscription of 1595 includes two impressed seals of Wen Yuanfa (*zi* Zifei, 1529–1602). These seals indicate that Wen was familiar with this album and perhaps even that he once owned it. Wen Yuanfa was a painter and calligrapher who worked in the manner of his grandfather, Wen Zhengming; he was the son of Wen Peng and the father of Wen Zhenheng, the seventeenth-century scholar and cataloguer of taste.

The Chinese began to carve inscriptions on stone tablets at least as early as the third century B.C.[2] The first such tablets were probably erected for commemorative purposes. By the sixth century the rubbings were taken from the stone engravings for the dissemination of orthodox versions of the classical texts. Before the invention of printing, not only were rubbings less laborious to prepare than hand-copied texts, but they were free of transcription errors.

Probably in the Tang period, connoisseurs came to appreciate the artistic value of rubbings, realizing that stone engravings—and rubbings taken from them—were excellent for preserving pictorial and calligraphic styles as well as texts. From then on, famous works of calligraphy, and sometimes painting, were faithfully engraved in stone, preserving the style, flavor, and nuance of the original. Rubbings were avidly collected by the Song. They were appreciated as beautiful objects, but their main value lay in the antique styles they preserved. In that sense, they served as source books that could be copied in practicing calligraphy or studied in tracing the history of calligraphy.

82. *Gu* Wine Vessel

Shang, 12th–11th century B.C.
Bronze, with *taotie* decoration, Metropolitan style, Anyang type, Style V, cast inscription on the base reading ? *Fu Ding*, H. 30.1, D. (mouth) 17.5 cm

GU BEAKERS are often found in Shang burial sites in combination with *jia* and *jue* vessels (no. 83), suggesting that they were used together in rituals and ceremonies. They most likely contained a fermented beverage made from millet,[1] which was presented as an offering to the ancestral spirits.

Shang and early Zhou bronzes exhibit great creativity in their surface ornaments, with designs ranging from dragons, fish, and birds to cicadas, silkworms, and snakes. The most popular of all decorative motifs, however, was the so-called *taotie* mask—a fierce face with bulging eyes and snarling mouth often with fangs. The meaning of the designs, if any, remains unknown.

Developed to a high art by the Shang people, bronze casting reached its apogee during the latter part of the dynasty, when the kings based their capital at Anyang (ca. 1300–ca. 1028 B.C.). During this phase the bronze designers evolved a style of decoration, now called Style V, in which the principal decorative motifs rise in low relief, usually against a *leiwen* background. The *taotie* mask of this *gu* beaker is dispersed, so that its components are not directly connected, but float independently against the *leiwen* pattern.

Like many Shang bronzes, this *gu* bears a short dedicatory inscription cast integrally with the vessel itself. The first character of the inscription cannot be read, but it is thought to be a clan symbol; the second and third characters read *Fu Ding* (Father Ding). The inscription thus indicates that this *gu* was dedicated to "Father Ding [of] Clan X," in whose funerary services it would have been used.

Song connoisseurs, who were keen antiquarians, began to assemble collections of archaic bronze vessels which they prized not only as works of art but as tangible relics of the venerable past. This interest in the bronze vessels of old, combined with the Song desire to assert the superiority of native traditions over foreign ones borrowed during the Tang, inspired the reinstitution of old ceremonies and the production of archaistic bronzes.

By the late Ming, Shang and Zhou bronzes were both avidly collected and used, but in a context quite different from that for which they were originally created. Treatises on flower arranging, for example, recommend archaic bronzes, especially the *gu* and the *zun*, as the most suitable vases for winter and Song and early Ming ceramic vases as best for the summer. Paintings of the period depicting scholars frequently include archaic bronzes, signaling the identification of the scholar with traditional culture.[2]

In his *Zhangwu zhi* of 1637, Wen Zhenheng remarked: "Old bronzes that have been buried for a long time and that are well patinated can be used for growing flowers. The color of the flowers will be fresh and bright."[3] Although the use of ancient vessels as vases and flowerpots reached its peak during the late Ming, the custom originated much earlier, presumably during the Song. In his *Gegu yaolun* of 1388, Cao Zhao had already noted that ancient bronzes could be used

for growing flowers.[4] The wording of Wen Zhenheng's discussion is so similar to Cao Zhao's that he must have been merely repeating what had become conventional wisdom by the seventeenth century.

83. *Jue* Wine Vessel

Shang, 12th–11th century B.C.
Bronze, with *taotie* decoration, Metropolitan style, Anyang type, Style IV, cast inscription under the handle reading *You*, H. 18.1, W. (across spout and tail) 16.2 cm

THE *jue* was a wine vessel and was used, at least sometimes, in conjunction with the *gu*. Its exact function remains uncertain, but large ones may have served as wine-warming vessels and smaller ones as drinking vessels. The latter might account for the placement of the handle on the *jue* at a quarter turn from the spout.

This *jue* is slightly earlier in style than the *gu* beaker discussed in no. 82. Decorated in what is now called Style IV, the principal motifs do not rise in relief; instead, broad and unembellished lines, flush with the *leiwen* background, define the dispersed *taotie* mask. The later Style V decor, as seen on the *gu* beaker, evolved logically and directly from this type of decoration.

A single character reading *You* appears under the handle, the usual placement of inscriptions on *jue* vessels. The character is probably a family name, but could be the name of the person who commissioned the vessel.

The ancient bronze *jue* inspired countless copies in ceramics and jade in the Ming and Qing. Blue-and-white porcelain examples are known that may have been made for ceremonial use in Ming imperial rituals. The Dehua tripod cup (no. 37) derives from a hybrid of the *jue* and its close relative, the *jiao*.

84. *Gui* Food Vessel

Shang, 12th–11th century B.C.
Bronze, with boss-and-lozenge decoration, Metropolitan style, Anyang type, Style V, cast inscription on the interior floor reading *You Fu Gui*, H. 17.5, W. (across handles) 32.5, D. (mouth) 23.7 cm
Gift of Wu Qingyi

A VESSEL for serving offerings of boiled grain, probably millet, the *gui* is a deep, handled bowl mounted on a splayed circular foot. Although the *taotie* mask was the most common decorative motif on archaic bronzes, it was not the only one. Also frequently used in the late Shang were abstract, nonrepresentational decorative schemes, including vertical ribbing, lozenges, or bosses, as in this vessel.

The short inscription on the interior floor indicates that this superbly cast *gui* vessel was made by You for his father, Gui. The names of Father Gui and of the *gui* vessel are homonyms, but they are written differently and have entirely unrelated meanings.

The *gui* vessel spawned many bronze and jade imitations in the Ming and Qing, such as the small jade *gui* in this exhibition (no. 51). The most celebrated bronze casters of the late Ming, Hu Wenming and his son Hu Guangyu (no. 62), frequently cast *gui*-shaped incense burners.

PUBLISHED: Tokyo National Museum, comp., *Chūka jinmin kyōwakoku kodai seidōki ten* (*An Exhibition of Ancient Chinese Bronzes from the People's Republic of China*), Tokyo: Tokyo National Museum, 1976: 147–148, no. 11
A Selection of Ancient Chinese Bronzes, Beijing: Wenwu Press, 1976: 4, no. 11 and plate 11
Shanghai Museum, comp., *Shanhai hakubutsukan*, volume 8 in *Chūgoku no hakubutsukan* (*The Museums of China*), Tokyo: Kodansha, 1983: 189, no. 58
Shen Zhiyu, ed., *The Shanghai Museum of Art*, New York: Harry N. Abrams, 1983: 110 and 150, no. 65
René-Yvon Lefebvre d'Argencé, ed., *Treasures from the Shanghai Museum: 6,000 Years of Chinese Art*, San Francisco: Asian Art Museum of San Francisco, 1983: 76 and 150, no. 18
Shanghai Museum, comp., *Shang Zhou qingtongqi wenshi* (*Ornaments of Shang and Zhou Bronze Vessels*), Beijing: Wenwu chubanshe, 1984: 12 and 125, no. 355, and 32 and 314, no. 912

85. *Liding* Food Vessel

Early Western Zhou, ca. 11th–early 10th century B.C.
Bronze, with *taotie* decoration, Metropolitan style, Style V, H. (with handles) 22.0, D. (mouth) 16.9 cm

TRIPOD VESSELS rank among the oldest bronze shapes, with clear antecedents in Neolithic pottery. The *li* and *ding* tripods were cooking vessels, probably used mainly for boiling, simmering, and stewing.[1] *Li* and *ding* vessels are closely related in shape, each having three legs and two loop handles. The *ding* has a circular mouth and belly with a rounded bottom; although the *li* has a circular mouth, its belly is gently divided into three lobes. The *liding* represents a combination of the *li* and *ding* shapes; its lobes are more gently and subtly divided than those of the *li*.

This *liding*, similar in style and shape to tripod vessels of the late Shang, actually dates to the beginning of the Western Zhou. In typical early Zhou fashion, the *taotie* mask is unified in a manner that suggests the face of a single animal presented frontally. In Shang vessels the mask is usually rendered so that it can be read both as one head seen frontally and as two confronting heads, each seen in profile. These differences, along with a *leiwen* pattern whose individual spirals are slightly more curvilinear and of more consistent size throughout, distinguish this as an early Zhou piece.

Tripod vessels were the most favored of all Chinese bronzes, especially in the late Ming, and they were widely imitated in Ming and Qing decorative arts. Although the ancient bronze tripods were cooking vessels, the later imitations were often made as censers. Cao Zhao had already mentioned in 1388 that archaic bronzes were used as censers, noting that "[in earliest times] there were no incense burners. . . . Ancient vessels used as incense burners today were sacrificial vessels and not (real) incense burners."[2]

A handscroll by Tang Yin (1470–1523), *The Qin Player*,

shows the scholar Yang Jijing playing the *qin* and surrounded by antiquities and other elegant objects, including an archaic bronze *ding* or *liding*. The vase-shaped holder with implements for burning incense and the red lacquer or porcelain box for incense pellets depicted in this painting leave little doubt about the function of the bronze vessel.[3]

86. Chimera-shaped Water Dropper

Six Dynasties, probably 4th–6th century (modified in late Ming)
Bronze, H. 9.8, L. 18.3 cm
Gift of Li Yinxuan and Qiu Hui

CAST DURING the Six Dynasties period, this piece might have been made as a water dropper or, as some have suggested, as a lamp.[1] In either case the hollow body would have been filled with the appropriate liquid, which could then be dispensed into the cup through a small hole between the front teeth. Whatever its original function, this piece was certainly used as a water dropper by scholars of the late Ming, whose writings occasionally mention the modification of antiques to serve new roles.

This stout beast, perhaps a relative of the *bixie* chimera (see no. 52), is one of a host of new mythological creatures that entered the sculptor's vocabulary during the Han dynasty. The typical Han example is a fully self-assured beast that crouches slightly as if poised to strike and holds its mouth open as if growling in defense. The creature was particularly popular in the Eastern Han and Six Dynasties but was seldom represented in succeeding periods. Earlier pieces tend to exhibit an alert countenance and plastically modeled surface details; later ones appear timid and stylized, often with linear surface patterns as in this rotund example.[2]

In its timidity and high degree of stylization, this bronze compares favorably with a recumbent chimera in the Mr. and Mrs. John D. Rockefeller 3rd Collection, The Asia Society, New York.[3] The Rockefeller piece has not been securely dated, but several scholars have assigned it to the fifth or sixth century.[4] If that dating is correct—and the logic of degree of stylization suggests that it could well be—then this Shanghai Museum water dropper most likely also dates from the same period.

The winged, or eared, wine cup first appeared during the Warring States period.[5] Made of bronze, jade, gold, silver, or painted lacquer, it was apparently a regular feature of Han life. Its popularity began to wane with the fall of the Han, but examples from the Six Dynasties are not uncommon.

87. Four Seals

Han (206 B.C.–A.D. 220)–Six Dynasties (220–589)

A. Set of three nested square seals, the outer one with turtle knob and relief legend reading *Liang Bing yin xin* (Official seal of Liang Bing), the middle one with turtle knob and relief legend reading *Liang Bing*, the inner one with tile knob and relief legend reading *Yuan xi*, Western Jin (265–316), bronze, outer seal: H. 2.8, W. 2.8 cm, middle seal: H. 1.6, W. 1.5 cm, inner seal: H. 0.8, W. 1.2 cm

B. Set of two nested square seals, the outer one with turtle knob and intaglio legend reading *Wang An si yin* (Private seal of Wang An), the inner one with tile knob and intaglio legend reading *Wang Zi ban yin* (Seal of Wang Ziban), bronze, Western Han (206 B.C.–A.D. 9), outer seal: H. 1.9, W. 1.7 cm, inner seal: H. 1.0, W. 1.4 cm

C. Square seal with turtle knob and intaglio legend reading *Guan zhong hou yin* (Seal of the Marquis of Guanzhong), gilt bronze, Three Kingdoms (220–265), H. 2.7, W. 3.1 cm

D. Square seal with tile knob and intaglio legend reading *Wang Chang fu yin* (Seal of Wang Changfu), Eastern Han (25–220), bronze, H. 1.9, W. 2.0 cm

THESE CAST bronze seals are representative of official and private seals produced in the Han dynasty. In typical fashion, all are small and have knobs in the shape of either a turtle or a roof tile. Some were produced as sets that nestle snugly one inside the next, a type referred to as *zimu yin*, or mother-and-child seals.

These seals were cast with both relief (A) and intaglio (B, C, D) legends. The compositions of the legends are neatly divided into halves and quarters so that individual characters occupy roughly the same amount of space. Except for the outer seal of B (reading *Wang An si yin*), which employs an embellished form of calligraphy, the characters are presented in their basic forms without extraneous flourishes. The calligraphy is bold and direct so that the legends are ordered and thus easy to read. The elegant simplicity and purity of expression seen in these seals led to their designation as classical models in Ming times, when they were especially prized (see nos. 27 and 72).

The discovery of several cast bronze seals at Anyang indicates that they were already in use by the Shang dynasty. Excavations at a number of Han and pre-Han sites have yielded seals in a variety of materials, including bronze, gold, jade, turquoise, and soapstone, suggesting that their use was widespread by Han times. The earliest seals tend to have only rudimentary handles, but by the Han, ring and tile-shaped handles had appeared, as had decorative knobs in the form of animals—such as turtles, dragons, bears, and occasionally camels. The decorative knobs seen here—both tile and animal ones—were the inspiration for those on Ming seals (see nos. 70 and 71). The handles of Han seals are almost always pierced so that the seal could be suspended from the belt by a cord. Sets of nestled seals were especially popular during the Han.

Seals with turtle knobs similar to the ones shown here were excavated from the Western Han tomb No. 2 (2nd century B.C.) at Mawangdui near Changsha.[1] A number of related examples of Han date are in the collection of the Art Gallery of the Chinese University of Hong Kong.[2]

The earliest seals were stamped in moist clay to seal bundles of documents rather than directly on the documents themselves. It is uncertain when the Chinese began to impress seals on silk, but the earliest known example is a fragment from Dunhuang dating to the first century.[3] The earliest seal marks on paper and silk are in black, probably impressed with ink. From the fifth century onward, seals have generally been applied in vermillion paste. The earliest red seal paste was water-based, but by Song times the paste was generally oil-based.

88. Vase

Southern Song–Yuan, 13th–14th century
Guan ware, black stoneware body with crackled bluish-green
celadon glaze, H. 13.9, D. 7.2 cm

KNOWN IN CHINESE as "hanging-gall shaped vases," such small vessels might have been used as bottles, but they were more likely intended as flower vases. In 1953 a virtually identical vase and a censer were excavated from the thirteenth-century Ren family tombs in Qingpu xian, Shanghai,[1] suggesting they might have comprised a set. An unpublished Shen Zhou handscroll in the Shanghai Museum depicts two such vessels with flowers standing on either side of a small censer on an altar in a family compound, indicating that by the fifteenth century they were often used as vases. Ming printed books also include illustrations of such vases holding flowers or, in the case of the *The Swallow Messenger of Love* (no. 28), two peacock feathers. The appearance of crackled *ge* and *guan* ware in literati paintings illustrates the scholarly taste for such pieces and conveys insight into their uses. Though made as a functional vessel in the Southern Song or Yuan, this vase would have been treasured as a collector's item in the late Ming, viewed and appreciated but seldom used.

In his *Zhangwu zhi* of 1637, Wen Zhenheng mentions that such "hanging-gall shaped vessels" in *ge* and *guan* ware are appropriate for flower vases, specifying that ceramic vases are best for the warmer months and bronze ones for the winter. In discussing incense-burning accoutrements, he remarks that *ge*, *guan*, and Ding ware bottles are the best for holding incense tongs, but recommends against using them daily because of their value and fragility.[2]

Rounded vases with elongated necks have a long history in China. They doubtless first appeared during the Sui and Tang, when they were crafted in both silver and pottery. Although most Tang and Song examples have an everted lip, the potters of the Jun kilns produced vases with flaring necks but without lips in the late Northern Song.[3] Organically shaped vases with straight necks were favored during the Southern Song and Yuan, especially in *guan* and Longquan wares.

An interesting variation of this shape is the *touhu* vase, which has two open-ended, tubular appendages on the neck, just below the lip. These appear in *ge*, *guan*, and Longquan wares and derive from early examples of *touhu* vases used for the arrow game (compare no. 63).

PUBLISHED: René-Yvon Lefebvre d'Argencé, ed., *Treasures from the Shanghai Museum: 6,000 Years of Chinese Art*, San Francisco: Asian Art Museum of San Francisco, 1983: 101 and 162, no. 83

89. Conical Bowl

Ming, Chenghua period (1465–1487)
Jingdezhen *ge*-type ware, porcelain body with crackled grayish-blue glaze and with an underglaze cobalt-blue mark reading *Da Ming Chenghuanian zhi* within a double circle on the base, H. 4.5, D. 11.6 cm

CONICAL BOWLS first appeared among Tang wares, particularly the celadons,[1] but the majority of these exhibit relatively wide footrings so that the proportions are markedly different. Bowls similar in proportion and shape to this one evolved during the Northern Song in black- and persimmon-glazed wares produced by the Ding and Cizhou families of kilns. By the Southern Song, potters of the Longquan, *guan*, and *qingbai* kilns were also creating such bowls.[2]

This appealing bowl is one of a handful of Chenghua marked *ge*-type pieces.[3] Although Chenghua marks on contemporaneous blue-and-white porcelains and *doucai* enamel pieces are well known, their occurrence on *ge*-type wares is extremely rare. The paucity of Ming reign marks has led many scholars to attribute most post-Song *ge* examples to the Qing dynasty, particularly to the Yongzheng and Qianlong eras when marked *ge* and *guan* pieces proliferate. The style, calligraphy, and light blue color of the present mark are identical to those on Chenghua marked examples in other ceramic wares, confirming the authenticity of the bowl. The porcelain body and thin, lustrous, translucent glaze distinguish this bowl from earlier *ge* ware. The imperial mark suggests that this bowl was most likely made for court use, but similar pieces without marks were no doubt made for less exalted households. This is one of two identical Chenghua marked bowls in the collection of the Shanghai Museum.

PUBLISHED: Wang Qingzheng, "Guan, ge liang yao ruogan wenti tansuo," ("Difficult Questions Concerning *Guan* and *Ge* Wares") in Zhongguo kaogu xuehui, ed., *Di san ci nianhui lunwen ji*, Beijing: Wenwu chubanshe, 1981: 187

90. Two Covered Boxes with Floral Decoration

Ming, Yongle period (1403–1424)
Brownish-red lacquer with dark brown lacquer interiors and bases, each with an inscription reading *Da Ming Yonglenian zhi* incised on the base, excavated in 1962 from the tomb of Zhang Yongxin (16th century) at Maqiao, Shanghai xian, (A) H. 3.3, D. 5.8 cm, (B) H. 3.1, D. 5.8 cm

SMALL COVERED BOXES have been used for seal paste since the Song period, but these pieces were more likely made to contain incense pellets. Wen Zhenheng stated that lacquer was the preferred material for incense boxes; in writing about seal paste containers, however, he remarked that although plain, undecorated lacquer ones could be used, carved and inlaid lacquer ones were insufficiently elegant.[1] From this it can be inferred that at least in the early seventeenth century these circular boxes would have been considered best suited for incense.

Carved black lacquers first appeared in Hangzhou during the late Song, replacing in popularity undecorated monochrome brown and black ones. Carved cinnabar lacquers probably first appeared in the fourteenth century. Like Yuan blue-and-white porcelains, carved lacquers of the fourteenth century typically display a dense, exuberant decorative scheme that covers the entire surface of the object. By the early fifteenth century, most carved lacquers were decorated

either with an overall pattern of flowers, like these Shanghai Museum boxes, or with a landscape scene.[2]

Although the principal flowers decorating these circular boxes are probably *mudan*, or tree peonies, a botanist has suggested that others may well be chrysanthemums and *chun* (*Cedrela sinensio*). Wen Zhenheng recommended both for cultivation.[3]

Probably manufactured in the lower reaches of the Yangzi River valley, most early Ming lacquers were constructed with numerous layers of lacquer over a wood core. Each paper-thin layer had to dry thoroughly for four or five days and be polished before the next could be applied, so one piece could take several years to produce. A different color, often yellow, was frequently used for the lowest layers, so that a deft carver could produce red relief designs against a contrasting ground. By the sixteenth century, lacquers of the early Ming were considered the very best. Their exquisite craftsmanship and bold designs tempered with the subtlety of a twisting leaf or petal folded back on itself ensured their status as China's classical carved lacquers.

Many early fifteenth-century lacquers bear reign marks on the base. The authenticity of such marks has occasioned considerable debate, some scholars arguing that they are contemporaneous with the lacquer itself, and others contending that they were added later—perhaps in the second half of the sixteenth century, not as spurious reign marks but as a connoisseur's indication of the possible date of manufacture.[4]

These two marked boxes were excavated from the tomb of Zhang Yongxin, a Daoist priest. Zhang's certificate of ordination, dated to 1507, was among the artifacts recovered, indicating that the tomb most likely dates to the mid-sixteenth century.[5] The excavation from a sixteenth-century tomb confirms that the Yongle marks on these boxes had already been incised by that time.

Related boxes of Ming date are in the collection of the Palace Museum, Taibei.[6] Incense boxes of this shape and size, decorated with flowers, continued to be popular throughout the Ming and Qing periods.

PUBLISHED: Sekino Takeshi, Hayashi Minao, and Hasebe Gakuji, *Shanhai hakubutsukan shutsudo bumbutsu seidōki tōjiki* (*The Shanghai Museum: Excavated Cultural Relics, Bronzes, and Ceramics*), Tokyo: Heibonsha, 1976: no. 26

Tian Zibing, *Zhongguo gongyi meishushi* (*A History of Chinese Handicrafts*), in *Zhongguo gongyi meishu congshu* (*Collected Works on Chinese Handicrafts*), Shanghai: Zhishi chubanshe, 1985: 297 and plate 110

and D). Until securely dated and signed examples of such fans come to light, the question of Chinese, Korean, or Japanese origin will remain open. The stylized "fish net" decoration is quite unlike that of fans that have survived above ground in China and has occasioned considerable debate about their country of origin. Ample literary evidence attests that folding fans were imported from Korea and Japan throughout the Ming. In his *Zhangwu zhi*, Wen Zhenheng notes that "among those [fans] imported from Japan there are still ones that are superb,"[1] suggesting that there must have been a lively market for them. With its intense patterning and its lavish use of gold for coloristic effect, the design of this fan conveys a strong sense of the Japanese aesthetic.

The folding fan did not appear in China until the early Ming. It met with immediate success and was popular throughout the Ming and Qing periods. Artists found the unusual shape a challenge and often decorated the fans with intimate landscapes or delicate scenes of birds and flowers.

Fans had been popular in China since antiquity. Early examples were typically lollipop-shaped with a simple wooden or bamboo handle and a circular head, often decorated with painting or calligraphy.

The folding fan, which was very popular in the late Ming period, had a frame usually constructed of fine wood or bamboo, although ivory was occasionally used as well. A frame constructed from a particularly handsome specimen of wood or bamboo might be left undecorated, but most examples have carved or lacquered designs on the end panels and often some inlay work in mother-of-pearl. Many Ming fans originally sported a silk tassel, sometimes also with an ornament such as the carved sachet seen here.

This fan was excavated from the tomb of Zhu Chunchen and his wife (surnamed Yang) in Songjiang county.[2] The tomb included two separate but adjacent graves, one on the east for Zhu Chunchen and one on the west for his wife. Although Zhu Chunchen died in 1601, documents recovered from the tomb indicate that his wife lived until 1624. This fan was recovered from the wife's grave and had been placed in her left hand. Three additional fans, all painted with monochrome ink landscapes, were discovered in Zhu's grave, one in his left hand and the other two in his right hand. One of the three fans bears an inscription and signature, but only the artist's surname, Feng, is still legible in the signature. A seal reading *Yunyi* appears near the signature and again on the second fan.

PUBLISHED: Shanghaishi wenwu baoguan weiyuanhui, comp., "Shanghai shijiao Ming mu qingli jianbao" ("Brief Report on the Excavation of a Ming Tomb in the Suburbs of Shanghai"), *Kaogu* (Beijing) 1963, no. 11: 620–622, plate 7, fig. 7

91. Folding Fan with Net Decoration

Ming, late 16th–early 17th century, before 1624
Ink on gold-flecked, persimmon-colored paper, 22-rib bamboo frame with black lacquer on the end panels, excavated in 1962 from the grave of the wife of Zhu Chunchen (d. 1624) in Chengxi, Songjiang xian, Shanghai, W. 58.5 cm

THIS FAN is one of a number of such pieces that have recently been excavated from late sixteenth- and early seventeenth-century tombs in the Shanghai area (compare no. 69 C

Notes

Chapter I

1. Arthur Symons, Introduction to Samuel Taylor Coleridge, *Biographia Literaria* in the 1906 Everyman's Library edition; see note 2.

2. Editors' Introduction to Coleridge, *Biographia Literaria*, James Engell and W. Jackson Bate, eds. (Princeton: Princeton University Press, 1983), p. xliii. The quote from Arthur Symons appears earlier in the same Introduction.

3. In *juan* 3 of the *Wang Wencheng Gong Quanshu*, a collection of Wang Shouren's writings and teachings edited by disciples, one finds a passage where Wang compares the cultivation of virtue (*de*) and humanity (*ren*) to the construction of a permanent dwelling. Artistic activities and other accomplishments such as poetry, music, and archery are the decoration. If the house is not built, there is no point in having decorations, and "nowhere to hang the pictures."

4. Again in *juan* 3 of *Wang Wencheng Gong Quanshu* is recorded a dialogue in which a friend pointed to a flowering tree in the crags, while on a walk in the country with the Master, and asked: "[You say] there is nothing outside the mind in the universe. Take this flowering tree, for example, the flowers bloom and fall of their own in a secluded mountain. What have they to do with my mind?" The Master replied, "Before you looked at these flowers, the flowers and your mind were both in a quiescent state, but when you came to look at these flowers, the colors of the flowers became immediately revealed. Therefore you know that the flowers did not exist outside of your mind."

5. Li Yu in his *Xianqing ouji*, 1671 (Reprint Taibei: Taiwan shidai shuju, 1975), *juan* 1, in the section on the writing of dramatic songs, cites the example of Wang Shouren's reply to the question: "This [innate] 'knowledge of virtue,' is it black or white?" The Master's reply was, "It is neither white nor black. That which is a little bit red is knowledge of virtue."

6. Xie Zhen, *Siming Shihua juan* 4, item 82 (Renmin Wenxue Chubanshe edition, Peking, 1961).

7. Ibid.

8. Ibid., *juan* 3, item 71.

9. Ibid., *juan* 3, item 41.

10. Jao Tsung-i, "Painting and the Literati in the Late Ming," in *Proceedings of the Symposium on Painting and Calligraphy by Ming I-min*, special issue of *The Journal of the Institute of Chinese Studies* (Hong Kong) 8 no. 2 (December 1976). An abbreviated English translation appears in *The Translation of Art* (Seattle, 1976).

11. Yuan Hongdao, "Letter to Qiu Zhangru," in Qian Bocheng, ed., *Yuan Hongdao ji jianjiao* (Shanghai: Guji chubanshe, 1981), p. 208.

12. Zhou Hui, *Jinling Suoshi* (Wenxue Guji Kanxinshe edition, Peking, 1955).

13. Li Rihua, *Zitaoxuan zazhui* ca. 1617, *juan* 1, entry on Hao Shijiu (Reprint Shanghai: Zhongyang Book Co., 1935).

14. Anonymous, *Tan Meiren* [*On Feminine Beauty*], collected by Wei Yong in *Zhenzhongmi*.

15. Yuan Zhongdao, *Kexuezhai Wenji*, *juan* 1 collected in *Zhongguo wenxue zhenben congshu* (Shanghai, 1936). See also *Kexuezhai jinji* (Shanghai, 1982) listed in Bibliography.

16. For a brief summary of critical views of late Ming folk songs by contemporary writers, see Liao Fushu, *Zhongguo gudai yinyue jianshi* [*A Brief History of Ancient Chinese Music*] (Beijing: Renmin yinyue chubanshe, 1982), pp. 110-111.

17. Xu Wei, *Xu Wenchang ji*, *juan* 17 (1911 edition).

18. Wang Shizhen, *Yanzhou Shanren sibugao, yiyuanzhiyan*, collected in *Lidai shihua xubian* (printed 1916).

19. Li Rihua, *Zhulan huaying*, *juan* 1, "On another fan painting for [Xiang] Yufan."

20. Yuan Hongdao, "Preface to Chen Zhengfu's *Huixinji*," in Qian Bocheng, ed., *Yuan Hongdao ji jianjiao*, pp. 463–464.

21. Li Rihua, *Zitaoxuan zazhui*, *juan* 1, entry on the library.

22. Uvedale Price, *Essays on the Picturesque* (London, 1794). The 1795 and subsequent editions usually include the correspondence with Humphrey Repton.

23. Li Yu's views on "design for living," household objects, and antiquities are contained in *juan* 8-11 of his *Xianqing ouji*.

24. Qian Qianyi, "Preface to the Poems of Li Zizhong [Li Yizhi]," in *Youxue ji*, *juan* 20.

25. An extraordinarily painstaking and sympathetic study of Liu Rushi's life and times has been made by the historian Chen Yinke (1890–1969) and published posthumously in 1980 in Shanghai under the title *Liu Rushi biezhuan* (Shanghai: Guji chubanshe, 1980), 3 volumes.

26. Yuan Hongdao, "A Postscript to Zhang Youyu's [Zhang Xianyi's] Poem on the Huishan Springs," in Qian Bocheng, ed., *Yuan Hongdao ji jianjiao*, pp. 194–195.

27. See Robert Mowry's notes on cat. no. 88.

28. Wang Shizhen, *Gubugu lu*, 1585, in *Congshu jicheng, jianbian* edition.

29. Chen Shiqi, "Mingdai gongjiang zhidu [On the Adminstration System Relating to Artisans in the Ming Period]," *Lishi yanjiu*, 6 (1955). On page 79 Chen Shiqi quotes the memorial from Hu Shining to the emperor recommending that bonus payments and conferment of official ranks on artisans be stopped, arguing that it was the "duty" of artisans to work to the best of their ability.

30. Fan Lian, *Yunjian jumuchao*, in *Biji xiaoshuo daguan*, 1590s; (Early 20th century lithograph edition, Yangzhou: Jiangsu guangling guji keyinshe reprint, 1983), VI.

31. Fu Yiling, *Mingdai Jiangnan shimin jingji shitan* [*An Investigation into the Economy of the Urban Population of Jiangnan in the Ming Period*] (Shanghai: Renmin chubanshe, 1963), quoting Li Le, *Jianwen zazhi*, *juan* 10.

32. Also quoted by Fu Yiling, ibid.

33. Fan Lian, *Yunjian jumuchao*, section on Customs.

34. Shen Congwen, *Zhongguo gudai fushi yanjiu* [*A Study of the Costume of Ancient China*] (Hong Kong, 1981), quotes the *Zhuzi Yulu* [*sic*] as recording that Cheng Yi (1033–1107), the Neo-Confucian philosopher, was fond of wearing tall hats, saying that "this is the dress of rustics" and that the bucket-top hat was the dress of the hermit.

35. See Shanghaishi wenwu baoguan weiyuanhui [Committee for the Preservation of Cultural Properties of the Municipality of Shanghai], comp., *Shanghai gudai lishi wenwu tulu* [*An Illustrated Catalogue of Ancient Cultural Objects from Shanghai*] (Shanghai: Jiaoyu chubanshe, 1981), p. 93.

36. Zhang Dai, "Letter to the Zixiang," in *Langhuan wenji*, in *Zhongguo wenxue zhenben congshu* (Shanghai: Zazhi gongsi, 1935).

37. The English reader can get a taste of this class of literature in Sir Percival David, ed. and trans., *Chinese Connoisseurship: The Ko Ku Yao Lun, The Essential Criteria of Antiquities* (New York and Washington, D.C.: Praeger, 1971).

38. As discussed, for example, in Uvedale Price, *Essays on the Picturesque*.

Chapter II

1. The theory was first developed in the capital of the Northern Song dynasty, Bianjing (now Kaifeng), by a group of artists, the most important member of whom was Su Shi, a high official known for his poetry, painting, and calligraphy. For a general discussion of the development of literati art theory see Susan Bush, *The Chinese Literati on Painting: Su Shih (1037–1101) to Tung Ch'i-ch'ang (1555–1636)* (Cambridge, Mass.: Harvard University Press, 1971); the first two chapters deal with the Song development.

2. For the major ideas of these literati artists see ibid., chapter 2.

3. See ibid., chapter 4.

4. Li Rihua, *Zitaoxuan zazhui*, ca. 1617 (Reprint Shanghai: Zhongyang Book Co., 1935), I: p. 13 (see cat. no. 24). Li quotes Jiang Kui (ca. 1155–1221), known as a Southern Song poet and musician from Jiangxi province (see *Cihai: Separate Volume on Literature*, Shanghai: Cishu Publishing Co., 1980 , p. 69, and Wen Zhengming),

the dominant artistic personality in Suzhou during the sixteenth century (see L. Carrington Goodrich and Chaoying Fang, eds., *Dictionary of Ming Biography: 1368–1644*, New York and London: Columbia University Press, 1976, pp. 1471–1474). In neither case does Li mention his source, though Wen's statement probably came from an inscription on a painting no longer extant.

5. Li Rihua, *Zhulan Mojun tiyu*, 1600s, in Deng Shi and Huang Binhong, comps., *Meishu congshu* (Shanghai: Shenzhou guoguangshe, 1912–36), 2/2/4, p. 10b.

6. Li Rihua, *Meixu xiansheng beilu*, 2 vols., 1600s, in *Yimen guangdu* (*Baibu congshu* ed.), (Taibei, 1965, no. 13), 1968, 38/13b.

7. Dong was the target of a number of riots among the disaffected in Songjiang; see Nelson I. Wu, "Tung Chi-ch'ang (1555–1636): Apathy in Government and Fervor in Art," in Arthur F. Wright and Dennis C. Twichett, eds., *Confucian Personalities* (Stanford: Stanford University Press, 1962), pp. 260–293.

8. In the history of Chinese calligraphy these four are know as the "Four Great Calligraphers of Song," a concept that probably came into general use in the late Ming.

9. All three were leading calligraphers of the Yuan dynasty; among them Zhao is the best known and the most influential.

10. In Dong Qichang's theory discussed later in this essay, both Ma and Xia were considered as belonging to the Northern school of landscape painting, not regarded as in the mainstream of Chinese painting. Here it is interesting to note that Li Rihua still ranked them higher than the Ming literati painters, although lower than the Yuan artists.

11. Li singles out Shen Zhou and Wen Zhengming, both major literati artists of the Ming, as the great masters of the dynasty in which he lived.

12. Of the major calligraphers of the Ming, Zhu seems to have appealed to Li as a great master.

13. Li refers to two rather rare kinds of ancient jade.

14. Lingyan Hall was established by Emperor Taizong of the Tang dynasty in 643 to honor twenty-four loyal and distinguished high officials and scholars. For that occasion the emperor himself composed the eulogies; Zhu Ruiliang, a famous calligrapher, wrote them down; and Yan Liben, an outstanding painter, painted portraits. Although the tradition of Lingyan Hall was supposed to have gone back to the Han dynasty, no detail of its activities has been recorded. See Zhonghua Book Company Editorial Committee, comp., *Cihai* (Taibei and Hong Kong, 1978 and 1982), p. 659.

15. Li Rihua, *Zitaoxuan zazhui*, IV: pp. 109–110. The same passage is recorded in his *Weishuixuan riji*, 1609–16 (Woodblock reprint Beijing: Wenwu Press, 1982, 8 volumes), VIII: pp. 4b–5a. At the age of twenty-two Dong Xian (23–1 B.C.), a favorite of Emperor Aidi of the Western Han dynasty, was made commander-in-chief, one of the three dukes at court who helped the emperor to rule over the country. Acting like a regent, Dong used his position to enrich himself and all his relatives. Not long afterwards, when the emperor died, he was forced to commit suicide.

16. Chen Jiru, *Nigulu*, ca. 1635, in Deng and Huang, comps., *Meishu congshu*, 1/10/4, p. 1. The *Nigulu* records Chen's major ideas on painting and calligraphy.

17. Chen Jiru, *Shuhua jintang*, in Deng and Huang, comps., *Meishu congshu*, 1/10/2, p. 1.

18. For the development of Yixing ware see Terese Tse Bartholomew, *I-hsing Ware* (New York: China Institute in America, 1977); Shi Dabin (Shi Ta-pin) is mentioned as the first great master of this tradition, pp. 24–25.

19. Hu Guangyu, son of Hu Wenming, was a well-known bronze caster of Songjiang, home of Dong Qichang and Chen Jiru; see Wango Weng and Yang Boda, eds., *The Palace Museum, Peking: Treasures of the Forbidden City* (New York: Abrams, 1982), p. 274, and Li Juanyai, comp., *Zhongguo yishujia zhenglüe* (Taibei: Zhongua Book Co., 1968), p. 6a–b.

20. Cheng Junfang (Dayue), a native of Huizhou, was one of the best-known makers of inksticks in the late Ming; see Mu Xiaotian and Li Minghui, *Zongguo Anhui wenfang sibao* [*The Four Treasures of the Scholars's Studio in Anhui, China*] (Hefei: Anhui Scientific and Technical Press, 1983), p. 70. Fang Yulu, a native of Shexian, was another famous inkstick maker of the late Ming; see ibid., pp. 71–72. Wang Hongjian was a native of Haiyang, now in Xiuning, south of Shexian in southern Anhui; he and his son were both prominent members of the Xiuning School of Inkmakers in the late Ming, see ibid., p. 77.

21. Natives of Jiading, near Shanghai, Shen Dasheng, Zhang

Xihuang, and Feng Xilu were all well-known bamboo carvers in the late Ming and early Qing periods. Shen was an outstanding painter in his own right and also practiced medicine. See Li Juanyai, comp., *Zhongguo yishujia zhenglüe*, pp. 31a (Shen), 33b–34a (Feng), and 42b–43b (Zhang). For Feng Xilu see also Wang Shixiang, "Moulded Gourds," in *Chinese Translations* no. 10 (London: Oriental Ceramic Society, n.d. but ca. 1983), p. 30.

22. You Kan, a native of Wuxi, Jiangsu, was so well known in the late Ming and early Qing as a carver of rhinoceros horn that he was asked to serve in the court of Emperor Kangxi (1622–1722); see Li Juanyai, comp., *Zhongguo yishujia zhenglüe*, p. 65b.

23. Wei Rufen is not recorded in any of the sources available. Yang Ji, from Zhangpu, Fujian, was active in the early Qing period.

24. Zhang Jing (?) xiu must have been active during the late Ming and early Qing periods, since the date of the inscription on this instrument corresponds to 1643.

25. Known for his archaic style, Chen Hongshou was a native of Zhuqi, Zhejiang, not far from Hangzhou, and was active in the late Ming and early Qing periods; see James Cahill, *The Compelling Image: Nature and Style in Seventeenth-Century Chinese Painting* (Cambridge, Mass.: Harvard University Press, 1982), pp. 106–145.

26. Yuan Mei, from Hangzhou, Zhejiang, was the holder of a *jinshi* degree and served as a magistrate of Jiangning (now Nanjing) during the reign of the Qianlong emperor; after his retirement Yuan continued to live in Jiangning, where he was the central figure of a literary circle; see Arthur Waley, *Yuan Mei, Eighteenth-Century Chinese Poet* (New York: Grove Press, 1956).

27. Li Rihua, *Tianzhitang ji*, 1638 (Ming facsimile edition Taibei: National Central Library, 1971, 6 vols.), XXXVIII: p. 25b.

28. Li Rihua, *Zitaoxuan zazhui*, part II, vol. II: p. 47.

29. Dong Qichang, *Huazhi*, in Dong Qichang, *Rongtai ji*, 1630 (Ming facsimile edition, 4 volumes Taibei: National Central Library, 1968), 6/1b.

30. Li Rihua, *Zitaoxuan zazhui*, part I, vol. I: p. 13.

31. Bai Juyi was the most popular poet of the late Tang, and his poems "The Everlasting Sorrow Song" and "The Lute Song" are among the most memorable in the history of Chinese poetry. See Herbert A. Giles, *A Chinese Biographical Dictionary* (London: Bernard Quaritch, and Shanghai and Yokohama: Kelly and Walsh, 1898), pp. 630–631.

32. Wang Xizhi, from Shanyin, Zhejiang province, is regarded as the greatest calligrapher in the history of Chinese calligraphy, and his works were prized by later emperors and collectors; see Giles, *A Chinese Biographical Dictionary*, pp. 821–822.

33. Dong Qichang, *Rongtai bieji*, in Dong, *Rongtai ji*, 6/19b. The quotation is from a statement that was originally a colophon for a painting by Ni Zan.

34. This is the most important of the five colophons written by Dong on Zhao Mengfu's handscroll, now in the National Palace Museum, Taibei; see Chu-tsing Li, *The Autumn Colors on the Ch'iao and Hua Mountains: A Landscape by Chao Meng-fu* (Ascona, Switzerland: *Artibus Asiae*, Supplementum XXI, 1965), p. 98. The colophon was written in 1605.

35. Wang Shouren, from Yuyao, Zhejiang province, is generally regarded as the greatest philospher of the Ming period and is known as the founder of the School of the Mind. See Goodrich and Fang, eds., *Dictionary of Ming Biography*, pp. 1408–1416.

36. Li Zhi, native of Jinjiang, Fujian province and a great philosopher of the late Ming, has attracted attention in recent years owing to his rebellion against the conservatism of contemporary philosophers and to his interest in the life of the common people. See Goodrich and Fang, eds., *Dictionary of Ming Biography*, pp. 807–818.

37. Yuan Hongdao, of Gongan, Hubei province, was the leader of the Gongan School in late Ming literature. See Goodrich and Fang, eds., *Dictionary of Ming Biography*, pp. 1635–1636.

38. During the late Ming both the novel and the drama, which traditionally had not been regarded as serious literature, became extremely popular and were adopted as vehicles by many talented writers.

39. The Donglin movement was a group of several hundred scholars and students at the Donglin Academy at the foot of Mt. Lu in Jiangxi province, who under the leadership of Gu Xiancheng (1550–1612) and Gao Panlong (1562–1626) strongly criticized late Ming court affairs. See Goodrich and Fang, eds., *Dictionary of Ming Biography*, pp. 701–710 (Gao) and 736–744 (Gu).

40. Fu She grouped together a number of intellectual organizations in the south during the last years of the Ming dynasty, under the

leadership of Zhang Pu (1602–1641); see Arthur W. Hummel, ed., *Eminent Chinese of the Ch'ing Period (1644–1912)* (Washington, D.C.: Library of Congress, 1943–44), pp. 52–53.

41. Dong Qichang, *Huazhi*, 6/5a. The poem by Su Dongpo, see Bush, *The Chinese Literati on Painting*, p. 26.

42. Dong Qichang, *Huazhi*, 6/3a.

43. This comes originally from his colophon on an album by Dong Qichang. See Yu Jianhua, comp., *Zhongguo hualun leibian*, 2 volumes (Beijing: Chinese Classical Art Publishing Co., 1957), p. 754.

44. Ibid., p. 753.

45. Mt. Kuanlu is the old name of Mt. Lu, located near Jiujiang, Jiangxi province, and traditionally regarded as the abode of the immortals. For a translation of the poem see the essay "The Literati Life" in this catalogue.

46. Du Fu, from Gongxian, Henan province, one of the greatest poets of the Tang dynasty, was noted for his poems on the suffering of the people during the turbulent period following the rebellion of An Lushan against Emperor Minghuang. See Giles, *A Chinese Biographical Dictionary*, pp. 780–782.

47. Lou Jian, a native of Jading near Shanghai, was a well-known scholar and a friend of Li Rihua. See National Central Library, comp., *Mingren zhuanji ziliao suoyin* [*An Index of Ming Biographical Materials*] (Taibei, 1965–66), p. 611.

48. Dong Qichang, *Huazhi*, 6/10a–b; trans. Osvald Siren, *The Chinese on the Art of Painting*, (Peiping, 1936; Hong Kong, 1963), p. 136.

49. Ibid., 6/5b–6a; trans. Siren, *The Chinese on the Art of Painting*.

50. One of the most important concepts in modern Chinese art criticism, the term *yijing* is not found in traditional treatises on art, although it was used frequently in literary criticism.

51. Li Rihua, *Zhulan huasheng*, in Deng and Huang, comps., *Meishu congshu*, 2/2/3, p. 4a.

52. Ibid.

53. Ibid., p. 10b.

54. Ibid., p. 3b.

55. See Giles, *A Chinese Biographical Dictionary*, p. 542, Lu Chung-lien.

56. See ibid., pp. 401–401, K'ung Jung.

57. See ibid., p. 616, P'ang Kung.

58. See ibid., pp. 119–120, Chi K'ang.

59. See ibid., pp. 717–718, T'ao Ch'ien.

60. See ibid., pp. 810–811, Wang Chi.

61. Li Rihua, *Zhulan Mojun tiyu*, p. 9a.

62. Ibid., p. 3b

63. Ibid., pp. 7b–8a.

64. See Fu Shen, "A Study of the Authorship of the So-Called 'Hua-shuo' Painting Treatise," in *Proceedings of the International Symposium on Chinese Painting* (Taibei: National Palace Museum, 1972), pp. 85–115; and Wai-kam Ho, "Tung Ch'i-ch'ang's New Orthodoxy and the Southern School Theory," in Christian Murck, ed., *Artists and Traditions* (Princeton: Princeton University Press, 1976), pp. 113–129.

65. The well-known division of Chan Buddhism into the Southern and Northern schools took place under Sixth Patriarch Huineng during the Tang dynasty; see Kenneth Ch'en, *Buddhism in China: A Historical Survey* (Princeton: Princeton University Press, 1963), pp. 353–357.

66. According to Dong Qichang, the Northern school started with Li Sixun and his son Zhaodao, both of the middle Tang period. The history of the school can better be traced through Zhao Gan of the tenth century, Zhao Boju and Zhao Bosu of the twelfth century, and Ma Yuan and Xia Gui of the thirteenth century; an element in Dong's system of classification seems to be these artists' association with the court academy of the day.

67. The major figures in Dong's Southern school, originated by the Tang painter Wang Wei, were Zhang Zao of the eighth century; Jing Hao, Guan Tong, Dong Yuan, Juran, and Guo Zhongshu of the tenth century; Mi Fu and Mi Youren of the early twelfth century, and the four Yuan masters of the fourteenth century.

68. See Ch'en, *Buddhism in China*, p. 357.

69. Dong Qichang, *Huazhi*, 6/6b–7a; trans. Siren. The extract comes from the treatise *Huashuo*, once attributed to Mo Shilong but now thought to be by Dong Qichang. The same ideas were expressed by Mo, Chen Jiru, and Dong himself elsewhere, but this passage gives the best and most extensive description of the theory. See Fu, "A Study of the Authorship of the So-Called 'Hua-Shuo' Painting Treatise" and Ho, "Tung Ch'i-ch'ang's New Orthodoxy and the Southern School Theory."

Chapter III

1. Sherman E. Lee and Wai-kam Ho, *Chinese Art Under the Mongols: The Yüan Dynasty (1279–1368)* (Cleveland: The Cleveland Museum of Art, 1968), no. 37.

2. Ibid., cat. nos. 289, 290, 293, and 294. See also carved lacquers with Zhang Cheng signatures in the Beijing Palace Museum, *Wenwu* no. 10 (1956), and in the Anhui Museum, *Wenwu* no. 7 (1957); and the famous circular box from Ryūgen-in, Kyoto, with the signature of Yang Mao, *Seikai bijutsu zenshu* XVI: pl. 90.

3. Sun Fuqing, ed., *Yuanyanghu zhaoge* (*Zuili yishu* edition).

4. Pu Fangjun, *You Mingshenghu riji*, in Zhu Jianxin, ed., *Wan Ming xiaopinwen xuan* (Shanghai, 1937), IV: p. 340.

5. Zhu Yizun, *Pushuting ji*, juan 9 p. 15b (*Sibu congkan* edition).

6. Xie Guozhen, ed., *Mingdai shehui jingji shiliao xuanbian* [*Materials on Socio-Economic Conditions during the Ming Dynasty*] (Fuzhou, 1980), I: p. 128.

7. Liang Qingyuan, *Diaoqiu zalu*, juan 15, quoted in Xie Guozhen, ed., *Mingdai shehui jingji shiliao xuanbian*, I: p. 106.

8. Qian Yong, *Lüyuan conghua*, juan 1, p. 27 (Beijing, 1979 reprint).

9. The price of rice from 1624 to 1629 in the Lake Tai region is given in *Qizhen jianwen lu*, juan 1, and quoted by Wu Han, "Wan Ming liukou zhi shehui beijing [The Social Background for the Rebelbandits in Late Ming]," in *Wu Han shixue lunzhu xuanji* (Beijing, 1984), I: p. 491.

10. Wai-kam Ho, "Nan-Ch'en Pei-Ts'ui: Ch'en of the South and Ts'ui of The North," *The Bulletin of The Cleveland Museum of Art*, 49 (January 1962), pp. 2–11.

11. For Zhang Dai's semi-autobiography, see his "Ziwei muzhiming," in *Langhuan wenji*, in *Zhongguo wenxue zhenben congshu* juan 5, p. 140 (Shanghai: Zazhi gongsi, 1935). See also Arthur W. Hummel, ed., *Eminent Chinese of the Ch'ing Period (1644–1912)* (Washington, D.C.: Library of Congress, 1943–44), I: p. 53; and He Guanbiao, "Zhang Dai bieming zihao jiguan ji zunian kaobian," *Zhonghua wenshi luncong* no. 3 (1966), pp. 167–194.

12. Li Rihua, *Zitaoxuan zazhui* (*Zuili yishi* edition), juan 3, p. 27; also *Zitaoxuan youzhui*, juan 2, pp. 6–7.

13. See for example in a letter to Xu Youjie by Zhou Rong, in *Chunjiutang wencun* juan 3, pp. 44–46. (*Siming congshu* edition).

14. Zhou Lianggong, *Shuying*, preface dated to 1667, juan 4, p. 123 (Shanghai, 1958 reprint).

15. Discussion on fabrication of old texts by late Ming scholars can be found in Qian Xiyan, *Xi xia*, juan 3, pp. 52–53. (*Congshu jicheng* edition). See Wei Tongxian, "Cong shizhuan shishuo tan dao zuowei bianwei wenti," *Wenxian* no. 2 (1985), pp. 1–10.

16. Paul Pelliot, "Le pretendu album de porcelaines de Hsiang Yuan-pien," *Toung-pao* (Leiden, 1936), XXXII: pp. 15–58.

17. Yang Xin, *Xiang Shengmo*, in *Zhongguo huajia congshu* (Shanghai, 1982), pp. 1–16.

18. For degree purchase compare a similar experience of another wealthy writer from Jiaxing. See Zhang Zengyuan's study on the life of some obscure dramatists in the Yuan, Ming, and Qing periods in *Zhonghua wenshi luncong* no. 1 (1986), pp. 234–235.

19. For Li Rihua's biography, see L. Carrington Goodrich and Chaoying Fang, eds., *Dictionary of Ming Biography, 1368–1644* (New York and London: Columbia University Press 1976), I: pp. 826–830. Also see *Ming shi* [*History of the Ming Dynasty*], juan 288, p. 714 (*Kaiming* edition, Taibei, 1963 reprint).

20. Ibid., juan 74, pp. 165–166.

21. Zhu Yizun, *Jingzhiju shihua*, in Chen Tian, ed., *Mingshi jishi* (Taibei, 1971 reprint), VI: p. 3383.

22. *Ming shi*, juan 244, pp. 593–594.

23. Ibid., juan 243, pp. 590–591.

24. Xu Shu'an, "Mingchao di keju xuanguan zhidu," *Wenxian* no. 3 (1985), pp. 256–269.

25. cf. Zhao Yi, *Nianershi daji*, juan 34, p. 718 (*Congshu jicheng* edition).

26. Du Naiji, *Mingdai neige zhidu* (Taibei, 1961), pp. 62–65.

27. Xu Yishi, *Ming fu qijia kao*, in Tao Ting, ed., *Xu shuo fu* (Taibei, Xinxing shuju reprint), pp. 289–291.

28. Yao Shuxiang *Jianzhi bian*, juan 1, p. 38 (*Congshu jicheng* edition).

29. This poem is discussed in Yoshikawa Kojirō, *Genminshi gaisetsu* (Tokyo, 1963), pp. 159–161.

30. For an analysis of the Ming industry of book publishing, see Li Zhizhong, "Mingdai keshu shulüe," *Wenshi* no. 23 (1984), pp. 127–158.

31. Qian Qianyi, *Liechao shiji xiaozhuan* (completed 1649), I: pp. 161–162. See also Cheng Hong, "Jie xueshi shi kao," *Wenxue yichan* no. 3 (1960), p. 63.

32. Qian Qianyi, *Liechao shiji xiaozhuan*, II: pp. 620–621. See especially the same author, "Nanjing guozijian jijiu Fenggong muzhiming," in *Youxue ji*, part II, *juan* 51, pp. 588–589 (*Sibu congkan* edition).

33. Feng Mengzhen, *Kuaixuetang ji, juan* 45, pp. 8–10 (Wanli edition, 1616).

34. Ibid., *juan* 45, pp. 7–8.

35. Gu Yanwu, *Rizhi lu, juan* 16.

36. Zhou Lianggong, *Shuying, juan* 1, p. 18. Cf. Kristin Yü Greenblatt, "Chu-hung and Lay Buddhism in the Late Ming," in Wm. Theodore de Bary, ed., *The Unfolding of Neo-Confucianism* (New York, 1975).

37. See *Yuhuitang shiji, juan* 5, p. 85 (*Congshu jicheng* edition).

38. Gui Zhuang, "Wang Fengchang Yanke xiansheng qishi shou xu," in *Gui Zhuang ji* (Beijing, 1961 reprint), I: p. 251.

39. Cited in Hu Rulei, *Zhongguo fengjian shehui xingtai yanjiu* (Beijing, 1979), p. 85.

40. Gui Youguang, *Zhenchuan xiansheng wenji, juan* 17, (*Sibu congkan* edition), reprinted in Sichuan shifan xueyuan, ed., *Zhongguo lidai wenxuan*, (Beijing, 1980), II: pp. 828–833.

41. Ding Yaokang, *Chu jie jilüe*, in *Mingshi ziliao congkan* (Yangzhou, 1982), II, p. 160.

42. From Cyril Birch's partial translations of *The Peony Pavilion* published in *Renditions* (Hong Kong) (Autumn, 1974), p. 157.

43. Qian Qianyi, *Liechao shiji xiaozhuan*, I: p. 100.

44. Cheng Benli, "Zongti Tongshoutang ji," in *Xunyin wenji* (*Zuili yishu* edition), pp. 39a–40b.

45. For Wang Fuyuan's life and his friendship with Li Rihua, see Li, *Zitaoxuan youzhui, juan* 2, pp. 7–8 (*Zuili yishu* edition). Also *Jiaxing fuzhi, juan* 5, p. 79.

46. Shen Defu, *Wanli yehuo (xin) bian*, preface dated to 1606, (Beijing, 1959 reprint), *juan* 23, pp. 584–587.

47. Zhou Lianggong, *Shuying, juan* 1, p. 4.

48. Fu Yunzi,"Guajier yu Pipoyu," in *Baichuan ji* (Taibei, 1979 reprint), pp. 205–540.

49. Li Rihua, *Zitaoxuan youzhui, juan* 2, p. 9.

50. Gui Zhuang, "Bigeng shuo," in *Gui Zhuang ji, juan* 10, p. 490.

51. Shao Changheng, *Jingwu ji, juan* 2, pp. 15–16.

52. Shen Defu, *Feifu yulüe*, see esp. pp. 2–3, 4, 9, and 10–12.

53. For the tragedy related to this famous Northern Song scroll, see Wu Han, "Qingming shang he tu yu Jinpingmei di gushi ji qi yanbian," *Wu Han shixue lunzhu xuanji* (Beijing, 1984), I: pp. 37–54, 75, and 80.

54. *Gujin tushu jicheng* (Zhifang dian: Jiaxingfu jishi), *juan* 966.

55. *Jiaxingfu zhi, juan* 4, pp. 35–38.

56. Zhu Yizun, "Yuanyanghu zhaoge," one hundred poems in *Pushuting ji, juan* 9, pp. 107–112 (*Sibu congkan* edition).

57. Bai Juyi, *Baishi Changqing ji, juan* 10, p. 49 (*Sibu congkan* edition).

58. Kong Qi, *Zhizheng zhiji, juan* 2, pp. 5–6 (*Aoyatang congshu* edition).

59. Mo Shilong, *Bi chen* (*Qijinzhai congshu* edition), p. 9.

60. Gui Zhuang, "Taicang Gushizhe ji," in *Gui Zhuang ji, juan* 6, pp. 350–351.

61. Pang Shangpeng, *Pangshi jiaxun*, quoted by Hu Rulei, *Zhongguo fengjian shehui xingtai yanjiu*, p. 250.

62. Gui Zhuang, "Wangshi Xitian shixu," in *Gui Zhuang ji, juan* 3, pp. 184–185.

63. Arthur Waley, trans., *170 Chinese Poems* (London, 1947 reprint), p. 76.

64. Wen Zhenheng, *Zhangwu zhi jiaozhu* 1637 (Nanjing, collated and annotated edition, 1984), preface by Shen Shunze, pp. 10–11.

65. Li Rihua, *Zitaoxuan zazhui, juan* 1, pp. 27–28.

66. Yuan Zhongdao's journal from *juan* 1 to *juan* 13 appears as *Yuan Xiaoxiu riji*, published by Beiye shanfang in 1933 as part of *Zhongguo wenxue zhenben congshu*.

67. Gui Zhuang's diary recording his search for flowers is entitled *Xunhua riji*; see *Gui Zhuang ji, juan* 6, pp. 375–403.

68. Gong Zizhen, "Bingmeiguan ji," in *Gong Zizhen quanji* (Bei-

jing, 1974 reprint), I: p. 186.

69. A detailed account on activities of the Qingxishe in the late Ming can be found in Zhu Mengzhen, *Yusi shitan, juan* 1–2, pp. 1–31 (*Congshu jicheng* edition).

70. The poem is by Wang Guangcheng, *Lianshan caotang shichao, juan* 2, p. 39 (*Congshu jicheng* edition).

Chapter IV

1. For a more thorough discussion of this painting see my article in the forthcoming (1987) special issue of the *Journal of the Shanghai Museum* commemorating the 35th anniversary of the founding of the museum in 1952.

2. Zhang Qi, who is also known as Yuqi, was a native of Jiaxing. A pupil of Zeng Jing, the most famous portrait painter of the late Ming, who is said to have had some Western influence, Zhang was also known as a portrait painter. See *Zeng Jing di xiaoxiang hua* [Zeng Jing's *Portrait Painting*] (Beijing: Renmin meishu chubanshe, 1981.)

3. For the life of Li Rihua see Li's biography in L. Carrington Goodrich and Chaoying Fang, eds., *Dictionary of Ming Biography, 1368–1644* (New York and London: Columbia University Press, 1976), I: pp. 826–830.

4. For a discussion of upward mobility in Ming and Qing society see Ping-ti Ho, *The Ladder of Success in Imperial China* (New York: Columbia University Press, 1962.)

5. For a good glimpse of this period see Ray Huang, *1587: A Year of No Significance* (New Haven: Yale University Press, 1981).

6. For the life of Zhou Lijing, see Li Rihua, *Meixu xiansheng beilu* in *Yimen guangdu* (Taibei: Yiwen edition, 1965).

7. Tao Qian, also known as Tao Yuanming (365–427) was the great hermit poet of nature greatly admired for his moral integrity as well as for his literary achievement. Li Bai (712–756) was the great poet of Tang dynasty known for his romantic expression. Bai Juyi (772–846) was the most popular poet of late Tang noted for his narrative poems of dramatic subjects. Feng Haisu (ca. 1257–ca. 1314), a leading poet of early Yuan, was known for his songs of everyday life. All of them were models of Zhou Lijing. See Herbert A. Giles, *A Chinese Biographical Dictionary* (London: Bernard Quaritch, and Shanghai and Yokohama: Kelly and Walsh, 1898), pp. 717–718 (Tao), 45–46 (Li), and 630–631 (Bai). For Feng Haisu see *Cihai: Separate Volume on Literature* (Shanghai: Cishu Publishing Co., 1980), p. 75.

8. Zhou Lijing, *Wuliu kengge*, in *Yimen guangdu* (Taipei: Yiwen edition, 1965), IV: p. 54b.

9. See Li Rihua, *Meixu xiansheng beilu*, I: p. 46a–b.

10. Zhou Lijing, *Qunxian jiangji yu*, in *Yimen guangdu*, postscript by Li Rihua, p. 45a.

11. For the various activities of Xiang Yuanbian see Zheng Yinshu, *Xiang Yuanbian's Collection of Calligraphy and Painting and His Art* (Taibei, 1984), and K.S. Wong, "Hsiang Yuan-pien and Suchou Painters," paper presented at the Symposium on Chinese Painting at the Nelson-Atkins Museum of Art, Kansas City, 1980.

12. For the biography of Dong Qichang see Hironobu Kohara, *Tō Kishō no shoga* [*Dong Qichang, the Man and His Works*] 2 vols. (Tokyo: Nigensha, 1981) and Arthur W. Hummel, ed., *Eminent Chinese of the Ch'ing Period (1644–1912)* (Washington, D.C.: Library of Congress, 1943–44), pp. 787–789.

13. For the biography of Chen Jiru see Hummel, *Eminent Chinese of the Ch'ing Period*, pp. 83–84. This colophon is recorded in Li Rihua, *Tianzhitang ji*, 1638 (Facsimile reprint, Taibei: National Central Library, 1971,6 vols.) 37 pp. 17b–18a.

14. For a discussion of works signed by Dong but actually executed for him by his pupils and friends see Qi Gong, "Dong Qichang shuhua daibiren kao [A study of the People Who Did Paintings and Calligraphy in Dong Qichang's Name]" in *Qi Gong conggao* (Beijing: Zhonghua Book Co., 1981), pp. 149–164, and Xu Bangda, "Guhua bianwei shizhen (3)—Dong Qichang, Wang Shimin, Wang Jian zuopin zhenwei kao," *Flowery Cloud* (Shanghai), no. 6 (1984), pp. 197–225.

15. Li Rihua, *Weishuixuan riji*, 1609–16 (Woodblock reprint, Beijing: Wenwu Press, 1982), entry for the 10th day of the first month of the year corresponding to 1609, in I: p. 2a.

16. Ibid., entry for the 15th day of the first month of the year corresponding to 1609, in I: pp. 2b–3a.

17. Chen Jiru, *Shuhua shi*, 1600s, in Deng Shi and Huang Binhong, comps., *Meishu congshu* (Shanghai: Shenzhou guoguangshe, 1912–36), 1/10/2, pp. 1b–2a.

18. Chen Jiru, *Nigulu*, ca. 1635, in Deng and Huang, comps., *Meishu congshu*, 1/10/4, III: p. 8b.

19. Li Rihua, *Weishuixuan riji*, entry for the 10th day of the 11th month of the year corresponding to 1610, in II: p. 73b.

20. Wen Jia, also known as Wen Xiucheng, was the second son of Wen Zhengming and a young brother of Wen Peng. He was quite well known as a painter whose style was strongly influenced by his father; see Yu Jianhua, ed., *Zhongguo meishujia renming cidian* [*A Dictionary of Chinese Artists*] (Shanghai: Renmin meishu chubanshe, 1981), p. 39.

21. Zhou Gongxia, better known as Zhou Tianqiu (1514–95), a native of Suzhou, was a pupil of Wen Zhengming and a friend of Wen Jia. He was well known for both calligraphy and painting; see Guoli zhongyang tushuguan [National Central Library], *Mingren zhuanji ziliao suoyin* [*An Index of Ming Biographical Materials*] (Taibei, 1965), p. 315; and Yu, ed., *Zhongguo meishujia renming cidian*, p. 475.

22. Cai Shupin is unrecorded but was probably a native of Suzhou and a friend of the Wen family.

23. Wen Peng, the eldest son of Wen Zhengming, was better known as a calligrapher and seal carver, although he was also a painter. See National Central Library, *Mingren zhuanji ziliao suoyin*, p. 17; and Yu, ed., *Zhongguo meishujia renming cidian*, p. 38.

24. Zhu Zilang, better known as Zhu Lang (active mid-16th century), a native of Suzhou, was also a pupil of Wen Zhengming. His paintings were said to resemble Wen's so closely that they often passed as his teacher's works. See Yu, ed., *Zhongguo meishujia renming cidian*, p. 215.

25. Qian Shubao, better known as Qian Gu (1508–ca. 1578), a native of Suzhou, was also a pupil of Wen Zhengming, known for both calligraphy and painting. See Yu, ed., *Zhongguo meishujia renming cidian*, pp. 1435–1436, and Goodrich and Fang, eds., *Dictionary of Ming Biography*, pp. 236–237.

26. Peng Kongjia, better known as Peng Nian (1505–1566), a native of Suzhou, was a calligrapher and seal carver and a friend of the Wen family. See Yu, ed., *Zhongguo meishujia renming cidian*, p. 1066.

27. Shen Xiuwen, better known as Shen Damo, was a friend of the Wen family.

28. Hu Shaozhi is not identified but must have been a friend of the Wen family.

29. Shi Minwang is not identified but must have been a friend of the Wen family.

30. Lu Zizhi, better known as Lu Zhi (1496–1576), a native of Suzhou, was a pupil of Wen Zhengming in painting and Zhu Yunming in calligraphy. Noted as a hermit and as a filial son, he was a painter, calligrapher, and poet. See Goodrich and Fang, eds., *Dictionary of Ming Biography*, pp. 990–991.

31. The Seven Sages of the Bamboo Grove refer to seven eccentric poets during the mid-third century who used to gather together in a bamboo grove in present-day northern Henan. Among them Ruan Ji (210–263) and Xi Kang (223–262) are the best known. See *Cihai: Separate Volume on Literature*, p. 259. The Six Hermits of the Bamboo Stream refer to a group of six poets, led by Li Bai, who lived as hermits in a retreat by a bamboo stream in a mountain near Rencheng (present-day Shandong) during the middle of the eighth century. They indulged in wine and song and composed poetry. See ibid. p. 261.

32. The Literary Gathering of the Western Garden refers to a legendary gathering of a group of literati, including such famous artist-poets as Su Shi, Huang Tingjian, Mi Fu, Li Gonglin, and a number of others, in the Western Garden of Wang Shen, son-in-law of Emperor Yingzong, in the capital city of Kaifeng in the year 1087. It became a tradition constantly depicted in later Chinese paintings and mentioned in literature as one of the greatest occasions in the history of Chinese culture. Recently this has been found to be a fabrication, for a gathering of that kind did not actually take place. See Ellen Johnston Laing, "Real or Ideal: The Problem of the 'Elegant Gathering in the Western Garden' in Chinese Historical and Art Historical Records," *Journal of the American Oriental Society*, 88 no. 3 (1968), pp. 419–435.

33. The story of Wang Xiang, one of the concubines of Emperor Yuandi of Han (r. 48–33 B.C.), first recorded in *Hou Hanshu*, was in later periods dramatized in literature and drama to become one of the most popular female figures in the public mind. When the chieftain of the nomadic Xiongnu tribes requested a lady from the Han court to be his wife, the emperor ordered portraits made of all the ladies in his harem. While most of the concubines bribed the painters to make them look more beautiful, Wang Xiang, who was the most beautiful, refused to do the same. Her portrait thus showed her to be less satisfying than the others. On that basis, she was selected to be married to the Xiongnu chieftan. When all the arrangements had been made, she came to bid farewell to the emperor. It was then that the emperor realized the great mistake he had made. In deep regret and in great anger he ordered all those painters that had been involved in doing the portraits to be executed. Lady Wang, better known as Wang Zhaojun, eventually spent her entire life among the Xiongnu tribes.

34. Xu Renqing was a friend of Li Rihua in Jiaxing. Living as a hermit, Xu was also a calligrapher, painter, and connoisseur who lived to the age of seventy. His paintings were said to be very close to those of Yao Shou. Among his close friends were Monk Qiutan and Chen Jiru. After his death Li Rihua wrote his biography. See *Tianzhitang ji*, XXV: pp. 11b–14b.

35. See especially ibid., pp. 13a–14a.

36. This album has been published in portfolio form.

37. An extensive biography of Tao Zongyi can be found in Goodrich and Fang eds., *Dictionary of Ming Biography*, pp. 1268–1272. A chronology of his life has been reconstructed by Chang Bide in *Shuofa Kao* (Taibei: Wenshijie Publishing Co., 1979), pp. 407–482.

38. A biography of Wu Kuan can be found in Goodrich and Fang eds., *Dictionary of Ming Biography*, pp. 1487–1489.

39. The biography of Yang Xunji can be found in *Ming shi* [*History of the Ming Dynasty*], one of the *Twenty-four Official Histories* (Kaiming edition, Taibei, 1963 reprint), 286/15.

40. Major studies of Wen Zhengming include Ann deCoursey Clapp, *Wen Cheng-ming: The Ming Artist and Antiquity* (Ascona, Switzerland: *Artibus Asiae* Supplementum XXXIV, 1975); Richard Edwards, ed., *The Art of Wen Cheng-ming (1470–1559)* (Ann Arbor: Museum of Art, University of Michigan, 1976). For a discussion of his art and his influence on Suzhou artists see James Cahill, *Parting at the Shore: Chinese Painting of the Early and Middle Ming Dynasty (1368–1580)* (New York: Weatherhill, 1978), Chap. VI.

41. Yang Wencong, a native of Guizhou province, later served as one of the last Ming generals fighting against the invading Manchu armies south of the Yangzi River. Defeated and captured in Fujian, he was executed. His biography can be found in *Ming shi*, 277/18. He was also a calligrapher and painter.

42. Shen Hengji, also known as Shen Heng (1409–1477), a native of Suzhou, was the father of Shen Zhou. Also a painter, he and his brother Zhenji were both influential in the early development of Shen Zhou. His short biography can be found in Zhang Chang, *Wuzhong renwuzhi* (facsimile edition of Ming original, Taibei: Student Book Co., 1969), XIII: p. 26b.

43. Concerning this episode in Dong's life, see Nelson I. Wu, "Tung Ch'i-ch'ang (1555–1636): Apathy in Government and Fervor in Art," in Arthur F. Wright and Dennis C. Twichett, eds., *Confucian Personalities* (Stanford: Stanford University Press, 1962).

44. Li Rihua, *Zhulan huasheng*, in Deng and Huang, comps., *Meishu congshu*, 2/2/3, p. 7b.

45. Mt. Baiyue, located in Xiuning, Anhui province, not far from the famous Mt. Huang, is part of the range generally known as Mt. Qiyun. During the Tang and Song periods, Mt. Baiyue was already well-known for some of the temples. During the Ming period, ever since Emperor Jiajing (r. 1522–1566) ordered the construction of temples there by imperial command, the mountain was filled with large temple complexes, both Buddhist and Daoist, and attracted large numbers of pilgrims from all over the country. See *Zhongguo mingsheng cidian* (Shanghai, 1981), p. 437.

46. Mt. Xu is a hill not far from the town of Jiading. When he was young, Xiang Shengmo visited this hill often; he called himself "The Woodcutter of Mt. Xu." In his family estate there were many large tall pines, from which Xiang derived his studio name Songtao Sanxian (The Free Immortal of Soughing Pines).

47. Lu Ji, a native of Songjiang, was one of the leading poets and essayists in Luoyang, capital of the Western Jin dynasty. He was also a high official and a general who lost his life in the constant warfare of that chaotic period. See Giles, *A Chinese Biographical Dictionary*, p. 539. Zuo Si, a native of Shandong province, was also a leading poet and essayist in Luoyang in the Western Jin. One of his poems, "Ode to the Three Capitals," was said to be so popular that it led to the rise in the price of paper in the capital. See ibid., p. 770.

48. Wang Wei, a native of Shanxi province, was a high official and a poet and painter in the middle of the Tang dynasty. After the development of the literati theory in the eleventh century, he was regarded as the originator of the whole tradition of literati painting. See Giles, *A Chinese Biographical Dictionary*, p. 848.

49. Pan Yue, a native of Henan province, was a famous poet of the Western Jin who enjoyed great reputation with both Lu Ji and Zuo Si. See Giles, *A Chinese Biographical Dictionary*, pp. 615–616.

50. Xiao Tong (501–531), a native of Changzhou, Jiangsu province, was the eldest son of Emperor Wu of the Liang dynasty who showed a great interest in literature. Before his untimely death at the age of thirty-one, he gathered together a group of scholars to compile a collection of early literature, *Wenxuan*, in thirty volumes, which had extensive influence in later periods. See Giles, *A Chinese Biographical Dictionary*, pp. 283–284.

51. Jing Hao, Guan Tong, Dong Yuan, and Juran are considered the great masters of the period of Five Dynasties (907–960); they made important contributions to the formation of the monumental landscape tradition in painting.

52. Wei Yingwu, a native of Chang'an, the Tang capital, was one of the leading poets of middle Tang known for his poetry of the simple life of the countryside. See Giles, *A Chinese Biographical Dictionary*, p. 871.

53. Li Tang, a native of northern Henan province, was a great painter of the first half of the twelfth century. A member of the painting academy in the court in Kaifeng during the last years of the Northern Song, he escaped to the south after the fall of the capital to the Jin invaders and became a leading force in the academy in the newly established capital at Hangzhou.

54. Lu Hong, a native of Luoyang in Henan province, was a hermit living in Mt. Song in the early eighth century. He was both a calligrapher and a painter. One of his works, "Ten Views from a Thatched Hut," was his most famous; it inspired many copies and imitations in later periods. The best version of this painting is now in the National Palace Museum, Taibei.

55. In Chinese legend, the Weaving Maid was the granddaughter of the Queen Mother of the West, who lived on the east side of the Milky Way. The romance of the Weaving Maid and the Cowherd became extremely popular in later literature.

56. From the point of view of late Ming artists, Southern Song painters such as Li Tang, Ma Yuan, Xia Gui and many others marked a decline in the development of Chinese painting since they departed from the mainstream of literati painting. This was especially the viewpoint of Dong Qichang and Li Rihua.

57. Neither of these two paintings is extant. Indeed, aside from this mention by Li Rihua, neither of them is recorded in late Ming or Qing catalogues. At present, almost all the surviving works of Xiang Yuanbian are on the subjects of bamboo, plum blossoms, and rocks rather than figure paintings. In fact, Xiang has never been known as a figure painter. However, this is a record of his contemporary on the little-known side of Xiang.

58. Wuwa has been known since the Han dynasty as the area where magnificent horses came from, especially during the Han and Tang periods. Here, the idea of dragon seeds refers to the seeds of these horses.

59. In his long inscription for this handscroll, he indicated that this was the second scroll after his Calling for Reclusion, based on the sceneries of the rocks he constructed and the pines he planted around his studio. During the course of painting this scroll, he went on a long trip north with Li Rihua and visited Shandong, Beijing, and outside the Great Wall in 1628. See my article "Xiang Shengmo zhi zhaoyin shihua [Xiang Shengmo's Poetry and Painting on Eremitism]," in *Proceedings of the Symposium on Painting and Calligraphy by Ming I-min*, a special issue of *The Journal of the Insitute of Chinese Studies* (Hong Kong) 8, no. 2 (December 1976), pp. 539–540.

60. This is discussed in ibid., p. 541.

61. This refers to the situation after the Manchus had captured the country in 1644, when the invading armies continued their thrusts southward. In the rather chaotic situation following the collapse of the Ming court, many local officials organized their own local forces to try to resist the Manchu armies.

62. Chu-tsing Li, "Xiang Shengmo zhi zhaoyin shihua," p. 542.

63. Ibid., p. 545.

64. Ibid., pp. 545–546.

65. Ibid., p. 545.

66. The translation of this inscription is based on that by Ling-yun

Shih Liu and Wai-kam Ho in Wai-kam Ho, Sherman E. Lee, Laurence Sickman, and Marc F. Wilson, *Eight Dynasties of Chinese Painting* (Cleveland: The Cleveland Museum of Art, 1980), p. 251.

67. See Wai-kam Ho, et al., *Eight Dynasties of Chinese Painting*, pp. 251–252.

68. Zhou, *Qunxian jiangji yu*, op cit.

Catalogue

1

1. For a discussion of Chinese portraiture see James Cahill, *The Compelling Image: Nature and Style in Seventeenth-Century Chinese Painting* (Cambridge, Mass.: Harvard University Press, 1982), pp. 106–145.

2. *Songtao Sanxian tu*, also translated as *The Free Immortal of Soughing Pines*. Illustrated in James Cahill, *The Distant Mountains: Chinese Painting of the Late Ming Dynasty 1570–1644* (New York: Weatherhill, 1982), p. 228, fig. 116.

3. This possibility is discussed in a forthcoming article on this painting by Chu-tsing Li, to appear in the *Shanghai bowuguan guankan [Journal of the Shanghai Museum]*.

4. See Chu-tsing Li, "Xiang Shengmo zhi zhaoyin shihua [Xiang Shengmo's Poetry and Painting on Eremitism]," in *Proceedings of the Symposium on Painting and Calligraphy by Ming I-min*, a special issue of *The Journal of the Institute of Chinese Studies* (Hong Kong) 8:2 (December 1976), pp. 531–559, fig. 5.

5. See Cahill, *The Distant Mountains*, p. 228, fig. 115.

6. See ibid., p. 229, fig. 118.

7. See Shenzhou guoguangshe, comp., *Shenzhou daguan [Compendium of Chinese Paintings]* (Shanghai: Shenzhou guoguangshe), I: 1912, n.p.

2

1. Chaoying Fang, "Li Jih-hua [Li Rihua]," in L. Carrington Goodrich and Chaoying Fang, eds., *Dictionary of Ming Biography: 1368–1644* (New York and London: Columbia University Press, 1976), I: pp. 826–830, esp. 829.

2. For information on Zeng Jing see Cahill, *The Distant Mountains*, pp. 213–214; Réne-Yvon Lefebvre d'Argencé, ed., *Treasures from the Shanghai Museum: 6,000 Years of Chinese Art* (San Francisco: Asian Art Museum of San Francisco, 1983), pp. 169–170, no. 105 and color pl. XXXIII; Wang Bomin, *Zhongguo huihua shi [History of Chinese Painting]* (Shanghai: Renmin meishu chubanshe, 1982), pp. 523–525.

3. See d'Argencé, ed., *Treasures from the Shanghai Museum*, color pl. XXXIII, no. 105.

4. See Wai-kam Ho, Sherman E. Lee, Laurence Sickman, and Marc F. Wilson, *Eight Dynasties of Chinese Painting: The Collections of the Nelson Gallery-Atkins Museum, Kansas City, and The Cleveland Museum of Art* (Cleveland: The Cleveland Museum of Art, 1980), pp. 30–33, no. 18.

4

1. For information on successive generations of the Li family see Pan Guangdan, *Ming Qing liangdai Jiaxing di wanzu [The Famous Clans of Jiaxing during the Ming and Qing Periods]* (Shanghai: Shangwu yingshuguan, 1947).

2. For information on He Shi see Yu Jianhua, ed., *Zhongguo meishujia renming cidian [A Dictionary of Chinese Artists]* (Shanghai: Renmin meishu chubanshe, 1981), p. 258, He Shi.

3. Yu, ed., *Zhongguo meishujia renming cidian*, p. 388, Li Qizhi.

5

1. Although Dong Qichang was born into a family of humble means, ample income from official service enabled him to become a wealthy land-owner. An arrogant man, he was disliked by the local populace of Songjiang, many of whom were his tenants. In late April,

1616, the escapades of one of his sons sparked a riot that resulted in the destruction of the family home and art collections. For additional information see Chaoying Fang, "Tung Ch'i-ch'ang [Dong Qichang]," in Arthur W. Hummel, ed., *Eminent Chinese of the Ch'ing Period (1644–1912)* (Washington, D.C.: Library of Congress, 1943–1944) II: pp. 787–789; Nelson I. Wu, "Tung Ch'i-ch'ang (1555–1636): Apathy in Government and Fervor in Art," in Arthur F. Wright and Dennis C. Twichett, eds., *Confucian Personalities* (Stanford: Stanford University Press, 1962) pp. 260–293.

6

1. For information on Du Qiong see T.W. Weng, "Tu Ch'iung [Du Qiong]" in Goodrich and Fang, eds., *Dictionary of Ming Biography*, II: pp. 1321–1322; James Cahill, *Parting at the Shore: Chinese Painting of the Early and Middle Ming Dynasty, 1368–1580* (New York: Weatherhill, 1978), pp. 60 and 77–78.

2. For more information on the rise of literati painting in Suzhou during the Yuan period see Chu-tsing Li, "The Development of Painting in Soochow During the Yuan Dynasty," in *Proceedings of the International Symposium on Chinese Painting* (Taibei: National Palace Museum, 1972), pp. 483–528.

7

1. For information on the Wu school see National Palace Museum, comp., *Wupaihua jiushinian zhan [Ninety Years of Wu School Painting]* (Taibei: National Palace Museum, 1975); Anne deCoursey Clapp, *Wen Cheng-ming: The Ming Artist and Antiquity* (Ascona, Switzerland: *Artibus Asiae Supplementum* XXXIV, 1975); Richard Edwards, ed., *The Art of Wen Cheng-ming (1470–1559)* (Ann Arbor: University of Michigan Museum of Art, 1976); Marc F. Wilson and Kwan S. Wong, *Friends of Wen Cheng-ming: A View from the Crawford Collection* (New York: China Institute in America, 1974).

2. See Alice R.M. Hyland, *The Literati Vision: Sixteenth Century Wu School Painting and Calligraphy* (Memphis, Tenn.: Memphis Brooks Museum of Art, 1984), pp. 44–45, fig. 25.

3. Wu School depictions of garden retreats sometimes refer to an essay by the Northern Song historian Sima Guang (1019–1086) memorializing his garden. Herb gardens in Chinese paintings often specifically refer to Han Kang, a paragon of honesty who lived during the Eastern Han. For additional discussion see Ho, et al., *Eight Dynasties of Chinese Painting*, pp. 206–208, no. 166.

8

1. See Zhu Huiliang, *Zhao Zuo yanjiu [Research on Zhao Zuo]* (Taibei: unpublished master's thesis submitted to National Taiwan University, 1977), pl. 26.

9

1. Fang, "Li Jih-hua [Li Rihua]," in Goodrich and Fang, eds., *Dictionary of Ming Biography*, I: p. 829.

2. For information on the manual and Li Zhaoheng's ownership see National Palace Museum, comp., *Yuan si dajia [The Four Great Masters of the Yuan]* (Taibei: National Palace Museum, 1975), Chinese text p. 48, no. 210, leaf 11, and fig. 210–11. The transcription of Li's name as "Li Chao-hsiang" is incorrect (English text, p. 56); Editorial Board of the National Palace Museum and National Central Museum, comps., *Gugong shuhua lu [Catalogue of Painting and Calligraphy in the Palace Museum]* (Taibei: Zhonghua congshu weiyuanhui, 1956) vol. xia, juan 6, p. 17.

3. See Chu-tsing Li, *The Autumn Colors on the Ch'iao and Hua Mountains: A Landscape by Chao Meng-fu* (Ascona, Switzerland: *Artibus Asiae Supplementum* XXI, 1965), frontispiece and figs. 1 and 8.

4. Ibid., pp. 28–30 and 54, and note 131, p. 54.

5. Li, "The Development of Painting in Soochow During the Yuan Dynasty," p. 503 note 26, and fig. 16.

10

1. For information on Dong Qichang see Fang Chaoying, "Tung Ch'i-ch'ang [Dong Qichang]," in Hummel, ed., *Eminent Chinese of the Ch'ing Period*, II: pp. 787–789; Wu, "Tung Ch'i-ch'ang

(1555–1636): Apathy in Government and Fervor in Art" in Wright and Twichett, eds., *Confucian Personalities*; Nelson I. Wu, "The Evolution of Tung Ch'i-ch'ang's Landscape Style as Revealed by His Works in the National Palace Museum," in *Proceedings of the International Symposium on Chinese Painting*, pp. 1–51; Wai-kam Ho, "Tung Ch'i-ch'ang's New Orthodoxy and the Southern School Theory," in Christian Murck, ed., *Artists and Traditions* (Princeton: Princeton University Press, 1976); Cahill, *The Distant Mountains*, pp. 87–128; Cahill, *The Compelling Image*, pp. 36–69; Wen Fong, et al., *Images of the Mind: Selections from the Edward L. Elliott Family and John B. Elliott Collections of Chinese Calligraphy and Painting at The Art Museum, Princeton University* (Princeton: The Art Museum, Princeton University, 1984), pp. 164–212.

11

1. Tseng Yu-ho Ecke, "Calligraphy of the Seventeenth Century," in *Proceedings of the Symposium on Paintings and Calligraphy by Ming I-min*, pp. 469–474, esp. 470.

2. Dong Qichang, *Rongtai ji*, 1630, *Shi [Poetry] juan* 3, reprinted in Guoli zhongyang tushuguan [National Central Library], comp., *Mingdai yishujia ji huikan [Collected Works of Ming Artists]* (Taibei: Guoli zhongyang tushuguan, 1968) 4 volumes; the "Thirty Poems for Chen Jiru," in III, pp. 1522–1538; the four poems in this handscroll are nos. 21, 25, 27, 29, pp. 1533, 1535–1537.

12

1. For information on Chen Jiru see Chaoying Fang "Ch'en Chi-ju [Chen Jiru]," in Hummel, ed., *Eminent Chinese of the Ch'ing Period* I: pp. 83–84.

2. See Jiang Yihan, "Zhao Mengfu shu Huzhou Miaoyan si ['Record of Miaoyan Temple': A Calligraphic Handscroll by Chao Meng-fu]," *National Palace Museum Quarterly* (Taibei) X: no. 3 (Spring 1976), pp. 59–80; Fong, et al., *Images of the Mind*, pp. 284–287, no. 7.

13

1. See Editorial Committee of the Joint Board of Directors of the National Palace Museum and National Central Museum, comps., *Three Hundred Masterpieces of Chinese Painting in the Palace Museum* (Taizhong, Taiwan: National Palace Museum, 1959) I: no. 46.

14

1. For information on Zhao Zuo see Cahill, *The Distant Mountains*, pp. 68–70 and 79–82; Zhu, *Zhao Zuo yanjiu*.

2. Cahill, *The Distant Mountains*, p. 69.

3. See Zhu, *Zhao Zuo yanjiu*, pl. 7.

4. See Kurosawa Institute of Ancient Cultures, comp., *Collection of Chinese Paintings in Ming and Ch'ing Dynasties* (Ashiya, Japan: Kurosawa Institute of Ancient Cultures, 1954), pl. 6.

5. See Zhu, *Zhao Zuo yanjiu*, pl. 22.

6. See ibid., pl. 21.

15

1. For information on Xiang Shengmo see Li, "Xiang Shengmo zhi zhaoyin shihua" pp. 531–559; Chu-tsing Li, *A Thousand Peaks and Myriad Ravines: Chinese Paintings in the Charles A. Drenowatz Collection* (Ascona, Switzerland: *Artibus Asiae* Supplementum XXX, 1974), I: pp. 90–93, nos. 19 and 20; Cahill, *The Distant Mountains*, pp. 130–132 and 214–216; Liu Wei-p'ing, "Hsiang Sheng-mo [Xiang Shengmo]," in Goodrich and Fang, eds., *Dictionary of Ming Biography*, I: pp. 538–539.

2. Although traditional sources state that Xiang Shengmo's father was Xiang Dexin, Chu-tsing Li has discovered new evidence indicating that his father was actually Xiang Deda, Xiang Dexin's brother. Chu-tsing Li will present this evidence in a forthcoming article on *Venerable Friends* (no. 1) in the *Shanghai bowuguan guankan [Journal of the Shanghai Museum]*. See also Hu Yi, "Huashi xiyi erti [A Clarification of Two Points in the History of Painting]," in *Xuelin manlu* (Beijing: Zhonghua, 1985) *ji* 11: pp. 207–209.

3. See Li, "Xiang Shengmo zhi zhaoyin shihua," fig. 2.

16

1. See Sherman E. Lee and Wai-kam Ho, *Chinese Art Under the Mongols: The Yüan Dynasty (1279–1368)* (Cleveland: The Cleveland Museum of Art, 1968), no. 180.
2. See Li, "Xiang Shengmo zhi zhaoyin shihua," fig. 8.

17

1. See Li, "Xiang Shengmo zhi zhaoyin shihua," fig. 3.
2. See ibid., fig. 7.

19

1. See Li, "Xiang Shengmo zhi zhaoyin shihua," figs. 2–4.
2. See ibid., fig. 5.

20

1. Yu, *Zhongguo meishujia renming cidian*, p. 1397, Lu Dezhi.
2. For the development of bamboo painting in the Yuan see Li, "The Development of Painting in Soochow During the Yuan Dynasty," esp. pp. 490–492; Richard M. Barnhart, *Along the Border of Heaven: Sung and Yüan Paintings from the C.C. Wang Family Collection* (New York: The Metropolitan Museum of Art, 1983), pp. 128–144.
3. See Li, "The Development of Painting in Soochow During the Yuan Dynasty," fig. 3.
4. Its current ownership is uncertain as this scroll is listed under two different collections. See Suzuki Kei, comp., *Chūgoku kaiga sōgo zuroku [Comprehensive Illustrated Catalogue of Chinese Paintings]*, IV, Japanese Collections: Temples and Individuals, IV–189 (no. JP 7-017) and IV–286 (no. JP 16-013).

21

1. For information on Li Liufang see L. Carrington Goodrich and Nelson Wu, "Li Liu-fang," in Goodrich and Fang, eds., *Dictionary of Ming Biography*, I: pp. 838–839; Cahill, *The Distant Mountains*, pp. 133–135; James Cahill, ed., *Shadows of Mt. Huang: Chinese Painting and Printing of the Anhui School* (Berkeley: University Art Museum, University of California, 1981) pp. 62–66.
2. Ruo Yu, "Zhukeshi hua [A Discussion of the History of Bamboo Carving]," in *Yilin congshu* (Hong Kong: Shangwu yinshuguan Xianggang fenguan, 1973), part 8, p. 315.
3. See Cahill, *The Distant Mountains*, pp. 142–143, fig. 63.
4. Lou Jian and Li Liufang are considered two of the Four Masters of Jiading (*Jiading si xiansheng*), along with Tang Shisheng (1551–1636) and Cheng Jiasui; the designation comes from the title of a volume of their collected poetry which the local magistrate, Xie Sanbin, published in 1625. The same men, less Li Liufang, were also known as the Three Elders of Lianchuan (*Lianchuan sanlao*). Not to be slighted, Li Liufang was grouped among the Nine Friends of Painting as well as among the Three Talents (*Sancai*), together with Wang Zhijian and Gui Changshi (see cat. no. 72 A). For additional information on Li Liufang and Cheng Jiasui (cat. no. 22) and conditions in Jiading in the seventeenth century see: Jerry Dennerline, *The Chiating Loyalists: Confucian Leadership in Seventeenth Century China* (New Haven: Yale University Press, 1981).

22

1. For information on Cheng Jiasui see J.C. Yang, "Ch'eng Chia-sui [Cheng Jiasui]," in Hummel, ed., *Eminent Chinese of the Ch'ing Period*, I: pp. 113–114; Marilyn and Shen Fu, *Studies in Connoisseurship: Chinese Paintings from the Arthur M. Sackler Collection in New York and Princeton* (Princeton: The Art Museum, Princeton University, 1973), pp. 98–101, no. V; Cahill, *The Distant Mountains*, pp. 135–136; Cahill, ed., *Shadows of Mt. Huang*, pp. 62–65.
2. For an illustration of the Dong Qichang handscroll see Wu, "The Evolution of Tung Ch'i-ch'ang's Landscape Style as Revealed by His Works in the National Palace Museum," p. 29 and fig. 8. For an illustration of the Wang Shen handscroll, see National Palace Museum and National Central Museum, comps., *Three Hundred Masterpieces of Chinese Painting in the Palace Museum*, II: no. 86.

3. See National Palace Museum, comp., *Yuan si dajia*, fig. 306, and discussion in Chinese text, p. 52.
4. Ibid., Chinese text, p. 52.

23

1. A separate note accompanying the present scroll written by Gong Zhaoyun (*zi* Huaixi) in Beijing when Gong was 64 *sui*. Gong was an official in the closing years of the Qing dynasty and had served as the Chinese ambassador to London in the 1890s.
2. See Shanxisheng wenwu guanli gongzuo weiyuanhui, comp., *Yonglegong* (Beijing: Renmin meishu chubanshe, 1964), pls. 137 and 138.
3. See Lee and Ho, *Chinese Art Under the Mongols*, no. 298; James C.Y. Watt, *Chinese Jades from Han to Ch'ing* (New York: The Asia Society, 1980), p. 159, no. 131.
4. For information on Xuan paper see Tsien Tsuen-hsuin, *Paper and Printing*, V, part I, in Joseph Needham, ed., *Science and Civilisation in China* (Cambridge: Cambridge University Press, 1985), pp. 61–62 and 89–90.

24

1. Fang, "Li Jih-hua [Li Rihua]," in Goodrich and Fang, eds., *Dictionary of Ming Biography*, I: pp. 826–830.
2. For information on Chinese bookbinding see E. Martinique, *Chinese Traditional Bookbinding: A Study of Its Evolution and Techniques* (San Francisco and Taibei: Chinese Materials Center, 1983); Sören Edgren, et al., *Chinese Rare Books in American Collections* (New York: China Institute in America, 1984), pp. 16–25. For explanations and diagrams of the standard format of the Chinese woodblock-printed book page see ibid., pp. 10–15.

25

1. Shanghaishi wenwu guanli weiyuanhui daoguzu, comp., "Shanghai faxian yipi Ming Chenghua nianjian keyin di changben, chuanqi [A Group of Ming Chenghua-period Woodblock-printed *Changben* and *Chuanqi* Books Discovered in Shanghai]", *Wenwu* (Beijing), 11: (1972), p. 67.
2. For information on printing and printed books in China see Tsien, *Paper and Printing*; Edgren, et al., *Chinese Rare Books*; Thomas Francis Carter, *The Invention of Printing in China and Its Spread Westward* (New York: Columbia University Press, 1925, rev. ed. L. Carrington Goodrich, New York: Ronald Press, 1955); Wang Bomin, *Zhongguo banhua shi [A History of Chinese Woodblock Prints]* (Shanghai: Renmin meishu chubanshe, 1961); Guo Weiqu, *Zhongguo banhua shilüe [A Short History of Chinese Woodblock Prints]* (Beijing: Zhaohua meishu chubanshe, 1962).
3. Edgren et al., *Chinese Rare Books*, pp. 82, no. 19, and 84–85, no. 20.

26

1. The summary of the story recounted here has been adapted from Josephine Huang Hung, *Ming Drama* (Taibei: Heritage Press, 1966). A complete English translation of the play appears in J. Mulligan, *The Lute* (New York, 1980). The *Pipa ji* is one of the best known Chinese dramas in the West, having been translated into French, German, and English. It was performed on Broadway in 1946, with Yul Brenner as Cai Bojie and Mary Martin as Wu Niang, in a version adapted by Will Irwin and Sidney Howard in 1925.
2. Bai Juyi's "Pipa xing" was a popular theme for painting among Ming artists of the Wu School; see Ho et al., *Eight Dynasties of Chinese Painting*, pp. 201–203, no. 164, and 237, no. 185.
3. L. Carrington Goodrich, "Kao Ming [Gao Ming]" in Goodrich and Fang, eds., *Dictionary of Ming Biography*, I: pp. 699–700.
4. For information on the Huang family see Wang, *Zhongguo banhua shi*, pp. 88–91; Hiromitsu Kobayashi and Samantha Sabin, "The Great Age of Printing," in Cahill, ed., *Shadows of Mt. Huang*, pp. 25–33; Tsien, *Paper and Printing*, pp. 266–269.

27

1. A general account of Chinese ornamental letter papers is given in Tsien, *Paper and Printing*, pp. 91–96.

2. For information on Su Wu and the story of the goose carrying the letter see Herbert A. Giles, *A Chinese Biographical Dictionary* (London: Bernard Quaritch, and Shanghai and Yokohama: Kelly and Walsh, 1898), pp. 684–685, entry 1792, Su Wu.

3. Shen Zhiyu, "Ba Luoxuan biangu jian pu [A Postscript to the Wisteria Studio Album of Stationery Decorated with Ancient and Modern Designs]," *Wenwu* (Beijing), no. 7 (1964), pp. 7–9. The single-block printing technique seems to have been employed for the several colored illustrations in the *Chengshi moyuan* of 1606 (see cat. no. 75). The technique as used in the *Chengshi moyuan* is succinctly described in Cahill, ed., *Shadows of Mt. Huang*, p. 26.

4. See Wang Qingzheng, "The Arts of Ming Woodblock-printed Images and Decorated Paper Albums," in this catalogue; Edgren, et al., *Chinese Rare Books*, p. 39.

5. The *Chengshi moyuan* of 1606 includes a few color illustrations, but does not employ multiple-color prints to the same extent as the *Luoxuan biangu jian pu*.

6. Tsien, *Paper and Printing*, p. 286, note C.

7. Shen, "Ba Luoxuan biangu jian pu," pp. 7–9.

28

1. The summary of the story recounted here has been adapted from Hung, *Ming Drama*.

2. Earl Swisher, "Juan Ta-ch'eng [Ruan Dacheng]," in Hummel, ed., *Eminent Chinese of the Ch'ing Period*, I: pp. 398–399.

3. The *kunqu* form arose in Suzhou during the first half of the sixteenth century, apparently developed by Wei Liangfu and his son-in-law, Zhang Yetang, who were contemporaries, fellow townsmen, and perhaps friends of Wen Zhengming and his sons, Wen Peng and Wen Jia (see cat. nos. 7 and 72). For additional information see Hung, *Ming Drama*; Dell R. Hales, "Wei Liang-fu," in Goodrich and Fang, eds., *Dictionary of Ming Biography*, II: pp. 1462–1464.

4. Yu, *Zhongguo meishujia renming cidian*, p. 1123, Xiang Nanzhou.

29

1. For general information on Chinese ink-rubbings see Tsien, *Paper and Printing*, pp. 139–146; Robert H. vanGulik, *Chinese Pictorial Art as Viewed by the Connoisseur* (Rome: Instituto Italiano per il Medio ed Estremo Oriente, 1958, reprinted New York: Hacker Art Books, 1981), pp. 86–101.

2. According to vanGulik, "The term *wu-chin* [*wujin*] belongs to metallurgy where it stands for a mixture of about 9 parts copper and 1 part gold, which is said to have a dark, purplish lustre. Hence the term is used also with reference to the lustre of good ink" (*Chinese Pictorial Art as Viewed by the Connoisseur*, p. 87, note 1). With their white designs against a solid ground of glossy black, *wujin ta* rubbings are the most spectacular. To produce a black-gold rubbing, a very heavy, sized paper is used along with ink of superior quality. The paper is held over boiling water to soften it—without actually wetting it—then applied to the engraved stone. It is tamped with the brush in the usual manner, after which it is thoroughly inked. Since it is heavy, the paper will not tear even if virtually saturated with ink. After the rubbing has dried, it is burnished to a sheen. The technique works best if the stone surface is smooth and the design deeply engraved.

30

1. Although the *Mochitang xuantie* rubbings (cat. no. 29) are the best cut of Ming rubbings, the *Yugangzhai momiao* rubbings present the best interpretation of calligraphic styles. The *Xihongtang fashu* rubbings commissioned by Dong Qichang, however, are generally considered the very best in terms of selection of authentic texts. A rare set of the *Xihongtang* rubbings appears in the collection of the Shanghai Museum.

2. So named because of their seemingly transparent character, the cicada-wing rubbings are the most typical. A thin paper sized with a solution of alum to which a considerable quantity of glue has been added is generally used in preparing such rubbings. After affixing it to the stone and tamping it into the engraved areas, the slightly moistened paper is lightly inked. The effect is sometimes enhanced by sprinkling powdered mica on the surface.

3. Guoli zhongyang tushuguan [National Central Library] comp.,

Mingren zhuanji ziliao suoyin [*An Index of Ming Biographical Materials*] (Taibei: Guoli zhongyang tushuguan, 1965–66), I: p. 40.

31

1. The poem is composed in four-character lines in a form known as *ming*. Popularized by the Northern Song literatus Su Shi (1037–1101), the rather forced *ming* form was often used for light-hearted, amusing poetry.

2. For information on the development of alcoholic beverages in China see K.C. Chang, "Ancient China," and Frederick W. Mote, "Yüan and Ming," in K.C. Chang, ed., *Food in Chinese Culture: Anthropological and Historical Perspectives* (New Haven and London: Yale University Press, 1977), esp. pp. 30 and 202.

3. Jonathan Spence, "Ch'ing," in Chang, ed., *Food in Chinese Culture*, p. 277.

4. Mote, "Yüan and Ming," in Chang, ed., *Food in Chinese Culture*, p. 246.

32

1. K.C. Chang, "Ancient China," in Chang, ed., *Food in Chinese Culture*, p. 29; Edward H. Schafer, *The Golden Peaches of Samarkand: A Study of T'ang Exotics* (Berkeley: University of California Press, 1963), pp. 119–120.

2. For a Tang example in silver see John Alexander Pope and Thomas Lawton, *The Freer Gallery of Art* I, *China* (Tokyo: Kodansha, n.d. but ca. 1972), p. 176, no. 107. For a Song example in gold see Sotheby's, comp., *Art at Auction: The Year at Sotheby's 1985–86* (New York: Sotheby's Publications, 1986) p. 369.

3. National Palace Museum and National Central Museum, comp., *Three Hundred Masterpieces of Chinese Painting in the Palace Museum*, III: no. 128.

4. For a more complex, eighteenth-century decorative bamboo carving of two melons see Bo Gyllensvärd and John Alexander Pope, *Chinese Art from the Collection of H.M. Gustaf VI Adolf of Sweden* (New York: The Asia Society, 1966), pp. 112 and 142, no. 132.

5. Wen Zhenheng, *Zhangwu zhi* (1637, juan 7), in Deng Shi and Huang Binhong, comps., *Meishu congshu* (Taibei: Yiwen yinshuguan, photo reprint of 1947, 4th rev. ed.), XV 3/9: p. 204.

33

1. See Watt, *Chinese Jades from Han to Ch'ing*, p. 139, no. 115; Gyllensvärd and Pope, *Chinese Art From the Collection of H.M. Gustaf VI Adolf of Sweden*, pp. 106, 107, and 142, no. 125.

34

1. Wen, *Zhangwu zhi*, juan 7, p. 203.

2. For discussions of the relationship of silver, lacquer, and ceramic shapes see Robert D. Mowry, "Koryo Celadons," *Orientations* (Hong Kong), 17 no. 5 (May 1986), pp. 24–39, esp. 31–37; Jessica Rawson, "Song Silver and Its Connexions with Ceramics," *Apollo* (London), 120 no. 269 (new series) (July 1984), pp. 18–23; Jessica Rawson, *Chinese Ornament: The Lotus and the Dragon* (London: British Museum Publications, 1984).

35

1. For information on Shi Dabin see Terese Tse Bartholomew, *I-hsing Ware* (New York: China Institute in America, 1977), pp. 15 and 24.

2. Jiangsu Yixing taoci gongye gongsi, comp., *Zisha taoqi zaoxing* (Beijing: Qinggong ye chubanshe, 1978), pp. 2–3.

3. There is little question that Shi Dabin and other Yixing potters were well acquainted with Chen Jiru. In fact, The Asian Art Museum of San Francisco has a small melon-shaped teapot by Shi Dabin that bears an inscription by the artist dedicating the pot to Chen Jiru; see Bartholomew, *I-hsing Ware*, pp. 24–25, no. 2.

4. Wen, *Zhangwu zhi*, juan 12, p. 265.

36

1. J.P. Donnelly, *Blanc de Chine: The Porcelain of Tehua in Fukien*

(New York and Washington, D.C.: Praeger, 1969), pp. 105, 124, and pl. 69D.

2. See similarly shaped examples in Donnelly, *Blanc de Chine*, pls. 28–31 and 66A.

37.

1. For an example of a bronze *jiao* vessel see John Alexander Pope, Rutherford John Gettens, James Cahill, and Noel Barnard, *The Freer Chinese Bronzes* (Washington, D.C.,: Smithsonian Institution, Freer Gallery of Art, Oriental Studies no. 7, 1967), pp. 150–153, no. 26.

2. For information on Dehua ware see James C.Y. Watt, *An Exhibition of Te Hua Porcelain* (Hong Kong: Art Gallery, Institute of Chinese Studies, Chinese University of Hong Kong, 1975); Donnelly, *Blanc de Chine*.

3. Ye Wencheng and Xu Benzhang, "The Extensive International Market for Dehua Porcelain," *Chinese Translations* no. 10 (London: Oriental Ceramic Society, n.d. but ca. 1983), pp. 1–15, trans. Rose Kerr. The original, Chinese version of this article appeared in *Haiwai jiaotongshi yanjiu* (Quanzhou, Fujian, 1980), no. 1.

38

1. See diagram in Wang Shixiang and Wan-go Weng, *Bamboo Carving of China* (New York: China Institute in America, 1983), p. 50, fig. 34.

2. See ibid., p. 17, figs. 3 and 3a.

3. Donnelly, *Blanc de Chine*, p. 126.

39

1. Compare Shōsō-in jimusho, comp., *Shōsō-in no tōki* [*Ceramics in the Shōsō-in*] (Tokyo: Nihon keizai shimbunsha, 1971), pls. 83–114.

2. For a Wanli period waterpot of similar shape but with a cover see The Joint Board of Directors National Palace Museum and National Central Museum, comps., *Porcelain of the National Palace Museum: Blue-and-white Ware of the Ming Dynasty* (Hong Kong: Cafa Company, 1963), book VI, pp. 40–41, pls. 6 and 6 a–c.

3. See ibid., book V, pp. 54–55 (pls. 17 and 17 a–b).

40

1. See National Palace Museum and National Central Museum, comps., *Porcelain of the National Palace Museum: Blue-and-white Ware of the Ming Dynasty*, book VI, pp. 74–75, pls. 23 and 23 a–c.

2. See Daisy Lion-Goldschmidt, *Ming Porcelain* (New York: Rizzoli, 1978), p. 104, fig. 179.

41

1. For Chenghua period depictions of dragons paired with water but without rocks see Robert D. Mowry, *Handbook of the Mr. and Mrs. John D. Rockefeller 3rd Collection* (New York: The Asia Society, n.d. but 1981), p. 77, nos. 1979.173 and 1979.174.

2. For a Jiajing period blue-and-white ewer with dragon/rock/wave decoration, see Lion-Goldschmidt, *Ming Porcelain*, p. 142, fig. 122.

3. Fujioka Ryōichi and Hasebe Gakuji, *Min* [*Ming Dynasty*] *Sekai tōji zenshū* [*Ceramic Art of the World*] XIV (Tokyo: Shogakukan, 1976), p. 203, pl. 205; Seizo Hayashiya and Henry Trubner, *Chinese Ceramics from Japanese Collections: T'ang Through Ming Dynasties* (New York: The Asia Society, 1977), p. 106, no. 59.

42

1. See Wang Shixiang, "Moulded Gourds," *Chinese Translations* no. 10 (London: Oriental Ceramic Society, n.d. but ca. 1983), pp. 16–30, trans. Craig Clunas. The original, Chinese version of the article appeared in *Gugong bowuyuan yuankan* (Beijing) no. 1 (1979); Schuyler Cammann, "Chinese Impressed Gourds Reconsidered," *Oriental Art* (London) new series X no. 4 (Winter 1964), pp. 217–224; J.M. Addis, "Impressed Gourds," *Oriental Art* (London) new series X no. 1 (Spring 1964), pp. 17–31.

2. See Hayashiya and Trubner, *Chinese Ceramics from Japanese Collections*, p. 66, no. 26.

3. National Palace Museum and National Central Museum, comps., *Porcelain of the National Palace Museum: Blue-and-white Ware of the Ming Dynasty*, book V, pp. 28–29, pls. 4 and 4 a–d; pp. 30–31, pls. 5 and 5 a–b; and pp. 44–45, pls. 12 and 12 a–b.

4. Robert D. Mowry, "A Ming Blue-and-white Plate," *Art and Auction* (New York) 7 no. 4 (November 1984), pp. 109–111; Mowry, *Featured Masterpiece from the Mr. and Mrs. John D. Rockefeller 3rd Collection: A Fourteenth-century Chinese Porcelain Jar Decorated in Underglaze Copper Red* (New York: The Asia Society, 1984).

5. Lion-Goldschmidt, *Ming Porcelain*, p. 209, fig. 214.

43

1. See John Hay, *Kernels of Energy, Bones of Earth: The Rock in Chinese Art* (New York: China Institute in America, 1985).

2. Fang, "Li Jih-hua [Li Rihua]," in Goodrich and Fang, eds., *Dictionary of Ming Biography*, I: p. 827.

3. See Cahill, ed., *Shadows of Mt. Huang*; Cahill *The Compelling Image*, pp. 1–35.

44

1. For information on cricket-keeping in China see Berthold Laufer, *Insect-Musicians and Cricket Champions of China* (Anthropology Leaflet XXII, Chicago: Field Museum of Natural History, 1927); L.C. Arlington, "Cricket Culture in China," *The China Journal* 10 no. 3 (1929), pp. 135–142; A. deC. Sowerby, "Cricket Gourds and Culture in China," *The China Journal* 18 no. 3 (1933), pp. 157–162.

2. Herbert Franke, "Chia Ssu-tao [Jia Sidao]" in Herbert Franke, ed., *Sung Biographies* (Wiesbaden: Franz Steiner Verlag GMBH, 1976), I: p. 206.

3. See Laufer, *Insect-Musicians and Cricket Champions of China*, frontispiece opp. p. 1.

45

1. For information on Lu Zigang and carved jade hairpins see Watt, *Chinese Jades from Han to Ch'ing*, pp. 23, 24, and 200, nos. 195 and 196; Ip Yee, *Chinese Jade Carving* (Hong Kong: Urban Council and the Hong Kong Museum of Art, 1983), pp. 230 and 276, nos. 207, 208, and 251. Deng Shuping, "Lu Zigang ji qi diaoyu [Lu Zigang and His Carved Jades]," *Gugong jikan* [*National Palace Museum Quarterly*] (Taibei) 16 no. 1 (Autumn 1981), pp. 73–89.

2. See Foreign Languages Press, comp., *Historical Relics Unearthed in New China* (Beijing: Foreign Languages Press, 1972), no. 212.

3. See British Museum, comp., *Jewelery Through 7000 Years* (London: British Museum Publications, 1976), p. 169, no. 276.

46

1. Watt, *Chinese Jades from Han Ch'ing*, p. 194, no. 184.

2. See Max Loehr and Louisa G. Fitzgerald Huber, *Ancient Chinese Jades form the Grenville L. Winthrop Collection in the Fogg Art Museum, Harvard University* (Cambridge Mass.: Fogg Art Museum, 1975), pp. 327, 328, and 336, nos. 477–479 and 494.

3. See Watt, *Chinese Jades from Han to Ch'ing*, p. 202, no. 199.

47

1. See Loehr and Huber, *Ancient Chinese Jades*, pp. 315–326, nos. 462–476; 376–377, nos. 539 and 540; and 395–396, nos. 572–573.

2. Watt, *Chinese Jades from Han to Ch'ing*, p. 194, no. 185.

3. Wen, *Zhangwu zhi*, juan 7, pp. 208–209.

4. Guoli zhongyang tushuguan, comp., *Mingren zhuanji ziliao suoyin*, II: p. 775.

48

1. Watt, *Chinese Jades from Han to Ch'ing*, p. 192, no. 181; James C.Y. Watt et al., *Selections of Chinese Art from Private Collections* (New York: China Institute in America, 1986), p. 54, no. 17.

49

1. Robert D. Mowry, "Chinese Jades from Han to Qing," *Archaeology* (New York) 34 no. 1 (January–February 1981), pp. 52–55.
2. See Heilongjiang sheng wenwu daogu gongzuodui, "Heilongjiang pan Suibin Zhongxing gucheng he Jindai muxun [The Old City of Zhongxing, Suibin County, Heilongjiang, and a group of Jin Dynasty Tombs]," *Wenwu* (Beijing) no. 4 (1977), pp. 40–49, esp. pl. 7, fig. 3.
3. Compare Mikami Tsuguo, *Ryō Kin Gen [Liao, Jin, and Yüan Dynasties]* XIII in *Sekai tōji zenshū* (Tokyo: Shogakukan, 1981), p. 71, pl. 56.
4. See Shanghai bowuguan, "Shanghai Pudong Ming Lushi mu jishu," *Kaogu* (Beijing) no. 6 (1985), pp. 540–549, illustration p. 54, pl. I, fig. 6.
5. See Watt, *Chinese Jades from Han to Ch'ing*, p. 102, no. 89; René-Yvon Lefebvre d'Argencé, *Chinese Jades in the Avery Brundage Collection* (San Francisco: The deYoung Museum Society and Patrons of Art and Music for the Center of Asian Art and Culture, 1972), pp. 28–29, pl. VII.

50

1. See Watt, *Chinese Jades from Han to Ch'ing*, pp. 211–213, nos. 212–214.

51

1. See Max Loehr, "The Emergence and Decline of the Eastern Chou Decor of Plastic Curls," in Loehr and Huber, *Ancient Chinese Jades*, pp. 21–28; see also Loehr and Huber, ibid., pp. 236–237, no. 351 and ff.
2. See Loehr and Huber, *Ancient Chinese Jades*, pp. 352–353, no. 521 and pp. 362–363, no. 526, and ff.

52

1. Watt, *Chinese Jades from Han to Ch'ing*, pp. 19 and 42, no. 11.
2. Mowry, "Chinese Jades from Han to Qing," pp. 52–55.
3. For information on staining see Watt, *Chinese Jades from Han to Ch'ing*, pp. 28–29.

53

1. See Li, *A Thousand Peaks and Myriad Ravines*, II: pls. VII–IX, fig. 5.
2. Ibid., I: pp. 22–25, no. 3.
3. See Paul Moss, *The Literati Mode: Chinese Scholar Paintings, Calligraphy and Desk Objects* (London: Sydney L. Moss, 1986), pp. 204–205, no. 83.
4. Watt, *Chinese Jades from Han to Ch'ing*, pp. 28–29.

54

1. Watt, *Chinese Jades from Han to Ch'ing*, p. 67, no. 49.

55

1. For information on bamboo carving see Wang and Weng, *Bamboo Carving of China*; Ip Yee and Laurence C.S. Tam, *Chinese Bamboo Carving*, 2 vols (Hong Kong: The Urban Council and the Hong Kong Musuem of Art, I, 1978, II, 1982); Jin Xijia and Wang Shixiang, *Zhuke yishu [The Art of Bamboo Carving]* (Beijing: Renmin meishu chubanshe, 1980).
2. Few works by the Three Zhus are extant; one of the rare treasures of the Shanghai Museum is an aromatics container by Zhu Ying excavated in 1966 from the same Wanli tomb that yielded the 14 scholar's accoutrements (cat. no. 69). See d'Argencé, ed., *Treasures from the Shanghai Museum*, pp. 117 and 173, no. 119.
3. Yee and Tam, *Chinese Bamboo Carving*, I: pp. 132–133, no. 3.
4. See Wang and Weng, *Bamboo Carving of China*, pp. 60–61, figs. 47, 47a, and 48.
5. For information on these two pieces see note 2 above and Yee and Tam, *Chinese Bamboo Carving*, I: pp. 190–191, no. 31.

56

1. See Wang and Weng, *Bamboo Carving of China*, p. 19, figs. 5 and 5 a–b.
2. See examples in Wang and Weng, *Bamboo Carving of China*, pp. 66–67, no. 5; Yee and Tam, *Chinese Bamboo Carving*, I: pp. 140–153, nos. 7–13; 156–157, no. 13; and 256–257, no. 62; Watt, *Chinese Jades from Han to Ch'ing*, p. 131, no. 108.
3. See Yee and Tam, *Chinese Bamboo Carving*, I: pp. 256–257, no. 62.
4. Zhou Hao studied painting under the early Qing master Wang Hui (1632–1717). For information on Zhou Hao see Yu, *Zhongguo meishujia renming cidian*, p. 504; Wang and Weng, *Bamboo Carving of China*, pp. 32 and 98–99.
5. See diagram in Wang and Weng, *Bamboo Carving of China*, p. 50, fig. 34.

57

1. See Museum of Fine Arts, comp., *Asiatic Art in the Museum of Fine Arts* (Boston: Museum of Fine Arts, 1982), p. 143, no. 134. The Freer Gallery brushpots are illustrated in Wang and Weng, *Bamboo Carving of China*, pp. 57, fig. 43, and 76, no. 16.
2. For examples of lacquer and jade pieces see James C.Y. Watt, *The Sumptuous Basket: Chinese Lacquer with Basketry Panels* (New York: China Institute in America, 1985), pp. 50–51, no. 11; Watt, *Chinese Jades from Han to Ch'ing*, p. 130, no. 107.

58

1. For information on Dongfang Shuo see Burton Watson, *Courtier and Commoner in Ancient China: Selections from the "History of the Former Han" by Pan Ku* (New York and London: Columbia University Press, 1974); Giles, *A Chinese Biographical Dictionary*, pp. 792–793, entry 2093, Tung-fang So.
2. See Cahill, ed., *Shadows of Mt. Huang*, p. 88, no. 29; Edgren et al., *Chinese Rare Books in American Collections*, p. 34, fig. 19.
3. See Wang and Weng, *Bamboo Carving of China*, pp. 55, fig. 41, and 84–85, figs. 51 and 51a.

59

1. See Pope and Lawton, *The Freer Gallery of Art* I, *China*, p. 158, no. 41 and pl. 41.
2. For information on Feng Xilu see Yang Boda, "Yuan Ming Qing gongyi meishu zongxu [A General Introduction to Yuan, Ming, and Qing Handicrafts]," *Gugong bowuyuan yuankan* (Beijing) no. 4 (1984), p. 12; Wang and Weng, *Bamboo Carving of China*, p. 30, fig. 15.
3. See Wang and Weng, *Bamboo Carving of China*, p. 30, fig. 15.

60

1. See Watt, *Chinese Jades from Han to Ch'ing*, pp. 78–79, no. 61, and 134–135, no. 111.
2. Tseng Yu-ho, "A Report on Ch'en Hung-shou," *Archives of the Chinese Art Society of America* (New York) 13 (1959), pp. 75–88.

61

1. See Soame Jenyns, "The Chinese Rhinoceros and Chinese Carvings in Rhinoceros Horn," *Transactions of the Oriental Ceramic Society* (London) 29 (1954–1955), pp. 31–62, pls. 15 A and C).
2. See Jenyns, "The Chinese Rhinoceros," pls. 17 B–D, and 18 B; Sheila Riddell, *Dated Chinese Antiquities, 600–1650* (London and Boston: Faber and Faber, 1979), p. 244, fig. 193.
3. Sir Percival David, ed. and trans., *Chinese Connoisseurship: The Ko Ku Yao Lun, The Essential Criteria of Antiquities* (New York and Washington, D.C.: Praeger, 1971), pp. 124–125.
4. Wen, *Zhangwu zhi, juan* 7, p. 224.
5. For information on You Kan see Jenyns, "The Chinese Rhinoceros," p. 57, note 101; Ip Yee, "Notes on a Collection of Chinese Rhinoceros Horn Carvings," *International Asian Antiques Fair Catalogue* (Hong Kong: Andamans East International Ltd., 1982).
6. See Watt, *Chinese Jades from Han to Ch'ing*, pp. 154–155, no. 127.

62

1. For a Han gilt-bronze example see Mowry, *Handbook of the Mr. and Mrs. John D. Rockefeller 3rd Collection*, p. 52, no. 1979.107. For a Song ceramic example see Hasebe Gakuji, *Sō* [Sung Dynasty] XII in *Sekai tōji zenshū* (Tokyo: Shogakukan, 1977), pp. 71–72, no. 62. For decorated Yuan ceramic examples see Riddell, *Dated Chinese Antiquities*, p. 37, fig. 7, dated to 1303; Mikami, *Ryō Kin Gen* [Liao, Jin, and Yuan Dynasties], pp. 42, no. 30, and 182, no. 151.

2. See Feng Hsien-ming, "Problems Concerning the Development of Chinese Porcelain," *Chinese Translations* no. 8 (London: The Victoria and Albert Museum in association with The Oriental Ceramic Society, 1978), fig. 4, trans. Katherine Tsiang. The original, Chinese version of this article appeared in *Wenwu* (Beijing) no. 7 (1973), pp. 20–27 and 14.

3. Hu Wenming's dated works range from 1583 through 1613, but a recorded remark by the sixteenth-century connoisseur Xiang Yuanbian indicates that Hu's censers must have been well known already by 1573. For information on Hu Wenming and Hu Guangyu see Aschwin Lippe, "Two Archaistic Bronzes of the Ming Dynasty," *Archives of the Chinese Art Society of America* 11 (1957), pp. 78–79; Gerard Tsang and Hugh Moss, "Chinese Metalwork of the Hu Wenming Group," *International Asian Antiques Fair Catalogue*. (Hong Kong: Andamans East International Ltd., 1984).

4. See Tsang and Moss, "Chinese Metalwork of the Hu Wenming Group," nos. 43 and 44.

5. Paul Moss, *The Literati Mode*, p. 290, no. 144.

6. See Sir Harry Garner, *Chinese Lacquer* (London and Boston: Faber and Faber, 1979), pp. 132, fig. 68, and 133, fig. 71.

7. Wen, *Zhangwu zhi*, juan 10, p. 241.

8. Tu Long, *Xiangjian* [Treatise on Incense] (n.d. but late 16th century), in Deng Shi and Huang Binhong, comps., *Meishu congshu* (photo-reprint of the 1947, 4th rev. ed.), X 2/9: pp. 159–160.

63

1. For information on the *touhu* game and its vessels see Robert Poor, "Evolution of a Secular Vessel Type," *Oriental Art* (London) new series 14 no. 2 (Summer 1968), pp. 98–106; G. Montell, "T'ou-hu: The Ancient Chinese Pitch-pot Game," *Ethnos* 5 (1940).

2. Ch'u Chai and Winberg Chai, eds., *Li Chi: Book of Rites* (New Hyde Park, N.Y.: University Books, 1967), II: pp. 397–401, trans. James Legge.

3. See Poor, "Evolution of a Secular Vessel Type," pp. 99, fig. 1, and 100, fig. 3.

4. See Thomas Lawton, *Chinese Figure Painting* (Washington, D.C.: Smithsonian Institution, 1973), pp. 34–37, no. 3; Bradley Smith and Wan-go Weng, *China: A History in Art* (New York: Doubleday, n.d. but ca. 1972), pp. 212–213.

5. See Ryoichi Hayashi, *The Silk Road and the Shōsō-in*, The Heibonsha Survey of Japanese Art VI (New York and Tokyo: Weatherhill/Heibonsha, 1966 and 1975), p. 160, fig. 188, trans. Robert Ricketts.

6. See Poor, "Evolution of a Secular Vessel Type," p. 100, fig. 4.

64

1. See Thomas Lawton, *Chinese Art of the Warring States Period: Change and Continuity, 480–222 B.C.* (Washington, D.C.: Smithsonian Institution, Freer Gallery of Art, 1982), pp. 77–79, nos. 35 and 36.

2. S. Howard Hansford, *The Seligman Collection of Oriental Art* I, *Chinese, Central Asian and Luristan Bronzes and Chinese Jades and Sculptures* (London: The Arts Council of Great Britain and Lund Humphries, 1957), p. 89, no. A.87, and pl. XLIII, fig. A 87.

65

1. For discussion of these small animal shapes in Chinese jades see Watt, *Chinese Jades from Han to Ch'ing*, pp. 59–60, nos. 36 and 38; Mowry, "Chinese Jades from Han to Qing."

2. Wen, *Zhangwu zhi*, juan 7, p. 205.

66

1. See National Palace Museum and National Central Museum, comps., *Three Hundred Masterpieces of Chinese Painting in the Palace Museum*, III: no. 108.

2. Translation adapted from Arthur Waley, *The Way and Its Power: A Study of the Tao Te Ching and Its Place in Chinese Thought* (Boston and New York: Houghton Mifflin, 1935), p. 195.

3. Translation adapted from Richard Wilhelm, trans., *The I Ching or Book of Changes* (New York: Bollingen Foundation and Pantheon Books, Bollingen Series XIX, 1950), I: p. 342. Wilhelm's German version translated into English by Cary F. Baynes.

4. Bernard Karlgren, "Grammata Serica, Script and Phonetics in Chinese and Sino-Japanese," *Bulletin of the Museum of Far Eastern Antiquities* (Stockholm) no. 12 (1940), pp. 124–125, 2u, and 356–357, 873 a–d.

67

1. Wen, *Zhangwu zhi*, juan 7, p. 210.

2. J. LeRoy Davidson, "The Origin and Early Use of the *Ju-i*," *Artibus Asiae* (Ascona, Switzerland) 13 no. 4 (1950), pp. 239–249, esp. 247.

3. See James C.Y. Watt, "The Qin and the Chinese Literati," *Orientations* (Hong Kong) 12 no. 11 (November 1981), pp. 38–49, illustration top 42 and 43.

4. J. LeRoy Davidson, *The Lotus Sutra in Chinese Art: A Study in Buddhist Art to the Year 1000* (New Haven: Yale University Press, 1954), pp. 32–39.

5. See Museum of Fine Arts, comp., *Asiatic Art in the Museum of Fine Arts*, p. 116, no. 106.

6. See Riddell, *Dated Chinese Antiquities*, p. 148, fig. 137; Moss, *The Literati Mode*, pp. 300–301, no. 152; R. Soame Jenyns and William Watson, *Chinese Art: The Minor Arts—Gold, Silver, Bronze, Cloisonné, Cantonese Enamel, Lacquer, Furniture, Wood* (New York: Universe Books, 1963), pp. 92–93 and 152–153, no. 70.

68

1. For information on the iron-picture tradition see Yao Wengwang, "Tang Tianchi he Liang Yingda di tiehua [Iron Pictures by Tang Tianchi and Liang Yingda]," *Wenwu cankao ziliao* (Beijing) no. 3 (1957), pp. 22–24; Jenyns and Watson, *Chinese Art: The Minor Arts*, pp. 93 and 156–157.

2. Yao, "Tang Tianchi he Liang Yingda di tiehua," p. 23.

3. There is some confusion concerning Liang's dates and given name. Yao Wengwang asserts that Liang's name was Yingda and that Yingfeng is a textual error. Yu Jianhua (*Zhongguo meishujia renming cidian*, p. 913) states that his name is Yingfeng but lists Yingda as an alternate rendering. Yao Wengwang suggests that Tang Peng was most likely active in the Shunzhi (1644–1661) and early Kangxi (1662–1722) periods but that Liang was probably not born until after 1690.

69

1. See Watt, *Chinese Jades from Han to Ch'ing*, p. 143, no. 119.

2. Wen, *Zhangwu zhi*, juan 7, pp. 205–206.

3. The similarity in style to the bamboo carving by Zhu Ying suggests that this jade plaque was new at the time it was buried. See d'Argencé, ed., *Treasures from the Shanghai Museum*, p. 117, figs. 119 a–b.

4. See Smith and Weng, *China: A History in Art*, illustration bottom p. 213.

5. Wen, *Zhangwu zhi*, juan 7, pp. 201–202.

6. See Wang and Weng, *Bamboo Carving of China*, p. 66, no. 4; Yee and Tam, *Chinese Bamboo Carving*, pp. 170–173, nos. 22 and 23.

7. Wen, *Zhangwu zhi*, juan 7, p. 202.

70

1. For information on seals see vanGulik, *Chinese Pictorial Art as Viewed by the Connoisseur*, pp. 417–457; Qian Juntao and Ye Luyuan, "Hui-Zhe liangpai di zhuanke [Two Schools of Seal-Carving:

Anhui and Zhejiang]," *Yilin congshu* (Hong Kong: Shangwu yinshuguan Xianggang fenguan, 1964), IV: pp. 256–262.

72

1. For a Han seal with a calligraphic style of the type that could have inspired this one see Xianggang zhongwen daxue [The Chinese University of Hong Kong], comp., *Xianggang zhongwen daxue wenwuguan cang yin ji* [*A Collection of Seals in the Art Gallery of the Chinese University of Hong Kong*] (Hong Kong: Chinese University of Hong Kong, 1980), p. 14.

73

1. For information on inkstones see Robert H. vanGulik, *Mi Fu on Ink Stones: Translated from the Chinese with an Introduction and Notes* (Beijing: Henri Vetch, 1938); Liu Yanliang, *Duanxi mingyan* [*Duanxi Inkstones*] (Guangzhou: Guangdong renmin chubanshe, 1979); Mu Xiaotian, ed., *Zhongguo wenfang sibao shi* [*A History of the Four Treasures of the Chinese Scholar's Studio*] (Hong Kong: Nantong tushu gongsi, rev. ed., n.d.); Ye Qiu, "Kandan yanshi ziliao shuoming [An Explanation of Materials on the History of Inkstones]," *Wenwu* (Beijing) no. 1 (1964), pp. 49–52.
2. Wen, *Zhangwu zhi, juan* 7, p. 219.

75

1. For information on Chinese ink see Wang Chi-chen, "Notes on Chinese Ink," *Metropolitan Museum Studies* (New York: The Metropolitan Museum of Art) III part 1 (1930), pp. 114–133; Tsien, *Paper and Printing*, pp. 233–252; Sung Ying-hsing, *T'ien-kung K'ai-wu: Chinese Technology in the Seventeenth Century* (University Park and London: The Pennsylvania State University Press, 1966), pp. 285–288, trans. E-tu Zen Sun and Shiou-chuan Sun; Mu, ed., *Zhongguo wenfang sibao shi*, pp. 14–34.
2. See Chang Bide, *Mingdai banhua xuan chuji* [*A Selection of Ming Dynasty Prints, First Collection*] (Taibei: Guoli zhongyang tushuguan, 1969), I: p. 48.
3. For information on Cheng Junfang see K.T. Wu, "Ch'eng Ta-yüeh [Cheng Dayue]," in Goodrich and Fang, eds., *Dictionary of Ming Biography*, I: pp. 212–215; Wang, "Notes on Chinese Ink"; Edgren et al., *Chinese Rare Books*, pp. 104–105, no. 30.
4. Watt, *The Sumptuous Basket*, pp. 48–49, no. 10.

76

1. Translation from Hans H. Frankel, "Poems about the Flowering Plum," in Maggie Bickford et al., *Bones of Jade, Soul of Ice: The Flowering Plum in Chinese Art* (New Haven: Yale University Art Gallery, 1985), pp. 152–153.
2. For information on Fang Yulu see K.T. Wu, "Fang Yü-lu," in Goodrich and Fang, eds., *Dictionary of Ming Biography*, I: pp. 438–439; Wang, "Notes on Chinese Ink"; Edgren et al., *Chinese Rare Books*, pp. 102–103, no. 29.

77

1. For information on Wang Hongjian see Mu Xiaotian and Li Minghui, *Zhongguo Anhui wenfang sibao* [*The Four Treasures of the Scholar's Studio in Anhui, China*] (Hefei: Anhui kexue jishu chubanshe, 1982), p. 77.
2. See Cahill, ed., *Shadows of Mt. Huang*, p. 29, fig. 2a.

78

1. For Han and Tang examples see Garner, *Chinese Lacquer*, pp. 47–48, figs. 16–18.
2. See Watt, *The Sumptuous Basket*.
3. For an illustration of the Cleveland Museum brush see Wang and Weng, *Bamboo Carving of China*, p. 63, no. 1. For the Jiajing-period brush, see Tsien, *Paper and Printing*, p. 235, fig. 1161.

79

1. For information on the *qin* see Robert H. vanGulik, *The Lore of the Chinese Lute: An Essay in Ch'in Ideology* (Tokyo: Sophia University, 1940, *Monumenta Nipponica Monographs* III; 2nd ed. Tokyo: Sophia University and Tuttle, 1969); Watt, "The Qin and the Chinese Literati."
2. See Watt, "The Qin and the Chinese Literati," illustration p. 43.

80

1. See Shōsō-in jimusho, comp., *Shōsō-in no gakki* [*Musical Instruments in the Shōshō-in*] (Tokyo: Nihon keizai shimbunsha, 1967), pp. 78–80 and pls. 66–92.

81

1. Edgren et al., *Chinese Rare Books*, pp. 28–29.
2. Tsien, *Paper and Printing*, p. 140.

82

1. Chang, "Ancient China," in Chang, ed., *Food in Chinese Culture*, p. 30.
2. See Lawton, *Chinese Figure Painting*, pp. 190–191, no. 48.
3. Wen, *Zhangwu zhi, juan* 7, pp. 211–212.
4. David, *Chinese Connoisseurship*, p. 13, for Chinese text, see pp. 338, 7b.

85

1. Chang, "Ancient China," in Chang, ed., *Food in Chinese Culture*, p. 34.
2. David, *Chinese Connoisseurship*, p. 12, for Chinese text, see pp. 338, 7a.
3. See Watt, "The Qin and the Chinese Literati," illustration pp. 48–49.

86

1. Desmond Gure, "An Early Jade Animal Vessel and Some Parallels," *Transactions of the Oriental Ceramic Society* (London) 31 (1957–59), p. 77. Writing in 1637, Wen Zhenheng comments that his contemporaries used a variety of antique, animal-shaped bronzes—including small lamps—as water droppers and that connoisseurs were aware that many were not originally designed as such. See Wen, *Zhangwu zhi, juan* 7, p. 204.
2. For an Eastern Han example see Wang Zhongshu, *Han Civilization* (New Haven and London: Yale University Press, 1982), p. 116, fig. 137, trans. K.C. Chang and collaborators. For a third-century example see Osaka shiritsu bijutsukan [Osaka Municipal Museum], comp., *Rokuchō no bijutsu* [*Arts of the Six Dynasties*] (Tokyo: Heibonsha, 1976), p. 292, no. 159.
3. Mowry, *Handbook of the Mr. and Mrs. John D. Rockefeller 3rd Collection*, p. 53, no. 1979.111.
4. Jenyns and Watson, *Chinese Art: The Minor Arts*, pp. 138–139, no. 61.
5. See Loehr and Huber, *Ancient Chinese Jades*, pp. 354–357, no. 522; Lawton, *Chinese Art of the Warring States Period*, pp. 155, no. 102, and 181–183, nos. 134–135.

87

1. See Wang, *Han Civilization*, pp. 209 and 224–225, figs. 306–307.
2. Xianggang zhongwen daxue, comp., *Xianggang zhongwen daxue wenwuguan cang yin ji*.
3. Tsien, *Paper and Printing*, p. 137.

88

1. Shanghai bowuguan, Shen Lingxin, and Xu Yongxian, "Shanghaishi Qingpu xian Yuandai Renshi muzang jishu [The Yuan-period Ren Family Tombs in Qingpu xian, Shanghai]," *Wenwu* (Beijing) no. 7 (1982), pp. 54–59 and pls. IV and V. For recent scholarship on *guan* and *ge* wares see Zhou Ren and Zhang Fukang, "Guanyu chuanshi 'Song geyao' shaozao didian di chubu yanjiu [Preliminary Research on the Place of Manufacture of Heirloom 'Song *Ge* Ware' Pieces] *Wenwu* (Beijing) no. 6 (1964), pp. 8–13; Li Zhiyan, "Cong Longquanyao di diaocha he fajue tan geyao wenti [A Discussion of *Ge* Ware Based on the Investigation and Excavation of the Longquan Kilns]," *Zhongguo lishi bowuguan guankan* (Beijing, 1981), pp. 104–109; Feng Xianming, "'Geyao' wenti zhiyi [Problems of '*Ge* Ware']," *Gugong bowuyuan yuankan* (Beijing) no. 3 (1981), pp. 33–35; Wang Qingzheng, "Guan, ge liangyao ruogan wenti di tansuo [Difficult Problems Concerning *Guan* and *Ge* Wares]," in Zhongguo kaogu xuehui, ed., *Di san ci nianhui lunwen ji* (Beijing: Wenwu chubanshe, 1981), pp. 182–188.
2. Wen, *Zhangwu zhi, juan* 7, p. 212.
3. See Basil Gray, *Sung Porcelain and Stoneware* (London: Faber and Faber, 1984), p. 87, pl. 66.

89

1. See Mary Tregear, *Catalogue of Chinese Greenware* (Oxford: Oxford University Press at the Clarendon Press, 1976), nos. 177, 233, 245, and 249.
2. For a Ding example see Sotheby's comp., *Important Chinese Ceramics and Works of Art: The Collection of Mr. and Mrs. Eugene Bernat*, catalogue of an auction held November 7, 1980 (New York: Sotheby Parke Bernet, 1980), lot 91. For a Longquan example see Margaret Medley, *Illustrated Catalogue of Celadon Wares* (London: University of London Percival David Foundation of Chinese Art, 1977), p. 17, no. 35 and pl. IV, no. 35. For a *guan* example see Gray, *Sung Porcelain and Stoneware*, p. 142, pl. 113.

3. A Xuande marked *ge* dish is in the Palace Museum, Taibei, and other Chenghua marked *ge* examples are in the Palace Museum, Beijing, the Palace Museum, Taibei, and the Shanghai Museum. For the Taibei examples see National Palace Museum, comp., *Porcelain of the National Palace Museum: Monochrome Ware of the Ming Dynasty*, book I (Hong Kong: Cafa Company, 1968), pp. 77, pls. 16 and 16a, and 82, pls. 3 and 3a.

90

1. Wen, *Zhangwu zhi, juan* 7, pp. 198–199.
2. See Garner, *Chinese Lacquer*, pp. 83, fig. 30; pp. 107–109, figs. 43–45; and p. 112, fig. 48.
3. Sekino Takeshi, Hayashi Minao, and Hasebe Gakuji, *Shanhai hakubutsukan shutsudo bumbutsu seidōki tōjiki* [*The Shanghai Museum: Excavated Cultural Relics, Bronzes, and Ceramics*] (Tokyo: Heibonsha, 1976), no. 26; Wen, *Zhangwu zhi, juan* 2, pp. 142 and 144.
4. See discussion in Garner, *Chinese Lacquer*, pp. 95 and 98.
5. Shanghaishi wenwu baoguan weiyuanhui [Committee for the Preservation of Cultural Properties of the Municipality of Shanghai], comp., "Shanghai shijiao Ming mu qingli jianbao [Brief Report on the Excavation of a Ming Tomb in the Suburbs of Shanghai]," *Kaogu* (Beijing) no. 11 (1963), pp. 620–622.
6. See National Palace Museum, comp., *Masterworks of Chinese Carved Lacquer Ware in the National Palace Museum* (Taibei: National Palace Museum, 1971), pl. 18.

91

1. Wen, *Zhangwu zhi, juan* 7, p. 215.
2. Shanghaishi wenwu baoguan weiyuanhui, comp., "Shanghai shijiao Mingmu qingli jianbao [Brief Report on the Excavation of a Ming Tomb in the Suburbs of Shanghai]." This fan is illustrated in pl. 7, fig. 7. Two of the three other fans from the same tomb are also illustrated in pl. 7, figs. 1 and 2.

Bibliography

Contag, Victoria. *Chinese Masters of the Seventeenth Century.* Rutland, Vt. and Tokyo: Charles Tuttle, 1969.

A

Addis, J.M. "Impressed Gourds." *Oriental Art* (London) new series 10, no. 1, Spring 1964, pp. 17–31.

Aiura, Shizui. *Take no fudezutsu* [*Bamboo Brushpots*]. Tokyo: Mokujisha, 1980.

d'Argencé, René-Yvon Lefebvre, ed. *Treasures from the Shanghai Museum: 6,000 Years of Chinese Art.* San Francisco: Asian Art Museum of San Francisco, 1983.

Arlington, L.C. "Cricket Culture in China." *The China Journal* 10, no. 3, 1929, pp. 135–142.

B

Bartholomew, Terese Tse. *I-hsing Ware.* New York: China Institute in America, 1977.

deBary, William Theodore, ed. *Self and Society in Ming Thought.* New York: Columbia University Press, 1970.

Bush, Susan. *The Chinese Literati on Painting: Su Shih (1037–1101) to Tung Ch'i-ch'ang (1555–1636).* Cambridge, Mass.: Harvard University Press, 1971.

Bush, Susan, and Christian Murck, eds. *Theories of the Arts in China.* Princeton: Princeton University Press, 1983.

C

Cahill, James. *The Compelling Image: Nature and Style in Seventeenth-Century Painting.* Cambridge, Mass.: Harvard University Press, 1982.

———. *The Distant Mountains: Chinese Painting of the Late Ming Dynasty, 1570–1644.* New York: Weatherhill, 1982.

———. *Fantastics and Eccentrics in Chinese Painting.* New York: The Asia Society, 1967.

———, ed. *The Restless Landscape: Chinese Painting of the Late Ming Period.* Berkeley: University Art Museum, University of California, 1971.

———, ed. *Shadows of Mt. Huang: Chinese Painting and Printing of the Anhui School.* Berkeley: University Art Museum, University of California, 1981.

Cammann, Schuyler. "Chinese Impressed Gourds Reconsidered." *Oriental Art* (London) new series 10, no. 4, Winter 1964, pp. 217–224.

Chen Jiru. *Chen Meigong shizhong,* 1630s. Reprint, Taibei: Guangwen Book Co., 1968.

———. *Nigulu,* ca. 1635. In Deng Shi and Huang Binhong, comps., *Meishu congshu,* 1912–36, V:1/10.

———. *Shuhua jintang,* 1600s. In Deng Shi and Huang Binhong, comps., *Meishu congshu,* 1912–36, V:1/10.

———. *Shuhua shi,* 1600s. In Deng Shi and Huang Binhong, comps., *Meishu congshu,* 1912–36, V:1/10.

Chen Shiqi. "Mingdai gongjiang zhidu [On the Administration System Relating to Artisans in the Ming Period]." *Lishi yanjiu* 6, 1955.

Chen Yinke. *Liu Rushi biezhuan,* 3 vols. Shanghai: Guji chubanshe, 1980.

Cheng Benli. *Xunyin wenji* (*Zuili yishu* edition).

Clapp, Anne deCoursey. *Wen Cheng-ming: The Ming Artist and Antiquity.* Ascona, Switzerland: *Artibus Asiae* Supplementum XXXIV, 1975.

D

Deng Shi and Huang Binhong, comps. *Meishu congshu.* Shanghai: Shenzhou guoguangshe, 1912–36. Also Taibei: Yiwen yinshuguan, photo-reprint of 1947, 4th rev. ed.

Deng Shuping. "Lu Zigang ji qi diaoyu [Lu Zigang and His Carved Jades]." *Gugong jikan* (Taibei) 16, no. 1, Autumn 1981, pp. 73–89.

Dennerline, Jerry. *The Chia-ting Loyalists: Confucian Leadership in Seventeenth Century China.* New Haven: Yale University Press, 1981.

Ding Yaokang. *Chu jie jilüe.* In *Mingshi ziliao congkan,* II, Yangzhou, 1982.

Dong Qichang. *Huachanshi suibi,* 1720. In Dong Qichang, *Rongtai ji.*

———. *Huayan,* 1630s. In Deng Shi and Huang Binhong, comps., *Meishu congshu,* 1912–36, 1/3.

———. *Huazhi,* 1630s. In Dong Qichang, *Rongtai ji.*

———. *Rongtai ji,* 1630. Facsimile reprint by Taibei: National Central Library, 1968, 4 volumes.

———. *Rongtai bieji,* 1630s. Volume IV in Dong Qichang, *Rongtai ji,* 1968.

Du Naiji. *Mingdai neige zhidu.* Taibei, 1961.

E

Ecke, Tseng Yu-ho. "Calligraphy of the Seventeenth Century." In *Proceedings of the Symposium on Painting and Calligraphy by Ming I-min,* 1976.

Edgren, Sören, et al. *Chinese Rare Books in American Collections.* New York: China Institute in America, 1984.

Edwards, Richard, ed. *The Art of Wen Cheng-ming (1470–1559).* Ann Arbor: Museum of Art, University of Michigan, 1976.

F

Fan Lian. *Yunjian jumuchao,* 1590s. In *Biji xiaoshuo daguan,* early 20th century lithograph edition, Yangzhou: Jiangsu guangling guji keyinshe reprint, 1983, VI.

Feng Mengzhen. *Kuaixuetang ji.* (Wanli edition, 1616).

Fong, Wen, et al. *Images of the Mind: Selections from the Edward L. Elliott Family and John B. Elliott Collections of Chinese Calligraphy and Painting at the Art Museum, Princeton University.* Princeton: The Art Museum, Princeton University, 1984.

Fu, Marilyn, and Shen Fu. *Studies in Connoisseurship: Chinese Paintings from the Arthur M. Sackler Collection in New York and Princeton.* Princeton: The Art Museum, Princeton University, 1973.

Fu Yiling. *Mingdai Jiangnan shimin jingji shitan* [*An Investigation into the Economy of the Urban Population of Jiangnan in the Ming Period*]. Shanghai: Renmin chubanshe, 1963.

Fu Yunzi. *Baichuan ji.* Reprint, Taibei, 1979.

Fujioka Ryoichi and Hasebe Gakuji. *Min* [*Ming Dynasty*]. Volume 14 in *Sekai tōji zenshū* [*Ceramic Art of the World*] Tokyo: Shogakukan, 1976.

G

Garner, Sir Harry. *Chinese Lacquer.* London and Boston: Faber and Faber, 1979.

Goodrich, L. Carrington, and Chaoying Fang, eds. *Dictionary of Ming Biography, 1368–1644,* 2 vols. New York and London: Columbia University Press, 1976.

Greenblatt, Kristin Yü. "Chu-hung and Lay Buddhism in the Late Ming." In William Theodore deBary, ed., *The Unfolding of Neo-Confucianism,* New York: Columbia University Press, 1975.

Gui Youguang. *Zhenchuan xiansheng wenji (Sibu congkan* edition). Reprinted in Sichuan shifan xueyuan, ed. *Zhongguo lidai wenxuan,* II, Beijing, 1980.

Gui Zhuang. *Gui Zhuang ji.* Reprint, Beijing, 1961.

vanGulik, Robert H. *The Lore of the Chinese Lute: An Essay in Ch'in Ideology.* Tokyo: Sophia University, *Monumenta Nipponica* Monographs III, 1940; 2nd ed. Tokyo: Sophia University and Charles Tuttle, 1969.

H

Ho, Wai-kam. "Nan-Ch'en Pei-Ts'ui: Ch'en of the South and Ts'ui of the North." *The Bulletin of the Cleveland Museum of Art* 49, January 1962, pp. 2–11.

———. "Tung Ch'i-ch'ang's New Orthodoxy and the Southern School Theory." In Christian Murck, ed., *Artists and Traditions,* 1976.

Huang, Ray. *1587: A Year of No Significance.* New Haven: Yale University Press, 1981.

Hummel, Arthur W., ed. *Eminent Chinese of the Ch'ing Period (1644–1912).* Washington, D.C.: Library of Congress, 1943–44.

Hung, Josephine Huang. *Ming Drama.* Taibei: Heritage Press, 1966.

J

Jao, Tsung-i. "Painting and the Literati in the Late Ming." In *Proceedings of the Symposium on Painting and Calligraphy by Ming I-min,* 1976.

Jenyns, R. Soame. "The Chinese Rhinoceros and Chinese Carvings in Rhinoceros Horn." *Transactions of the Oriental Ceramic Society* (London), 29, 1954–55, pp. 31–62.

Jiaxing fuzhi (Gazetteer of Jiaxing). Facsimile reprint of 1879 edition, Taibei: Chengwen Reprint Co., 1970.

Jin Xijia and Wang Shixiang. *Zhuke yishu [The Art of Bamboo Carving].* Beijing: Renmin meishu chubanshe, 1980.

K

Kerr, Rose. "The Evolution of Bronze Style in the Jin, Yuan and Early Ming Dynasties." *Oriental Art* (London) new series 28, no. 2, Summer 1982, pp. 146–158.

Keswick, Maggie. *The Chinese Garden.* London: Academy Editions, 1978.

Kohara Hironobu. *Tō Kishō no shoga [Dong Qichang: The Man and His Work],* 2 vols. Tokyo: Nigensha, 1981.

Kong Qi. *Zhizheng zhiji. (Aoyatang congshu* edition).

L

Laufer, Berthold. *Insect-Musicians and Cricket Champions of China (Anthropology Leaflet 22).* Chicago: Field Museum of Natural History, 1927.

Lee, Sherman E., and Wai-kam Ho. *Chinese Art Under the Mongols: The Yüan Dynasty (1279–1368).* Cleveland: The Cleveland Museum of Art, 1968.

Li, Chu-tsing. "The Development of Painting in Soochow During the Yuan Dynasty." In *Proceedings of the International Symposium on Chinese Painting,* 1972.

———. *A Thousand Peaks and Myriad Ravines: Chinese Paintings in the Charles A. Drenowatz Collection.* Ascona, Switzerland: Artibus Asiae Supplementum XXX, 1974.

———. "Xiang Shengmo zhi zhaoyin shihua [Xiang Shengmo's Poetry and Painting on Eremitism]." In *Proceedings of the Symposium on Painting and Calligraphy by Ming I-min,* 1976.

Li, Hui-lin. *Chinese Flower Arrangement.* Princeton, 1956.

Li Rihua. *Liuyanzhai biji,* 3 parts, 1626, 1630, and 1635. Reprint, Shanghai: Zhongyang Book Co., 1935.

———. *Meixu xiansheng bielu,* 2 vols, 1600s. In *Yimen guangdu (Baibu congshu* ed.), Taibei, 1965, no. 13.

———. *Tianzhitang ji,* 1638. Facsimile reprint, Taibei: National Central Library, 1971, 6 vols.

———. *Weishuixuan riji,* 1609–16. Woodblock reprint, Beijing: Wenwu Press, 1982, 8 vols.

———. *Zhulan huasheng,* ca. 1614. In Deng Shi and Huang Binhong, comps., *Meishu congshu,* 1912–36, VI:2/2.

———. *Zhulan xu huasheng,* ca. 1625. In Deng Shi and Huang Binhong, comps., *Meishu congshu,* 1912–36, VI:2/2.

———. *Zhulan Mojun tiyu,* 1600s. In Deng Shi and Huang Binhong, comps., *Meishu congshu,* 1912–36, VI:2/2.

———. *Zitaoxuan zazhui,* ca. 1617, and *Zitaoxuan youzhui,* ca. 1623. In the exhibition. For reference, reprint Shanghai: Zhongyang Book Co., 1935.

Li Yu. *Xianqing ouji,* 1671. Reprint, Taibei: Taiwan shidai shuju, 1975.

Li Zhaoheng. *Zui'ou Mojun tiyu,* 1600s. In Deng Shi and Huang Binhong, comps., *Meishu congshu,* 1912–36, VI:2/2.

Li Zhizhong. "Mingdai keshu shulüe." *Wenshi* 23, 1984, pp. 127–158.

Liang, David Ming-yueh. *The Chinese Ch'in: Its History and Music.* Taibei: Zhonghua guoyuehui, 1969.

Liao Fushu. *Zhongguo gudai yinyue jianshi [A Brief History of Ancient Chinese Music].* Beijing: Renmin yinyue chubanshe, 1982.

Lion-Goldschmidt, Daisy. *Ming Porcelain.* New York: Rizzoli, 1978. Trans. Katherine Watson.

Liu Yanliang. *Duanxi mingyan [Duanxi Inkstones].* Guangzhou: Guangdong renmin chubanshe, 1979.

Lo, K.S. K.S. Lo Collection in the Flagstaff House Museum of Tea Ware, parts I and II. Hong Kong 1984.

M

Ming shi [History of the Ming Dynasty]. One of the *Twenty-four Official Histories. Kaiming* edition. Reprint, Taibei, 1963.

Mote, Frederick W. "Yuan and Ming." In K.C. Chang, ed., *Food in Chinese Culture: Anthropological and Historical Perspectives,* New Haven and London: Yale University Press, 1977.

Mu Xiaotian, ed. *Zhongguo wenfang sibao shi* [*A History of the Four Treasures of the Chinese Scholar's Studio*]. Hong Kong: Nantong tushu gongsi, n.d., rev. ed.

———, and Li Minghui. *Zhongguo Anhui wenfang sibao* [*The Four Treasures of the Scholar's Studio in Anhui, China*]. Hefei: Anhui Scientific and Technical Press, 1983.

Murck, Christian, ed. *Artists and Traditions*. Princeton: Princeton University Press, 1976.

N

National Palace Museum, comp. *Wupaihua jiushinian zhan* [*Ninety Years of Wu School Painting*]. Taibei: National Palace Museum, 1975.

———, comp. *Yuan si dajia* [*The Four Great Masters of the Yuan*]. Taibei: National Palace Museum, 1975.

Nienhauser, William H., Jr., ed. and comp. *The Indiana Companion to Traditional Chinese Literature* (Bloomington: Indiana University Press, 1986).

P

Paintings and Calligraphy by Ming I-min from the Chih-lo Lou Collection. Hong Kong: Art Gallery of the Institute of Chinese Studies of the Chinese University of Hong Kong, 1975.

Pan Guangdan. *Ming Qing liangdai Jiaxing di wanzu* [*The Famous Clans of Jiaxing during the Ming and Qing Periods*]. Shanghai: Shangwu yinshuguan, 1947.

Pang Yuanji. *Xuzhai minghualu*, 16 vols., supplement 4. vols.

Peterson, Willard J. *Bitter Gourd: Fang I-chih and the Impetus for Intellectual Change*. New Haven: Yale University Press, 1979.

Proceedings of the International Symposium on Chinese Painting. Taibei: National Palace Museum, 1972.

Proceedings of the Symposium on Painting and Calligraphy by Ming I-min, a special issue of *The Journal of the Institute of Chinese Studies* (Hong Kong) 8, no. 2, December 1976.

Q

Qian Qianyi. *Liechao shiji xiaozhuan*, 1649.

———. *Chuxue ji* and *Youxue ji. Sibu congkan* edition.

S

Sekino Takeshi, Hayashi Minao, and Hasebe Gakuji. *Shanhai hakubutsukan shutsudo bumbutsu seidōki tōjiki* [*The Shanghai Museum: Excavated Cultural Relics, Bronzes, and Ceramics*]. Tokyo: Heibonsha, 1976.

Shanghai bowuguan, Shen Lingxin, and Xu Yongxiang. "Shanghaishi Qingpuxian Yuandai Renshi muzang jishu." *Wenwu* (Beijing) 7, 1982, pp. 54–60.

Shanghai Museum, comp. *Shanhai hakubutsukan* [*The Shanghai Museum*]. Volume 8 in *Chūgoku no hakubutsukan* [*The Museums of China*]. Tokyo: Kodansha, 1983.

———, comp. *Bamboo Carving*. Shanghai: Shanghai Museum, 1986.

Shanghaishi wenwu baoguan weiyuanhui, comp. "Shanghai shijiao Ming mu qingli jianbao [Brief Report on the Excavation of a Ming Tomb in the Suburbs of Shanghai]." *Kaogu* (Beijing) 11, 1963.

———, comp. *Shanghai gudai lishi wenwu tulu* [*An Illustrated Catalogue of Ancient Cultural Objects from Shanghai*]. Shanghai: Jiaoyu chubanshe, 1981.

Shanghaishi wenwu guanli weiyuanhui daoguzu, comp. "Shanghai faxian yipi Ming Chenghua nianjian keyin di changben, chuanqi [A Group of Ming Chenghua-period Woodblock-printed *Changben* and *Chuanqi* Books Discovered in Shanghai]." *Wenwu* (Beijing) 11, 1972, p. 67.

Shao Changheng. *Jingwu ji.*

Shen Defu. *Feifu yulüe*. In *Congshu jicheng*. Shanghai: Shangwu yinshuguan, 1935–37.

———. *Wanli yehuo (xin) bian*, 1606. Reprint, Beijing, 1959.

Shen Zhiyu. "Ba Luoxuan biangu jian pu [A Postscript to the Wisteria Studio Album of Stationery Decorated with Ancient and Modern Designs]." *Wenwu* (Beijing) 7, 1964.

———, ed. *The Shanghai Museum of Art*. New York: Harry N. Abrams, 1983.

Songjiang fuzhi [*Gazetteer of Songjiang*]. Facsimile reprint of 1817 edition, Taibei: Chengwen Reprint Co., 1970.

Sowerby, A. deC. "Cricket Gourds and Culture in China." *The China Journal* 18, no. 3, 1933, pp. 157–162.

Sung, Ying-hsing. *T'ien-kung K'ai-wu: Chinese Technology in the Seventeenth Century*. University Park and London: The Pennsylvania State University Press, 1966. Trans. E-tu Zen Sun and Shiou-chuan Sun.

Suzuki Kei, comp. *Chūgoku kaiga sōgō zuroku* [*Comprehensive Illustrated Catalogue of Chinese Paintings*], 5 vols. Tokyo: University of Tokyo, 1982–83.

T

Tsang, Gerard, and Hugh Moss. "Chinese Metalwork of the Hu Wenming Group." In *International Asian Antiques Fair Catalogue*, Hong Kong: Andamans East International, 1984.

Tsien, Tsuen-hsuin. *Paper and Printing*. Volume 5, part 1 in Joseph Needham, ed., *Science and Civilisation in China*. Cambridge: Cambridge University Press, 1985.

Tu Long. *Xiangjian* [*Treatise on Incense*], late 1500s. In Deng Shi and Huang Binhong, comps., *Meishu congshu*, 1912–36, X 2/9.

W

Wang, Chi-chen. "Notes on Chinese Ink." *Metropolitan Museum Studies* (New York) 3, part I, 1930, pp. 114–133.

Wang Qingzheng. "Guan, ge liangyao ruogan wenti di tansuo." In Zhongguo kaogu xuehui, comp., *Di san ci nianhui lunwen ji*, Beijing: Wenwu chubanshe, 1981.

Wang, Shixiang. *Classic Chinese Furniture: Ming and Early Qing Dynasties*. Hong Kong: Joint Publishing Co., 1986. Trans. Sarah Handler and the author.

———. "Moulded Gourds." In *Chinese Translations* no. 10, London: Oriental Ceramic Society, n.d. (but ca. 1983), pp. 16–30. Trans. Craig Clunas. The original, Chinese version appeared in *Gugong bowuyuan yuankan* (Beijing) no. 1.

——— and Wan-go Weng. *Bamboo Carving of China*. New York: China Institute in America, 1983.

Wang Shizhen. *Gubugu lu*, 1585. In *Congshu jicheng, jianbian*. Shanghai: Shangwu yinshuguan, 1935–37.

———. *Yiyuan zhiyan*, 1558–72. In Wang Qiyuan, *Tanyizhu congshu*, Changsha, 1885.

Watt, James C.Y. *Chinese Jades from Han to Ch'ing.* New York: The Asia Society, 1980.

———. "The Qin and the Chinese Literati." *Orientations* (Hong Kong) 12, no. 11, November 1981, pp. 38–49.

———. *The Sumptuous Basket: Chinese Lacquer with Basketry Panels.* New York: China Institute in America, 1985.

Wen Zhenheng. *Zhangwu zhi,* 1637. In Deng Shi and Huang Binhong, comps., *Meishu congshu,* 1912–36, XV 3/9. Also, *Zhangwu zhi jiaozhu,* 1637. Nanjing, collated and annotated edition, 1984, with a preface by Shen Shunze.

Weng, Wan-go H.C. *Gardens in Chinese Art.* New York: China Institute in America, 1968.

Wilson, Marc F., and Kwan S. Wong. *Friends of Wen Chengming: A View from the Crawford Collection.* New York: China Institute in America, 1974.

Wong, K.S. "Hsiang Yüan-pien and Su-chou Painters." Paper presented at the Symposium on Chinese Painting at the Nelson-Atkins Museum of Art, Kansas City, 1980.

Wu Han. "Wan Ming liukou zhi shehui beijing [The Social Background for the Rebel-bandits in Late Ming]." In *Wu Han shixue lunzhu xuanji,* Beijing, 1984.

Wu Lanxiu. *Duanxi yanshi* [*History of Duan Inkstones*]. Privately printed, 1834.

Wu, Nelson I. "Tung Ch'i-ch'ang (1555–1636): Apathy in Government and Fervor in Art." In Arthur F. Wright and Dennis C. Twitchett, eds., *Confucian Personalities,* Stanford: Stanford University Press, 1962.

———. "The Evolution of Tung Ch'i-ch'ang's Landscape Style as Revealed by His Works in the National Palace Museum." In *Proceedings of the International Symposium on Chinese Painting,* 1972.

Wu Zhao and Liu Dongsheng. *Zhongguo yinyue shilüe* [*A Short History of Chinese Music*]. Beijing: Renmin yinyue chubanshe, 1958.

X

Xie Guozhen, ed. *Mingdai shehui jingji shiliao xuanbian* [*Materials on Socio-economic Conditions during the Ming Dynasty*]. Fuzhou, 1980.

Xu Shu'an. "Mingchao di keju xuanguan zhidu." *Wenxian* 3, 1985, pp. 256–269.

Xu Yishi. *Ming fu qijia kao.* In Tao Ting, ed., *Xu shuo fu,* Taibei: Xinxing shuju reprint.

Y

Yao Wengwang. "Tang Tianchi he Liang Yingda di tiehua."

Wenwu cankao ziliao (Beijing) 3, 1957, pp. 22–24.

Ye Qiu. "Kandan yanshi ziliao shuoming [An Explanation of Materials on the History of Inkstones]." *Wenwu* (Beijing) 1, 1964, pp. 49–52.

Yee, Ip. *Chinese Jade Carving.* Hong Kong: The Urban Council and the Hong Kong Museum of Art, 1983.

———. "Notes on a Collection of Chinese Rhinoceros Horn Carvings." In *International Asian Antiques Fair Catalogue,* Hong Kong: Andamans East International, 1982.

———, and Laurence C.S. Tam. *Chinese Bamboo Carving,* 2 vols. Hong Kong: The Urban Council and the Hong Kong Museum of Art, part I, 1978, part II, 1982.

Yu, Chun-fang. *The Renewal of Buddhism in China: Chuhung and the Late Ming Synthesis.* New York: Columbia University Press, 1981.

Yu Jianhua, comp. *Zhongguo hualun leibian,* 2 vols. Beijing: Chinese Classical Art Publishing Co., 1957.

Yuan Hongdao. "Letter to Qiu Zhangru," "Preface to Chen Zhengfu's *Huixinji,*" "A Postscript to Zhang Youyu's [Zhang Xianyi's] Poem on the Xiaoshan Springs." In Qian Bocheng, ed., *Yuan Hongdao ji jianjiao,* Shanghai: Guji chubanshe, 1981.

Yuan Zhongdao. *Kexuezhai jinji,* 1600s. Zhongyang shuju edition of 1936. Reprinted by Shanghai: Shanghai shudian, 1982.

Yuanyanghu zhaoge (Sun Fuqing, ed., *Zuili yishu* edition).

Z

Zeng Jing di xiaoxiang hua. Beijing: Renmin meishu chubanshe, 1981.

Zhang Dai. *Langhuan wenji.* In *Zhongguo wenxue zhenben congshu* (Shanghai: Zazhi gongsi, 1935).

Zhang Yangsheng. *Shanben beitie lu* [*An Annotated List of Rare Rubbings*]. Beijing: Institute of Archaeology, Academy of Social Sciences, 1984.

Zhang Zengyuan. *Zhonghua wenshi luncong.* 1986.

Zhao Yi. *Nianershi daji.* In *Congshu jicheng.* Shanghai: Shangwu yinshuguan, 1936–37.

Zhou Lianggong. *Shuying,* 1667. Shanghai, 1958 reprint.

Zhu Jialian. "Shuo yan [On Inkstones]." *Wenwu* (Beijing) 12, 1954, 18–20.

Zhu Jianxin, ed. *Wan Ming xiaopinwen xuan.* Shanghai, 1937.

Zhu Mengzhen. *Yusi shitan.* In *Congshu jicheng.* Shanghai: Shangwu yinshuguan, 1936–37.

Zhuanxue congshu [*Collection of Thirty-two Works on Seal Carving*]. Shanghai, 1918.

List of Artists

Bai Juyi (772–846)　　　　　　　　白居易

Cai Yong (133–192)　　　　　　　　蔡邕

Cao Zhao (act. 14th century)　　　　曹昭

Cao Zhibo (1271–1355)　　　　　　曹知白

Chen Congzhou (Qing period)　　　陳從周

Chen Hongshou (1599–1652)　　　　陳洪綬

Chen Ji (1370–1434)　　　　　　　陳繼

Chen Jiru (1558–1639)　　　　　　陳繼儒

Chen Ruyan (ca. 1331–1371)　　　　陳汝言

Cheng Jiasui (1565–1644)　　　　　程嘉燧

Cheng Junfang (1541–ca. 1616)　　程君房

Cheng Tinglu (1796–1858)　　　　　程庭鷺

Dai Jin (1388–1462)　　　　　　　戴進

Ding Yunpeng (1547–ca. 1621)　　丁雲鵬

Dong Qichang (1555–1636)　　　　董其昌

Dong Yuan (d. 962)　　　　　　　董源

Du Fu (712–770)　　　　　　　　杜甫

Du Mu (803–852)　　　　　　　　杜牧

Du Qiong (1397–1474)　　　　　　杜瓊

Du Yu (d. 1397)　　　　　　　　杜玉

Fan Lian (b. 1540)　　　　　　　范濂

Fang Yulu (act. 1573–1620)　　　　方于魯

Feng Fang (*jinshi*, 1523)　　　　　豐坊

Feng Menglong (1574–1646)　　　　馮夢龍

Feng Mengzhen (1548–1605)　　　　馮夢楨

Feng Xijue (act. 1622–1722)　　　　封錫爵

Feng Xilu (act. 1662–1722)　　　　封錫祿

Feng Xizhang (act. 1662–1722)　　　封錫璋

Gan Yang (act. 1573–1620)　　　　甘暘

Gao Ming (ca. 1305–after 1368)　　高明

Gao Shiqi (1645–1703)　　　　　　高士奇

Gongchun (act. 1506–1521)　　　　供春

Guan Chiqing (act. 1573–1620)　　　管馳卿

Gui Changshi (1573–1644)　　　　歸昌世

Gui Youguang (1506–1571)　　　　歸有光

Gui Zhuang (1613–1673)　　　　　歸莊

He Liangjun (1506–1573)　　　　　何良俊

He Shi (16th–early 17th century)　　何適

He Zhen (act. 1573–1620)　　　　　何震

Hongren (1610–1664)　　　　　　弘仁

Hu Guangyu (act. late 16th–first half 17th century)　胡光宇

Hu Wenming (act. 1573–1620)　　　胡文明

Hu Zhengyan (ca. 1582–1672)　　　胡正言

Huang Duanfu (act. 1573–1620)　　黃端甫

Huang Fengchi (act. 1573–1620)　　黃鳳池

Huang Gongwang (1269–1354)　　　黃公望

Huang Yibin (act. 1573–1620)　　　黃一彬

Huang Yifeng (b. 1583)　　　　　黃一鳳

Huang Yikai (act. 1573–1620)　　　黃一楷

Huang Yingrui (act. 1573–1620)　　黃應瑞

Ji Cheng (1582–after 1640)　　　　計成

Ji Yuanru (act. mid-16th century)　計元儒

Juran (act. 960–980)　　　　　　巨然

Li Bai (712–756)　　　　　　　李白

Li Gonglin (1049–1105/06)　　　　李公麟

Li Hangzhi (d. 1644)　　　　　　李杭之

Li Hanmei (act. late 17th–early 18th century)　李含渼

Li Kan (1245–1320)　　　　　　李衎

Li Liufang (1575–1629)　　　　　李流芳

Li Qizhi (1622–after 1699)　　　　李琪枝

Li Rihua (1565–1635)　　　　　　李日華

Li Rongjin (act. 14th century)　　　李容瑾

Li Shixing (1282–1328)　　　　　李士行

Li Shizhen (1518–1593)　　　　　李時珍

Li Sixun (653–718)	李思訓	Su Qin (d. 317 B.C.)	蘇秦
Li Tinggui (act. 950–980)	李廷珪	Su Shi (1037–1101)	蘇軾
Li Xinzhi (*juren*, 1642)	李新枝	Su Wu (ca. 143–60 B.C.)	蘇武
Li Yu (1611–1679)	李玉	Sun Kehong (1532–1610)	孫克宏
Li Zhaodao (ca. 670–730)	李昭道	Tan Qian (1593–1657)	談遷
Li Zhaoheng (ca. 1592–ca. 1662)	李肇亨	Tang Peng (act. 17th century)	湯鵬
Li Zhi (1527–1602)	李贄	Tang Xianzu (1550–1616)	湯顯祖
Liang Yingfeng (act. 17th–18th century)	梁應逢	Tang Yifen (1778–1853)	湯貽汾
Ling Mengchu (1580–1644)	凌濛初	Tang Yin (1470–1523)	唐寅
Lou Jian (1567–1631)	婁堅	Tao Qian (365–427)	陶潛
Lu Dezhi (1585–after 1660)	魯得之	Tao Zongyi (1316–1403)	陶宗儀
Lu Wuqing (act. 17th century)	陸武清	Ting Shou (prob. Qing period)	廷橋
Lu Zhi (1496–1576)	陸治	Tu Long (1542–1605)	屠隆
Lu Zigang (act. mid-late 16th century)	陸子剛	Wang Hongjian (act. 17th century)	汪鴻漸
Luo Zhichuan (d. before 1330)	羅稚川	Wang Hui (1632–1717)	王翬
Ma Shouzhen (1548–1604)	馬守真	Wang Kentang (b. 1553)	王肯堂
Meng Ren (prob. act. late 16th–17th century)	孟仁	Wang Meng (1308–1385)	王蒙
Meng Yuanlao (ca. 1090–1150)	孟元老	Wang Mian (1287–1359)	王冕
Mi Fu (1052–1107)	米芾	Wang Sanglin (act. 16th–17th century)	汪泰林
Mi Wanzhong (1570–after 1628)	米萬鍾	Wang Shen (ca. 1048–ca. 1103)	王詵
Mi Youren (ca. 1072–1151)	米友仁	Wang Shimin (1592–1680)	王時敏
Mo Shilong (1539?–1587)	莫是龍	Wang Shizhen (1526–1590)	王世貞
Ni Zan (1301–1374)	倪瓚	Wang Shouren (1472–1528)	王守仁
Pan Yunduan (1526–1601)	潘允端	Wang Wei (701–761)	王維
Qian Gu (1508–ca. 1578)	錢穀	Wang Xianzhi (344–388)	王獻之
Qian Qianyi (1582–1664)	錢謙益	Wang Xizhi (321–379 or 303–361)	王羲之
Qian Xuan (ca. 1235–after 1301)	錢選	Wang Zhenpeng (act. late 13th–14th century)	王振鵬
Qiu Ying (1494/95–1552)	仇英	Wang Zhideng (1535–1612)	王穉登
Qiutan (1558–1630)	秋潭	Wei Dan (179–253)	韋誕
Ruan Dacheng (ca. 1587–1646)	阮大鋮	Wei Rufen (prob. 17th century)	魏汝奮
Shao Yong (1011–1077)	邵雍	Wen Jia (1501–1583)	文嘉
Shen Dasheng (act. first half 17th century)	沈大生	Wen Peng (1498–1573)	文彭
Shen Defu (1578–1642)	沈德符	Wen Tong (1018/19–1079)	文同
Shen Heng (1409–1477)	沈恆	Wen Yuanfa (1529–1602)	文元發
Shen Zhou (1427–1509)	沈周	Wen Zhengming (1470–1559)	文徵明
Shi Dabin (act. 1573–1620)	時大彬	Wen Zhenheng (1585–1645)	文震亨
Shi Peng (act. 1573–1620)	時朋	Weng Songnian (1647–1728)	翁嵩年
Song Xu (1525–ca. 1607)	宋旭	Wu Daozi (act. ca. 710–ca. 760)	吳道子
Song Yingxing (b. 1587)	宋應星	Wu Faxiang (b. 1578)	吳發祥

Wu Kuan (1436–1504)	吳寬	Zhang Shaoping (b. 160 B.C.)	張少平
Wu Zhen (1280–1354)	吳鎮	Zhang Shiche (1500–1577)	張時澈
Wu Zhifan (act. second half 17th century)	吳之璠	Zhang Wen (act. 16th century)	章文
Xi Kang (223–262)	奚康	Zhang Xihuang (act. 17th century)	張希黃
Xiang Deda (act. 16th–early 17th century)	項德達	Zhang Yongxin (act. 15th–16th century)	張永馨
Xiang Nanzhou (17th century)	項南洲	Zhang Zao (b. 1547)	章藻
Xiang Shengbiao (act. 17th century)	項聲表	Zhao Mengfu (1254–1322)	趙孟頫
Xiang Shengmo (1597–1658)	項聖謨	Zhao Nanxing (1550–1628)	趙南星
Xiang Yuanbian (1525–1590)	項元汴	Zhao Zuo (ca. 1570–after 1633)	趙左
Xiao Yuncong (1596–1673)	蕭雲從	Zhou Ding (1401–1487)	周鼎
Xie Bin (b. 1602)	謝彬	Zhou Hao (1686–1773)	周灝
Xie Zhen (1495–1575)	謝榛	Zhou Jing (act. 16th century)	周經
Xu Wei (1521–1593)	徐渭	Zhou Lianggong (1612–1672)	周亮工
Yan Zhenqing (709–785)	顏真卿	Zhou Lijing (16th century)	周履靖
Yang Ji (act. 17th century)	楊璣	Zhu Bao (1481–1533)	朱豹
You Kan (prob. act. 17th century)	尤侃	Zhu Chaqing (d. 1572)	朱察卿
Yuan Hongdao (1568–1610)	袁宏道	Zhu Chunchen (d. 1601)	諸純臣
Yuan Jiong (1495–1560)	袁褧	Zhu Haihe (act. mid-Ming)	祝海鶴
Yuan Mei (1716–1798)	袁枚	Zhu He (act. 16th century)	朱鶴
Yuan Zhongdao (1570–1623)	袁中道	Zhu Lang (act. mid-16th century)	朱朗
Zeng Jing (1564–1647)	曾鯨	Zhu Shoucheng (d. Wanli period 1573–1620)	朱守城
Zhang Aochun (act. early 17th century)	張鰲春	Zhu Ying (act. late 16th–early 17th century)	朱纓
Zhang Dai (1597–1679)	張岱	Zhu Yizun (1629–1709)	朱彝尊
Zhang Jing(?)xiu (act. late Ming)	張敬(?)修	Zhu Yunming (1461–1527)	祝允明
Zhang Qi (act. mid-17th century)	張琦	Zhu Zhizheng (act. 1620–1645)	朱稚征
Zhang Qian (2nd century B.C.)	張騫	Zou Zhilin (jinshi, 1610)	鄒之麟